"William Dyrness and Roberta King have assembled an amazing collection of essays that speak of the power of art in making peace, contextualizing theology, and aiding in the evangelization of peoples. Ordinarily we speak of the dialogue of life, common witness, theology, and spirituality. This collection introduces another way of thinking about dialogue: the dialogue of beauty. The beauty of music, dance, poetry, and the visual is one that can transcend faiths and lead to a new way of experiencing how God's grace incarnates itself in human experience. This is a pioneer volume. I hope it begins to point to a new way of thinking about theology and mission."

Stephen Bevans, SVD, Catholic Theological Union, Chicago

"Professors King and Dyrness have gathered a bouquet of perspectives on the arts and multifaith contexts from specialists in theology, missiology, ethnomusicology, ethnodoxology, arts education, artistic creation, performance, and more. This volume highlights the powerful ways that engagement with the arts can help us better understand and engage with the complex belief systems of our globalized world. Be prepared to have your vision expanded and your perspective challenged!"

Robin Harris, director of the Center for Excellence in World Arts at Dallas International University, president of the International Council of Ethnodoxologists

"*The Arts as Witness in Multifaith Contexts* is a breath of fresh air for those seeking to engage the arts in mission today. The various authors provide a multitude of examples to demonstrate this creative engagement from contexts around the world. Instead of a 'cookbook' approach, the authors demonstrate both the complexities and opportunities for contextualization facing mission practitioners. This timely book provides helpful insight for missiology in today's pluralistic world."

W. Jay Moon, professor of intercultural studies and director of the Office of Faith, Work, and Economics, Asbury Theological Seminary

THE ARTS AS WITNESS IN MULTIFAITH CONTEXTS

Edited by
ROBERTA R. KING
and WILLIAM A. DYRNESS

ivp
Academic
An imprint of InterVarsity Press
Downers Grove, Illinois

InterVarsity Press
P.O. Box 1400, Downers Grove, IL 60515-1426
ivpress.com
email@ivpress.com

InterVarsity Press® is the book-publishing division of InterVarsity Christian Fellowship/USA®, a movement of students and faculty active on campus at hundreds of universities, colleges, and schools of nursing in the United States of America, and a member movement of the International Fellowship of Evangelical Students. For information about local and regional activities, visit intervarsity.org.

All Scripture quotations, unless otherwise indicated, are taken from The Holy Bible, New International Version®, NIV®. Copyright © 1973, 1978, 1984, 2011 by Biblica, Inc.™ Used by permission of Zondervan. All rights reserved worldwide. www.zondervan.com. The "NIV" and "New International Version" are trademarks registered in the United States Patent and Trademark Office by Biblica, Inc.™

While any stories in this book are true, some names and identifying information may have been changed to protect the privacy of individuals.

Cover design and image composite: David Fassett
Interior design: Beth McGill
Image: © Hibrida13 / iStock / Getty Images Plus

ISBN 978-0-8308-5106-5 (print)
ISBN 978-0-8308-5796-8 (digital)

Printed in the United States of America ∞

InterVarsity Press is committed to ecological stewardship and to the conservation of natural resources in all our operations. This book was printed using sustainably sourced paper.

Library of Congress Cataloging-in-Publication Data
Names: King, Roberta Rose, 1949- editor. | Dyrness, William A., editor.
Title: The arts as witness in multifaith contexts / edited by Roberta R. King and William A. Dyrness.
Description: Downers Grove, Illinois : IVP Academic, an imprint of InterVarsity Press, [2019] | Includes
 bibliographical references and index.
Identifiers: LCCN 2019029425 (print) | LCCN 2019029426 (ebook) | ISBN 9780830851065 (paperback) | ISBN
 9780830857968 (ebook)
Subjects: LCSH: Christianity and the arts--Case studies. | Christianity and culture—Case studies. | Witness bearing
 (Christianity) | Christianity and other religions--Case studies.
Classification: LCC BR115.A8 A7755 2019 (print) | LCC BR115.A8 (ebook) | DDC 261.5/7—dc23
LC record available at https://lccn.loc.gov/2019029425
LC ebook record available at https://lccn.loc.gov/2019029426

P	22	21	20	19	18	17	16	15	14	13	12	11	10	9	8	7	6	5	4	3	2	1
Y	39	38	37	36	35	34	33	32	31	30	29	28	27	26	25	24	23	22	21	20	19	

In memory of
Lamin Sanneh
and
J. H. Kwabena Nketia

Contents

List of Figures and Tables ix

Introduction 1
Roberta R. King and William Dyrness

PART I: SETTING THE STAGE

1 Arts and Mission: A Complex Story of Cultural Encounter 21
James R. Krabill

2 Performing Witness: Loving Our
Religious Neighbors Through Musicking 39
Roberta R. King

PART II: CHRISTIANS REACHING OUT TO THEIR NEIGHBORS

3 God Moves in a Mysterious Way: Christian
Church Music in Multifaith Liberia, West Africa,
in the Face of Crisis and Challenge 69
Ruth M. Stone

4 Sounds, Languages, and Rhythms:
Hybridized Popular Music and Christian-National
Identity Formation in Malaysia, Thailand, and Cambodia 87
Sooi Ling Tan

5 Art as Dialogue: Exploring Sonically Aware Spaces for
Interreligious Encounters 107
Ruth Illman

6 "*Simba Nguruma*": The Labor of Christian Song in Polycultural,
Multifaith Kenya 126
Jean Ngoya Kidula

PART III: CHRISTIANS CREATING NEW INTERFAITH EXPRESSIONS

7 Crate-Digging Through Culture: Hip-Hop and Mission
in Pluralistic Southern Africa 149
Megan Meyers

8 "Let the Sacred Be Redefined by the People": An Aesthetics
of Challenge Across Religious Lines 171
Michelle Voss Roberts and Demi Day McCoy

9 Wild, Wild China: Contemporary Art and Neocolonialism 190
Joyce Yu-Jean Lee

10 The Poetic Formation of Interfaith Identities:
The Zapatista Case 213
William Dyrness

List of Contributors 231

Image Credits 233

Name and Subject Index 235

Scripture Index 243

List of Figures and Tables

FIGURES

1.1.	Bridge illustration	29
2.1.	Musical spaces of discovering and relating	43
2.2.	Musicking toward neighborly relations	59
3.1.	St. Peter's Lutheran Kpelle Choir	71
3.2.	Videographer James Weegi, St. Peter's Lutheran Church, Monrovia, Liberia (2016)	72
3.3.	St. Peter's Lutheran Church Kpelle Choir (2016)	79
7.1.	Ranked concerns for African youth	164
9.1.	Huang Yong Ping, *Theater of the World* (1993)	191
9.2.	Sun Yuan and Peng Yu, *Dogs That Cannot Touch Each Other* (2003)	192
9.3.	Xu Bing, *A Case Study of Transference* (1994)	193
9.4.	Huang Yong Ping, *Theater of the World* (2017)	194
9.5.	Chen Hu, *Station 12 of the Cross: Jesus Dies on the Cross* and *Station 14 of the Cross: Jesus Is Laid in the Tomb* (2015)	197
9.6. and 9.7.	Huma Bhabha, *We Come in Peace* (2017)	199
9.8.	Joyce Yu-Jean Lee, *Verti-Call* (2016)	200
9.9.	Joyce Yu-Jean Lee, *FIREWALL*	210
10.1.	Mural portraying first national indigenous congress, 1974	218
10.2.	*Caracoles* (conches) offer religious and cosmic symbolism	220
10.3.	Those who hold up the sky while listening	221

10.4. *Vida y Sueño de la Cañada Perla* mural in Taniperla, Chiapas (destroyed) 222

10.5. Testimony to Acteal massacre 223

10.6. Symbols of Mayan corporate identity 226

10.7. Anonymous community artists (*camilios*) promote corporate vision of community 227

10.8. *Pasamontana* (ski mask) as representation of subversive identity 227

10.9. Subversive liturgy at Pasadena police station 230

TABLES

4.1. Acts of Christ Church, Bangkok, songs 100

7.1. Globalization's impact on culture 152

Introduction

Roberta R. King and William Dyrness

This collection represents some initial reflections on the role the arts play in the global life and mission of the church. While many of the authors have thought deeply and long on this topic, the scholarly project of reflection on arts and mission amid growing religious and cultural pluralism is still in its infancy. This is not to say that the global church has not faced these issues: Christians, like adherents of any (or no) faith, increasingly live beside neighbors (and in families) who practice different religions. Churches in many places welcome people with diverse religious and cultural backgrounds, and these new friends have often brought with them their musical and aesthetic preferences, and many responses to this diversity already include some form of the arts—the growing role that anthropologists play in mission education has often referenced the arts, as we will note presently. In an important sense, the actual interaction of art and mission is already well advanced. In this book we seek to step back and ask, What is the significance of this interaction? And what are its present and future prospects?

One might ask why this engagement with the arts in its global dimension has only recently attracted the widespread attention of scholars of mission and world Christianity. There are historical reasons for this: the Western colonial mindset of mission that too often dismissed the value of local cultural forms; the overly cognitive approach to religious belief that privileged the verbal over the affective; and the related influence of Protestantism that preferred music to other forms of art (an influence that is surely evident in the selection of articles presented here!). But the more important reason for the new interest in art and mission is the fresh assessment of the global

landscape: it is safe to say the major challenge facing any careful consider-
ation of arts and mission today is the inescapable complexity of the mixture
of local and global influences—cultural, political, and religious—that Chris-
tians face today. This mashup is evident in many of the chapters of this book
but is perhaps best seen in the chapters on hip-hop, which describe a global
phenomenon with deep local impact. Indeed, it is sometimes impossible to
trace all the crosscurrents at work in the diverse world Christian believers
face and that influence the works that artists and composers come up with.
All of this reflects a diversity at once invigorating and, for some, unsettling.

American Christians are only too aware of the radical changes in the re-
ligious landscape over the past fifty years. New waves of immigrants, first
prompted by the 1965 Immigration and Naturalization Act, are emerging
and growing with ever-increasing waves of peoples arriving from all over
the globe.[1] With them have come adherents of religious traditions of the
world—Islamic, Hindu, and Buddhist. In addition to bringing their faith
practices, these diasporic faith communities are also transporting their aes-
thetic and musical performance traditions. Across the continental United
States, for example, annual Middle East arts festivals are taking place, com-
plete with websites highlighting the foods, dances, and musics that make up
each festive celebration. In Southern California alone, a plethora of Thai,
Chinese, Korean, Mediterranean, and Indian restaurants reveal some of the
diversity of peoples taking up residence in our daily lives. Not only are the
demographics of our local neighborhoods shifting, but religious practices
and cultural preferences are expanding.

Indeed, in our era of heightened globalization, Christians worldwide
experience movements of peoples that significantly impact social, religious,
and ethnic interactions in daily life settings. Similar to the United States,
Europe has watched the international migration first initiated in the late
1960s result in its religious landscape "becoming a complex pattern of
ethnic and religious affiliations."[2] Globalization and immigration create
boundaries that "run along religious, ethnic and national divides, reflecting

[1]Diana L. Eck, *A New Religious America: How a "Christian Country" Has Become the World's Most Religiously Diverse Nation* (New York: HarperCollins, 2001).
[2]Margit Warburg, "Globalization, Migration and the Two Types of Religious Boundary: A Euro-pean Perspective," in *Religion, Globalization, and Culture,* ed. Peter Beyer and Lori Beaman (Leiden: Brill, 2007), 80.

that religious diversity is interwoven with cultural diversity."[3] In non-Western settings, by contrast, such encounters with religious and ethnic diversity form the warp and woof of daily life. In sub-Saharan Africa, for example, Muslims represent 30 percent of the more than one billion population, while Christians constitute 62.9 percent.[4] That adherents of both faiths coexist, even within the same family, is an assumed fact of life.[5] Folk religion, Hinduism, and Judaism also contribute streams of diverse faith practices on the continent.

The diversity of world faiths in the Middle East and Indonesia, among others, expands the complexity of its staggering flows even further. While the Arab world is dominated by Muslims and Christian adherents, the vast array of Christian confessions, such as Maronite Catholic, Greek Orthodox, Coptic Catholic, and Coptic Evangelical (Protestant), adds to the heightened complex diversity situated among distinctive Muslim groups, such as Sunni, Shi'i, and Ibadi.[6] In Indonesia, on the other hand, hundreds of local religions and six or seven world religions have coexisted for centuries.[7] "Currently, Indonesia defines six religions as officially recognized and supported by the state. They are Islam, Protestantism, Catholicism, Hinduism, Buddhism and Confucianism."[8] As in Africa, these communities have lived side by side with many families composed of members following different religions. Thus, peoples around the world either coexist in a complex tapestry of religious and ethnic diversity or are experiencing religious encounters previously unknown due to globalization and immigration.

[3]Warburg, "Globalization, Migration," 80.

[4]Pew Research Center, "Religion and Education Around the World," December 13, 2016.

[5]Chrispin Dambula, "Muslim and Christian Conflict in Sub-Saharan Africa: Due to Christianity or Western Christians?," paper presented at the American Anthropological Association annual conference, San Jose, California, November 14, 2018. African students at Fuller Seminary have often commented on having Muslims as family members, including most recently Chrispin Dambula from Malawi (October 22, 2018) and Yossam Manafa from Uganda (November 15, 2018).

[6]Jon Hoover, "Muslim-Christian Relations and Peacemaking in the Arab World," in *(un)Common Sounds: Songs of Peace and Reconciliation Among Muslims and Christians*, ed. Roberta R. King and Sooi Ling Tan (Eugene, OR: Cascade, 2014), 51-70.

[7]Berney Adeney-Risakotta, "Peacemaking in the Indonesian Context," in King and Tan, eds., *(un) Common Sounds*, 71-86.

[8]Adeney-Risakotta, "Peacemaking in the Indonesian Context," 72. "Indonesia includes the largest Muslim community in the world with over 200 million Muslims, which is more than all the Middle Eastern countries put together. There are approximately 25 million Christians in Indonesia, equal to the entire population of Malaysia. Hindus include over 7 million people and Buddhists and Confucianists have one to two million followers each."

What, then, are the implications for the arts and mission in relation to religious neighbors? In the West, changing neighborhoods means changing ways of relating to our neighbors. "Who is my neighbor?" brings new questions to the table. Many, if not most, of our new neighbors are "religious" neighbors, people who do not share a common Judeo-Christian heritage. Scholars note that "there are more Muslim Americans than Episcopalians, more Muslims than members of the Presbyterian Church USA, and as many Muslims as there are Jews—that is, about six million."[9] Astonishingly, Los Angeles is considered the most complex Buddhist city in the world, with a Buddhist representation spanning the whole range of Asian Buddhists.[10] If these are our new neighbors, how do we practice loving our "religious" neighbors as ourselves? How do we practice loving the foreigners among us? (Mt 22:39; Deut 10:18-19). And in non-Western contexts, how do we witness among our religious neighbors—including family members—in ways that do not ignore their religious backgrounds? More to the point addressed in this book, How can Christians offer hospitality via the multiple aesthetic styles and forms confronting them?

The Power of the Arts

As Christians are exposed to neighbors of other faiths, they also encounter new forms of art and performance. And as they do, they come to realize how powerful various art forms are for expressing national and religious identity. When people hear their heart music, they spring to attention; they cry or dance. But more than this, performance of these musics, as many chapters illustrate, create spaces where these experiences can be shared. All of this speaks to the power of the arts, which calls for further comment in this introduction.

The arts of course have been deeply rooted in all human cultures from the very beginning. The impulse to dance, sing, dramatize, or draw is common to all human communities; indeed, Christians believe it reflects the image of the creator God. Missionaries and the global media may suggest particular songs or styles with varying degrees of success, as James Krabill's examples show, but they do not necessarily bring the itch to create that is culturally embedded worldwide. This creativity takes many different

[9]Eck, *New Religious America*, 2-3.
[10]Eck, *New Religious America*, 2-3.

cultural forms. The Yapese culture, Sherwood Lingenfelter reports, features speech art, and elaborate stories and proverbs, but no visual art; Ruth Stone describes a culture where music and dance is prominent; other cultures feature elaborate face and body art that color their ritual performance.

But this collection amply illustrates another characteristic of the arts: while creative performances are always grounded in specific historical and cultural settings, they easily travel. Indeed, art forms are not constricted by geographic or even religious boundaries. Sooi Ling Tan's chapter shows how praise and worship music from various places has influenced Christian worship in Malaysia, Thailand, and Cambodia. While Tan shows this can contribute to the perception that Christianity is a "potted plant," it can also be embraced and adapted by local musicians; the hymns missionaries bring can be strange—as in Krabill's example from *The African Queen*—but they can also become a beloved anthem—as was true of William Cowper's "God Moves in a Mysterious Way" in Liberia. The clearest examples of the mobility of art forms are found in Michelle Voss Roberts and Demi Day McCoy's and Megan Meyer's chapters on hip-hop, which has animated youth culture around the world. Meyer's description of this in Mozambique, however, demonstrates the creative role that local performers play in making this music culturally appropriate.

The example of hip-hop embodies another characteristic of the power of art. Experiencing art together can spark deep-seated emotions: it can evoke home and family or help negotiate pain or struggle. Many chapters in the book show how art performance or display creates a "shared space" where people can come together in ways that are nonthreatening and potentially transformative. Encountering the art of other cultures and religions sparks curiosity and opens one to new ways of seeing the world. Art has been called a "transformative practice" that not only transfigures its materials but creates spaces for communal awakening that can be powerfully unifying.[11] Several articles describe these shared experiences, something especially embodied in what Roberta King discusses as "musicking," which calls attention to the total experience of performer, audience, and participants in the live event. Experiencing art together, whether as a performer or listener, solicits participation,

[11]George Steiner, *Real Presences* (Chicago: University of Chicago Press, 1989).

as Ruth Illman seeks to show in her description of the Interreligious Choir of Frankfurt. The case studies of Roberta King powerfully illustrate this ability of music to create shared encounters that bridge divides separating people. On the basis of this limited data one might even suggest the following hypothesis: one of the natural roles of art is to open spaces for transformative human encounters. When thoughtfully and intentionally pursued, music forges mutual bonding; it is not disposed to creating divisions.

But it would be a mistake to see art only as promoting momentary glimpses of a common humanity; its power extends well beyond this. Ruth Stone's chapter demonstrates the extent of the power of music making during both the time of the civil war and of the Ebola crisis in Liberia. In both cases, and with similar rhythms, the music not only became an "emotional glue" that held people together but embodied their protest against the pain and injustice accompanying the rule of Samuel Doe. Women of faith, both Christian and Muslim, could dance and sing "Doe must go" with potent results, a precedent later transposed into "Ebola must go!" Their music literally gave them strength to face extreme crises and survive these life-threatening events. Michelle Voss Roberts and Demi McCoy argue that hip-hop has been uniquely able to carry the impulse to resist the injustice of the marginalized communities that have produced this style. Picking up on the interfaith context of these discussions, they appropriate categories of Indian aesthetics to argue that hip-hop has specifically embodied the impulse to resist the status quo, proposing this even adds an additional emotion of "challenge" to the traditional nine Indian *rasas*.

This last example highlights the local impulses that spark creativity. While they can embrace and adapt global forms like hip-hop, composers and artists more often seek to recover and develop indigenous forms. Jean Kidula provides an excellent example of this process in her study of the renowned Kenyan Christian composer and producer Reuben Kigame. He has been able to combine indigenous musical styles, often those picked up in the "spirit" churches, with influences from the soukous style of Congo, which is itself a remake of Cuban son and rumba. The result contributes both to enhanced Christian worship and to African identity formation. This fusion of influences is also displayed in William Dyrness's chapter on the Zapatista movement in southern Mexico. There, Christian believers have

drawn from their indigenous Mayan tradition as well as their reading of Christian Scripture to form a vibrant, self-sufficient community that is able to resist the oppressive (and sometimes violent) hegemony of the Mexican state. But what is significant for purposes of this book is the way these values are carried by unique and powerful forms of both visual art and song produced by multiple (and mostly anonymous) artists. These examples in fact suggest that local art forms play a critical role in the recovery and enhancement of traditional values that are so often threatened by the dominant global culture.

THE PROBLEM OF THE ARTS AND THE GLOBAL CHURCH

What is particularly striking about these last examples is that while they may have some level of support from the church, these art forms mostly develop in the larger world outside church structures. Indeed, in some cases the influence of such movements has been from the larger world back into the churches. Ruth Stone notes how the music and dancing of these mobilized Liberian women "ignited the clergy." This leads us to make two extended comments that suggest the larger implications of this study and, we hope, open the way to further investigation and reflection. First, the fact that much art practice and experience takes place outside the church speaks to the problematic relationship the church, and the Western church in particular, has had with the arts in its recent history. It is no secret that all the major religious traditions have been deeply invested and influential in the arts over the long arcs of their histories. Throughout the world it is impossible to describe the religious culture of the major religions without reference to the arts, whether this be medieval cathedrals in Europe, Buddhist temples, or Muslim mosques, with their attendant inscriptions and artifacts. But for various historical reasons, at least in the Christian tradition, recent history has exposed a problematic relationship between religion and artistic developments. Though Orthodox and Roman Catholic traditions feature a rich history of art that has served their worshiping communities, both have resisted modern traditions of the arts, which have mostly developed outside the doors of their cathedrals. Since Vatican II, this has begun to change in the Catholic Church, with a special focus on embracing contextualized worship arts in diverse local contexts; change has come more slowly in

Eastern Orthodoxy. Meanwhile Protestants, the tradition mostly represented by this collection, still struggle with iconoclastic patterns that were established during the Reformation and, until recently, have resisted modern developments altogether, dismissing them as secular.

This recent history surely accounts for the fact that the increasingly complex and diverse developments in arts, music, dance, and theater—and one could add other forms of popular entertainment such as movies and TV—have taken place not only outside the church but without any significant religious input. There is an important caveat to be made against this generalization, which is evident in this book. The one significant place where attention is paid to the arts in the global context is mission anthropology, which is increasingly sophisticated and has produced new fields of inquiry: ethnomusicology and, more recently, ethnodoxology.

As missiologists and mission educators increasingly recognized a growing need for pursuing an anthropology of music and the arts, the discipline of ethnomusicology was already discussing the intersection of music and culture. The proverbial saying that "music is a universal language" experienced a transformative paradigm shift when investigations revealed that "music is universal; its meaning is not."[12] This led to broadened concepts of music and the arts based on local, cultural definitions that immediately challenged Western Christian concepts. For example, music in Africa also simultaneously incorporates movement, dance, drama, clapping, and visual elements bundled together as one artistic performance event. The implications for witness and communication of the gospel are staggering, forcing missiologists and mission practitioners to develop new and broadening approaches for integrating music and the arts as a normative partner in mission praxis.

Discovering the vast intersections of music and the arts in cross-cultural communication and worldwide contexts emerged as an ever-expanding spiral. Vida Chenoweth pioneered and forged a new pathway in the realm of Bible translation. Working solo in the early 1960s with Wycliffe Bible Translators, she began exploring what missionaries could do to foster ethnic church music in spite of not having trained as musicians. She argued that

[12]Jeff Todd Titon, ed., *Worlds of Music: An Introduction to the Music of the World's Peoples* (Belmont, CA: Schirmer Cengage Learning, 2002), 3.

"each culture should produce its own songs, pray its own prayers, and thus worship with true understanding."[13] This was a groundbreaking proposal, since teaching the hymns of Western Christianity was the standard missional practice of the day. She exposed the dangers of rejecting people's music, of ill-designed music workshops that lacked significant research and knowledge of local music cultures, and of introducing Western instruments and equipment. She warned that "the well-intentioned missionary may, unawares, contribute to the obliteration of a culture's music system."[14] Instead, she promoted fostering indigenous musical leadership that released local believers to engage in creating their own worship songs, profound and full of meaning to local believers.

By the late 1970s, the quest broadened to creating understanding of the gospel message in diverse cultural contexts via cultural musics and arts. The focus turned to moving into the musical and artistic worlds of the peoples with whom one is working, not forcing them to leave their own worlds of aesthetic languages. This led to early ethnomusicological work that translated both Scripture and music into culturally appropriate worship songs to communicate at deeper levels and also to impacting a society not only for the gospel but in all of life. Working among the Senufo of Côte d'Ivoire, Roberta R. King began pursuing this with a view of reaching out to local peoples while also developing new songs for worship based on Scripture.[15] The result contributed significantly to discipling the burgeoning local churches.

The importance of culturally appropriate music and the arts took on increased impact due to issues of orality, where many peoples functioned without essential reading skills. In such contexts, the languages of cultural music and the arts serve as core elements in processing everyday life issues and communicating messages. Holding new song workshops for worship, often in tandem with translation teams, began emerging as standard praxis for creating musical bridges in Christian communication.[16] Ultimately,

[13]Vida Chenoweth, "Spare Them Western Music!," in *Worship and Mission for the Global Church: An Ethnodoxology Handbook*, ed. James R. Krabill (Pasadena, CA: William Carey Library, 2013), 120.
[14]Chenoweth, "Spare Them Western Music!," 123.
[15]Roberta R. King, *Pathways in Christian Music Communication: The Case of the Senufo of Côte d'Ivoire* (Eugene, OR: Pickwick, 2009).
[16]Roberta R. King, "Musical Bridges in Christian Communication: Lessons for the Church," in Krabill, ed., *Worship and Mission for the Global Church*, 110-18.

this led to new considerations in the roles and functions of the arts and music embedded in the total life of the church, whatever the context. It also saw new collaborations of missionaries, national leaders, and scholars in worship and theological training joining together in research, writing, and mission.[17] The call to be intentional in our studies of music in mission and "to integrate music (and the arts) into mission rather than compartmentalizing it out of the mission agenda"[18] began to take shape. This interdependent relationship between music and mission was emerging as an "essential component in missiology."[19]

Indeed, the ever-expanding spiral of engaging cultural musics and arts broadened further in praxis, research, and nomenclature. In order to encourage and invite theologians, practitioners, and the worldwide church to fully participate in engaging cultural music and arts as essential to ministry and mission, a new term was coined: *ethnodoxology*. Paul Neeley, one of its early proponents, explained that "ethnodoxology is the theological and anthropological study, and practical application, of how every cultural group might use its unique and diverse artistic expressions appropriately to worship the God of the Bible."[20] This opened the door to a plethora of approaches and emphases. Ethnodramatology, for example, arose out of the researched conviction that "plays written out of the local worldview using indigenous styles are best able to resonate with contemporary audiences."[21] Whether music, drama, visual arts, or other arts, the goal became one of sparking creativity that assists believers and "local communities to meet their own needs."[22] These approaches converged and expressed themselves in theological terms as "ethnoartistic cocreation in the kingdom of God."[23]

[17]See Roberta R. King, Jean Ngoya Kidula, James Krabill, and Thomas Oduro, *Music in the Life of the African Church* (Waco, TX: Baylor University Press, 2008).

[18]Roberta R. King, "Toward a Discipline of Christian Ethnomusicology: A Missiological Paradigm," in *Missiology: An International Review* 32 (2004): 296.

[19]King, "Toward a Discipline of Christian Ethnomusicology," 296.

[20]Paul Neeley, "What Is Ethnodoxology?," ICE International Council of Ethnodoxologists, November 24, 2018, www.worldofworship.org.

[21]Julisa Rowe, "Creating Local Arts Together: The Manual Summary," Krabill, ed., *Worship and Mission for the Global Church*, 62.

[22]J. Nathan Corbitt and Sarah Rohrer, "Making a Difference in a Week: Eight Principles for Art Making in Short-Term Engagement," in Krabill, ed., *Worship and Mission for the Global Church*, 125.

[23]Brian Schrag, "Ethnoartistic Cocreation in the Kingdom of God," in Krabill, ed., *Worship and Mission for the Global Church*, 49-56.

Its intent became the integration of the arts in worship—and witness—that engages all that we are in response to God's continuously outpouring nature.[24] This quest to fulfill the call to spark creativity in today's world of globalization remains immense, fascinating, challenging, and unending.

Yet in spite of such comprehensive attempts to integrate cultural musics and the arts into dynamic worship and witness, what became obvious with the attacks on the World Trade Center on September 11, 2001, was the lack of intentional engagement with music and the arts in light of world faiths. Suddenly, pursuing questions of peacebuilding in a divided world demanded investigating how to create understanding among peoples of diverse faiths via their artistic expressions. Indeed, the greatest commandment of loving God with all our heart, soul, body, and mind is left incomplete without also loving our neighbors as ourselves, including our religious neighbors (Lk 10:25-27 NIV). A large grant from the Luce Foundation presented opportunities to explore the contribution of music and the arts in fostering sustainable peacebuilding among Muslims and Christians (2008–2014).[25] Consultations of Christian and Muslims scholars took place in Beirut, Lebanon, and Yogyakarta, Indonesia, with a view to making sense of the role of the arts in multifaith contexts and their potential for interfaith dialogue. Thus, the transformative bridges of cultural music and the arts in peacebuilding and interfaith dialogue had broadened yet again to include a much larger world.[26] They necessitated deeper and ongoing investigations.

This rich harvest has made possible the best chapters in this collection, but it has also highlighted the limitations of this research. While mission anthropology has made important efforts to explore the arts at the level of popular music and performance, it has not made much headway in illuminating the modern developments of the visual arts nor the global flows of concert music and literature, or even the global expansion of the entertainment arts. These arts are left to specialists in these various fields,

[24]See Harold M. Best, *Unceasing Worship: Biblical Perspectives on Worship and the Arts* (Downers Grove, IL: InterVarsity Press, 2003), 18.

[25]See www.songsforpeaceproject.org. See also King and Tan, eds., *(un)Common Sounds*. A later Luce grant to Fuller extended this research to Buddhist communities and included a study of visual art. See William Dyrness, *Senses of Devotion: Interfaith Aesthetics in Buddhist and Muslim Communities* (Eugene, OR: Cascade Books, 2013).

[26]See Roberta R. King, "Music, Peacebuilding, and Interfaith Dialogue: Transformative Bridges in Muslim-Christian Relations," *International Bulletin of Mission Research* 15 (2016): 202-17.

whose critical (and often valuable) work remains outside the purview of church and mission leaders. Though often dismissed as "elite culture," these fields play an important and often overlooked role not only in global flows of culture but, increasingly, in the global life and mission of the church. These lacunae surely contribute to the unfinished agenda of mission reflection.

This recent historical context also explains why there is a dearth of specific reference to the visual arts in this book. The major exception, apart from the Zapatista chapter, is the important paper of Joyce Lee, which addresses this issue directly. She is a practicing artist with an international reputation, and she is also a believing Christian. She reports, however, she has had to keep these two parts of her life separate. This surely is the result of the mutual incomprehension in both the Western church and the art world in recent history. This incomprehension has led to the reality, for Lee, that the arts and the church in fact inhabit separate worlds. Though this is gradually changing, and there have been attempts to nuance this allegation,[27] the divide persists. As with the hip-hop movements, however, Lee points to examples in China of galleries that create spaces where religious, and even specifically Christian, forms can be displayed and discussed. These examples, which could be multiplied and extended to other parts of the world, once again take place outside any specific relationship with formal church (or even specifically Christian) structures.

But the fact that significant examples of art with Christian values or content are thriving outside the church leads us to a second, more constructive comment. Perhaps, we argue, this fact ought to be recognized as an opportunity and not simply lamented as a deficiency. Many of the descriptions in these papers, even when they are placed within a Christian context, reference events where art generates shared human experiences that are without particular Christian content. As we have noted, art experiences spill over our jealously guarded political and religious divides; one might even suggest the experience of art is provisionally nonsectarian. Authors and respondents have sometimes referred to these as possible places where God's love may be shared, and this is certainly an important potential aim

[27]See, for example, Jonathan Anderson and William Dyrness, *Modern Art and the Life of a Culture: The Religious Impulses of Modernism* (Downers Grove, IL: InterVarsity Press, 2016).

of such experiences; but it may be true in an even larger sense that all such experiences find their ultimate meaning and purpose in referencing the love of the creator God. Joining in singing, dancing together, or enjoying a sunset or mountain vista are human experiences that all people share, but this does not keep them from being a vital dimension of the global mission of God (and even of God's people). Such shared experiences recall the work of the Spirit in Acts 2:44, where "all who believed were together [were one] and had all things in common" (NRSV). But though this production of shared life is a special work of God among Christian believers, the significance of the power of arts extends beyond this to the whole human community; God's work in creation and redemption is not limited to what goes on inside the walls of the church and its programs. Rather that space is meant to summon believers to see God's work of creation and re-creation in the larger world—and not only to see and enjoy but to participate in it: loving God and neighbor and incarnating this love in just and aesthetically pleasing cultural forms. This too is part of what God is up to in the world. Hip-hop can spark the attention of otherwise disaffected youth and call them to resist injustice, and special gallery spaces can enhance and highlight religious values and inspire strangers to embrace each other. This is part of what God is doing in building his kingdom, and this work, the prophets tell us, extends to the ends of the earth. And in this opus the arts, in all their stunning diversity, play a particularly prominent—even indispensable—role. This role is exemplified by many papers in this book, but even these merely scratch the surface of noticing what God is up to in the world.

But how, then, might these questions be pursued in greater depth? While undeveloped in this book, there are suggestions of paths that might be followed in the future. One nagging question is how music and art forms may be evaluated in ways consistent with, if not bound by, particular religious convictions. To suggest the experience of art resists—or better, transcends—particular religious forms does not mean that all art is equally good or that all experiences are equally helpful. Critique is always called for and invites the question, Does this music, artwork, or artistic event reflect the glory of God and lead back to God? Hiebert's seminal work in critical contextualization—based on local communities engaging both God's Word and cultural contexts—lays out an important initial framework for appropriating

cultural music and arts in witness.[28] Here (ethno)musicologists, art critics, ethnodoxologists, and theologians have more work to do together to develop categories that can be shared—middle axioms—and offer guidance to church leaders, even as they promote conversation across religious and cultural boundaries. We propose Megan Meyers's chapter offers a start in such a development. In her conclusion, she proposes considerations for culturally appropriate communication of the Christian gospel: authenticity, solidarity, hospitality, and mutuality. Categories like these may perhaps be elaborated not only to suggest norms for creation and performance of art forms but for evaluating artwork in ways that promote human flourishing and even move toward healing the split that often exists between artists and religious communities.

Meanwhile we look forward to the continuing influence of those writing in these pages, and especially of their students, to call the church to its role of anticipating the splendor of the world God is bringing into existence.

HOW THIS BOOK IS ORGANIZED

This work is organized around three major foci. Part one sets the stage both historically and in terms of contemporary praxis. In chapter one, "Arts and Mission: A Complex Story of Cultural Encounter," James R. Krabill lays out a framework for understanding the critical issues, gaps, misunderstandings, and missiological complexity of witnessing to the goodness of God via music and the arts. Krabill begins with a comparative study of Western outsiders bringing classic hymns into a new East African context, as parodied in the movie *The African Queen*, with a Liberian (African evangelist William Wadé Harris) who gave permission for the Dida people of Côte d'Ivoire to compose songs of praise to God in their own language and cultural music. These two cases illustrate the impact—and lack thereof—of cultural encounters that play critical roles in mission praxis. He identifies central themes of importance surrounding the arts in context and points to related, critical, interconnected missiological issues in practicing witness via the arts. In chapter two, "Performing Witness: Loving Our Religious Neighbors Through Musicking," Roberta R. King moves us into the realm of engaging

[28]Paul G. Hiebert, "Critical Contextualization," in *Anthropological Insights for Missionaries* (Grand Rapids: Baker Books, 1985), 171-92.

our religious neighbors through the performing arts in a post–9/11 world. Based on recent ethnographic research conducted in southern California, King provides a set of contemporary case studies where Muslims and Christians are rubbing shoulders with each other through music making in dynamic and meaningful ways. She argues that mutual music making and performance engender spaces and opportunities for discovering and relating with religious neighbors in ways that bridge relationships, generate community, interact with multiple religious communities, and testify to the love of God.

Part two turns to Christians reaching out to their neighbors through the arts. In chapter three, renowned ethnomusicologist Ruth M. Stone provides rich ethnographic gleanings from Liberia, West Africa. Her analysis points to the critical role and agency that Christian music played during the Liberian Civil War in the late twentieth century and, more recently, the Ebola crisis. "God Moves in a Mysterious Way: Christian Church Music in Multifaith Liberia, West Africa, in the Face of Crisis and Challenge" reveals how Liberian Christians and Muslims took a Western hymn, encoded it with meaning that spoke into their immediate historical context, and employed it in culturally appropriate ways, both political and religious. Stone's research further reveals how Christian hymns serve as part of an emotional glue that held people together during the war and fostered the processing and venting of deeply felt anger and fear at funerals. Amazingly, the Ebola crisis sparked similar responses.

Sooi Ling Tan in chapter four moves us to the Southeast Asian context, where she addresses the longstanding problem of the Christian church coming across as foreign, giving off the image of a potted plant that does not move beyond its Western boundaries. In "Sounds, Languages, and Rhythms: Hybridized Popular Music and Christian-National Identity Formation in Malaysia, Thailand, and Cambodia," Tan provides a comparative study of contrasting contexts dealing with issues common to each. What is it to be a Malaysian, Thai, or Cambodian Christian where the multireligious contexts are taken into consideration in ways that speak into issues of injustice, poverty, and ethnic-religious tensions? She investigates these questions and shows how Southeast Asian musicians express their personal and national identities. Ultimately, Tan argues for a fusion of hybridized popular music

interjected with local musical elements, instruments, and visuals in collaboration with lyrical content that addresses contextual interests and concerns.

In "Art as Dialogue: Exploring Sonically Aware Spaces for Interreligious Encounters," Ruth Illman takes us to Germany, where peoples of the three Abrahamic faiths are practicing respectful interreligious dialogue through music. The Interreligiöser Chor Frankfurt performs psalm concerts with the goal of not only impacting the lives of the musical participants but also transforming society through their musical offerings. Illman argues that such practices promote intellectual, emotional, cognitive, and embodied dimensions that form sensitive and comprehensive engagement across religions. In contrast, the Kenyan gospel composer, singer, and apologist Reuben Kigame addresses multifaith issues through his inclusive approach to composition. Drawing from his rich and deep knowledge of musical and language elements associated with diverse world faiths, in particular Islam and Hinduism in the East African context, Kigame sings with profound insight into his diverse Kenyan context. In "'Simba Nguruma': The Labor of Christian Song in Polycultural, Multifaith Kenya" (chap. six), Professor Jean Ngoya Kidula takes us on a musicological analysis that unearths the multi-layered elements drawn from across the continent commonly associated with Arab and Indic musical styles. She also demonstrates how they are linked with lyrical worldview issues that index the Kenyan coast, an area highly populated by Muslims and peoples of Indian origin. Ultimately, Kigame validates all peoples, no matter their faith origins. His inclusive composition and lyrics call out to praise and worship the God of the universe—the "Lion of Judah"—the one who speaks into the spiritual worlds of multifaith peoples from the Kenyan coast, into the hinterlands of western Kenya, and beyond.

Part three launches us into the arena of Christians creating new interfaith expressions appropriate to their contexts. Megan Meyers uncovers for us the case of Mozambique, in southern Africa, where young people are exploring and asserting themselves in their globalizing urban worlds. Focusing on one facet of the burgeoning African Christian theater, "Crate-Digging Through Culture: Hip-Hop and Mission in Pluralistic Southern Africa" explores the life of a Christian rap artist in order to understand how Mozambican Christian youth are making sense of their changing urban

world—one fraught with multifaith tensions. Meanwhile, in "'Let the Sacred Be Redefined by the People': An Aesthetics of Challenge Across Religious Lines" (chap. eight), Michelle Voss Roberts and Demi Day McCoy take up joining people where they are by discerning the contours of the gospel in an age of militarized police forces, for-profit prisons, and systematic dehumanization of African American peoples in the United States. Drawing from *Rasa* theory, a kind of Indian aesthetic flavor that generates contemplative abstraction, the authors pursue understanding transcendence in hip-hop music and the role of aesthetics in bridging diverse cultural and religious groups in resisting injustice. They propose a new *rasa* of challenge that weaves throughout the contemporary moment as "an aesthetic that hones and heightens the mood of protest, that rises against injustice in the face of danger, and that inspires solidarity among diverse cultural and religious groups."

The last two chapters address visual art. In "Wild, Wild China: Contemporary Art and Neocolonialism," Joyce Yu-Jean Lee takes up the ways in which contemporary Chinese art reveals and critiques current, modern-day society with all its ills and injustices. Beginning with the controversial Guggenheim Museum exhibition *Art and China After 1989: Theater of the World*, spanning 1989 to 2008, Lee illuminates the ways in which contemporary Chinese art is meant "to provoke analysis of this political and economic relationship between the West and China." Yet the exhibition was misperceived and demonstrated against in the United States, providing powerful insights into the importance of understanding the original context. As commonly occurs, what the artist intends is often lost, oversimplified or misinterpreted when exported overseas. Here, the implications for art and witness in context cry out for negotiating understanding in the midst of people's suffering and angst. As a Christian artist, Lee takes us into a world of asking important questions of identity—for instance, What is "Chineseness"?—of relevance to today's world of injustice and oppression and of the relationship-cum-compartmentalization of art and religion. Ultimately she argues that art can become "a third space for mutual learning and deeper exchanges" between diverse peoples.

Finally, in chapter ten William Dyrness reflects on "The Poetic Formation of Interfaith Identities: The Zapatista Case." Dyrness focuses on the religious

and aesthetic practices of the Zapatista movement in Chiapas, located in southern Mexico. Recognizing that they must be investigated within their specific political and cultural context, he pays particular attention to the important role of women in negotiating change through a multiplex of local arts. Dyrness begins with a comparative religion study, gleaning insights from "parallel Islamic and Hindu situations in Iran and South India." He then argues for the critical importance of Zapatista aesthetics for gaining perspective on the multiple roles of religion in the Zapatista context and provides insights into how studying the *palabra de Dios* inspired Zapatista women to draw, sculpt, and sing their way to empowerment. From among a constellation of aesthetic forms, Dyrness offers us theological and missiological gleanings that arise out of struggle and oppression among a people whose expressive life encompasses the visual and audible—storytelling and song, or oral traditions—for actively engaging societal issues as a community of believers.

In each topic discussed in this volume, we invite you to join us in considering the splendor, critical significance, and dynamic agency of the arts and witness in multifaith contexts.

PART I

Setting the Stage

Arts and Mission

A Complex Story of Cultural Encounter

James R. Krabill

Describing the Encounter

In 1951, John Huston released his film drama, *The African Queen*, based on a 1935 novel of the same name by C. S. Forester. The backdrop for this Oscar-winning saga of adventure, humor, and romance is the missionary efforts of a stuffy and out-of-place British couple, Samuel and Rose Sayer, a brother and sister duo played masterfully by Robert Morley and Katharine Hepburn. The geographical setting of the story is East Africa's Ruiki River in the then-Belgian Congo and the British protectorate of Uganda.

The stage is set already in the opening scene as the film credits come into view on a bright blue and billowy, clouded sky seen through palm branches of a tropical rain forest. The camera follows the treetops of the jungle before gradually descending upon a village cluster of thatch-roofed huts. On one of the buildings, there is a cross perched atop a steeple as a title in bolded letters appears on the screen: "German East Africa, September 1914." Focusing in more closely from the cross and slowly through the narrow doorway of the building, one catches a glimpse of a stone-carved plaque identifying the location: First Methodist Church, Kung Du.

We hear faint sounds of music as we enter the church building and find Rev. Sayer struggling valiantly, but with little success, to lead the congregation in a rousing rendition of the eighteenth-century hymn, "Guide Me, O Thou Great Jehovah." This faltering effort, we later learn, is not the only endeavor in Sayer's life that has turned out badly. His very decision, in fact,

to volunteer as a missionary early in life came as a result of demonstrating low-level language facility by failing his Greek and Hebrew exams.

Utterly devoted to her brother and adorned in a prim and proper, high-collared, Victorian Sunday-go-to-meetin' dress, sister Rose works up a sweaty lather in the tropical heat as she fervently pounds and pedals a pump organ, almost as if to drown out the cacophony of atonal noises coming from the uncomprehending members of the village congregation. "Songs of praises, songs of praises, I will ever sing to thee," she bellows forth determinedly in a scene that leaves the movie viewer emotionally stranded somewhere between pain, pity, and pure hilarity.

We never find out what might have happened in the Sayers' unwavering effort to pass along to their East African congregants the "heart music" they had learned to love in their home country. For soon after this worship scene, German-led troops raid and destroy the missionaries' village, capturing and hauling off the indigenous population to become forced soldiers or slave laborers. Samuel protests the troops' violent and destructive actions and is dealt a blow to the head from a rifle butt. He subsequently becomes delirious with fever and soon dies, leaving behind a distraught and discouraged Rosa, looking on helplessly as her world crumbles around her.

On the other side of the African continent in precisely the same month and year of September 1914, William Wadé Harris—a fifty-four-year-old Liberian prophet-evangelist—was reaching the peak of his ministry popularity in southern Ivory Coast. The evangelist's preaching, fetish-burning, and baptizing ministry lasted a mere eighteen months, from mid-July 1913 until his expulsion from the newly formed French colony in January 1915. But the impact he created in this short time was one of the most remarkable in the history of the church in Africa with an estimated 100,000 to 200,000 people from a dozen different ethnic groups turning from traditional religious beliefs and practices to faith in the "the one, true God."[1]

[1]Sources on the life and ministry of Harris include Gordon Mackay Haliburton, *The Prophet Harris: A Study of an African Prophet and His Mass Movement in the Ivory Coast and the Gold Coast, 1913-1915* (London: Longman, 1971); David A. Shank, *Prophet Harris, the "Black Elijah" of West Africa* (Leiden: Brill, 1994); and my own work, *The Hymnody of the Harrist Church Among the Dida of South-Central Ivory Coast, 1913-1949* (Frankfurt: Peter Lang, 1995). This latter publication—the basis of my PhD thesis (University of Birmingham, UK, 1989)—brings together 250 original Harrist hymns, transcribed in the Dida language, translated into colloquial French, and analyzed for their historic-religious content.

In general, Prophet Harris was a man on the move, never lingering long in any one location. In some instances, villagers would travel long distances to meet him, receive baptism from his hand, then return home all in the same day, never to see him again.

One of the questions asked of Harris by new converts during those brief encounters concerned the type of music they should sing once they had arrived back home to their villages. "Teach us the songs of heaven," they pleaded, "so that we can truly bring glory to God."

It is important to understand Harris's background in order to appreciate his response to the thousands of new believers who crowded around him, clinging desperately to every word of counsel he could give them. Born to a Methodist mother sometime around 1860, Harris had spent nearly four decades attending and actively serving the so-called civilized Methodist and Episcopal churches of eastern Liberia. Quite understandably, the Western hymn traditions of these churches became the sacred music that Harris himself dearly loved and cherished. When asked in 1978 whether Harris had any favorite hymns, his grandchildren immediately recalled, "Lo, He Comes with Clouds Descending" (his favorite hymn, which he sang repeatedly), "What a Friend We Have in Jesus," "How Firm a Foundation, Ye Saints of the Lord," "Jesus, Lover of My Soul," and—most interestingly, given the scene recounted above from the film *The African Queen*—"Guide Me, O Thou Great Jehovah."

Yet confronted with new converts seeking his advice about the music to be sung in the faith communities taking shape in the wake of his ministry, Harris wisely counseled, "I cannot tell you what kind of music is sung in heaven. I have never been to God's royal village. But be assured of this: God has no personal favorite songs. It is sufficient for us to compose hymns of praise to him in our own language and with our own music for him to understand."

When asked further how exactly they were to proceed in composing these new "songs of God," the prophet told the people to begin by using the music and dance forms with which they were already acquainted. For the Dida people—one of the first and largest ethnic groups to feel the impact of the prophet's ministry—this represented a remarkable repertoire of at least thirty distinct classifications of traditional musical genres, ranging from love

ballads and funeral dirges to songs composed for hunting, rice planting, and
rendering homage to wealthy community leaders.[2]

There are fascinating stories of how Harris engaged people in a dis-
cernment process for choosing appropriate songs. In one instance among
the Dida, Harris rejected a song offered to him in the *zlanje* genre of love
songs with suggestive lyrics designed to seduce sexual partners. "That song
does not honor God!" Harris said. "Sing something else!"

> So, another singer came forward proposing a *dogbro* tune, a type of "praise
> song" that literally "hurls forth" or "shouts out the name" of a nature spirit, a
> wealthy family head, or clan leader deserving special attention or recognition.
> "That's it!" exclaimed Harris. "That is the music you must work with! Though
> now you must refrain from using these songs for earthly rulers and lesser
> spirits and begin transforming the words bit by bit to bring glory to God!"[3]

Empowered by these words from the prophet, people returned to their vil-
lages and busily went to work composing praise hymns to God.

> It was the Lord who first gave birth to us and placed us here.
> How were we to know
> That the Lord would give birth to us a second time?
> Thanks to Him, we can live in peace on this earth![4]

In the years following Harris's phenomenal ministry in Ivory Coast—and
continuing right up to the present day—composers with the Harrist
movement have written thousands of hymns, exploring fresh themes and
developing new musical styles. As composers learned to read the Bible and
grew in spiritual insight, they recounted Scripture-based stories and related
events of God's work among them. Some hymn texts function as mini-
sermons, as prayers, or as faith confessions—all set to music for the church,
by members of the church, and in a style and language that the church well

[2]James R. Krabill, "'Teach Us the Songs of Heaven!' An African Evangelist Encourages Indigenous
Hymnody," chapter 13 in *All the World Is Singing: Glorifying God Through the Worship Music of the
Nations*, Frank Fortunato, with Paul Neeley and Carol Brinneman, ed. (Tyrone, GA: Authentic
Publishing, 2006), 51-57.
[3]James R. Krabill, "Gospel Meets Culture: A West African Evangelist Provides Clues for How It's
Done," in *Is It Insensitive to Share Your Faith?* (Intercourse, PA: Good Books, 2005), 96.
[4]This is one of the earliest Harrist hymn texts, composed sometime during the first ten years of
the movement; see Krabill, *Hymnody of the Harrist Church*, 427.

understands. One composer adapted the opening lines of the Apostles'
Creed in this way:

> My God, our Father, Almighty, Almighty,
> Creator of the heavens and the earth,
> It is He who is Truth, our Father alone.
> And it is Jesus who is our Defender.
> As for the Holy Spirit sent by Jesus,
> He is Life and Healing for us all.[5]

DEFINING AND LIMITING THE SCOPE

The two brief stories related here are hardly sufficient to address the many
complex issues of this book. We do nonetheless encounter in these narra-
tives central themes of key importance that point us in helpful directions
and invite us to pursue their interconnectivity.

There are first of all *the arts*—singing, instruments, solo and corporate
performance, song genres, dance, memorization, composition and trans-
mission, church architecture, painted signage and decor, stone-carved
plaques, benches, pulpits and altars, the cross and other Christian symbols,
religious vestments, persuasive preaching, effective teaching, locally crafted
objects of worship, language, oral imagery, and musical forms of prayer,
sermons, and confessions of faith. All of these artistic expressions and many
more are part of the larger conversation under consideration when we ex-
plore what happens when the arts and gospel communication meet.[6]

There is also much about *mission* in these stories—diverse understandings
and styles of mission, such as "etic" mission (where art forms are imported
from outside the culture) and "emic" mission (where a discernment process

[5]Krabill, *Hymnody of the Harrist Church*, 519-20.
[6]For a more comprehensive definition of "aesthetics and the arts," see Benjamin M. Stewart,
"What, Then, Do Theologians Mean When They Say 'Culture'?," in *Worship and Culture: Foreign
Country or Homeland?*, ed. Gláucia Vasconcelos Wilkey (Grand Rapids: Eerdmans, 2014), 49,
where the following elements of culture are highlighted: "music; dance and gesture; material craft
in the making of shelter, furniture, tools, and clothing; various forms of adornment (sometimes
paint, dyes, stones, plants, clay, and cloth); patterns of speech; representational and abstract im-
ages; and methods of heightening attention to interactions with the wider natural world, includ-
ing its creatures and cycles." Students of popular culture will likely wish to add film, cartoons,
comics, animated television, websites, and other media; see Mark Roncace and Patrick Gray, eds.,
in *Teaching the Bible Through Popular Culture and the Arts* (Atlanta: Society of Biblical Literature,
2007).

seeks to find appropriate artistic expressions from within the culture). Depending on the missional approach gospel communicators adopt, everything will change—their starting points, their aesthetic and cultural sensitivities, their search for and application of "usable" artistic expressions, and the final results that emerge from the choices they have made along the way.

Ecclesio-denominational traditions and preferences are equally a part of the picture. In our stories, we encounter Methodist and Anglican-Episcopal patterns against a backdrop of Roman Catholic mission initiatives in both the Congo and Ivory Coast. How do these realities shape the intercultural dynamics at work? Michael J. Bauer has noted that the Roman Catholic church has a long-standing tradition of embracing the fine arts while at the same time encouraging private devotional art.[7] By contrast, the Orthodox tradition is "centered on the icon, church architecture, and sung choral liturgy." Protestants, according to Bauer, "tend to be influenced by the surrounding culture and its art forms . . . both popular culture and the classical fine arts, depending on the dominant cultural milieu at any particular place and time."[8] None of these assessments directly address the more evangelically inclined Protestants and charismatic-Pentecostals who, nonetheless, constitute a significant portion of the global missionary community today.

There is also the important *historico-political context* in which mission transpires. Both of our narratives take place in sub-Saharan Africa in late 1914, at the outset of the First World War, just as the colonial fervor for Americo-Liberians, British, French, Belgians, and Germans was gaining momentum. These are very specific times and realities. How do they shape the story? In Ivory Coast, virtually all of the Catholic priests were called back to France during the war to serve as chaplains in the army, leaving no spiritual experts on the ground to consult with when the charismatic, non-Catholic, English-speaking prophet-evangelist William Wadé Harris burst upon the scene and sent French colonial administrators into a panic. To be serious students of history, careful attention must be given to the conditions in which the arts and mission meet, be that in the Greco-Roman world of the church's early years, the eighth-century Germanic tribal villages of the Frankish

[7] *Arts Ministry: Nurturing the Creative Life of God's People* (Grand Rapids: Eerdmans, 2013), 13.
[8] Two additional resources that explore these matters further are Kathy Black, *Culturally Conscious Worship* (St. Louis: Chalice, 2000), esp. chap. 3; and Phillip Tovey, *Inculturation of Christian Worship: Exploring the Eucharist* (Burlington, VT: Ashgate, 2004).

Empire, the Hindu kingdom of Nepal in the mid-twentieth century, or hip-hop Algerian immigrant communities in the *banlieues* of Paris, France, today.

Finally, there are the vitally important *socio-religious realities* to consider in times and places where the arts and mission meet. The two stories from Africa included in this chapter depict situations where the Christian faith and local, ethnic religions represent the primary encounter taking place. But as one moves to other world locations, new questions and challenges arise. In a collection of essays edited by Lawrence E. Sullivan titled *Enchanting Powers: Music in the World's Religions*, one is plunged into the deep and dense musical universes of Jewish mysticism, sacred teaching of the Javanese gamelan, Choctaw Indian social dance, the Confucian sacrificial ceremony, the controversial musical recitation of the message of Islam, and the ecstatic vocalizations of Kabbalah.[9] Eminent scholars from diverse disciplines explore how music articulates religious belief and serves as a conduit to the spirit world, a medium for dramatizing sacred history, an expression of social action, and an instrument for restoring collective identity. These functions should sound familiar to people of biblical faith, since similar claims are likewise held to be true of Christian music and other artistic expressions. Recent efforts to research these dynamics in multifaith contexts will certainly yield a rich harvest of reflection in the years ahead.

It will be impossible in this short chapter to present a comprehensive picture of all the ways gospel communicators throughout Christian history have engaged people of other faiths. But keeping in mind the multiple artistic forms at the church's disposal, the importance of embracing a missional stance where local arts are taken seriously, and the constant awareness of how ecclesial traditions, historico-political contexts, *and* socio-religious factors are key to how the good news is embodied and articulated will go a long way in equipping and preparing the church for the arts and mission encounter.

GROUNDING IN SCRIPTURE

Central to equipping and preparing God's people for this encounter is the biblical narrative, which serves as the church's grounding and guide. From the opening verses of that narrative we are presented with the activity of a

[9]Cf. Lawrence E. Sullivan, ed., *Enchanting Powers* (Cambridge, MA: Harvard University Press, 1997).

Creator God, and that sets the tone for everything to follow. Erwin Raphael McManus notes,

> From the very beginning, the Scriptures describe God as an artist. At his core God is an artisan. On the seventh day he rested not from his work of engineering or his work of teaching or his work of administrating, but from his work of creating. . . . Six times it was good enough to describe creation as good. But . . . it was only when God created us that he upgraded the compliment and said not only that it was good, but it was very good. . . . Our story begins with a kiss, mouth-to-mouth resuscitation, God pressing against us. We begin when God exhales and we inhale. This is the level of intimacy and synchronicity for which we were always intended. While all creation declares the glory of God, we humans bear the image of God.[10]

Based on these foundational observations from the first chapters of the book of Genesis, McManus makes four summary declarations: To create is to be human. To create is to fulfill our divine intention. To create is to reflect the image of God. To create is an act of worship.[11]

These statements serve as a launchpad for God's people to claim and reclaim their creative essence and embrace their calling as stewards of the artistic gifts and talents given them. Not surprisingly, this sense of participation in the divine creative process unleashed a flurry of artistic expressions from the earliest pages of the biblical story on through the history of the Christian movement.

Much of the artistic energy in the Old Testament was focused on worship-related activities, which Emily R. Brink classifies in three categories: what we see (architecture, furnishings, dress, and decorum), what we hear (singing, music, and proclamation), and when we move (pageantry, drama, and dance).[12] Considerable attention is given in the biblical narrative to detailed descriptions of the artistic energy employed in designing, creating, equipping, and maintaining worship spaces (the tabernacle and temple), worship times and feasts (Sabbath and Passover), worship furnishings (bowls, incense, and the ark of the covenant), worship officiants (priests and

[10]Erwin Raphael McManus, *The Artisan Soul: Crafting Your Life into a Work of Art* (New York: HarperCollins, 2014), 10-11.

[11]McManus, *Artisan Soul*, 9-10.

[12]See her article, "The Significance of Beauty and Excellence in Biblical Worship," in *Worship and Mission for the Global Church: An Ethnodoxology Handbook*, ed. James R. Krabill (Pasadena, CA: William Carey Library, 2013), 9-12.

Levites), worship rituals (water cleansings and sacrifices), worship garments (ephods, breastplates, and turbans), worship instruments (harps and cymbals), worship artists and composers (Bezalel, the sons of Asaph, and King David), and worship songs and liturgy (the Psalm collection and the public reading of the law).

Mission itself was closely related to these worship patterns, for there was coming a day, proclaimed the prophet Micah, when people from all the surrounding nations would stream up to the Lord's house in Jerusalem, learn of God's ways, and sing Yahweh's songs on Mount Zion (4:1-2). "Mission accomplished" for the Hebrew people would happen in worship, in the temple, and in Jerusalem—understood to be the veritable center of Yahweh's universe.

This all begins to shift in the life, ministry, and "Great Commission" of Jesus, who sends his followers *out* of Jerusalem to the nations. "Mission accomplished" for the New Testament church would happen when groups of believers—as small in number as two or three—in every corner of the known world would gather in Jesus's name and worship God "in spirit and in truth" (Jn 4:24).

Now, there will necessarily be some "biblical constants" in this worship as we see modeled in early church practice through proclamation of God's Word, fellowship, prayer, praise, Christ-centeredness, and the Lord's Supper (Acts 2:42, 46-47). Likewise, there are a set of commonly held "biblical principles" with worship that is God-focused, Christ-centered, Spirit-enabled,

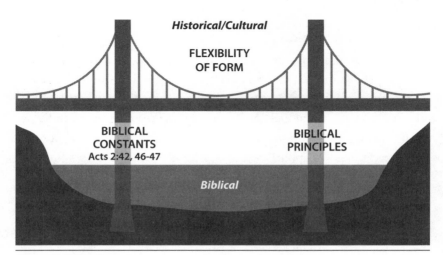

Figure 1.1. Bridge illustration

dialogical between worshipers and God, multi-voiced, participatory, and edifying both for individual worshipers and for the corporate body, equipping them for more effective participation in God's mission.[13]

But aside from these two mutually shared pillars of worship, the amazing freedom and flexibility that the New Testament grants to local communities of faith in developing their own forms and patterns of missional worship is nothing short of stunning. There appears to be little interest in the many objects and patterns of Old Testament worship, as if to encourage emerging congregations to find or create within their own widely dispersed and varied settings the worship places, times, dress, furnishings, and songs that build the local body of Christ in culturally appropriate yet faithful ways. As John Piper rather starkly puts it, "Almost every worship tradition we have is culturally shaped rather than biblically commanded. . . . There is a reason for the radical spirituality of worship in the New Testament. And the reason is this: The New Testament is a missionary document! The message found here is meant to be carried to every people on earth and incarnated in every culture in the world."[14]

This dramatically transforms the missionary mandate of God's people, reminding them never to lock the gospel treasure of new life in Jesus Christ in any specific cultural pattern but rather to encourage the creative work of the Holy Spirit in the lives of local believers, in every time and place where the seeds of the good news are planted.

IDENTIFYING APPROACHES

If this is an accurate reading of the shifting paradigm found in Scripture, then gospel communicators will embrace the view that God has given to every culture all it needs in artistic expression for the life, worship, and witness of faith communities coming into existence and growing in Christlikeness within that culture. This does not preclude choices such communities might make to appreciate and appropriate artistic forms from other cultures, past or present, but it is not a requirement for faithfulness. Rather,

[13]These observations and the accompanying illustration are adapted from the work of Ron Man in his chapter, "'The Bridge': Worship Between Bible and Culture," in Krabill, ed., *Worship and Mission*, 17-25.

[14]See Piper in his chapter, "The Missional Impulse Toward Incarnational Worship in the New Testament," in Krabill, ed., *Worship and Mission*, 101.

it is the primary responsibility and divine calling of church communities in every time and place to research and discern which cultural forms are best suited for the advancement of God's kingdom purposes in their context.

The primary role of supportive outsiders to the culture—sometimes referred to as arts advocates—is to become acquainted with local artists and what they prefer, produce, and perform in ways that spur these artists to create in the forms they know best. "The advocate," writes Brian Schrag, "enters local creative processes, helping give birth to new creations that flow organically from the community. This approach usually requires longer-term relationships with people, and above all, a commitment to learn."[15] The ministry of the prophet-evangelist William Wadé Harris, described at the outset of this chapter, offers us a truly remarkable example of how that can happen.

The process of determining which artistic expressions are suitable and useful for the life of God's people requires cultural expertise, aesthetic awareness and sensitivity, social intuition, biblical and theological familiarity, community discernment, and a heart and mind fine-tuned to the Spirit of God. All these will be required for navigating four choices to be made and actions to be taken with regards to a culture's artistic forms: *continuation* (forms that can simply be carried over into the life of the newly emerging faith community); *correction* (forms that are incompatible and unacceptable, no longer fit or make sense and simply drop off, or become irrelevant, disappear, or fade away); *completion* (forms that are not carried over intact or outright abandoned, but are rather modified and ultimately transformed—sometimes rapidly, sometimes gradually—never to be the same again); and *creation* (forms that never before existed but simply spring up out of nowhere or are deliberately created as obvious and necessary in light of life's new realities).[16]

[15]See Schrag's chapter, "Ethnoartistic Cocreation in the Kingdom of God," in Krabill, ed., *Worship and Mission*, 51-52. Schrag has designed an entire seven-step process for assisting communities in this endeavor and has published it in longer and shorter versions; see Brian Schrag, *Creating Local Arts Together: A Manual to Help Communities Reach Their Kingdom Goals* (Pasadena, CA: William Carey Library, 2013); and "Creating Local Arts Together: The Manual Summary," in Krabill, ed., *Worship and Mission*, 502-33.

[16]I develop these four processes more fully as a tool for assessing the ministry impact of William Wadé Harris in my book, *Is It Insensitive to Share Your Faith?* (Intercourse, PA: Good Books, 2005), 98-101.

The Christian movement in the early centuries of its existence models for us the kind of creative adaptation it undertook in thoughtfully engaging the artistic expressions of the Greco-Roman world. Eleanor Kreider highlights a number of these when she writes,

> In catacomb paintings and as bas-relief sculpture on *sarcophagi* (tombs), heroes and stories of the Bible appear clad in the iconography of Greco-Roman culture. Jesus, as healer and wonder worker, sometimes carries a "magic" wand. Depicted as a clean-shaven youth, Jesus could as easily be taken for an adolescent Orpheus, who in Greek mythology charmed all living beings with his music and challenged the power of the underworld. . . . In Roman times men of substance wore signet rings, which they used to authenticate documents or to label goods for trade. In the late second century, Clement of Alexandria instructed Christian men to wear the signet ring at the base of the little finger. On no account could the ring's image be a lover, "for we are a chaste people," nor a sword or bow, "for we cultivate peace," nor a drinking cup, "for we practice temperance." The image on the ring could be a dove, a fish, a ship in full sail, or an anchor, which could discretely evoke the cross. In this way Christians used distinctive and potent symbols to reflect their faith, values, and life practices.[17]

Sometimes in the mission history of the church, gospel communicators exhibited this level of creativity in engaging the artistic expressions of cultures they encountered. But often they adopted much harsher attitudes, demonstrating their own ignorance, fear, or disdain for forms unfamiliar to them. In some instances, they approached other cultures with a mindset of *tabula rasa,* or "blank slate." This Latin phrase comes from the wax tabula employed by the Romans for note taking. The process involved heating the wax and removing written messages by re-constituting a smooth surface. The English-language term, a "blank slate," finds its origins in this process of wiping a slate clean to prepare it for use in composing new messages.

Some European missionaries viewed non-Christian religions and their arts in precisely these terms—empty, blank slates that needed to be filled with Christian doctrines, images, worship, and practice. Interpreters of those religions from the majority world have persistently pushed back. No

[17]See Kreider's chapter, "Artistic Expression in Early Christianity," in Krabill, ed., *Worship and Mission,* 26-27.

less than five centuries after the first encounter between Western Christianity and sub-Saharan traditional religions, a group of African Roman Catholic priests, trained in Rome and various European universities, stepped forward to present themselves as "African Christians," not merely the "consumers" of a Eurocentric understanding of the Christian faith. One of the movement's early publications, *Des prêtres noirs s'interrogent*,[18] attempted to respond to "the assumption that Africa represented a cultural and religious *tabula rasa* for the implantation of a Christian civilization from Europe."[19] They insisted that African self-worth must be respected and that "room must be made for African genius and contribution in the establishment of the Catholica, not only among the peoples of Africa . . . but in the wider world as a whole."[20]

In other contexts where the arts and mission met, representatives of Western Christianity and culture worked under the assumption that the local slate was not blank, though it was inferior or demonic and needed to be discarded and replaced. "One use of the word 'culture' is as an adjective," notes Soong-Chan Rah, "as in, that person is very 'cultured,' implying that there is a hierarchy at work."[21] Commenting further on the gradations placed on culture, Rah references the three levels of culture highlighted by Kenneth Myers in his book, *All God's Children and Blue Suede Shoes*:

> Myers categorizes "high" culture as culture arising from a European heritage. "High" culture is Bach, Rembrandt, classical music, European art, and the theater (ballet and opera, not Broadway musicals). "Low" culture is Bon Jovi, Michael Jackson's "Thriller," Andy Warhol's soup cans, television that is not *Masterpiece Theater*, and other expressions of pop culture. The "high" culture of Europe stood far above "low" popular culture.[22]

Myers created a third category that he labeled as "folk" culture. "Folk" was a step above "low" but a step below "high" culture. "Folk" culture was African drumming, Korean fan dancing, or Native American jewelry. In this

[18]Albert Abble, ed., *Des prêtres noirs s'interrogent* (Paris: Cerf, 1957).
[19]Kwame Bediako, *Theology and Identity: The Impact of Culture upon Christian Thought in the Second Century and in Modern Africa* (Cumbria, UK: Regnum, 1999), 349.
[20]Bediako, *Theology and Identity*, 348.
[21]In Soong-Chan Rah, *Many Colors: Cultural Intelligence for a Changing Church* (Chicago: Moody, 2010), 21.
[22]See Kenneth Myers, *All God's Children* (Wheaton, IL: Crossway, 1989).

schema, culture that was of European origin was "high" (implied better) and closer to God, while folk culture (usually the culture of non-Western society) was a grade below European culture. The implication of these categories is that some cultures are superior to others. An additional implication in this gradation is the closeness of one culture over another to God's will and plan for creation.[23]

The impact of holding these views is obvious and, according to J. Andrew Kirk, resulted in the initial presentation of Christianity in Latin America as "largely a disaster."[24] Kirk notes, "Tragically, the Spanish and Portuguese *conquistadores* used religion as a weapon to control the subjugated people. . . . For nearly 500 years the indigenous peoples were not allowed to bring any of their traditions into relation with the gospel."[25] Protestant missionaries, adds Kirk, "believed that the task of evangelism was to rescue the people from darkness of their superstition. . . . The challenge was to educate the people in the Anglo-American traditions of freedom, democracy, work as vocation and sound economic practices."[26]

ASSESSING BEHAVIOR

It might be convenient to draw a straight line through history marking the attitudes and behavior of the Christian movement toward the arts of other religions and cultures. But that would not be possible, helpful, or accurate. To be sure, there are moments along the way that have shaped the encounter of local arts and the mission enterprise. One of those took place in the first half of the fourth century AD when, during the reign of Emperor Constantine I, Christianity in the West increasingly came to be associated with Roman socio-politics and with the imperial upper classes. By the end of that century, Christianity was declared the only legal religion, followed two centuries later by baptism being made compulsory. The religion spread, in many instances, by coercion with the aid of military power and with the goal of establishing a unitary Christian society—with common symbols, rituals,

[23]Rah, *Many Colors*, 22.
[24]See David Ruiz, "Global Shift from North to South: Implications for Latin American Worship," in Krabill, ed., *Worship and Mission*, 43-45.
[25]J. Andrew Kirk, *Mission Under Scrutiny* (Minneapolis: Fortress, 2006), 164.
[26]Kirk, *Mission Under Scrutiny*, 166.

liturgy, and hierarchical structures—called "Christendom."[27]

Local and regional expressions of Christianity, such as the celebrative spirit manifested in the vibrant, life-embracing music, art, poetry, dance, and spirituality of the Celtic Christian experience, were often suppressed and marginalized by the universalizing impulse from Rome. Similar effects, notes George G. Hunter III, were felt on other branches of the church—such as Eastern Orthodox, Oriental Orthodox (Armenian, Coptic, etc.), Slavic, Waldensian, African-initiated movements, and the Thomas churches of India. "Most Western Church leaders," says Hunter, "assume that the only useful stream of insight is, by definition, confined to Roman Christianity and its Reformation offshoots. . . . Few of us study other branches of the Church. . . . The assumption is blatant: The only church history really worth knowing is Latin church history and its Reformation spin-offs."[28] A sad consequence of such assumptions is that the Christian movement's understanding of God's purposes for the broader human family has been deprived of the potential enrichment other cultures and traditions might have contributed.

With the age of "discovery" and the nineteenth-century rise of nationalism in Europe, another wave of cultural influence was felt around the world. Accompanying colonial administrators were the pastors and priests who generally, though not always or automatically, shared the commitment of their European colleagues to advance the causes of the three Cs—Christianity, commerce, and civilization—throughout their respective empires. By the end of the nineteenth century, the success of the civilizing-Christianizing project was celebrated in the 1892 edition of *A Dictionary of Hymnology* under the entry title "Foreign Missions." In that piece, Rev. W. R. Stevenson reports with considerable excitement: "The fact is that the best hymns of . . . English, [German, and American] authors are now sung in China and South Africa, in Japan and Syria, among the peoples of India, and in the isles of the Pacific Ocean—indeed, in almost every place where Protestant missionaries

[27]See Alan Kreider and Eleanor Kreider, *Worship and Mission After Christendom* (Colorado Springs: Paternoster, 2009), esp. 17.

[28]See George G. Hunter, *The Celtic Way of Evangelism* (Nashville: Abingdon, 2000), 10. Two additional works treating this matter are Thomas Cahill, *How the Irish Saved Civilization: The Untold Story of Ireland's Heroic Role from the Fall of Rome to the Rise of Medieval Europe* (New York: Doubleday, 1995); and John Finney, *Recovering the Past: Celtic and Roman Mission* (London: Darton, Longman and Todd, 1996).

have uplifted the Gospel banner and gathered Christian churches."[29]

In reality, many Christians around the world came to genuinely cherish Euro-American music traditions and consider them as "their own." Asante Darkwa, speaking for himself and other Ghanaian Christians, has noted that "the hymn tune is perhaps the most commonly understood form of Western music by literates and preliterate Africans. Christians sing their favorite hymns not only at church services but also at wakes and burials and in other situations in which they find solace and comfort in those ancient and modern hymns which have done a wealth of good spiritually to Christians all over the world."[30] Catherine Gray likewise reports a similar situation among the Baganda in Uganda, where Western hymnody "is now so much a part of Christian worship and Baganda life that it could be called indigenous music."[31]

The Euro-American legacy is indeed a persistent one, rendered even more complex in a globalized world with today's flood of Internet images, lucrative music industries, and sensational praise and deliverance ministries setting the tone for what true worship is and how it should be expressed. The influences of Western aesthetic values, culture, beliefs, and control continue to shape the ways in which many of the faith communities around the world are run, what art, drama, and music appear in their churches and on worship platforms, and what is preached from the pulpit.

REDISCOVERING THE INCARNATION OF CHRIST

This alarming reality has prompted two eminent scholars, William R. Burrows and R. Daniel Shaw, to bemoan the fact that despite all the preparatory training offered to Western mission workers in recent years, little has resulted in reducing the clash that occurs when these gospel communicators encounter local people in eventual contexts of ministry. "The way Christianity has been portrayed," write Burrows and Shaw, "still emanates

[29]See W. R. Stevenson, "Foreign Missions," in *A Dictionary of Hymnology: Setting Forth the Origin and History of Christian Hymns of All Ages and Nations*, ed. John Julian (London: John Murray, 1892), 759.

[30]Asante Darkwa, "New Horizons in Music and Worship in Ghana," in *African Urban Studies* 8 (2001): 69.

[31]Katherine Morehouse, "The Western Hymn in Mission: Intrusion or Tradition?," in *Global Consultation on Music and Missions: The Proceedings*, ed. Paul Neeley et al. (Duncanville, TX: Ethnodoxology/ACT, 2006), 10, CD-ROM.

from Western assumptions and theological systematics reflecting how people are presumed to respond to God. Christianity around the world remains, for the most part, a Western perspective on God rather than allowing people to determine God's intent in their local context and realize God's presence in their midst."[32]

These are rather harsh words. But given that they are offered at the outset of the twenty-first century by Burrows and Shaw, two life-long observers of mission history and the world Christian movement—one Roman Catholic and the other evangelical Protestant—they represent a clarion call to wake up and pay attention. The collection of articles the two editors have assembled in their publication—written primarily by Christian scholars from the majority world and exploring the dynamic encounter between the arts, traditional rituals, and Christian worship in Costa Rican festivals, Korean ancestral rites, Indian ceremonies, Armenian pagan rituals and Orthodox beliefs, indigenous Igbo worship patterns, Japanese death rites, Melanesian ancestral relationships, a Native American cleansing ceremony, and a Messianic Jewish household ritual—point the way to a hopeful future while demonstrating the hard work of prayerful, scholarly discernment that remains ahead for God's people.

Foundational to the focus and passion the church must cultivate for local artistic expressions in all their color, vibrancy, and diversity are values and perspectives deeply rooted in Scripture and shaped by theological commitments. "The incarnation of Christ," writes Benjamin M. Stewart, "includes Christ's honoring of local cultural patterns including dress, language, cuisine, time-keeping, gesture, and relationship with local ecology. . . . The church as the body of Christ rightly honors each local culture grounded in the scriptural memory that, in Christ, God comes to the world 'deep in the flesh' of local culture."[33]

One can only speculate how the history of the encounter between the arts and mission might have been different had more gospel communicators probed the depths of this bedrock notion central to the Christian faith. And

[32]See William R. Burrows and R. Daniel Shaw, eds., *Traditional Ritual as Christian Worship: Dangerous Syncretism or Necessary Hybridity?* (Maryknoll, NY: Orbis, 2018), xix.

[33]Stewart, "What, Then, Do Theologians Mean?," 46. Stewart credits Anscar Chupungco with the inspiration for some of his thoughts on these matters.

one can only imagine what exciting days still lie ahead should God's people find ways of rediscovering that notion anew.

On that road to discovery, we are accompanied by a Native American artist who encourages us along the way with these challenging words:

> Jesus does not replace the messengers Creator sent to our peoples, He completes the messages they brought. He does not take away the ceremonies, He restores and strengthens them. His path is not that of assimilation, nor of destruction, but of peace, healing, restoration, and walking humbly with the Creator as the people He made us to be. I am in no way bound or oppressed by following Jesus, but free to follow Him on the Red Road, and take my place dancing before the Sacred Fire.[34]

When we heed this counsel, we join with William Wadé Harris and other faithful gospel communicators throughout the Christian movement in believing that the Creator God has given to people of all cultures whatever artistic expressions they need to be God's faithful people in worship and witness, both in this life and gathered forever with peoples, languages, and voices of praise "before God's throne and the Lamb" (Rev 7:9).

[34]Burrows and Shaw, *Traditional Ritual*, v, where the artist is simply identified as One Hot Mama.

Performing Witness

Loving Our Religious Neighbors Through Musicking

Roberta R. King

Loving our religious neighbors by performing the musics of and with religious neighbors propels us into relationships that testify to God's love and joy.[1] My purpose here is to investigate the broader dynamics of musical performance ("musicking") as a nexus for relational encounter and engagement among peoples of diverse faiths.[2] I explore the processes of dialogic encounter and show how music and the arts play sociological roles that impact relations within and between communities.

My research focuses on three ethnographic case studies situated in Southern California where Muslims and Christians are encountering and engaging with one another through musicking. They include a church-and-local community benefit concert, an area-wide heritage music ensemble, and an academic ethnic music ensemble. Each case demonstrates and models varying spheres of interaction and influence.[3] With a focus on Muslim-Christian interfaith dynamics, I argue that musicking fosters

[1] See Roberta R. King, *Global Arts and Christian Witness: Exegeting Culture, Translating the Message, Communicating Christ* (Grand Rapids: Baker Academic, 2019), chap. 3.

[2] This study builds on my earlier research focused on the contribution of music and the arts to sustainable peacebuilding among Muslims and Christians (2008–2013), published as Roberta R. King and Sooi Ling Tan, eds., *(un)Common Sounds: Songs of Peace and Reconciliation Among Muslims and Christians* (Eugene, OR: Cascade, 2014).

[3] In addition to relevant literature, research data is drawn from personal interviews of one ensemble director, four singer-performers, and nine years of my own participant observation and musicking in two local, Southern Californian, Arabic–Middle Eastern ensembles: *Kan Zaman* and *Layali Zaman*.

bridging relationships, generating community, and interactive engagement between diverse religious communities that offers opportunities for loving our religious neighbors.

PERFORMING AS BRIDGES TO RELATING

Musical performance (musicking) creates bridges that allow strangers to come together around a common event. While musicking applies to high art performance events of Western classical music, it also recognizes the classical, folk, and popular musics of diverse ethnic groups, such as classical Arabic musics and their related folk and popular musics. In our first case, we turn to a Southern California church's outreach into their changing local neighborhood.

Praising Allah in the sanctuary. It's a balmy evening in Southern California in the summer of 2017. My Israeli-born friend, Summer, and I have just enjoyed a Middle Eastern meal in a nearby university town. Summer (her given name is Samir) and I first met in a local Middle Eastern music ensemble that brings together Southern Californian musicians and music lovers originally from North Africa and the Middle East. Not sure what we would find that evening, we drive over to an evangelical church hosting a benefit Middle Eastern concert. As we enter the church, I become disoriented. Standing at the entrance and greeting us dressed in their brightly colored *hijab* are three lovely young Muslim women. The narthex is awash with lighthearted laughter and joy as a diversity of people continue entering the sanctuary.

The concert begins with a West African *griot* from Senegal performing on the *kora,* a twenty-one-string harp-lute.[4] The calabash gourd that functions as a resonator for this sophisticated instrument declares *Allah* in gold-leaf Arabic script. Senegal is 99 percent Muslim. The Muslim performer dedicates his music in honor of God to the newly arrived Syrian refugees, the recipients of the evening's benefit concert. He has come to play in solidarity with the community-within-a-community emerging among Christians and Muslims. The *griot's* mission is to help others. His songs, full of West African religious and cultural symbolism, reveal his contrasting

[4]The term *griot* refers to a "class of hereditary professional musical and verbal artisans" originating in the Senegambia region of West Africa. *Griot,* more generally, refers to any "African oral historian, praise-singer or musician, regardless of birthright." *The New Grove Dictionary of Music and Musicians,* 2nd ed., ed. Stanley Sadie (New York: Oxford University Press, 2001), 10:427.

worldview. For example, he explains that one of his songs tells how mothers and their wombs are the laboratory of God. Although I surmise many attendees have not fully understood the cultural implications of the metaphor, there is an open attitude and willingness to be together by listening and sharing in a diversity of non-Western musics.

The evening proceeds with more Middle Eastern music, followed by an informative intermission. One of the church leaders explains how a number of local churches have been coming together to help Syrian refugee children settle into their new local schools within the larger Southern California region.

To round off the musical event, a long-established Jordanian immigrant of Palestinian descent comes forward and begins playing his 'oud, "a short-necked plucked lute of the Arab world."[5] As a Christian, he sings, "*Salaam, salaam, yarabi salaam.*" ("Peace, peace, oh my Lord, peace.") The song evokes a wistful longing and nostalgia for everyone in the room. "How Great Thou Art" follows, alternating between the verses sung in Arabic and the chorus in English. He focuses on audience participation. Ultimately, the song becomes a type of prayer for the Syrian refugees. The event begins winding down.

Then it happens. The singer launches into a well-known Arabic folk song as the dynamics of the evening shift dramatically. The music slips off the stage and ripples throughout the audience. Faces light up with delight as Middle Easterners recognize one of their beloved songs. The song evokes a nostalgia of better times and of home. With growing momentum, the Middle Eastern newcomers move toward the front of the sanctuary and start to line dance, men clasping hands, holding them high in the air with large smiles on their faces. Now the church members and the local community gingerly come forward, attempting to join in. The young women in their *hijabs* bring out their smartphones to capture the excitement. It's a spontaneous moment breaking down multiple barriers. Joy and delight abound. But wait—as the music and dance begin to subside, there is weeping in the room. A lovely Syrian mother in silk headscarf reaches down to her tearful three-year-old daughter. Crying through her tears, she asks, "Why does the music have to stop?"[6]

[5]Sadie, ed., *New Grove Dictionary of Music and Musicians*, 25:25. The 'oud is commonly credited as the forerunner of the modern guitar.

[6]Adapted from *Global Arts and Christian Witness* by Roberta R. King, copyright © 2019. Used by permission of Baker Academic, a division of Baker Publishing Group.

What just happened? An Arabic folkdance migrated along with the ref-
ugees into a local church situated in Southern California, half a world away
from its origins. And there was joy! The church, located close to where an
Islamic terrorist attack had just taken place, had not only sponsored a benefit
concert but also laid the foundations of relating within a musical space.
Benedict Anderson suggests a "contemporaneous community" can form
around the performance of poetry and song that engenders "an experience
of simultaneity. At precisely such moments, people wholly unknown to each
other utter the same verses to the same melody."[7] There is an experience of
encountering one another. In the midst of musicking, multiple relational
dynamics were taking place.

Musical spaces of discovering and relating. The musicking that occurred
in the sanctuary that evening took place within a performance arena,
prompting people to relate with one another, each in their own way and at
a comfortable level of trust. Musicking, as a rich and complex social affair,
creates attitudes of openness to other peoples in the midst of performance
and sparks relationships at differing levels of engagement. In the "Musical
Spaces of Discovering and Relating" (fig. 2.1), we find people engaging and
discovering each other in joyful and non-threatening ways, allowing them
to more fully move toward relating as neighbors.

These spaces foster negotiating relationships that move people toward
one another on a continuum of five graduated levels and stages. Relational
attitudes and behaviors range from exclusion and enmity toward peoples of
difference to discovering themselves willingly relating and embracing one
another as neighbors.

A brief analysis of musicking in the sanctuary demonstrates the range of
dynamics taking place.

Stage one: Enmity and/or exclusion. Peoples of diverse nationalities,
such as newly arrived Syrian refugees and a local Southern California
community, who most likely had not had any previous long-term contact,
took the opportunity to come together around a music event. In essence,
they had previously been isolated from one another, perhaps showing
levels of exclusion due to linguistic, cultural, and religious differences. Not

[7]Benedict Anderson, *Imagined Communities: Reflections on the Origin and Spread of Nationalism* (New York: Verso, 2006), 145.

Figure 2.1. Musical spaces of discovering and relating

knowing how to engage with the newcomers, the concert in the church shifted those dynamics.

Stage two: Encounter. Local peoples and new neighbors are entering into the musical space and discovering themselves encountering peoples of differing faiths, nationalities, and languages. The benefit concert provided an arena for raising funds to meet the needs of the newcomers while also providing an opportunity to share common interests and demonstrate an openness to be together.

Stage three: Engage. Musical performance became the main attraction and medium for coming together in a fundraising event. The invited West African and Middle Eastern performers engaged in performing their cultural musics, giving them opportunities to reveal their unique

cultural heritage. The host church extended generous hospitality on multiple levels by welcoming peoples of diverse backgrounds and also performing their highly cherished cultural musics. Significantly, a people's cultural music forms an important part of their identity. As the evening progressed, experiencing Middle Eastern ways of life surfaced as the concert moved beyond politely listening into participatory elements such as dancing, clapping, and vocal exclamations typical of Middle Eastern music practices. Some people were fully engaged, while others participated on a listening-only level. When the pivotal moment occurred, the concert participants moved toward each other into a deeper level of interaction and embrace of one another.

Stage four: Embrace. The folk song at the end prompted participation on multiple levels. The song triggered Middle Easterners into dancing, joining hands, and delighting in participating together. A contagious desire to participate triggered some local community members to join in the dance. Joy permeated the room; people enjoyed being together and sharing their common humanity.

Stage five: Relating as neighbors. The "buzz" of joyful interaction and sense of being together in one community hit a peak level when the music finally stopped. People lingered and intermingled. The excitement continued. For many there was a desire to not let the music stop. The groundwork for continuing dialogues about one's faith in God and in sharing life together were established.

The "Musical Spaces of Discovering and Relating" aligns with Small's contention that a musical performance should be seen "as an encounter between human beings that takes place through the medium of sounds organized in specific ways."[8] Thus, we have seen how peoples from different walks of life freely and willingly enter into musical spaces of relating regardless of their differing levels of understanding and diverse religious perspectives. John Paul Lederach, noted peacebuilding scholar, argues compellingly that "the artistic five minutes, I have found rather consistently, when it is given space and acknowledged as something far beyond entertainment, accomplishes what most of politics has been unable to attain: It helps us

[8]Christopher Small, *Musicking: The Meanings of Performing and Listening (Music Culture)* (Middletown, CT: Wesleyan University Press, 1998), 11.

return to our humanity, a transcendent journey that, like the moral imagi-nation, can build a sense that we *are*, after all, a human community."[9]

Indeed, as people discover their common humanity through music making, they also experience the possibilities of living together as neighbors. Musicking establishes bridges to relating with one another. An initial trust is established for moving forward in relating neighborly and fosters living out witness in the midst of community. Yet relating neighborly needs to endure beyond a one-time musicking event. It also requires sustained en-gagement, to which we turn next.

PERFORMING AS COMMUNITY GENERATING

We have seen how the bridges of musicking bring together contrasting ethnic and religious neighbors. Diverse peoples are enabled to move into new arenas, somehow familiar yet also different. When practiced on a regular basis, musicking becomes more expansive and enduring. People in-teract with each other in deeper ways and build friendships. Community music performance groups that regularly rehearse and perform together participate in generating community among themselves and find that it also links with the larger local community. At such points, Christian witness is afforded opportunity to travel across the bridges of community building.

Discovering religious neighbors. There I stood, on stage at the Hun-tington Beach Library Theater, just before the beginning of the second half of the concert. The director of Kan Zaman Community Ensemble had asked me to share what it meant to me as a Caucasian woman to sing with an Arabic music ensemble. Stunned by his invitation and looking out over the Arab American audience, I began telling about the beauty, sophistication, and ecstasy of the Arabic music traditions I was discovering. Most important, I spoke about the privilege of performing with my new friends in the en-semble. Although I was still very much a novice in Arabic music perfor-mance, I had been warmly accepted into the Kan Zaman performance group.

My journey into Middle East musics started with receiving a research grant from the Luce Foundation for a project titled "Songs of Peace and

[9]John Paul Lederach, *The Moral Imagination: The Art and Soul of Building Peace* (Oxford: Oxford University Press, 2005), 153.

Reconciliation Among Muslims and Christians."[10] It took me to Fez, Morocco; Beirut, Lebanon; and Yogyakarta, Indonesia. Since my expertise was centered on African music, I needed to begin learning about and performing Arabic music. Surprisingly, I discovered that a Middle East music ensemble, Kan Zaman, rehearsed weekly a short two blocks from Fuller's Pasadena campus. Through musicking I engaged with peoples of Arabic heritage and gained access to the local Arab American community in Southern California. Discovering my religious neighbors through musicking initiated a delightful journey into a community other than my own. It launched me into relating within diverse communities.

Dynamics of generating community via musicking. Interreligious witness via musicking entails entering into a diasporic community and following the relationships. Musicking provides opportunities to enter into the webs of life happening among diverse groups of people. Lederach argues that "relationships are at the heart of social change." They take place in the social spaces of a peoples' daily life. Learning to strategically think, feel, and follow relationships leads to "the actual places of life where unusual relationships cross and interact."[11] What do we learn about a people through participating in performing their cultural musics? The ensemble members revealed four core dynamics that foster understanding a people's longings and needs, leading toward meaningful relationships among religious neighbors.

Reconnecting with one's heritage. The most prominent desire among members of the Arab American music ensemble Kan Zaman—now Layali Zaman—is the desire to reconnect to their cultural heritage through the arts, especially through music, both vocal and instrumental. Growing up in families "that loved the ecstasy of Arabic music and the sounds of music"[12] generates desires to perform on traditional Arabic instruments, such as the *nay* or *'oud*, and to engage with songs drawn from Arabic music traditions. Members speak of how performing their music is a "spiritual experience. . . . It's a consciousness-raising, and emotional-raising [experience] . . . it affects many parts of your life."[13] They emphasize how it also reinforces their identity

[10]See King and Tan, eds., *(un)Common Sounds.*
[11]Lederach, *Moral Imagination,* 86.
[12]Interview with Lana Kakish, June 11, 2018.
[13]Interview with Steve Kent, June 11, 2018.

through feeling pride in their heritage. Lana Kakish explains, "Everybody is helping each other and giving of themselves in volunteerism to something that's bigger than them. Keeping the heritage alive, feeling pride in something. They're all homesick and they're feeling this is bringing them back together and they're holding on to part of their heritage that makes them feel that as the Arabic world is being dismantled."[14]

Singing Arabic songs and playing traditional, classic instruments from the Arab world fulfills a need to relate to and identify with one's heritage in positive ways. It is the main draw for coming together as a community. It reminds the performers and their audiences of the importance of keeping their heritage alive and the quality it contains.

It's about the music. Ultimately, it is the music of one's heritage that draws them together. The range of musical interest varies widely. When asked a generic question, such as, "What interests you most about performing with Kan Zaman or Layali Zaman?" the focus turned to the music itself, both musical sound and lyrics. Responses included, "It's mostly the music. I don't have a favorite part. I like the variety. . . . I like the music of old, from my grandparents' time," and "It brings something out in me. It brings me alive. I love the words. I learn appreciation to the words. I didn't even know that I understood poetry."[15] They reveal a growing appreciation and depth of understanding regarding one's heritage music. Performing Arabic songs dives down deep into the historical recesses of one's life experience, especially in the emotional realm.

Summer explains, "The old, old songs like from Es-Mahan and Lela Murad, those are the ones that my Mother used to love, it brings me to tears. A lot of the music is so emotional and so deep and so real." The emphasis on "emotional, deep, and real" reveals a longing for authenticity and deeper attachment with their cultural identity. Steve Kent expands on this: "You develop a higher understanding and level. You get involved in the music more as you grow older because there's more of an understanding of all the facets of the music and how the different *maqams* changing in the song, how that affects you emotionally."[16] The impact of the music both cognitively and affectively propels some to record the music to save it for posterity as part of

[14]Interview with Lana Kakish, June 11, 2018.
[15]Interview with Summer Chatel, June 11, 2018.
[16]Interview with Steve Kent, June 11, 2018.

one's own family ethos. "Recording and having it saved was always important to me because it was important to my family that they pass that down. So, the group gives that opportunity."[17]

The lyrical content provides a major impetus for documenting and preserving treasured heritage while also speaking into contemporary society. Contemporary songs, though somewhat appreciated, are not considered as good and meaningful as the older songs. Multiple voices chime in and decry the fact that both contemporary music and lyrics do not contain the same depth. "It's not only the music and the composition of music, it's the words! People don't have those words anymore."[18] The lyrics impact performers and audience members deeply, evoking the performance to heightened levels.

The repertoire presents themes of love and suffering. The songs serve as "the generic form of speaking into society."[19] Song selection by both artistic directors, Wael Kakish and Adel Eskander, steer away from the divisive issues of politics and religions. Rather they address "how the people used arts to speak about love. It lets us face the struggle of life and we . . . could identify with that and get behind it. Because it was not stirring any conflict."[20]

Thus, these unifying themes draw diverse Arab peoples into the ensemble. Focused on their common life practices and experiences, the organizers realize how they can come together through performing the musics of their heritage. Lana Kakish states it boldly: "What's keeping me there is the music. Because of the music, that's why I'm staying. If they become a political group, they're not going to see me there."[21] First and foremost, it's about the music.

Discovering a place to belong. Less obvious than the importance of the music, yet profoundly significant, is the desire to find a place to belong. This happens on multiple levels: first is the need for musicking, followed by the need for relationship and ultimately making lasting friendships. Most musical performance, if not all, requires social spaces for group music making. People are looking for spaces where they can engage with music in a group. As Kent notes, "Well, I got tired of playing the violin, the *'oud*, the *darbuka*

[17]Interview with Steve Kent, June 11, 2018.
[18]Interview with Summer Chatel, June 11, 2018.
[19]Interview with Lana Kakish, June 11, 2018.
[20]Interview with Lana Kakish, June 11, 2018.
[21]Interview with Lana Kakish, June 11, 2018.

myself on a multi-track recorder to make it sound like a group. So, I thought it would make it a lot easier if I went to an actual group."[22] At the same time, others are looking to belong to a performance group in order to deal with the trauma of being widowed and the resulting social isolation. Chatel relates that she likes to be part of a group because its entertainment gives her life and offers her social engagement in the evenings. She adamantly states, "I'm in lala land until the next time when we rehearse or perform."[23]

As Arabic-speaking performers join a group, they find themselves linking with the "invisible" community and discover that a broader community exists. Kent explains, "You find out that there is an actual community in Southern California of people that you heard of, but that you never met. When you start in a group and that group performs, you start meeting these people. Because everybody goes to each other's performances. It's like a musical community within the bigger, larger population."[24]

Networking within the broader community becomes a reality. Performing with a group "widens your knowledge of people in Southern California that are of Arabic descent, including people from a wide range of jobs, coming from diverse Arabic and social backgrounds. Everyone is appreciating the music together."[25] Over a period of time, performers and audiences emerge as a community of musical sojourners.

Making friends through musicking becomes a major thread running throughout a performance group's ethos. Kent explains: "You make friends because you have the music in common even if nothing else is the same or in common. The music brings people together and makes for a common experience. You find friends coming out of the woodwork, wanting to engage with you in other areas besides just the immediate group."[26]

This is true for most people in the ensemble. As they come together, they discover that despite their geographical backgrounds, the similarities of their musical heritage also point to other areas of affinity, and friendships are initiated.

[22]Interview with Steve Kent, June 11, 2018. The *ʿoud* is a Middle Eastern lute-type instrument, while the *darbuka* is a goblet shaped hand-drum used in Middle Eastern music.
[23]Interview with Summer Chatel, June 11, 2018.
[24]Interview with Steve Kent, June 11, 2018.
[25]Interview with Steve Kent, June 11, 2018.
[26]Interview with Steve Kent, June 11, 2018.

Summer Chatel describes her experience in meeting Lana Kakish: "You know, we lived in different parts of the world all our lives. . . . When you meet her it's like you've known her for all your life. We're comfortable with each other; we can talk with each other. We can cry on each other's shoulders if we must."[27] Such friendships last longer than temporary acquaintances. As is common among Middle Easterners, most relationships "are a lifetime relationship."[28]

Dana Robert contends that global friendships function as an incarnational missional practice. She argues that "the longing for deep and consistent relationships remains a core part of being human."[29] Indeed, entry into cross-cultural friendships requires a mutuality of engagement that expects "both sides will be changed by the encounter."[30] As such, friendships of mutuality become pathways of transformation between insiders and outsiders alike.

Transformative interactions. Intercultural communication scholars theorize about building shared meanings in cross-cultural contexts.[31] Musical heritage performance groups provide a laboratory for developing what Broome calls "relational empathy," which fosters building shared meanings. Building shared meanings results in the emergence of a third culture, one that creates a small community within a community built on uniquely shared values, beliefs, norms, and symbols.[32] Musicking provides a platform for such engagement and growth among diverse peoples. For example, the diversity within the Arab American community in Southern California is high. Although Arab-speaking peoples share a common language, it is spoken in different ways and according to nationality. Thus, working toward shared meaning and mutual understandings emerges out of the relationship between individuals, each bringing their unique perspectives and experiences to the interactions. Individuals benefit from learning about themselves, and the group develops into a unique community.

[27]Interview with Summer Chatel, June 11, 2018.

[28]Interview with Steve Kent, June 11, 2018.

[29]Dana L. Robert, "Global Friendship as Incarnational Missional Practice," *International Bulletin of Mission Research* 39 (2015): 180.

[30]Robert, "Global Friendship," 182.

[31]James W. Neuliep, *Intercultural Communication: A Contextual Approach* (Los Angeles: SAGE, 2015), 342.

[32]See B. J. Broome, "Building Shared Meaning: Implications of a Relational Approach to Empathy for Teaching Intercultural Communication," *Communication Education* 40 (1991): 235-49.

Negotiating difference and diversity fosters learning to know one's self as one enters into the challenge of interacting with others. Kakish recalls how she began seeing "the good, the bad and the ugly parts of our being. And then you start seeing it in others and then you see it in yourself. And then you compare."[33] To the surprise of members from various Arab nations, conflict in the midst of rehearsing and performing emerges often. Thus, making music together unearths deep-seated differences between personalities and ways of interacting. Kakish reflects further that there were some prejudices she had no idea were a part of her thinking. She concludes, "It's just the best way to really discover the different parts of ourselves—the good, the bad, and the ugly. I came to realize that through interactions with others we see ourselves."[34]

Music becomes a common thread that helps overcome differences. It brings people of different nationalities, such as Egyptian, Lebanese, Palestinian, and Moroccan, together as they rehearse and perform in generating a new community distinctive to the Arab American ethos. While the main motivation is performing music of one's heritage and finding a place to belong, people experience feeling at home. Kakish shares her surprise at a powerful realization during a rehearsal, saying, "I sat there one day realizing 'Wow! We're multi-cultural Arabs, multi-religious Arabs, multi-class Arabs, multi-class Americans, multi-class people relating where usually we're separated."[35] The music brings people together from all walks of life. The impact is immense as she and others begin to realize the implications of belonging to a group of twenty-five to forty people with great socioeconomic diversity. Sitting next to each other, they find themselves interacting with a truck driver, a jet propulsion laboratory scientist, a housewife, a lawyer, a doctor, a highly evolved therapist, a dysfunctional human, and so on. The musicking group generates the emergence of a microcosm of the local Arab American community, a community bonded together around the performance of Arabic music. Kakish summarizes her discovery: "All of a sudden as I joined Kan Zaman, I was surprised to see that 'Wow! I'm home again!' But then, to my surprise, I realized, 'Wow! I'm in a different kind of home.

[33]Interview with Lana Kakish, June 11, 2018.
[34]Interview with Lana Kakish, June 11, 2018.
[35]Interview with Lana Kakish, June 11, 2018.

I'm in a multi-cultural, multi-faceted home.'"[36] Not only was her homesickness
soothed, but she was newly exposed to the dynamics of multiculturalism in
North America that brought her together with previously unknown Arab
peoples. This "new home" builds relational empathy and generates safe spaces
for relating with peoples of diversity. Nonexclusive in attitude, the group
includes non–Arab Americans, such as myself, pursuing relationship through
performing heritage music.

Thus, performing with a community group propels Christian witnesses—
both outsiders and insiders alike—into becoming a part of a community.
Rubbing shoulders over a period of time sets up opportunities for living life
together and engaging in incarnational witness. A nominal Muslim member,
for example, surprised me once with a challenge before a rehearsal held in
my home. He said, "OK, you evangelize me. And I will evangelize you." At
that moment, our relationship shifted to a deeper level of understanding
between us where the topic of faith could be discussed. The dialogue could
continue on as a natural part of performing in a local heritage ensemble.

In the above case study, we have identified a viable way of performing
incarnational witness by joining a local heritage ensemble composed mainly
of Arabic speakers. The next case study centers on educating and training
in musicking that prepares outsiders to engage with diverse peoples via di-
verse cultural music traditions.

PERFORMING AS COMMUNITIES INTERACTING

Performing witness takes place on multiple levels and in multiple ways. How
can such witness engage in ways that lead to deeper relational interactions?
Incarnational witness requires being with people on a regular basis over
longer periods of time and in multiple spaces of engagement. Jesus's practice
of friendship focused on fellowship and community. Dana Robert wisely
observes that "friendship is not 'random acts of kindness'; rather, it involves
systematic kingdom-based practices that require respect, compassion, hu-
mility, sharing, giving, and receiving."[37] What possibilities does musicking
offer for systematic engagement with religious neighbors over longer pe-
riods of time? The Middle East Ensemble at the University of California at
Santa Barbara suggests a possible model.

[36]Interview with Lana Kakish, June 11, 2018.
[37]Robert, "Global Friendship," 182.

Embracing religious neighbors via the academy. They were up and dancing, out of their seats and moving! The Persian community attending the end-of-the-quarter concert of the Middle East Ensemble at the University of California at Santa Barbara (UCSB) campus could not confine themselves to their chairs. One excited man turned to the European American woman sitting next to him and exclaimed, "This music! It's *my* music, it's my music!" The joy and thrill of having experienced a very precious musical moment permeated the university concert hall. A Persian song had just been performed by thirty instrumentalists—Arab and non-Arab—on Middle Eastern instruments—the *'oud,* the *nay,* a full set of Middle Eastern drums, and other instruments appropriate to the ensemble. A chorus and folk dancers completed the performance.

Looking throughout the audience, you can see communities of Greek people. You can see communities of Turkish people, plus a whole mix of Middle Eastern people. Each group is enjoying the other's heritage songs in anticipation of enjoying one of their own. Meanwhile, the European Americans are sensing they have just experienced something deeply meaningful. They have come longing to understand and feel the music as a Middle Easterner might feel it, as an Arab, Turk, or Persian. They find themselves saying, "My goodness, I feel like I was at a family event!" Joy, celebration, and a sense of family continues to permeate the event as the concert continues with a song from Turkey. Now the Turkish community relishes hearing their "home" music and feeling recognized.[38] People settle back into their seats and continue to fully enjoy the celebration of diversity through musicking.

The UCSB Middle East Ensemble was founded by professor of ethnomusicology, Scott Marcus, in 1990. It consists of an orchestra, a chorus, and a folk-dance troupe. Members include undergraduate and graduate students, faculty, and local community members. Loosely modeled to resemble a *firqa,* a type of ensemble that developed in the Arab world from about the 1940s, the ensemble performs at a variety of venues. They range from local children's fairs, ethnic festivals, multicultural dance festivals, performances at local schools, and a variety of university events to more formal concerts for

[38]Vignette based on interviews with Scott Marcus (July 18, 2018) and William Robert Hodges (September 27, 2018).

universities, academic conferences, and Middle Eastern communities throughout the state of California.[39] They have also toured in Egypt. Marcus emphasizes that "one of the defining aspects of the UCSB Middle East Ensemble is a strong sense of community—an enthusiastic esprit de corps—that exists within the ensemble itself. The ensemble is an open one: anyone can join, whether they are absolute beginners or experienced players."[40] Beyond the university ensemble members, FOMEMA (Friends of Middle East Music Association) provides support as a board and loyal audience members. In addition to their academic purpose of learning to perform and understand Middle Eastern cultural musics, the ensemble is a thriving model of generating community that expands into the broader local Santa Barbara community among peoples of diverse Middle Eastern backgrounds. Their sense of community and deep levels of friendship suggest ways to live among and with religious neighbors via long-term engagement. We consider the roles and dynamics an academic ethnomusicology ("ethno") ensemble can foster toward loving our religious neighbors.

Key dynamics of ethno ensembles. Musicking in academic ethno ensembles makes diverse webs of relationship visible in local communities. Performing the music of a region of the world such as the Middle East causes the peoples of that region to emerge to hear the music of "home." These webs of relationship generate a broader community centered around musicking, extending beyond the university classroom as it welcomes people from the broader community of Santa Barbara and Goleta, where the university is located.

Generating a third community. Ethno ensembles in the academy welcome students, no matter their heritage. In the case of the UCSB Middle East Ensemble, European Americans and other non-Arabic speaking peoples who engage in the music of Middle Eastern cultures discover themselves relating with the peoples of the specific music culture being performed. The ensemble is not restricted to university students and faculty. Rather, it invites local Middle Eastern Americans and non–Middle Easterners to join them. Marcus learned in the early years that performing a

[39]Scott L. Marcus, "Creating a Community, Negotiating Among Communities: Performing Middle Eastern Music for a Diverse Middle Eastern and American Public," in *Performing Ethnomusicology: Teaching and Representation in World Music Ensembles*, ed. Ted Solis (Berkeley: University of California Press, 2004), 202-3.
[40]Marcus, "Creating a Community," 209.

diversity of musics—for instance, Arab, Armenian, Greek, Turkish, and Persian music in the same concert—welcomes a broader range of people and generates a loyal following. Members from each of these communities in the local Santa Barbara area are able to join a friends' group of Middle Eastern music, creating a dynamic, interactive link with the university ensemble. Marcus notes, "So now, these people in the community embrace the ensemble as a celebration of their world."[41]

Every concert gives voice to various communities, with the result that the local community considers it as "their" own ensemble. There is a mutuality of ownership. Marcus recounts multiple stories of walking down the streets of Santa Barbara or attending local festivals, where Armenians or Persians walk up to him and say, "So, next concert we want to have significant Armenian representation," or Persian music. The next concert finds the ensemble performing a number of Armenian or Persian songs. These interactive links between the university ensemble and the diverse Middle Eastern community foster a sort of intercommunity, a give-and-take dialogue between peoples of diverse heritages and faith. There is a freedom of interaction between all participants, a third culture, of those involved in musicking via Middle Eastern musics.[42]

A performing community that bonds deeply. Marcus considers it stunning how people get multiple levels of meaning from performing with the ensemble. While some express it verbally, others express it by remaining in the ensemble for years upon years. "Yes, it definitely creates a family, it creates meaning for people in their lives that they're part of this larger project that we have. . . . One woman has been in the ensemble for some fifteen or twenty years and she says, 'Scott, you're like my rabbi!'"[43] Not a religious leader, Marcus concludes that he treats "the music as aspects of culture in deep ways . . . we do celebrate culture. We celebrate differences and we celebrate uniformities, common aspects of culture." When the ensemble stops rehearsals for the summer, members find it difficult since it's "like life has a

[41]Interview with Scott L. Marcus, July 18, 2018.
[42]Marcus maintains that the success of this intercommunity comes from the fact that Santa Barbara and Goleta are both small communities, totaling around 150,000 people. The heritage communities are thus small and do not form their own unique ensembles as often found in many metropolises, such as Los Angeles.
[43]Interview with Scott L. Marcus, July 18, 2018.

big hole in it." He categorically notes that "the sense of bonding, the sense of brotherhood, the sense of family within the community is *extremely* strong." With each performance cycle, the bonds grow a little bit deeper. The sense of family deepens further as people interact over longer, sustained periods of time, and relational empathy is intensified among diverse peoples. How is it that such deep bonds develop? The ensemble's professor-director models and sets the critical agenda that bonds the group.

Visionary bimusical leadership. The dynamics of bonding and building relationships among religious neighbors requires visionary and highly competent bimusical leadership.[44] Scott Marcus, the ensemble's director, excels in and pursues deeply committed intercommunity engagement. His welcoming approach and openness to local citizens performing with the ensemble has "generated a vehicle for peoples of the Middle East to present their music and their culture to the larger Santa Barbara community."[45] Flexibility in the rehearsal spaces and organization of the ensemble makes room for getting to know one another in contexts that foster professors, students, and ensemble members breaking down barriers of status from within the academy. The approach models engaging with multiple communities within the local region and generates friendships that bond them together as family.

The visionary director-cum-professor welcomes local Middle Eastern peoples whose music is being performed to express themselves and to tell their stories about the music and its role in their lives. Rob Hodges, who completed his PhD with Marcus and performed with the ensemble for more than three years, asserts that through the intentional leadership of an academic ethno ensemble, "We can *learn* about the rich diversity of religions and religious communities in the same country. I saw that happening with younger, undergrad students who were coming to the ensemble, who maybe never had any experience with music from another part of the world, who would listen to these stories and then participate, sing and play, singing in the chorus."

The ethno ensemble nurtures learning about diversity beyond the textbooks and media by regularly performing and interacting with diverse

[44]One of the goals of the discipline of ethnomusicology is to become musically proficient and functional within diverse music cultures, called "bimusicality."
[45]Interview with Rob Hodges, September 27, 2018.

peoples. A further critical skill of the director-cum-professor is teaching deep-level cultural understandings through music making. On the musico-logical level, this requires a high level of bimusical performance proficiency. In his teaching, Marcus repeatedly shows how the music praxis of the Middle East allows for making initial mistakes. When playing the 'oud, for example, he explains, "when you press down a note—and having pressed down a note you realize you're a little out of tune—right there I say to my people, 'That's ok, if you're out of tune. But, right there, you're required to fix it. Where it is unforgivable is if you play it again and you're still out of tune. That's allowed in the tradition.'"

Such elements of musical forgiveness in the tradition abound and stand in stark contrast to Western classical performance praxis that demands note-perfect production. Thus the visionary bimusical leader recognizes prime opportunities to teach cultural values through the teaching of cross-cultural performance.

Likewise, the visionary bimusical leader teaches practicing diversity through the broad range of music performed. The ensemble performs not only Arab and Turko-Arab repertoire but also specializes in Armenian, Greek, Egyptian, Persian, Sephardic and Oriental Jewish, and Turkish music and dance. The desire is to "present a dense multilayered sense of Middle Eastern cultures. The diversity is also based on a philosophy that individual pieces of music, whether a song, a dance, or even a culture-specific rhythm, are major sites for generating, recalling, validating, and celebrating personal, community, and national identity."[46]

The approach points to the sophistication of a people's music culture and generates further respect for the peoples from whom the music derives. The driving motivation behind such repertoire selection seeks to show "how deeply these pieces are connected within the culture, in terms of contexts, values, and meanings."[47] They give voice to the great cultural diversity of peoples found within the Middle East.

Finally, the visionary bimusical director promotes intercommunity engagement, often playing a role akin to peacebuilding. Hodges highlights how Marcus has "brought music from communities that are often in conflict with

[46]Marcus, "Creating a Community," 207.
[47]Marcus, "Creating a Community," 207.

one another and brought them into the same performance space."[48] His
astute selection of songs that share a common melody yet vary across ethnic
communities features prominently in the performances. A song from Turkey,
for example, is performed and then immediately followed by the very same
tune, but as a Greek song with different lyrics and perhaps played on a dif-
ferent instrument. Hodges sees it as a way "to very powerfully demonstrate
that we share so many of the same traditions, so many of the same tunes."[49]
For those who consider the songs exclusively belonging to their ethnic her-
itage only, they cannot imagine the songs might be sung by somebody else,
no less by people who they considered as enemies. Hodges concludes,
"Marcus really does a wonderful job of breaking down some of those barriers,
helping people to realize that the world is smaller than we think it is."[50] His
awareness of shared musical aspects among communities enhances building
bridges between peoples of diverse faiths.

Extending the musical spaces of relating. The musical performance cycle
occurs over space and time on a regular basis. University ethno ensembles
maintain a rhythm that prepares and trains performers before and after the
actual concert. Small argues that "musicking . . . takes in all the activities that
affect the nature of that event which is a performance. . . . That means that
composing, practicing and rehearsing, performing, and listening are not sep-
arate processes but are all aspects of the one great human activity that is called
musicking."[51] This results in generating multiple opportunities for incarnational
witness through musicking, ones that foster deepening neighborly relations.

Musicking toward neighborly relations (see fig. 2.2) points to the multiple
arenas that extend the spaces and amounts of time when people come to-
gether and dialogue via music. Planning, rehearsing, and performing con-
stitute spaces for negotiating questions of cultural and religious represen-
tation and serve as arenas of deep dialogue that foster incarnational witness.

Musicking toward religious neighbors involves a performance cycle consti-
tuted of five stages: (1) envisioning, planning, and facilitating; (2) rehearsals
—weekly and dress rehearsals; (3) the concert itself; (4) the after-party; and

[48]Interview with Rob Hodges, September 27, 2018.
[49]Interview with Rob Hodges, September 27, 2018.
[50]Interview with Rob Hodges, September 27, 2018.
[51]Small, *Musicking,* 11.

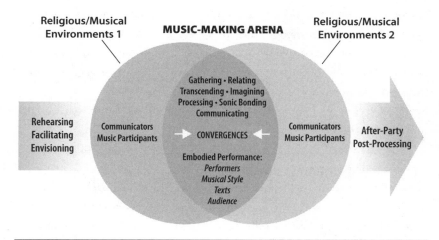

Figure 2.2. Musicking toward neighborly relations

(5) post-processing of the event among performers and the larger community. These are arenas wherein participants interact on a regular basis, building trust, offering respect and dignity, and deepening bonds of friendship. They are stages wherein relational empathy is developed and deepened, and shared meanings are generated.

Stage one: Envisioning, planning, and facilitating. Playing a key role in supporting and organizing the ensemble, especially as it links with the broader Santa Barbara–Goleta community, the FOFEMA board gives important leadership in planning and facilitating the ensemble organization.

Stage two: Rehearsals. Rehearsals function as pre-events that heighten the intermingling of academic music participants. Middle Eastern performers from the Santa Barbara–Goleta community practice alongside university students. From the very first welcome of new students into the ensemble, they are made to feel a part of the long-established community-cum-family. Rehearsals are recognized as joyous times when people come together at the end of the work day, put aside all the tensions of the day, and let them dissolve with the first downbeat. The atmosphere is relaxed yet also challenging. There is acceptance of people at all levels of performance skills. The leader plays key roles in teaching for inclusion of everyone in the group, taking time to repeat a particular phrase over and over again so that everyone can

reproduce it, often taking up to ten minutes to learn just sixteen measures of a piece. Marcus acknowledges that his approach is welcoming. He explains, "In the end, even the people who have no sense of notation, have learned it orally. And then the other people who have learned it from the very beginning, they can get more sophisticated with their ornamentation. . . . You end up bringing everyone along with you . . . it's a communal sense that we have moved forward."[52]

Thus, the art of teaching cross-cultural musics through high levels of repetition demonstrates a way of leaning into diversity in inclusive ways, especially as metaphors for rehearsing relationships on a cyclical basis. Repeating a phrase over and over again is done with the hope that the next time "it's already a known. It's already a friend of yours because we sat with it so long."[53] It subjectifies the learning and performing of a people's music culture, allowing the performers to identify with and deepen relational empathies toward one another.

Teaching for relational empathy requires teaching for more than mere production of musical notes. Marcus specializes in teaching the *maqam*, the Arabic melodic system. He takes time to enculturate students into the deeper levels of aesthetic beauty and meaning. He explains:

> I make sure that when we're getting to the 4th note of the scale, for example, I say, "You know, look at what we're doing here. It is such a gift to me as a musician, that this *maqam* has this moment because it's just sooo beautiful! I feel like I've just been given a huge gift." And I see that this turns people's orientation . . . just the students hearing that orientation, it shifts the focus from worrying about detail to experiencing the ecstasy that the music has inherent in it.

In such moments, the ensemble director-cum-professor teaches toward experiencing the music from the insiders' perspective—the concept of ecstasy in Arabic music—to understanding it beyond the technical level. He also teaches the gestures and responses inherent in the musical praxis, that is, raising an eyebrow and just feeling the beauty of the music by responding with the exclamation, "*Allah!*" He argues, "If you don't teach people that they are supposed to be feeling the beauty, then they don't even think about it."

[52]Interview with Scott L. Marcus, July 18, 2018.
[53]Interview with Scott L. Marcus, July 18, 2018.

His pedagogical commitment fosters situating the experience of performing "in the realm of experiencing beauty."[54]

The all-day dress rehearsal on the day of the concert heightens powerful lessons in cross-cultural learning and empathic understanding of a people through their music traditions. Beginning at 9:00 a.m., the instrumental ensemble, the chorus, and the dance troupe come together in a rehearsal that lasts until 5:30 p.m. This will later feed into the concert, followed by an after-party event that will go into the early morning hours. The group will be musicking together for fourteen hours. Hodges observes that it "generates a kind of intensity that's wonderful in terms of building relationships with people, friendships with people that are going to last."[55] Performers knowingly enter a mental space recognizing that they are working toward the concert, which morphs into an elongated, liminal moment where everyone is fully focused on performing and entering into the music traditions of the Middle East.

Stage three: The concert. The concert brings all performing groups together—chorus members, percussion ensemble, the regular instrumental ensemble, and the dancers. The program reflects a huge degree of diversity and variety. Hodges says, "I think the audience loves it. They know that's what's going to happen. It always ends with a big dance finale. . . . And there's usually fun repartee happening between the percussionists and the dancers. And there's lots of teasing that's going on. Its great! And then, it ends. Big number, big applause. All the soloists get recognized."[56] Multiple levels of meaning and interaction among the performers and within various groups in the audience make for a dynamic evening of celebration.

Marcus's main goal is to make the concert joyous. He tries to take out a lot of the tensions of performing. Before every concert, he gives a speech, stating, "Mistakes don't matter. If I make a mistake, just let it go . . . in our music tradition here, if you make a mistake, it's gone."[57] Such remarks free up the performers—many of them stunned—especially those who come from a Western classical background, which is demanding. They discover

[54]Interview with Scott L. Marcus, July 18, 2018.
[55]Interview with Rob Hodges, September 27, 2018.
[56]Interview with Rob Hodges, September 27, 2018.
[57]Interview with Scott L. Marcus, July 18, 2018.

that the music tradition differs from Western classical requirements. The
goal of the concert becomes making the occasion joyous and representative
of the musical traditions of the Middle East in ways that recognize and
honor the various groups in the audience.

The dynamic interplay between performers and audience generates ex-
periencing the music tradition together, bonding them on deeper levels. The
sense of community-as-family is heightened and intensified. At intermission,
for example, "Everyone has a sense of 'Wow—that was just stunning!' And
so, everyone hugs each other."[58] The sense of bonding, the sense of broth-
erhood, and the sense of family "grows a little bit deeper."[59] The backstage
area also promotes further deepening of relationships; the excitement of
performing raises a lot of "high fives" and the passing around of lots of hugs.
Marcus notes that after many performances, the warmth of the relational
dynamics evokes the feeling "like these are your family members in a very
intense way."[60] At such times, performing promotes more than just a com-
munity; it engenders a sense of family.

Stage four: The after-party. While many concert attendees may go out for
refreshments with friends, the musicking does not stop for ensemble
members and the Friends of the Middle East Music Association. Exhausted
and exhilarated from a dynamic performance, they move over to the direc-
tor's home for yet another kind of musicking event that may last another
four to five hours. People, including spouses of the ensemble, bring won-
derful homemade food and sit back, relax, and enjoy talking with one an-
other. Hodges explains, "Once you've gotten yourself recharged with some
food, then music-making happens all over again. Sometimes people sing
solos, who weren't soloists in the concert necessarily, but they're bringing
out their special skill. It's all Middle East music of various kinds; it can be a
time when there's music from the Arab world, from the Islamic world, from
the Jewish world." Other music professors join in, such as playing the *rabāb*
along with sung epic storytelling in the Egyptian tradition.[61] "We're listening

[58]Interview with Scott L. Marcus, July 18, 2018.
[59]Interview with Scott L. Marcus, July 18, 2018.
[60]Interview with Scott L. Marcus, July 18, 2018.
[61]"Rabāb, Arabic *rabābah*, Arab fiddle, the earliest known bowed instrument and the parent of
 the medieval European rebec. It was first mentioned in the 10th century and was prominent in
 medieval and later Arab music. In medieval times the word *rabāb* was also a generic term for

for twenty to twenty-five minutes to the story. It becomes a magical moment."[62] Hodges reminisces how such times induce liminal moments of being "wrapped into the musical space and time sort of disappears from you. There are these kind of transformative moments—when somebody is just such an amazing musician that you lose your sense of where you are. They are just beautiful moments."[63]

Such times engender fellowship where ensemble members and their loyal following embrace and relate as neighbors fully caught up in the joy of mu-sicking and discovering one another. It is in these moments that Hodges discovered "you have a chance to just sort of sit back and relax, talk together, and really kind of go deeper with people in terms of their own life experi-ences. You know, what this music means to them and how long have they been involved in the ensemble? Did they play this music when they were living in their home countries? . . . Those are really, really rich moments."[64]

They are also profound experiences that foster incarnational witness in multifaith contexts. Hodges, a vibrant Christian, speaks fondly of a friendship he made with a drummer in the ensemble. Very involved in the mosque, the drummer was the *muezzin,* the one who performs the call to prayer. From a minority group in Turkey, Essan was drawn to Hodges. The two performers developed a relationship. Hodges recalls,

> At one point, I had the opportunity to invite him to church because I was doing a series of Sunday School lessons on Islam. I brought him as a guest speaker to come talk to the adult class about Islam. It was just a wonderful experience. We went out and had a meal together afterward. I think he was really touched by how warmly he was received. He made a very powerful impression on the members of the class. The class was really touched by his genuineness, his gentleness, his love of Islam, *and* his respect for Christianity. He was just that kind of person. From then on, we always maintained a close relationship. He was kind of like this uncle and would just wrap me up in his arms, a very sweet and lovely man. His wife was the same way. Very sweet people.[65]

any bowed instrument." "Rabāb," *Encyclopedia Britannica,* www.britannica.com/art/rabab, ac-cessed October 23, 2018.
[62]Interview with Rob Hodges, September 27, 2018.
[63]Interview with Rob Hodges, September 27, 2018.
[64]Interview with Rob Hodges, September 27, 2018.
[65]Interview with Rob Hodges, September 27, 2018.

Hodges's experience points to how musicking at the after-party prompts friendships that emerge between peoples from divergent worlds, further deepening the bond between them. Such friendly relations move into the local neighborhood and community life.

Stage five: Post-processing of the music event. Many neighborly interactions continue beyond the concert itself. The bridge building continues as people visit one another in their homes and share in religious practices. During Ramadan, members from the Muslim community invite people from other religious traditions, for instance, Jewish and Christian communities. "Hey, come over and break the fast with us. Let's share this meal," becomes a welcoming invitation from Muslims. Hodges also points to visiting the mosque, the Islamic community center in Santa Barbara, and celebrating with them. He recounts sharing stories where people ask, "How did people celebrate Ramadan in Indonesia, in your part of Sumatra? Tell us a little bit about that." In such cases, performing in an ethno ensemble generates a growing web of relationships that move beyond the university concert hall. Friendships are established and grow in depth, intimacy, and durability.

From the local to the global. Finally, ethno ensembles do not necessarily limit themselves to their university and local community settings. Marcus, who has done extensive ethnomusicological fieldwork in Egypt over a number of years, toured the UCSB ensemble in Egypt. The tour provided new opportunities to practice incarnational witness. Rob Hodges, for example, found himself as a Christian singing a very significant Muslim song, *"Leghli-Nebi"* ("For the Sake of the Prophet"), in a Muslim context. Audience members were stunned and asked, "How is it possible that you as an American and as a Christian could sing this song?" They seemed bewildered, as if he had accomplished some impossible feat by singing the deeply moving song of repentance. His response: "You know, I don't have any kind of personal conflict with this song. The things that are being sung in this song, resonate for me as a Christian because I need to repent. I need to be able to tell God I'm sorry and ask for forgiveness. And that's what the singer is singing in the *mawal* (chorus) in the song. 'I repent, I repent, Oh Lord, I repent!' Those are a very big part of what it means to be a Christian, too; it is coming to God for forgiveness." Hodges considered it a great gift to

perform a song that resonated so deeply with the people, allowing him to speak directly into performing incarnational witness.

The academic ethno performance ensemble also fosters opportunities for practicing incarnational witness over extended periods of time. Due to the academic calendar, a regular rhythm of musicking cultivates friendships among religious neighbors and nurtures relational empathy, respect, compassion, sharing, giving, and receiving. The beginning of each new academic year, however, presents the critical challenge of welcoming in new students who have never experienced such diversity. Yet the training cycle continues forward as new students are folded into the existing ensemble and opportunities to learn loving their neighbors emerge.

Performing as Incarnational Witness: Missiological Implications

Performing incarnational witness through musicking offers opportunities to missionally engage with local and global communities as a way of being present to one another and generating community. Recognizing that witness is a process in which each participant brings his or her unique level of faith allegiance to the encounter, musicking provides liminal spaces for interacting with one another as a means of creating understanding of God's love for all peoples. Hodges identifies the essence of interfaith dynamics, stating that to some extent, "it's witness in that we're learning about not only the music of cultures in the larger Muslim world, but we're learning about and getting to know the people who are behind the music. The people who are making music, the people whose music it is. For me it gives me an opportunity to meet Christ in these people, whether they know Jesus or not. It is a way of showing respect and appreciation."[66] In so doing, interacting with one another via musicking forms bonds of friendship that initiate trust and develop a mutuality of engagement. Each learns about themselves through interacting with the other along with a growing mutual respect, dignity, and appreciation for each another.

Pursuing friendship and community via musicking holds out opportunities to forge relationships across religious divides. Engaging our neighbors

[66]Interview with Rob Hodges, September 27, 2018.

within musical spaces offers the generation of relational empathy among diverse communities. In spite of one's ethnicity and socioeconomic status, musicking promotes being together in deeply relational ways. Hodges argues that in "being respectful and listening and really wanting to engage, I think we bear witness to those people in those moments. I think it can make a huge impact on them. In doing that, we show them Christ in us." Thus, in performing witness via intentional and respectful musicking, we journey across "the bridges of God"[67] into the lives of our religious neighbors and the love of God is displayed. Indeed, as we love God with our whole heart, soul, and mind via musicking, the second greatest commandment of loving our neighbor as ourselves is fulfilled (Mt 22:38-39).

[67]See Donald A. McGavran, *The Bridges of God: A Study in the Strategy of Missions* (London: World Dominion, 1955).

Christians Reaching Out
to Their Neighbors

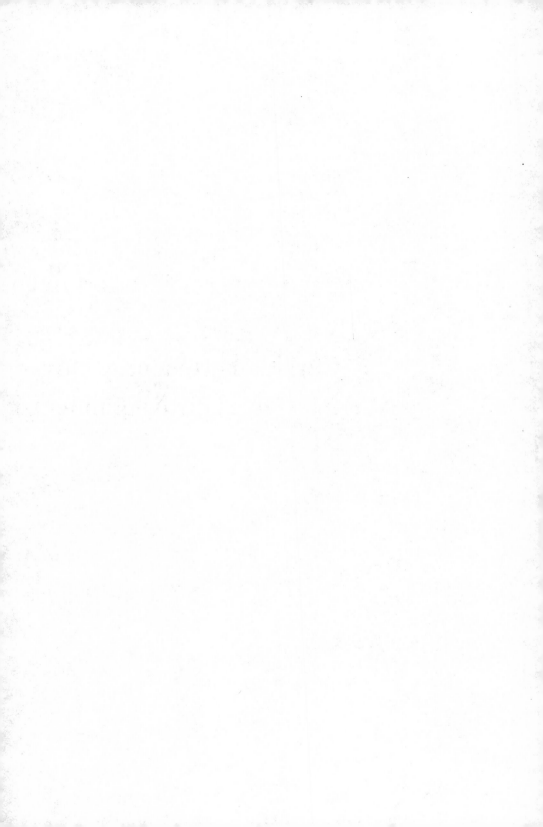

3

God Moves in a Mysterious Way

Christian Church Music in Multifaith Liberia, West Africa, in the Face of Crisis and Challenge

Ruth M. Stone

Christian music has played a powerful part in the life of the people of Liberia and has long been interwoven with the larger musical performance fabric.[1] This proved to be true particularly during the civil war period, from 1989 to 2003, and during the more recent Ebola epidemic of 2014–2016. When war or illness threatened during these periods of crisis, believers and members of various faith traditions in Liberia turned to powerful performances of singing, dancing, and instrumental playing to bring strength, hope, and healing.

All of this might be a bit surprising to missionaries from the middle of the twentieth century, who came to devote their lives to converting the Liberians to become Lutherans, Methodists, Baptists, Roman Catholics, African Methodist Episcopal (AME), and various Pentecostal groups. Many of them became discouraged at what they considered a low number of conversions and the fact that many Christians simultaneously maintained their indigenous practices. They had few converts to report to their sponsoring groups in the United States or Europe. And to complicate matters, during the push for independence throughout Africa in the mid-1950s, Liberian church members yearned to have Liberians control their administration and direction rather than foreign missionaries.

[1] Ruth M. Stone, "Bringing the Extraordinary into the Ordinary: Religious Processes in Entertainment Music Performance Among the Kpelle of Liberia," in *Religion in Africa*, ed. Thomas Blakely et al. (London: Thomas Currie, 1994), 396-407.

But if one looks to Liberia today, Christian churches are flourishing, though there may be practices and styles that would surprise their missionary founders. There has been a great deal of interchange of musical practices, for example, with African American religious traditions in all of the churches. Spirituals and gospel music are as likely to be performed as Euro-American hymns. Local instruments like drums and gourd rattles, as well as Western drum sets, electronic keyboards, and electronic amplifiers, form the tools of musicians across Liberia. These shared instruments and styles also draw from interchanges among musicians of various denominations within Liberia. They also derive from regular communication among musicians across the Liberian–North American diaspora. Liberian churches frequently send representatives abroad to find out about musical trends in the United States. Musicians from the United States travel to Liberia to conduct religious crusades and revivals. All of this sets up cycles of exchange in religious musical styles and performance. Particularly popular and favored are African American genres.

In the late 1980s this meant that spirituals were widely sung in many Liberian Christian churches. But in the early 2000s, gospel songs dominated in these churches and existed alongside indigenously composed songs as well as American and European hymns. Praise bands sometimes replaced or existed alongside more traditional choirs and organs. The pump organ that missionaries used in their services in the early twentieth century has been supplanted by electronic organs and keyboards. English language performances exist alongside indigenous choirs.

In the larger context, this Christian performance takes place within a total population in Liberia of 3.5 million people, of whom nearly three million identify as Christian and five hundred thousand identify as Muslim.[2]

My goal here is to report on and analyze some intensive ethnographic work that I first conducted in Liberia with church choirs beginning in the late 1980s and have extended to 2016. The case studies that I draw from are anchored in choirs that performed in the Kpelle language and affiliated with

[2]Government of the Republic of Liberia, *National Population and Housing Census: Preliminary Results* (Monrovia: Government of Liberia, 2008), www.emansion.gov.lr/doc/census_2008 provisionalresults.pdf.

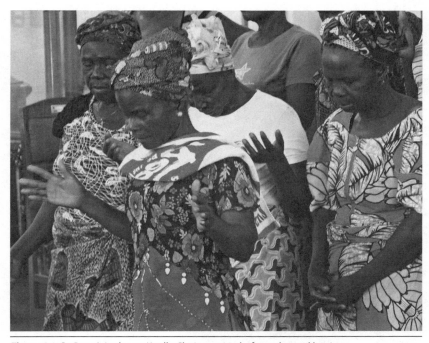

Figure 3.1. St. Peter's Lutheran Kpelle Choir, praying before rehearsal begins

the Lutheran church in Monrovia, the capital, and in Bong County, about ninety miles in the interior. The choir with whom I worked most intensively has been the St. Peter's Lutheran Kpelle choir, located in Sinkor, a suburb of Monrovia (see fig. 3.1).

My ethnographic method anchors itself in the phenomenological approach of Alfred Schutz,[3] which emphasizes the importance of understanding the perspectives of the people who perform or who are part of the audience as they create meanings in the course of social interaction that is Christian worship. The fieldwork from this perspective involves attending religious events and practices, during which I often video and audio record the music making. On occasion I then played back these recordings to the performers and congregation members for their response in what I term playback interviews. These playback interviews were also recorded and

[3]Alfred Schutz, "Making Music Together: A Study in Social Relationship," in *Collected Papers II: Studies in Social Theory* (The Hague: Martinus Nijhoff, 1971), 159-78.

transcribed for analysis and study.[4] The musicians and congregation assisted at every turn in discerning the important and critical meanings.

All this work has been a labor-intensive approach, beginning in spoken and written Kpelle that has then resulted in an academic interpretation and translation for a variety of audiences. In order to do this, I relied on a team that included my husband, Verlon Stone, who handled technical equipment and digital recording files; James Weegi, videographer who has worked for me since he was a high school student in the 1970s; Tepitapia Sannah, a Kpelle language specialist who is also a trained journalist and fluent French speaker with whom I've collaborated for nearly twenty years.

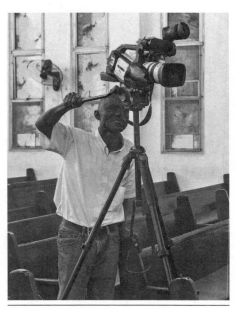

Figure 3.2. Videographer James Weegi setting up to film in St. Peter's Lutheran Church, Monrovia, Liberia (2016)

In order to better contextualize how I have arrived at my conclusions and the points I am making in regard to music during crisis and conflict, it is important that I share a bit of my own biography and how it interfaces with the work I do. I first arrived in Liberia at the age of three, the daughter of Lutheran missionaries. I was home schooled, and after a few hours of lessons in the mornings, I spent much of my days during those early years alongside the women in the rice fields or fishing in the creeks. My brother, and later sister, and I played with Kpelle children to set fish traps and build rafts and tree houses. These were children who spoke little or no English since we lived in Yanekwele, a village where there was no English language school. My father

[4]Ruth M. Stone and Verlon L. Stone, "Event, Feedback and Analysis: Research Media in the Study of Music Events," *Ethnomusicology* 25 (1981): 215-25; Angela Stone-MacDonald and Ruth M. Stone, "The Feedback Interview and Video Recording in African Research Settings," *Africa Today* 59, no. 4 (2013): 3-22.

was in charge of Kpelle language training for missionaries and of translating the New Testament into Kpelle. Once we were out of the house, we naturally and without effort spoke Kpelle with the people with whom we interacted. I returned to the United States to attend high school and college. When I discovered in graduate school that I could study African music as an academic subject in the field of ethnomusicology, I happily found a way to return to what for me had been a home and to consider music in Liberia from a new and yet different perspective. (My path was not so unique, for many missionary children have gone on to become anthropologists or ethnomusicologists.)

The Liberian Civil War

In late 1988 I studied Kpelle music as a Fulbright scholar in the urban and rural Kpelle areas. Liberians were on edge as Samuel Doe, the dictator, was increasingly imprisoning those he considered his enemies. He was abolishing the freedoms that people had enjoyed under the presidencies of William V. S. Tubman (1944–1971), the longest serving president, and William R. Tolbert (1971–1980) before he was killed in a coup. The choir members from St. Peter's often came to my apartment and shared in whispers their worries about their jailed families.

One evening I attended the wake of James Y. Gbarbea at St. Peter's Lutheran Church. The service opened as the congregation vigorously sang:

> God moves in a mysterious way, his wonders to perform;
> He plants his footsteps in the sea and rides upon the storm.

Multiple verses ensued, but the last two were intriguing to consider:

> His purposes will ripen fast, unfolding every hour;
> The bud may have a bitter taste, but sweet will be the flower.
> Blind unbelief is sure to err and scan his work in vain;
> God is His own interpreter; and he will make it plain.[5]

This hymn, now being sung in Liberia at this wake in Monrovia, with words by William Cowper (1774) had clearly been transmitted to this congregation via the American missionaries who had come to convert them. The tune

[5]William Cowper, "God Moves in a Mysterious Way," in *Twenty-Six Letters on Religious Subjects*, ed. John Newton (London: J. and W. Oliver, 1774).

drew from Western hymnody, even as the timbre of singing was hard-edged and driving in the aesthetically desirable style of this Liberian Christian group. But my curiosity was piqued as to why this particular hymn opened the wake for a prominent Liberian whom I had known for many years and who had resigned from the Doe government and lived in exile in Charlotte, North Carolina, until his death.

In the course of attending other funerals that year and questioning people about that choice, I learned that this song was a kind of anthem of the period. It was a coded way of communicating to people that while Samuel Doe may think that he could dominate and destroy many people, God and right would in the end prevail. I received further confirmation for this interpretation after a lecture I delivered at Harvard in 1998 when I alluded to this hymn and its performance during the war. As soon as the question-and-answer period began, Dr. Patrick Seyon, an academic and visiting Liberian scholar at Harvard that year, leaped to his feet and said, "That was our anthem!" He very closely identified with that song, which communicated in hidden ways about what would happen to Samuel Doe.

In the course of my research, it became abundantly clear that Christian hymns formed part of the emotional glue that held people together during the war. And people chose certain songs to express their deeply felt anger and fear as they sang them fervently in the churches, particularly at wakes and funerals. Church and state issues became inseparably intertwined as people expressed political views in the context of religious worship.

Some ten years following the civil war's end (in 2014), the horrific Ebola epidemic broke out in Liberia. When I returned in 2016 to study how music had been involved with the fight against this incredibly contagious disease, I went to St. Peter's Lutheran Church. The Kpelle choir reported that music was what held them together at a time when they were forbidden from touching one another. Sound transcended space and linked them in community in critical ways. Whether it was war and killing with guns or death by epidemic, the people of Liberia have turned in crisis over the years to music as a key part of their coping and recovery process. Though the civil war and Ebola epidemic have had somewhat different contours, they nevertheless displayed some important common themes. It is those themes that I would like to tease apart in more detail in the discussion that follows.

Music in the war: Singing the unspeakable. Shortly after I left Liberia following the end of my Fulbright research in July of 1989 and my extensive study of the Gbarbea funeral and its complexities, war broke out in December 1989. For the next fourteen years, civil war ensued and ebbed in what is sometimes referred to as a series of wars. Ultimately several hundred thousand people lost their lives, and it is estimated that nearly a million other Liberians were displaced from their homes to other places in Liberia, neighboring countries like Côte d'Ivoire and Ghana, or more distant new settlements in the United States and Europe.

St. Peter's Lutheran Church was the site of one of the single worst atrocities of that period. In July of 1990, about six hundred civilians who had sought refuge in the church that had Red Cross flags flying on it were murdered. Only a few children were found alive in the aftermath. During the Liberian civil war that followed, the Christian hymns sung in St. Peter's after it was reconsecrated and elsewhere often continued to serve as anthems to express hidden meanings. (Such a use of hidden meanings is reminiscent of spirituals during the period of slavery in the United States, where a text may speak of moving toward heaven but also imply that slaves were moving north to freedom.)[6]

But I also discovered another kind of transformative use of religious music. During James Y. Gbarbea's funeral service at St. Peter's Lutheran Church on the day *after* the wake where "God Moves in a Mysterious Way" galvanized the congregation, the Kpelle choir sang a Christian hymn drawing on indigenous sound structures, the Kpelle language, as well as Kpelle images. Feme Neni-Kole, the vocal soloist, composed as she led the choir. In it she sang that Jesus is the big, big *zoo* (ritual priest). She also sang that Doe will go. This was astonishing. During a time when Monrovia was like a tinder box in a preconflict mode, an ordinary Kpelle market woman was calling for the removal of the dictator. And she was portraying Jesus as the ultimately powerful ritual priest who would presumably prevail to make this happen. As the musicians and others explained, when I questioned

[6]See Mellonee V. Burnim, "Religious Music," in *African American Music: An Introduction*, ed. Mellonee V. Burnim and Portia K. Maultsby (New York: Routledge, 2006), 61; Charshee Charlotte Lawrence-McIntyre, "The Double Meanings of the Spirituals," *Journal of Black Studies* 17, no. 4 (1987): 379.

them later, Feme had the right to sing what no one could openly speak on the streets of the capital city without getting arrested. This right was understood in Kpelle society and throughout Liberia. And for Feme, moving back and forth between the indigenous religious figures like the *zoo* and Christian religious personages like Jesus was both natural and powerful in getting her message across.

Feme could communicate that day what even Bishop Ronald Diggs, who preached the funeral sermon, could not express directly. While Bishop Diggs spoke about the need for people to come together, he never approached calling for the outright removal of Samuel Doe, nor did he assert his belief that Doe would eventually go. The medium of music and singing afforded Feme and the women of the Kpelle choir that unique power, as the chorus responded, "*Doe e li, ee*" ("Doe must go, eh") over and over again.

St. Peter's Lutheran Kpelle choir exhibited again and again the power of music to help them and the larger congregation face extreme crisis and recover. They returned to the sanctuary to sing together. And they continued singing during the war, bringing strength to themselves and to the larger church community. Some singers fled to other countries. Feme, for example, ended up in Salt Lake City, Utah, and stayed there until just a few years ago, when she finally returned to Liberia. But other leaders stepped up to the soloist position, and the choir continues today as a pillar of the church and the larger community.

Interreligious singing for a common cause. St. Peter's Lutheran Kpelle choir operated within a larger context that is important to understand. For toward the end of the war, in 2003, there seemed to be no way to bring peace. Summit after summit was held, after which fighting among various factions would again break out. Finally, a gathering was called in Ghana, but Charles Taylor, the tyrant in charge, refused to attend. Then a mass movement of several thousand Christian and Muslim women came together and demanded peace. Dressed in white, they started at a market and moved to the main highway where all who traveled through the city would see them. They marched in the capitol city, prayed, danced, and sang, demanding that war must cease. And they did this daily until Charles Taylor relented, attended the talks, and a fragile peace was reached. What was significant was that the women were not just Christian women—though there were plenty of these. But the Muslim women joined the Christian women in a formidable show

of strength as they moved together in sound, singing, and sometimes silence. Among them was Leymah Gbowee, who later won the Nobel Peace Prize for her actions. All of this has been documented in the powerful film, *Pray the Devil Back to Hell.*[7]

The mention of the cooperation of women from many faith traditions is significant here. For not only did these ordinary women come from multiple faiths, but they hailed from a variety of ethnic groups. And this reach across the divide of belief and background paralleled another aspect of the Liberian civil war. From the beginning of the war, as Bishop Diggs told me in an interview, the Liberian Council of Churches, which included Muslim and Christians alike, worked together to keep the war from spinning out into a religious war. These leaders connected on a variety of levels to keep communication open and to prevent fracturing along the lines of religious belief. All of this prevailed in a climate where a number of religious leaders, including Bishop Ronald Diggs, were jailed for periods of time for standing up and speaking truth to the Liberian political leadership. For during the civil war, church leaders very much saw it as their responsibility to stand up for what they thought was right and to express those views to the politicians at all levels.

Music proved to be a powerful medium during the Liberian civil war to sustain communities and to move leaders to action. When I returned to work with the St. Peter's choir in 2007, they recounted the ways in which singing had carried them and how it continued to buoy them up as they attempted to reconstruct their lives with family and friends scattered around the globe. Though peace was important to recovery, it was by no means a total remedy for what they had suffered. But as they demonstrated, they were meeting to rehearse and sing and to connect to one another as they attempted to move forward in a new kind of normal.

"Ebola in Town"

A mere ten years after the end of the civil war, toward the end of 2014, the Ebola epidemic struck Liberia as well as neighboring Guinea and Sierra Leone. In the course of the rampage, Ebola infected nearly eleven thousand

[7]Gini Reticker, director, Abigail Disney, producer, *Pray the Devil Back to Hell* (Balcony Releasing, 2008).

people, and some five thousand people died in the region.[8] When I arrived
to study the role of music in the epidemic in the summer of 2016, the disease
was finally relenting nearly two years after it began in West Africa.

As I detail elsewhere, music and sound, including Christian music
making, served above all to strengthen and sustain communities during a
very frightening time.[9] While this epidemic was not war, it was a crisis of
another sort that threatened people in equally troubling ways. One of the
major prohibitions was against touching people—friends and loved ones
alike—for fear of transmitting Ebola. Pastor Lewis McCay of St. Peter's Lu-
theran told me how human touch was a key part of his ministry. He could
not shake hands and snap fingers in the customary greeting as parishioners
left the church at the end of the service. Yet music and sound proved to be
safe vehicles for binding congregants together. While touch could be conta-
gious, sound was not. The church held services throughout the epidemic
even though people sat some distance from one another, and the pastor
handed the communion bread to worshipers with a tweezers.

Pastor McCay spoke to me about the power of music to heal and unite
people. As he said of the music during that time, "When they sang those
songs, you know, they just calmed you down. And sometimes you didn't
even want to preach. You just felt that should be the sermon for the day."[10]
There were both hymns that were targeted for this crisis as well as religious
songs that were newly composed. In the case of hymns, one of the focal texts
proved to be, "It Is Well with My Soul," with a text dating from 1873 by
Horatio G. Spafford and a tune by Philip P. Bliss.

> When peace, like a river, attendeth my way,
> When sorrows like sea billows roll;
> Whatever my lot, Thou hast taught me to say,
> It is well, it is well, with my soul.[11]

[8]CDC (Centers for Disease Control and Prevention), "2014 Ebola Outbreak in West Africa—
Case Counts" (2017), www.cdc.gov/vhf/ebola/outbreaks/2014-west-africa/case-counts.html.
[9]Ruth M. Stone, "'Ebola in Town': Creating Musical Connections in Liberian Communities Dur-
ing the 2014 Crisis in West Africa," *Africa Today* 63, no. 3 (2017): 89.
[10]Ruth M. Stone, *Fieldwork in Liberia: Notes, Interviews, Song Texts* (unpublished manuscript, 2016)
as quoted in Stone, "Ebola in Town," 89.
[11]Philip P. Bliss and Ira D. Sankey, eds., *Gospel Hymns No. 2* (New York: Biglow and Main, 1876).

Much like "God Moves in a Mysterious Way" resonated in a special way for Liberians who endured the civil war, "It Is Well with My Soul" found special favor during the Ebola epidemic. And it was still being sung with special verve at St. Stephen's Episcopal in Sinkor, Monrovia, in 2016, where the high tenor voices soared in a descant above the other four parts every time the chorus returned.

During Ebola, the St. Peter's Lutheran Kpelle choir actively composed songs to address it. Singers told me that their most powerful song was "*Ebola E Li*" ("Ebola Must Go"). And the chorus sang that phrase again and again in an ostinato to the varied solo phrases that the soloist intoned. I was struck by the parallel this phrasing had with the song "Doe Must Go." In both cases, twenty-some years apart, the women's choir had confronted powerful and formidable foes. And they substituted Ebola for Doe to express their unshakable confidence. And it was as though they were not only sustaining themselves by singing, but they were also expressing their firm and unshakable belief that this end would be accomplished.

The nurses, doctors, and health care aides frequently drew on music to prepare for their grueling shifts working in the Ebola isolation units with

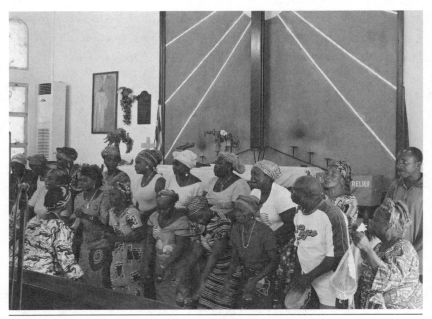

Figure 3.3. St. Peter's Lutheran Church Kpelle Choir performing (2016)

the highly contagious patients. They routinely sang hymns and danced to-
gether in preparation as they bonded and buoyed their spirits before they
dressed in the protective suits in which they had to work in the oppressive
heat and humidity. They found this both natural and comforting to ap-
proach their work with religious performance.[12]

Religious songs that bind people together flourished during Ebola in a
larger context of popular songs that warned and educated people about the
disease. Samuel "Shadow" Morgan led Edwin "D-12" Twe and Kuzzy of 2
Kings Shadow to perform one of the most popular hipco songs of the time,
"Ebola in Town."[13]

> Ebola in town.
> Don't touch a friend.
> No touching,
> No eating,
> No eating something dangerous.
> Ebola, Ebola in town.[14]

Singer Julie Endee worked with the Liberian Ministry of Health to
compose direct, didactic health messages for education and warning. Com-
posed in a laid-back, palm wine–guitar style that appealed to a more mature
population than the hipco generation, she developed versions in a range of
languages so as to transcend language and ethnic boundaries.[15]

> My people, Ebola is in Liberia.
> Ebola is real.
> Ebola can kill.
> Let's protect ourselves, oh.
> Chorus:
> Ebola is real.
> Let's protect ourselves and our family.
> Ebola can kill.
> It has no cure, but it can be prevented.

[12]Stone, "Ebola in Town," 90.
[13]Hipco is a form of Liberia genre that incorporates hip-hop and rap from the African American
tradition with texts that draw on local events.
[14]Stone, "Ebola in Town," 85.
[15]Palm wine–guitar music became popular in the 1950s and combined guitar performance with
calypso styles that were transmitted from the Caribbean.

Ebola, Ebola.

Let's fight it together.

Let's fight it together.

Ebola, Ebola.

Let's protect ourselves, our family, and our nation.

Always wash your hands with soap and water.

Always cook your food very well.

Go to the health facility anytime you have headache, fever, pinkeye,

Diarrhea, red eyes, and vomiting.[16]

The silence of death. While music had long been a customary part of death and funerals in Liberia, it proved eerily absent during the Ebola crisis. In a country where death rituals had been the most elaborated of the various life-cycle rituals, burial teams were instructed to keep everyone far away from their work of loading the dead into pickup trucks and transporting them for burial in mass graves or for cremation.[17] No religious rituals (with few exceptions) were observed, and by the end of the epidemic, people were still pained by the abrupt way in which they had been torn from family and friends who died during the epidemic. The burial teams themselves were shunned and avoided.[18] There were a few communities where family members, after the fact, held memorials that featured religious singing and performance to redress the loss that occurred during the epidemic. And that ritual formed the topic of a policy brief that I prepared during the epidemic in the hope that future epidemics would allow musicians and religious practitioners to be part of the burial team.[19]

Transcending the faiths in Ebola. Just as Christians and Muslims came together at various points during the civil war in Liberia—whether it was the clergy in the Liberian Council of Churches who stood up to the highest political leaders or the women who banded together at the end of the war to demand peace—so too cooperation ensued at a critical point during the Ebola crisis. As Mosoka Fallah, a Liberian epidemiologist, recounted, health workers had noticed a particularly high number of Ebola cases reported for

[16]Stone, "Ebola in Town," 86. Used by permission.
[17]Stone, "Ebola in Town," 91.
[18]Helene Cooper, "Liberia's Shunned Burners," *New York Times*, December 10, 2015.
[19]Ruth M. Stone, "Policy Brief: The Case to Incorporate Musicians as Members of Burial Teams in Liberia During the Ebola Crisis" (unpublished manuscript, 2014).

the Caldwell region of Monrovia where a high proportion of Muslims lived. When health workers investigated further, they learned that, contrary to all precautions that were being issued that people not touch patients or deceased who had Ebola, the Muslim community continued to care for the dead in the customary manner, carefully washing the bodies as they prepared them for burial. Once the workers from the Ministry of Health learned this, Mosoka led a group to meet with a prominent imam, a Muslim leader, and to explain the situation to him. Mosoka offered to train Caldwell Muslims to be part of burial teams so that they could handle the bodies for burial but do so with the protection of proper suits that would prevent the transmission of the disease. The imam agreed to the plan and admonished the community during his sermon at Friday prayers to cooperate with the health workers. Very shortly thereafter, the Ebola numbers dropped dramatically in the Caldwell neighborhood as the Muslims cooperated with the wider community to prevent Ebola casualties. When Muslims could continue to have Muslims handle Muslim casualties—albeit in protective suits—they were willing to work with the larger health community.[20]

THEMES IN TIMES OF CONFLICT AND CRISIS

A number of common elements can be discerned about how Christian musical expression has been central to Liberians' lives. If we look at the evidence from both the war and the Ebola epidemic, we can discern some of the complex ways that people interacted through performance, particularly within religious contexts. Among the themes that emerge in these times of crisis, we can focus on several salient ones.

Sounds, whether musical or not, are particularly noticed and attended to in times of crisis. During Ebola, for example, people noticed the sounds of sirens of ambulances and burial teams as they crisscrossed the capital city. Over time they began to react viscerally and negatively to hearing the sound, for they knew it likely signaled another Ebola case and perhaps another death or more in the uncontrolled spread of the disease. In fact, the response of local communities to this siren sound became so pronounced that as the Ebola epidemic was winding down, epidemiologist Mosoka Fallah worked

[20]Stone, *Fieldwork in Liberia.*

with the Ministry of Health to ask the ambulance and burial teams to go into neighborhoods where they were responding to a call for help *without* sounding their sirens. The health workers didn't want people to become any more agitated than they already were about the crisis at hand. And in early 2016, they were in fact much better able to respond to and control the outbreak. Part of controlling that crisis involved calming communities.[21] While people reacted negatively to a sound they were hearing in a siren, on other occasions they responded negatively to the absence of sound. This occurred when bodies were taken by the burial teams from homes or Ebola treatment units without the ritual sounds that were customarily associated with death. The negative consequences of the lack of funeral sounds are still being felt in Liberian communities and, in some cases, still being redressed with appropriate funerary performances.

All of this is not particularly surprising when we consider that Kpelle people, for example, emphasize and notice sounds. They possess an elaborate vocabulary for timbre or tone color. A drummer might demonstrate a pattern to a fellow player by speaking the following phrase: "*Kei zi-kee, zi kee.*" This phrase communicates mnemonically not only the appropriate rhythm to be played but also pitch and timbral aspects as well. A sound such as "*zi*" would be higher pitched and less resonant than the sound "*kee*," which would be lower pitched and more resonant in sound than the former. Furthermore, the particular drum phrase is associated with the voice of a particular bird in the forest.

Religious music performance has knit communities together in times of war as well as in times of epidemic. Locally composed religious songs and imported hymns alike were recontextualized and repurposed in both the civil war and the Ebola epidemic as they were sung. People developed special affinities for certain songs, such as "God Moves in a Mysterious Way" during the war and "It Is Well with My Soul" during the Ebola epidemic, that they perceived have particularly potent possibilities for communicating calm and connection. Whether they were communicating in music-coded meaning about a dictator or girding themselves as a group to battle the deep sorrow of losing many family and community members,

[21]Stone, "Ebola in Town," 92-93.

singing has possessed an important way to knit people together. The women protesting their demand for the end of the civil war sang together. And as they sang, Muslim and Christian women expressed themselves together even as their singing sometimes drew on religious Christian themes that were now retargeted. It is important here to note that performance implies not only singing and instrumental playing. This performance typically includes dance—even in the church. Performance implies a multimedia, multichannel complex that is inextricably bound together in creating expressive culture. That expressive culture also interweaves the spiritual with the political. When I returned to St. Peter's Lutheran Church in 2007 after the war, the choir, though not singing in protest of the dictator, was singing the Liberian national anthem in Kpelle and wanted me to record it for posterity. Music was the emotional glue for these complex expressions of the spiritual and political.[22]

The texts of one time of crisis transformed subtly to become the words to express deeply held feelings in the next crisis. The most obvious of these is the civil war text, *"Doe e lii, ee"* ("Doe must go, eh"), which morphed into *"Ebola e lii, ee"* ("Ebola must go, eh"). The target of the singers' fervor in the first case was the dictator Samuel Doe. In the second case the target became a dreaded disease. These texts shared a great deal in common and were adapted to fit the occasion.

While Christian and Muslim observances are distinct in their shape and context, communities have nevertheless been in a broad-based dialogue, spearheaded by faith leaders. During the war, the Liberian Conference of Churches very deliberately included Muslim religious leaders in their interactions with government leaders. Though this did not prevent all acts of violence between the communities, it did keep the civil war from becoming a religious war. At the end of the civil war, the Christian and Muslim women united to protest the conflict that they perceived the military factions were unwilling to end. And during the Ebola epidemic, health authorities worked directly with local imams to convince Muslim communities of the nature of Ebola and to let trained Muslim burial teams take care of bodies in order to drastically cut down on the rate of disease spread.

[22]Ruth M. Stone, "War and Wealth: Music in Post-Conflict Liberia," *Works in Progress: Magazine of the Philadelphia Folklore Project* 20 (2007), 9.

***The movement of music and sound during the war, and even more dra-
matically during the Ebola epidemic, has been accelerated dramatically
with the Internet.*** During my research on the Ebola epidemic, musicians
that I interviewed would inevitably refer me to Facebook. "Check out my
Ebola song on Facebook," they would say. Even though the musician may
not have had access to a personal computer, she or he would have found a
way to post his or her performances in a place where the world could access
it. And that access increased the linkages that musicians developed with
their relatives and friends, as well as others, in the diaspora. Many Liberians
had fled to neighboring countries or the United States or Europe. And the
Internet and cellphones now afforded the possibility of keeping in close
touch and knowing what was happening in Liberia.

In order to better understand these themes, it's appropriate to frame them
with some wisdom that a well-known blacksmith and ritual practitioner
shared with me many years ago during my doctoral dissertation fieldwork.
Ge-weli-wula, as I've recounted elsewhere, put it in this way:[23]

> *Meni nga golong, e pilang wule mai, e kula lii soli su.*
> What I know about song, it came from sorrow.
> *A nee i wolo, i meni kelee ke.*
> Even if you cry, you do everything.
> *Fe no, I pele ke.*
> You must perform.
> *Nalong aa ke pele-kei.*
> The man is performing.
> *Nii suu aa laygi.*
> The inside of his heart has cooled.
> *Nii a soli, ifa see tong ngono.*
> If your heart hurts, you can't sit quietly again.
> *Kele, befoo ba see tong, fe no i wule too.*
> But before you sit quietly, you must sing.[24]

As Ge-weli-wula saw it, music performance—including sound and
movement—provided an essential way to recover from pain or sorrow,

[23]Stone, "Ebola in Town," 80.
[24]Ruth M. Stone, *Let the Inside Be Sweet: The Interpretation of Music Event Among the Kpelle of Li-
beria*, 2nd ed. (Bloomington: Trickster, 2010), 81-82.

whether it was caused by death and destruction in a war or loss of family and friends from a fast-moving and highly contagious epidemic like Ebola. He spoke many years before either the civil war or the Ebola outbreak, but his philosophy applied nonetheless. People and communities became agitated and unsettled by grief. Music provided a way for their troubled bodies and souls to return to a place of metaphoric quiet.

Christian performance helped to heal the Kpelle choir and congregation of St. Peter's Lutheran after the horrendous massacre of 1990.[25] They drew on singing together to weather the war years and the desecration of their worship space. When they faced another crisis of a different sort only a decade after the end of the war, they refocused their efforts to rely on music once again. In the case of Ebola, they had the added challenge of not being able to touch one another and risking disease and death by even coming together to sing. But they adapted by increasing personal distance of one choir member to another, and found that sound was not contagious. In fact, it served to heal and make the community whole once again. They experienced the very situation that Ge-weli-wula had described many years earlier. If they sang together when they were troubled or agitated, they would return to calm. And they layered into the equation their Christian faith and belief as they sang and danced together.

Both when I returned in 2007 at the end of the war and when I conducted fieldwork in 2016 at the end of the Ebola crisis, I was deeply impressed and moved by the tenacity and calm of Liberians who had lived through so much. Christians and Muslims alike had relied on performance, among other resources, to move from trauma to peace. They were able to put their memories into perspective and forge ahead, confident that they had tools for confronting monumental challenges like war or epidemic. Whether in a Lutheran or Episcopalian or Baptist church, the repertoire bore a resemblance. The songs transcended denomination, ethnic group, and even language to bind people one to another.

[25]"Liberian Troops Accused of Massacre in Church," *New York Times*, July 31, 1990.

4

Sounds, Languages, and Rhythms

Hybridized Popular Music and Christian-National Identity Formation in Malaysia, Thailand, and Cambodia

Sooi Ling Tan

In 1986, Malaysian Anglican theologian Sadayandy Batumalai declared, "The Malaysian church in general mainly remains a 'potted plant.'"[1] Referring to the prevalence of Western influence on the Malaysian church in terms of communication, vehicles of worship, prayer, and theological training, this provoking analogy sadly remains largely true today. Twenty-two years later, Christianity has made some but very limited inroads in Southeast Asia. In the three countries featured in this chapter, the small percentage of Christians in Malaysia (9.2 percent),[2] Thailand (1.2 percent),[3] and Cambodia (0.5 percent)[4] confirms Christianity's status as a minority religion, particularly in Islamic or Buddhist majority countries. This chapter is a response to this troubling "potted plant" analogy and seeks to examine ways by which Christianity can be replanted and rooted in national soils. In other words, how can the church be perceived not as "a church in Southeast Asia" but a truly authentic "Southeast Asian church"?

[1] Sadayandy Batumalai, *A Prophetic Christology for Neighbourology: A Theology for Prophetic Living* (Kuala Lumpur: Batumalai, 1986), 154.
[2] Department of Statistics Malaysia, "Population and Basic Demographic Characteristic Report 2010," www.dosm.gov.my/v1/index.php?r=column/cthemeByCat&cat=117&bul_id=MDMxdH ZjWTk1SjFzTzNkRXYzcVZjdzo9&menu_id=LopheU43NWJwRWVSZklWdzQ4TlhUUT09.
[3] National Statistic Office Thailand, 2010, http://web.nso.go.th/en/census/poph/data/090913_Major Findings_10.pdf
[4] "Cambodian Inter-Censal Population Survey 2013," National Institute of Statistics, Phnom Penh, 2013, www.stat.go.jp/info/meetings/cambodia/pdf/ci_fn02.pdf.

In order to move in that direction, two deficiencies have to be addressed. The first has to do with a more robust contextual engagement. For Christianity to shed her foreign image, Edmund Chia challenges the Asian church to engage, dialogue, contact, and rub shoulders with her multireligious and multiethnic neighbors and to address the pertinent contextual issues of injustice, poverty, and ethnic-religious tensions.[5] The second has to do with identity formation. A deeper engagement with context flows from an understanding of a holistic Christian identity that includes the two aspects of "Christian" and "national."[6] Christians who are minorities in their countries often possess a strong faith and global church identity but have an ambiguous national one. Without a clear national identity, the church will always be regarded as foreign and an outsider. The focus in this paper is to examine the contribution of music and the performing arts in addressing these two gaps.

This chapter seeks to unravel the complexities of a Christian-national identity formation in three emerging nation states in Southeast Asia—Malaysia, Thailand, and Cambodia—through music and the arts. It explores how non-Christian and Christian Malaysian, Thai, and Cambodian musicians negotiate and express their personal and national identities through music and performance. It argues for developing a form of hybridized popular music that uses mainstream, contemporary, popular-styled worship music as a bedrock and integrate that with local musical elements, instruments, and visuals. Identity is understood, negotiated, and expressed through this fusion of new sounds and through the lyrical content that expresses contextual interests and concerns.

Comprising four parts, the first involves laying the groundwork by clarifying concepts pertinent to this discussion. The following three sections investigate how Malaysian, Thai, and Cambodian secular as well as Christian musicians imagine and construct their respective national identities. Finally, some proposals for a way forward will be suggested.

[5]Edmund Chia, "Asian Christianity: The Postcolonial Challenge of Identity and Theology," *Compass* 4 (2012).

[6]By "national," I am referring the national identity of the new or newly reconfigured nation states such as Malaysia, Thailand, and Cambodia. In other words, what is the Malaysian, Thai, or Cambodian identity? This will be explained further in the next section.

SETTING THE STAGE AND CLARIFYING CONCEPTS

On the concept of Christian-national identity, the use of the hyphen connecting Christian and national is intentional as it denotes two separate parts that form a greater whole when combined. This echoes Malaysian theologian Hwa Yung's insightful suggestion that Christians adopt a kingdom identity, which combines the Christian's identity as a member of the body of Christ with his or her identity within their own culture and society. He elaborates on these dual components by asserting that Christian identity is "based on a clear sense of self-worth, self-respect and dignity that we have in Christ. But Christian identity is also inseparable from who we are in our cultures and societies."[7] Hwa further maintains that "when either of these aspects of kingdom identity is weakened the church's missional engagement is weakened."[8] This holistic understanding of what constitutes Christian identity is the adopted understanding for this chapter.

Regarding the relationship of music and the arts with identity formation, studies in ethnomusicology have established that music is a constitutive part of culture and vitally contributes to the identity formation of individuals and societies. This takes place in various ways. First, music and the arts have a strong expressive function. Adopting a constructionist view, I contend that identity formation is a process.[9] Personal and collective identities are constantly evolving, being constructed and reconstructed. Music and the arts fittingly express the negotiation of preexistent, current, and emergent identities symbolically.[10] Music's ability to synthesize provides a platform to express the fluidity, hybridity, and multiplicity of identities present in contemporary societies. Second, music and the arts have constructive and formative capabilities. Here British ethnomusicologist Simon Frith's argument that popular music not only reflects or authenticates reality but constructs it has direct bearing.[11] Furthermore, music's ability to crisscross social, economic, ethnic, and national borders helps shape new identities and negotiate new

[7]Yung Hwa, "Kingdom Identity and Christian Mission," *Mission Round Table* 4, no. 2 (December 2008): 2-12.

[8]Hwa, "Kingdom Identity," 2-12.

[9]See Timothy Rice, "Reflections on Music and Identity in Ethnomusicology," *Musicology* 7 (2007): 24, www.doiserbia.nb.rs/img/doi/1450-9814/2007/1450-98140707017R.pdf.

[10]Rice, "Reflections on Music," 34-35.

[11]Simon Frith, *Taking Popular Music Seriously: Selected Essays* (Aldershot: Ashgate, 2007), 201.

boundaries.[12] The subversive power of music also empowers the marginalized to boldly imagine, dream, and create alternate visions of national identity through their performances. Finally, music's relational properties promote bonding. Christopher Small's concept of "musicking,"[13] where all participants in a musical performance are enabled to explore and celebrate their relationships, sheds light on how a musical experience can unite a group, close gaps, promote solidarity, and reinforce group identity.

Another feature is the emergence of new nation states in Southeast Asia in the twentieth century. Some are young nation states formed after independence from the British and the Dutch in the 1940s to 1960s, such as Malaysia, Singapore, and Indonesia. Other nations like Thailand, Myanmar, Vietnam, and Cambodia have rich and long kingdom histories but have been reconfigured geographically and politically. All these nations share a common history of the ramifications of Christianity being associated with colonialism and the need to now configure a national identity that is critical for unity, stability, and progress. Adding to the complexity is the understanding that religion, ethnicity, politics, and economics are almost inseparable. For example, in Malaysia, ethnic Malays are automatically Muslims. Buddhism is one of the three identity markers for Thais and Cambodians. An added dynamic is the politicization of religion that has resulted in the rise of a hegemonic privileged class that exerts political, economic, and religious authority over the minorities.

Finally, the global phenomenon associated with easier cross-border flow of goods, ideas, information, and people has uniquely impacted Southeast Asia in several ways. The global capitalist economy has unfortunately caused greater economic inequality through unfair distribution of gains. Regarding identity formation, encounters and interactions have produced a new kind of person with multiple identities and belongings. Lastly, the currents of global Christian culture have also reached Asian shores, particularly with contemporary worship songs becoming the staple worship music genre in Asian churches.

[12]S. Pettan and J. T. Titon, eds., *The Oxford Handbook of Applied Ethnomusicology* (New York: Oxford University Press, 2015).
[13]Christopher Small, *Musicking: The Meanings of Performing and Listening* (Hanover, NH: University Press of New England, 1998).

With all this as a backdrop, let us now turn to how musicians set about engaging with context: creating and expressing their identities through music and performance in Malaysia, Thailand, and Cambodia.

MALAYSIA

At the heart of the national identity dilemma in Malaysia is this essential question, Who decides what the elements of a national identity are? In Malaysia, this is dictated top-down by a privileged class that controls the political, religious, economic, and cultural affairs of the nation. The result is the formulation of a national cultural policy that runs along divisive ethnic-religious lines. It is pro-Malay and pro-Islamic.[14] This is problematic, as it runs counter to a vision of an inclusive and egalitarian multicultural society that Malaysia outwardly projects, stunting a healthy national identity development and stifling ownership of it. However, given artists' natural disdain for control over their art, this hegemony does not stop Malaysian musicians from envisioning alternative versions of a better Malaysia.

The way the sound fuses: Imagining a Malaysian identity. There are several Malaysian composers and musicians who express a more integrated, inclusive, and egalitarian Malaysia. P. Ramlee, the icon of Malay entertainment in the 1950s and 1960s, created a Malaysian folk-style music that incorporated various local and regional musical cultures. The music in his film *Ali Baba Bujang Lapok* reflected the Malay infused *joget* and *inang* while incorporating the Western waltz, rumba, as well as the Indian Hindustani melodies.[15]

In the 1980s and 1990s, the BM Boys introduced a genre of music that integrated their Malaysian and ethnic Chinese identity. Using Taiwanese popular music as their primary form, they incorporated drums from China, India, and the Malay community, used Chinese instruments such as *dizi* (Chinese flute) and *erhu* (two-string spiked fiddle), and sang in different languages and dialects such as Mandarin, Teochew, Hokkien, Hakka, and Malay, often switching between languages in one song. Sooi Beng Tan

[14]1971 national cultural policy states that the national culture must first be based on indigenous (Malay) culture, include permissible elements from other cultures, and be Islamic in orientation.
[15]C. S. C. Chan, "P. Ramlee's Music: An Expression of Local Identity in Malaya During the Mid-Twentieth Century," *Malaysian Music Journal* 1, no. 1 (2012): 16-32.

elaborates that their lyrics also saliently expressed the dilemmas experienced by the younger generation of that time, "such as arranged marriages and parents forcing their views on children."[16]

Finally, a contemporary example of expressing national Malaysian identity is located in the twenty-five-minute segment *Kita Serumpun* ("We Are One"), performed during the opening ceremony of the 2017 Southeast Asian games hosted by Malaysia. Opening ceremonies for international games such as these are used deliberately to showcase the host nation's rich history and current status. The musical director for *Kita Serumpun*, Michael Veerapen, a Christian and a prominent Malaysian jazz musician, was given three key performance indicators for this production. Together with a strong multimedia team led by renowned Malaysian film director Saw Teong Hin, he was tasked to create a musical performance that would (1) exemplify Malaysia as a modern and progressive nation, (2) represent the nation's culturally diverse and rich history, and (3) in so doing, create a distinct Malaysian sound.[17]

In an interview, Veerapen explained that keeping those indicators in mind, he chose the genre of Western popular film music to convey a sense of overarching grandeur.[18] "Think John Williams or Ennio Morricone," he says. To add the local flavor, he continues, "Upon the bed of those ideas, you fuse melodic riffs that are peculiar to Malaysia such as melodies using the pentatonic scale and co-mingle that with Malaysian ethnic instruments. It is *the way the sounds fuse* that make it modern, grand and quintessentially Malaysian."

Kita Serumpun takes the audience on the Malaysian journey in four acts through a rich, multisensory experience of music, dance, images, digital arts, and lights. The first act, "Provenance," opens with the mystical sounds, dance, and music of the *"orang asal"* ("the first peoples") in the land. The second act, "Similarities in Diversity," marks the arrival of different ethnic groups to Malaysia to resettle, bringing their musical traditions with them.

[16]Sooi Beng Tan, "Negotiating Identities: Reconstructing the 'Local' in Malaysia Through 'World Beat,'" *Perfect Beat* 5, no. 4 (2002): 7.

[17]It is interesting to note that the creative production team was multiracial in composition, and members were chosen on the basis of skill and not ethnicity. This is a break from national policy and protocol.

[18]Personal interview with Michael Veerapen, August 8, 2018.

The third act, "A Nation Built on Inclusion," expresses this utopian value of inclusion in nation building. The performance culminates in an explosion of colors and movement in the final act where all the different ethnic groups come together to *joget* (a social-popular dance form). The *joget*, according to Veerapen, signifies the blend of Malaysia and exemplifies the final theme, "Together We Are Stronger." Veerapen explains, "I could have ended the performance on a Western note, but the finale is what leaves the lasting impression on the audience. For me, the *joget* is the 'pure Malaysian sound.'" The philosophy behind this is simple, he explains: "The *joget* is a synthesis of a Portuguese folk dance and the Malay dancing style but today, it has evolved to become a distinct dance form of its own enjoyed by many Malaysian communities."[19]

Musically, the orchestration accompanying the *joget* was a remake of a hugely popular Malaysian song, "*Sinaran*" ("Ray" or "Illumination"), made popular by Sheila Majid. Significantly, "*Sinaran*" speaks of the hope of a bright, better future for all Malaysians. This song was reharmonized, re-scored, and performed by a large Western orchestra, with ethnic instrument interjections such as the Chinese *erhu*, and rhythmically driven by the interlocking rhythms of the Malay percussion instruments. This fusion or blending together with the strong visuals of all ethnicities dancing together in one common space truly symbolized a new Malaysia. Veerapen poignantly concludes, "*Kita Serumpun* was a rendition of where I thought it (Malaysian identity) was (in 2017)."[20]

Malaysian musicians and performers have expressed a hybrid nature of Malaysian identity, demonstrated in "the way the sounds fused." It also seeks to embody the value of going beyond multiculturality to interculturality, reflected by an inclusive intermingling of the various cultures as they celebrated in the final act of *Kita Serumpun*. Indeed, music and the performing arts subversively give space for musicians across divides to negotiate, construct, and enact their alternate visions of Malaysian identity. Possessing strong affective power, a performance like *Kita Serumpun* bonds the nation together, evokes patriotism, and affirms new constructs of Malaysian identity beyond the previously set parameters of ethnicity and religion.

[19]Personal interview with Michael Veerapen, August 8, 2018.
[20]Personal interview with Michael Veerapen, August 8, 2018.

Malaysian Christian music: Sound, language, and rhythm. The task of developing the "Malaysian" in the Christian-Malaysian identity has its challenges. Perhaps music is an appropriate way to start this process. Two examples show the way: Malaysia Gospel Music (MGM) and the music of Hezekiah Azim. MGM was formed in 2011 to help local songwriters write, develop, and disseminate locally written Christian worship songs. To date, they have produced three albums, *Adore* (2011), *Kasih (Love)* (2013) and *United* (2018), and organized regular MGM concerts to showcase these locally written songs.[21] Hezekiah, a *sape* player from the Kelabit community, blends the sounds of the *sape*, Sabah-Sarawak traditional rhythms, and Western instrumentation and style in his reworking of hymns, Indonesian Christian contemporary songs, and original compositions.[22] Both have intentionally created music with a Malaysian sound in four ways.

First, historically, hymns were brought to Malaysia by the early missionaries and are still being used today in traditional and mainline churches. However, most churches today use contemporary worship songs produced by Maranatha, Hosanna Integrity, Vineyard, Hillsong, and Planetshakers as well as regional popular music (Indonesian and Taiwanese) in their worship services. Because popular music is the dominant musical style used by Christians in Malaysia, it is natural that this becomes the base on which Malaysian Christian musicians create new songs. Local musical elements are then inserted to create the local flavor.

Second, multiple languages are being introduced, as evidenced in MGM's albums. Beginning with *Adore,* a purely English album, they have localized to include eleven Malay language songs (out of fifteen) in their second album, *Kasih (Love).* For *United,* they further diversified by including Tamil and Mandarin songs sung by native speakers of the language. The feature song, "United," has one verse and one chorus sung in four languages. What

[21]Their first album, *Adore* (2011), features twelve songs; their second, *Kasih,* has fifteen songs; and the third one, released in June 2018, has fourteen songs.

[22]*Sape,* a boat-lute shaped, plucked, stringed musical instrument played among the Kayan and Kenyah people in Central Borneo and the Dayak in Kalimantan, Indonesia. This musical instrument is also the symbol of the state of Sarawak. Connie Lim Keh Nie, "Evolution of *Sape*: From Longhouse to the International Stage," *Journal of Borneo Kalimantan,* www.borneo.unimas.my /images/jbk2016/4_evolution-of-sape_conniefadzil.pdf

stands out in this song is the use of the pronoun *our*, enabling a sense of identification with the nation of Malaysia.

United
There's a rhythm and sound from here
That flows from our soul to all spheres
Every tribe and tongue, as we unite as one
May Your Kingdom come O Lord
Your will be done as we declare
This is our song, this is our sound
This is our heartbeat of Malaysian praise
United as one, united in sound
Let the pulse of our worship be our identity.[23]

When asked what makes this song "Malaysian," Rev. Ng Wah Lok, a steering committee member of MGM, replied that it was "multi-lingual and included four languages—(it was) a truly Malaysian United worship."[24] Patrick Leong, the songwriter, explains that the overarching theme in the song is unity in diversity. Using the four languages of the primary ethnic groups in Malaysia expressed this unity. Leong concludes, "Through sound, language and rhythm, this song was a true representation of Malaysia."[25] It is also interesting to note here that Malaysians (as seen in the songs by BM boys) have the propensity to easily switch languages as they speak.

The lyrical themes in all three albums can be considered contextual as they represent the Christian-Malaysian experience. Christians in Malaysia experience struggle. They fight for the right to believe, the freedom to practice their religion, and against religious intolerance, injustice, and economic inequality. For Christians, the understanding of God as powerful, sovereign, and faithful is pivotal. Key truths like the power and authority of the cross affirm God as the highest power over powers held by other local deities. However, songs with a national emphasis are lacking. Nevertheless, let me highlight one exception, a song written by Patrick Leong titled "*Yang Mulia*" ("One Who Is Honored"). In this prayer song for Malaysia, he refers

[23]Patrick Leong, "United," January 2018, www.mgm.com.my/mgmalbumsunited.htm. Sung by Patrick Leong, Debra Robert, Prince Jon, and Carmen Sarah Chung. Used courtesy of Patrick Leong and Malaysia Gospel Music.
[24]Email interview with Ng Wah Lok, August 22, 2018.
[25]Email interview with Patrick Leong, August 24, 2018.

to Malaysia poignantly as *Tanahairku Kita* ("Our homeland"), a phrase that strikes deep in all Malaysians. For Malaysian Christians, however, it presents this dilemma: "Are we merely 'aliens' in this land, or is Malaysia truly our homeland?"

In their attempts to express "Malaysian" music, both MGM and Hezekiah combine local and Western elements in their music and fuse their sounds. The difference lies in the ratio of the local and Western elements. Is the music acculturated, where the dominant element is the local that is combined with the nonlocal, or popular and contemporary art music, where Western-based music is dominant and combined with local elements? MGM's music leans toward the popular music end, particularly in their first two albums, with the influences coming from Western, Indonesian, and Taiwanese contemporary worship styles. The third album features a slight variation, with a light incorporation of ethnic sounds and instruments. During the finale of the MGM concert in June 2018, vocalists, instrumentalists, and dancers from the various ethnic groups in Malaysia performed the song "United." In describing how diversity is represented in this song, Leong explains,

> Malaysia has over 59 indigenous tribes and it is impossible to represent every tribe in this song. So, we settled on using the four major languages in Malaysia. The rest of the diversity is represented through sound. Sounds of local instruments such as the *sape, seruling, gamelan* were added. The *erhu* added a distinct Chinese sound and the *tabla* and sitar the Indian sound. . . . The song "United" is a rhythm and blues piece but by incorporating the sounds of traditional instruments and using multi-lingual vocals, the past fuses with the present and this expresses a long-lasting heritage that is worth preserving.[26]

In Sarawak, it is exciting to hear Hezekiah Amin's arrangement and presentation of "Halleluyah" at the 2015 International Gospel Festival in Miri, Sarawak, where the music is predominantly syncretic or acculturated. In this song he keeps the integral elements of *sape* music as the base. The melody is constructed using the *sape* pentatonic scale; there is a continuous ostinato that is played every four beats by the one of the three *sape* players; and the other two *sapes* alternate the melodic accompaniment with an abundance

[26]Email interview with Patrick Leong, August 24, 2018.

of ornaments, the strict duple meter, and the gentle movements of the dance.[27] The drums, keyboards, and guitars are supporting instruments.

In summary, Malaysian Christian artists have begun exploring the construction of an elusive Malaysian sound to add to their repertoire of Christian music in three ways: using the languages of the Malaysian peoples' songs; blending contemporary musical sounds with local ones; and like the wider body of Malaysian musicians, hold up unity as an important ingredient in an ethnically polarized nation.

THAILAND

Thailand's national identity is characterized by the continuity between Thai traditional and Western-global influences. Traditionally, Narawan Pathomvat explains, "From birth to death, every Thai has been inculcated into just such an ideology—devotion to the triad of nation, religion (Buddhism) and monarchy (King)."[28] This triad of markers, however, has become unsettled by the national shifts that began in 1932. With the political shift from absolute monarchy to constitutional monarchy, the king no longer held absolute power. Buddhism has new rivals in Islam and Christianity. The country became more multicultural with the inclusion of ethno-linguistic tribes in the north and northeast Thailand. Finally, Thailand's modernization agenda welcomed congenial global influences. This constant dialectic between old and new is symbolic of the Thai experience.

Thai popular music: Negotiating continuity between tradition and innovation. Thai popular music represents this continuity very well. Of the two main subgenres of Thai popular music, *pleng luk thung* (Thai country music) and *pleng string* (Thai urban music), *pleng luk thung*, with its stronger link to Thai tradition and folk music, is perceived as more authentic than *pleng string*, which adopts the musical, fashion, and performance styles of the West. This brings us to the question of authenticity. What makes a song authentic, and what signals it is not? Connell and Gibson answer this question by asserting, "Authenticity is judged by perception, is socially con-

[27]See Patricia Matusky and Tan Sooi Beng, *The Music of Malaysia: The Classical, Folk and Syncretic Traditions* (New York: Routledge, 2019), 287.

[28]Narawan Pathomvat, "A Cartography of the 'Other': Social History and the Production of Space of 'Other' in Modern and Contemporary Art in Thailand," *Yishu: Journal of Contemporary Chinese Art* 11, no. 5 (2012): 81.

structed, and involves elements of a tradition but is constructed in relation to how continuity and change are perceived."[29]

Lukthung aptly demonstrates this dialectic of continuity and change. In the 1990s, *luk thung* was accused of losing its authenticity with the incorporation of Western-influenced rhythms such as rap, salsa, techno rhythms, and Western, "Madonna"-style dance movements. To this point, scholars like Amporn Jirattikorn rightly argue that it is this very act of negotiation of the old and new that makes *luk thung* authentic.[30] Tradition, or "Thainess," is expressed in its roots in folk music, particularly its expression of everyday emotion and evocation of a sincerity and straightforwardness long seen as fundamental to rural culture. The new is represented by the incorporation of Western-style rhythms, vocals, and dance movements. Contemporary artists such as (Bird) Thongchai McIntyre, Paradise Bangkok Molam International Band, and Rasmee Wayrana illustrate this with their bold fusion of the old and the new in their compositions and performances. Their songs possess a distinct and an unmistakable "Thainess" in their sound.

Bird Thongchai McIntryre, an established popular music icon in Thailand, made a departure from popular music by releasing a *luk thung* album, *Chud Rab Khak* ("*Living Room*"). In this album he retains his signature pop, rap, and techno styles but blends in Thai elements such as vocals using regional dialects and *mor lam*, the traditional musical style of northeast Thailand.[31] The single "*Fan Ja*" ("My Honey") features three guests, most notably Jintara Poonlarb, a *mor lam luk thung* singer, singing in the four different dialects that represent the distinctive vocal styles of Thailand's four different regions.[32] Jirattikorn vividly describes, "On this album Bird wears Western

[29]John Connell and Chris Gibson, *Sound Tracks: Popular Music, Identity and Place* (London: Routledge, 2012), 44.

[30]Amporn Jirattikorn, "*Lukthung*: Authenticity and Modernity in Thai Country Music," *Asian Music* (Winter/Spring 2006): 26.

[31]Originally *mor lam* was a form of local poetry set to music for religious ceremonies and festivals. Performers substantially improvised during the performance, adding humor and political messages. Transported to the city, *mor lam* lyrics were mixed with *luk thung* tunes, producing the subgenre of *mor lam luk thung*. The subject matter of the two styles is similar; the difference is that the rhythms of *mor lam* are faster, and its vocals are delivered in Lao. Jirattikorn, "*Lukthung*," 43.

[32]Joining Bird in this album are three special guests: Jintara Poonlarb, a *mor lam luk thung* singer, and Nat Meria Benedetti and Kateleeya English, both of whom are models-cum-actresses and pop singers.

hip-hop fashions and performs rap and techno music but he somehow still manages to be *lukthung.*" He concludes, "This is authentic Thai music, but it borrows from the world. This album has become an emblem of *khwam pen Thai* (Thai-ness)."[33]

More recent groups like Paradise Bangkok Molam International Band's unique Thai sound comes from the comingling of traditional and non-Thai instruments and styles. Thai instruments such as the traditional *phin* lute and *khaen* (a large harmonica constructed from bamboo pipes) are used alongside the Western bass guitar and drums. Their musical style mixes traditional Thai musical elements with blues, folk rock, and dub, and it is marked by a strong, pulsating rhythmic section. In a promotional writeup by NTS, their music is described appropriately as "vintage *morlam* played with a 21st century vibe, an infectious and highly danceable mixture."[34]

The music of singer-songwriter Rasmee Wayrana from northeast Thailand draws from an even wider blend of global musical influences. Her music integrates Western jazz, blues, rock, and pop with traditional Isan instruments and the *mor lam luk thung* style. Her lyrics are strong contextually and speak into social issues. For example, the song "Little Girls" from her first album, *Isan Soul,* describes the difficulties Isan children have of getting a good education because they live in remote areas. "Free Beauty" also criticizes the stereotype that beauty is measured by fairness and slimness.

These three Thai *luk thung* musicians have imagined and represented "Thainess" in their music by combining musical elements to reflect a historical continuity with tradition and a place in the global world. They have done this by using regional dialects and a fusion of musical styles. Rasmee's and Bangkok Paradise's performances in particular have become the space where the global and local meet, the two crucial constituents of "Thainess."

Thai Christian worship: A scent of Thainess. Having established that the wider Thai national identity is characterized by continuity of tradition and the new and that *luk thung* musicians retain authenticity in negotiating this continuity, let us examine how Thai Christians have or have not retained a sense of "Thainess" in their Christian music. The Thai church usually uses

[33]Jirattikorn, "*Lukthung,*" 44.
[34]"The Paradise Bangkok Molam International Band," NTS Radio, www.nts.live/artists/505-the -paradise-bangkok-molam-international-band.

three types of songs in their worship services: translated hymns that were introduced by early missionaries, popular contemporary praise and worship songs, and *mor lam luk thung* songs written as early as the 1970s and used particularly in the Isan churches in the north and northeast Thailand. Local Christian Thai composers, notably Crossover, W501, and Grateful Band, have also started composing their own praise and worship songs, mostly in Western contemporary worship styles. With the plethora of historical and foreign contemporary influences on Thai Christian music, I argue that there is still a scent of "Thainess" in the music.

This is demonstrated particularly in the lyrical content of worship songs. A survey conducted from November 8, 2015, to December 3, 2017 (ninety-six weeks) at the Acts of Christ Church, a Pentecostal-evangelical church in Bangkok,[35] revealed that the five most frequently sung praise and worship songs are contemporary worship music songs (see table 4.1).[36]

Table 4.1. Acts of Christ Church, Bangkok: Five most frequently sung praise and worship songs

	Praise Songs		Worship Songs	
	SONG NAME	SUNG BY	SONG NAME	SUNG BY
1	Blessed Be Your Name	Matt Redman	You Are Good	Gateway Worship
2	Now You're Near	Hillsong United	How Great Is Our God	Chris Tomlin
3	Day of Praise	W501	How Great Thou Art	Carrie Underwood
4	Our God	Chris Tomlin	Glory Is Your Name	Mehta Kriengparinyakij
5	Ruling over the Earth	Bongkot Hudson	Here I Am to Worship	Tim Hughes

From the chart above, seven songs are written and sung by Australian, British, and American contemporary worship music artists, and the remaining three by local composers, albeit using the same style. As such, at first glance there is very little or no musical evidence of "Thainess" in the songs. However, I argue that the contextual elements in these songs lie in the lyrical content of the songs. The themes in the songs encapsulate the Christian Thai experience of struggle. There is a struggle against the hegemony of Buddhism,

[35] Acts of Christ Church is a Pentecostal-evangelical church established October 26, 2008, with four hundred members, mostly from the middle and upper-middle class sectors in Bangkok.

[36] Kanok Leelahakriengkrai, "Investigating the Theology of Worship from the Worship Songs Sung in Acts of Christ Church, and Implications for Worship," DMin final research paper, Bangkok, Thailand, December 2017.

powerful spirit forces from their folk tradition, secularism, civil conflict, and the experience of socioeconomic inequality. Themes like God's power, sovereignty, ready intervention, abiding love, and the powerful work of Jesus Christ are very meaningful. Singing these songs reinforces theological truths that anchor Thai Christians in God, infuse hope, build solidarity, and create a strong Christian identity.

"Thainess," however, is also evident in *mor lam luk thung* songs, which remain popular among Thais living in tribal and rural areas as well as the working class in urban cities. The difficulty in including these songs in Bangkok lies in the perception that *luk thung* is considered "low-class" music and associated with unsophistication.[37] A favorite *luk thung* song is *"Pakping Nai Prajao"* ("Lean on God"), composed by Winidi Treepoonphol Chaissokthaksin in 1982. This song has traces of American country and Western music elements mixed with traces of Thai folk styled melodies and vocals. The strength of the song lies in the lyrical themes, where Thai identify with the theological truth that God is present and powerful. Despite the storms, they can lean on God. "Praise My Savior," written by Nigorn Sittijariyakorn (W501), is an upbeat, celebratory song. Central to this song is the *mor lam* rhythmic style that inspires the audience to get up and dance. It also is a long song, with eight verses and a chorus. Finally, from Hark Productions, Damrongsak Monprasit's and Duriya Tasana's song "Hymn of Philippians" has a more syncretic musical style and is considered a Thai hymn. The lyrics are lifted from the epistle to the Philippians, but the melody uses Thai scales, and it is accompanied by Thai instruments and Thai dancers.

Drawing from the above, there are several ways "Thainess" is present. First, in both *string* and *luk thung* songs, the content of the lyrics is relatable because they describe the struggles Thai Christians face, and they affirm the truth about the reliability and faithfulness of God. Setting Scripture in Thai song and using longer text form allows the Scriptures to be retained and internalized. Second, *luk thung* songs are sung in both Thai and regional dialects that urban and rural hearers can identify with. Third, the musical styles possess varying degrees of local Thai musical elements.

[37]Jirattikorn, "*Lukthung*," 43.

CAMBODIA

The poignant lament "Oh Phnom Penh"[38] blared over the loudspeaker in Phnom Penh, signaling the end of three years, eight months, and twenty days of the Khmer Rouge rule in Cambodia—and musical silence. The lyrics of this song express the pain of the Cambodian people suffered during this period, recall their past and proud history of courage and resilience, and declare a resolve to rebuild Phnom Penh. This lament reflects music's unique ability to express a grief and loss so deep that it is beyond words to describe. This song also had the capacity to galvanize Cambodians to hope and rebuild by recalling their nation's proud history of resilience and courage.[39]

Cambodian popular music: Innovating and creating hybrids. Cambodian popular singers, musicians, and composers have a remarkable capacity to innovate and create musical hybrids. They draw the best from all the available genres, local and nonlocal, and craft a hybrid culture.[40] This ingenuity and flexibility to borrow, adapt, and innovate is demonstrated throughout their musical history.

Following Cambodia's independence from a ninety-year French rule in 1953, the new nation-state pursued a modernization program through Prince Norodom Sihanouk. Explaining the role of music in this agenda, Saphan notes, "Music was used as a postcolonial reaffirmation of national identity, a nationalistic reminder that Cambodia had deep cultural roots but also that it was prepared to modernize its culture along with Western nations."[41] With this, French and Anglo-American musical influences were welcomed, leading to what has been dubbed the golden age of Cambodian popular music from the 1960s to 1975. What is unique in this period, according to Saphan, is the "musical hybridization of Western popular styles that were infused with the phonetic nuances of the Khmer language, indigenous musical pitch and rhythms."[42] A good example is the song "I'm Still Waiting for

[38]"Oh Phnom Penh" is a song written by Keo Chenda and performed by Cheam Chansovannary. Translated lyrics can be located at www.d.dccam.org/Archives/Musics/Lyrics_for_Oh_Phnom _Penh.htm.

[39]Linda Saphan, "Cambodian Popular Musical Influences from the 1950s to the Present Day," in *Sounds from the Periphery: Modernity and Development of Asia Pop 1960–2000* (Seoul: Chaeryun, 2017), 262-96.

[40]Saphan, "Cambodian Popular Musical Influences," 262.

[41]Saphan, "Cambodian Popular Musical Influences," 262-96.

[42]Saphan, "Cambodian Popular Musical Influences," 262-96.

You," by Cambodia's famous singer-songwriter Sin Sisamouth. He used the melody of Animal's "House of the Rising Sun," composed new lyrics, and rescored it. Saphan adds, "What made the sound of rock so unique in Cambodia was certainly the blend of Western tunes with a Cambodian twist."[43]

After three years of pitch-black musical silence under the Khmer Rouge rule, the nation began its hard journey of rebuilding in 1979. Popular music returned to a nation grappling with its identity and was largely imported from other countries. The sounds that emerged were, however, largely imitative.

As the country grew in confidence at the turn of the millennium, musicians began to step out of the box to innovate and create. "I Am Original" describes a movement among Cambodian musicians to write, sing, and produce Cambodian music. Bands like Small World, Small Band are now composing new melodies and resurrecting the art of storytelling by drafting lyrics that address real life issues. The pop and rap duo *Khmeng Khmer* (Young Cambodian) employs a mix of traditional instruments underneath R & B and hip-hop vocals. Their songs, such as "My Way" and "Life of Orphans," address the social issues of today's Cambodia and are sung with a mix of Khmer and English. Kampot Playboys is another unique group made up of six musicians playing a blend of traditional and modern instruments such as the guitar, *tro sau* (bowed string instrument), and accordion. Their music is a fusion of traditional Cambodian music, rock, pop, folk, and ska. These new, hybridized sounds differ from those in the 1960s as musicians today draw from a larger pool of global musical influences. They are unafraid to add their own Khmer "twist" and mirror a people growing in confidence of who they are and a nation with a promising future ahead.

Cambodian Christian music: Empowerment and expression. Although Christians are a small minority in Cambodia (only 0.5 percent of 14.6 million people), there have been reports of recent growth.[44] The Christian Missionary Alliance estimates that the Cambodian Christian population in their denomination has grown by more than half since 2010 and now includes three hundred thousand believers.[45] Because of the war,

[43]Saphan, "Cambodian Popular Musical Influences," 262-96.

[44]"Cambodian Inter-Censal Population Survey 2013," National Institute of Statistics, Phnom Penh, 2013, 22, www.stat.go.jp/info/meetings/cambodia/pdf/ci_fn02.pdf.

[45]Kate Shellnut, "Unlocking Cambodian Christianity," *Christianity Today*, June 2017, 35, www.chris tianitytoday.com/ct/2017/june/cambodians-usher-in-miraculous-moment-for-christianity.html.

Cambodia has a uniquely young population, with 68.5 percent under the age of thirty-five in 2013 and born after the Khmer Rouge rule. In fact, few Christians can say their faith dates back to before 1975, when the Khmer Rouge took power. Many in that generation have either been killed or have migrated.

Since the Cambodian Christians are either elderly or below thirty-five years old, it is natural that the older Christians still sing translated hymns brought in by early missionaries for worship, while according to Nhanh Chaantha from Chab Dai Coalition, the young generation prefers Christian contemporary worship songs by Hillsong, Planetshakers, Don Moen, and Matt Redman.[46] Nhanh was converted as a teenager and moved to Phnom Penh from the province to pursue her university studies. With a group of seven friends, they planted a house church in Phnom Penh and now have thriving church plants in and around Phnom Penh. She talks about one of her favorite songs, a song she maintains is a firm favorite among her circle of friends and the church in Cambodia, "Pray for Cambodia."

While this song adopts the musical style of contemporary worship music, it retains a Khmer authenticity through the distinct rhythm and sound of the Khmer language and a singing style that has a nasal quality and ornamentation.[47] On top of that, what enables Cambodian Christians to fully relate with this song is the lyrical content. In an interview, Nhanh expresses how this song brings comfort and the assurance that God will bless Cambodia and the Khmer people and hear their prayers. She remarks, "It motivates us and reminds us of our commitment to Him and to do His work. Despite the fact that we are 'small,' God still chooses us."[48] The lyrics express their explicit struggles and difficulties in a society grappling with issues of poverty, human trafficking, injustice, and continual simmering conflict. They also turn the Christian to God, who is sovereign and good, and will hear their prayers. This prayer-worship song well represents the two aspects of Christians as well as their Cambodian identity by engaging squarely with contextual realities and anchoring in God.

[46]Personal interview with Nhanh Chaantha, June 16, 2018.
[47]Sound of Praise, "Pray for Cambodia," www.youtube.com/watch?v=s3Mdy5-g8WA.
[48]Personal interview with Naan Chaantha, June 16, 2018.

A second example, Epic Arts, also demonstrates a strong engagement with context but with an added element of empowerment. An international, inclusive arts organization based in Cambodia and registered as a charity in the UK, Epic Arts uses inclusive arts for expression and empowerment. Through participation by those with and without disabilities in their education, creative arts, community, and social programs, it carries the message that "every person counts." Through their musical performances, empowerment takes place through the restoration of dignity, the practice of acceptance and equality, providing a space for healing, restoration, and hope.

A stirring example is their one-hour musical, *Come Back Brighter*, which traces the turbulent Cambodian journey through time by using a combination of theater, dance, and video through three acts. Choreographed by Amrita Performing Arts, the story consists of three acts depicting the three musical phases in Cambodian history. As performers move on the dance floor to the strains of rock 'n' roll, the first act portrays the bright and shiny pop period of the 1960s. This is contrasted with the depiction of darkness and death associated with the Khmer Rouge genocide. The final act is an explosion of joy and hope that a new dawn has arrived for Cambodia, epitomized by these final words on the screen: "Cambodia is rediscovering who it is again, its people are discovering their soul, and the arts are thriving."[49]

This performance represents the fine spirit of the new Cambodia. It tells us visually and experientially that disabilities do not hamper capabilities, and one can rise above any challenges. It promises that while Cambodians have suffered horrendously, they can come back brighter. Furthermore, it is a wonderful example of co-mixing and interculturality. "For the performers themselves, it's a fantastic opportunity to show what they can do, telling the story of so many people in this beautiful land, while celebrating the inclusive and diverse nature of Cambodia's growing arts and cultural landscape," says Onn Sokny, of Epic Arts's senior management team.[50] Ork Savy, age thirty and a member of the troupe, concludes, "This is a show about our history, our art and our identity."[51]

[49]Asia Life, "Come Back Brighter," April 2, 2016, www.asialifemagazine.com/cambodia/come
-back-brighter/.
[50]Asia Life, "Come Back Brighter," 2016.
[51]Asia Life, "Come Back Brighter," 2016.

Conclusion

In this chapter, I have provided snapshots of how music and the arts can contribute to a greater engagement with local contexts and move people toward identity formation in the countries of Malaysia, Thailand, and Cambodia. Epic Arts, through their programs and musical performances, show us a way forward to engage with communities that have experienced loss, loss of dignity, and hope. MGM and Hezekiah's music helps Christian Malaysians understand who they are in Christ and also as Malaysians. Additionally, through strong lyrical content, Christians are able to affirm and reinforce their identity in God as well as their national identity.

Music and the arts also help negotiate, construct, and express shifting and multiple identities. Especially important is the way musicians negotiate tradition and innovation in their music and value the continuity between the old and the new. They are able to choose the best elements from the local and nonlocal, the old and the new, fuse those sounds, and create a new, hybrid sound. This is the sound that the church in Southeast Asia needs to hear, one that affirms their local national identity and their Christian belonging. In pursuit of that, the church may have to expand its musical repertoire to include songs written in local languages and in local musical styles, write lyrics that are strong theologically and contextually, and be prepared to create and to innovate.

5

Art as Dialogue

Exploring Sonically Aware Spaces for Interreligious Encounters

Ruth Illman

I am convinced that [interreligious dialogue in words and music] will shape the future of humanity in an increasingly significant way. The encounter between religions can succeed only by being both curious and respectful at the same time."[1] In these words, the Jewish *hazzan* (or cantor) Daniel Kempin presents Interreligiöser Chor Frankfurt, which he leads together with his Christian (Evangelical Lutheran) colleague, Bettina Strübel. IRCF is an ambitious amateur choir working under the leadership of these two visionary cantors to promote interreligious dialogue in music. Since the start in 2012, they have sought to transform not just the lives of the singers in the choir but the surrounding society as well by showing how respectful interreligious dialogues can be built in music.[2]

The core of the choir's repertoire is the so-called Tehillim-Psalmen Project, which by now has resulted in a dozen concerts, one in the spring and one in the autumn each year. For each concert, the cantors choose a biblical psalm around which the entire concert program is built: approaching the text through compositions from various times and cultures representing

[1]Quoted at the website of the IRCF, http://ircf-frankfurt.de. All quotes from the website appearing in this chapter have been translated from German into English.

[2]Similar aims are promoted within the research project [un]Common Sounds at Fuller Theological Seminary, which seeks to explore "the contribution of music and the arts in fostering sustainable peacebuilding among Muslims and Christians." See www.songsforpeaceproject.org.

diverse voices from different Jewish and Christian perspectives. Islam is engaged through compositions by Muslim musicians, who create melodies for sacred Islamic texts and prayers that parallel the biblical psalm in focus. Each psalm concert is also accompanied by a panel discussion where scholars from different traditions ponder the theological themes and ethical perspectives brought to the fore in the concert.

Building on the theoretical framework developed in the books *Art and Belief: Artists Engaged in Interreligious Dialogue* and *Theology and the Arts: Engaging Faith*, this chapter presents the arts as dialogue in themselves and of their own right.[3] Focusing especially on music, the argument is put forward that the arts should not be regarded as mere illustrations of theological claims and cognitive contents, often assumed to be the "real" substance of dialogue. Instead, they can create nuanced dialogical spaces of their own. This approach, inspired by the ongoing aesthetic turn in religious studies, does not disqualify text-centered and rational dialogue efforts but rather suggests a more complex, nonbinary view of dialogue where intellectual and emotional, cognitive and embodied dimensions are integrated into a nuanced and comprehensive engagement across religions.[4]

To illustrate and develop these claims, the ground-breaking visions and works of Interreligiöser Chor Frankfurt is explored, focusing on how the choir uses music and singing to create open, embodied, and engaged spaces for Jewish-Christian-Muslim dialogue. The presentation builds on observation conducted at the tenth Tehillim-Psalmen Concert in Frankfurt in November 2017 as well as in-depth interviews with the choir leaders.[5] Furthermore, a rich variety of material from the Internet has been consulted along with program booklets and other written sources of information. The

[3]Ruth Illman, *Art and Belief: Artists Engaged in Interreligious Dialogue* (New York: Routledge, 2012); Ruth Illman and W. Alan Smith, *Theology and the Arts: Engaging Faith* (New York: Routledge, 2013).

[4]See, e.g., Rina Arya, ed., *Contemplations of the Spiritual in Art* (Berlin: Peter Lang, 2013); Arianna Borrelli and Alexandra Grieser, "Recent Research on the Aesthetics of Knowledge in Science and in Religion," *Approaching Religion* 7, no. 2 (2017): 4-21, https://doi.org/10.30664/ar.67710.

[5]The concert was held on November 21, 2017, in the concert hall of a previous Dominican monastery in central Frankfurt. The interview was conducted the day after at the local Lutheran study house Evangelische Akademie Frankfurt, where the trialogue discussion pertaining to the event was also held later that evening. The interview was recorded and later transcribed into a text document. During the interview, both German and English were spoken interchangeably. I have translated the German passages quoted in this chapter.

chapter begins with a presentation of the theoretical framework of the analysis. This is followed by a description of the choir and its background and a more detailed analysis of the particular concert experience constituting the ethnographic focal point of the study. As a conclusion, the theoretical perspective is reengaged, and key themes for more sonically aware research on interreligious understanding are suggested.

A NONBINARY APPROACH TO INTERRELIGIOUS DIALOGUE

The title of this chapter—"Art *as* Dialogue"—highlights a central claim advocated and advanced in this chapter. This claim is encapsulated in the small but significant preposition "as": that is, the suggestion that art in general, and music in particular, is dialogue in itself and of its own right. To fulfill this potential, interreligious dialogue needs to be defined through a nonbinary approach: a striving to formulate a conceptual framework within which intellectual content and artistic context, rational reasoning, and emotional expressiveness—words and melodies, to put it simply—are not regarded as binary opposites in the context of interreligious dialogue.[6] The arts should not be seen as mere illustrations of the theological claims and doctrinal definitions supporting dialogical endeavors—enriching but secondary aspects of dialogue—but as carriers and conveyers of meaning in themselves.[7] These claims may have seemed provocative to some scholars in the field in the past but are increasingly being accepted today. In accordance with this development, I seek to demonstrate what I mean over the following pages.

W. Alan Smith and I have argued for a theology of the arts that begins with the practices of faithful communities—in all the various forms they come—rather than abstract, one-dimensional theories about religion.[8] Our initial objective for engaging in the research on interreligious dialogue and the arts was our shared dissatisfaction with the long academic tradition of regarding the encounter with religious difference as an intellectual challenge to the mind only and the subsequent fixation with questions of how

[6]Aimee Upjohn Light, "Post-Pluralism Through the Lens of Post-Modernity," *Journal of Inter-Religious Dialogue* 1, no. 1 (2009): 71-74.

[7]Borrelli and Grieser, "Recent Research," 16.

[8]Illman and Smith, *Theology and the Arts*, 4-5.

religious otherness can be made intelligible and manageable. Such perspectives, we claim, result in a narrow preoccupation with the issue of truth and how to harmonize different claims to it.[9] Instead, we want to highlight that the challenge of meeting the religious other is not just an intellectual question of rationally fitting knowledge from different traditions together. It is also an ethical challenge of being able to find confidence in one's own choice of perspective, to be open to and respectful toward another perspective—relevant, legitimate, and sincere, even though it is not mine. Furthermore, it is a practical question of accepting the otherness of the other and living together in a pluralistic world.[10]

The aim of our exploration of communities around the world that have engaged in transformative practices through various art forms was not to disqualify intellectual questions and truth claims as aspects of interreligious dialogue—far from it. Rather, our vision was to broaden the scope and address the need for research focusing on other dimensions of dialogue than the rational. The arts, we claim, can illuminate dialogue as a nonbinary endeavor by offering a tangible space where conversations and reflections across religions can take form, allowing space for individuality as well as socially and culturally embedded dimensions, embodiment and emotions as well as rational reasoning.

Above all, the arts invite creativity; they have the ability to awaken the human capacity for imagination.[11] By reading a novel, watching a film, or attending to a work of art that "speaks from a place other than your own," your imaginative capacity can be engaged and curiosity toward the religious other awakened.[12] Therefore, the arts can provide significant starting points for transformative practices that enable a deepened understanding of otherness and other points of view as well as concrete interconnections with other human beings. By tapping into our imaginative resources, the arts can facilitate insights and experiences that stretch beyond the confinements of our immediate life-worlds, restrained by our practical situation, which is necessarily limited in time, space, and resources. Here, the arts may open a

[9]Illman and Smith, *Theology and the Arts*, 28-32.
[10]Illman, *Art and Belief*, 155-57.
[11]Borrelli and Grieser, "Recent Research," 7.
[12]Kwame Anthony Appiah, *Cosmopolitanism: Ethics in a World of Strangers* (New York: Norton, 2006), 85.

window to the wider religious landscape outside our own context and let us grasp other, valuable, legitimate, yet different viewpoints to the world.[13] Such a creative perspective neither eradicates nor solidifies difference but renders it accessible in significant ways. A work of art at best inspires us to stretch our imagination and reach beyond conventional, taken-for-granted apprehensions toward the previously unimagined, strengthening our wish to understand and engage in a multireligious reality.[14]

As mentioned above, the focus on art offers a complement to the established understanding of interreligious dialogue as an intellectual practice by acknowledging other dimensions of the religious consciousness, such as the visual, audible, and tactile. Such symbolically dense, aesthetic, and embodied contexts may provide new channels for understanding selves and others.[15] Art has the ability to touch us not only as rational beings but also as complex, experiencing subjects with feelings, attitudes, memories, and hopes for the future. The arts reveal that interreligious dialogue is a "major challenge to mind and heart," to borrow a formulation by Abraham Joshua Heschel.[16]

THE ROLE OF MUSIC IN INTERRELIGIOUS DIALOGUE

Focusing more specifically on the context of music, it is interesting to note that the use of music is often highlighted within contemporary theology of the arts as a particularly fruitful arena for interreligious engagement and dialogue between persons of different faiths. While creed and conduct may separate dialogue partners, music can offer a common-context language of spirituality and existential meaning that remains sensitive to differences and honors the integrity of each partaking individual.[17] This double character of music is crystallized in Frank Burch Brown's words: "Music is not just a sign of the differences between different groups; it is one of the ways

[13]Catherine Cornille, "Empathy and Interreligious Imagination," *Religion and the Arts* 12 (2008): 102-17.

[14]Illman and Smith, *Theology and the Arts*, 55-60.

[15]Kate Siejk, "Wonder: The Creative Condition for Interreligious Dialogue," *Religious Education* 90, no. 2 (1995): 227-40.

[16]Abraham Joshua Heschel, "No Religion Is an Island," in *Jewish Perspectives on Christianity*, ed. F. A. Rothschild (New York: Continuum, 1965), 309-24 (at 312).

[17]Amir Dastmalchian, "Music as a Means of Dialogue with/by Muslims," *Studies in Interreligious Dialogue* 26, no. 1 (2016): 92-110 (at 92).

of establishing those differences and of showing that they matter. Neither is music just a sign of the blessed ties that bind; it is one of the ways of making those ties binding to begin with."[18]

In dialogue settings, music seems particularly suited to engage people on several levels of being simultaneously, facilitating experiences that transform and expand their religious sensitivities. Alejandro García Rivera describes music and other art forms as "living theology," that is, dialogue situations that "live out that which 'textbook theology' attempts to understand."[19] On a similar note, Jeremy Begbie suggests that music has a special capability to engage persons on a spiritual level, enabling experiences that can be understood by the individual as holy and as a bridge between the human and the divine.[20] Indeed, dialogue in music "lacks the conceptual precision of verbal language," as Brown points out. Yet it is "both more refined and more powerful than mere words when it comes to giving voice to the inner and 'felt' meaning of thoughts, especially once those thoughts are uttered within the orbit of musical expression."[21]

To facilitate the kind of in-depth analysis of the relationship between music and interreligious dialogue outlined above, Rosalind Hackett's call for "more sonically aware religious studies" is significant.[22] She emphasizes that aesthetic factors, practices, and the senses at large are gaining ground in contemporary research on religion—stepping out of the shadows of texts and doctrines, which have traditionally attracted most of the scholarly interest. Today, we see a greater acknowledgment of the vast and varying field of sound "as it is variously perceived and conceptualised" in religious contexts, engaging body and mind, tradition and innovation, aesthetic preferences as well as cultural conventions.[23] Isabel Laack, for her part, notes that the "soundscapes of our world are strongly shaped by religious groups and

[18]Frank B. Brown, *Good Taste, Bad Taste, and Christian Taste* (New York: Oxford University Press, 2000), 163.

[19]Alejandro García Rivera, *A Wounded Innocence: Sketches for a Theology of Art* (Collegeville, MN: Liturgical Press, 2003), viii.

[20]Jeremy Begbie, *Resounding Truth: Christian Wisdom in the World of Music* (London: SPCK, 2007), 15-18.

[21]Brown, *Good Taste*, 183.

[22]Rosalind Hackett, "Sound, Music, and the Study of Religion," *Temenos: Nordic Journal of Comparative Religion* 48, no. 1 (2012): 11-27 (at 11).

[23]Hackett, "Sound, Music," 18.

behaviour, thereby influencing identity negotiations and political conflicts."[24]
Practices and experiences of music often lie at the heart of people's religious
identities, but due to the intellectual bias of our academic disciplines, such
aspects have received relatively modest attention also within the research on
interreligious dialogue.[25] To contextualize this theoretical outline, high-
lighting the dialogical character of the arts in general and music in par-
ticular, it is now time to turn to the ethnographic case study, which amply
supports the claims made above.

THE INTERRELIGIOUS CHOIR OF FRANKFURT

Interreligiöser Chor Frankfurt was founded in 2012 by the Christian (Evan-
gelical Lutheran) cantor Bettina Strübel and the Jewish *hazzan* Daniel
Kempin. Both of them had been engaged in interreligious work over a long
period of time in various institutional settings and contexts around Germany,
often combining their passion for and professional training in music with
an engagement for peace, equality, and dialogue. The initial aim was to
create a singular event; a group of dedicated and experienced choir singers
was gathered to perform a concert entitled "*Königin von Saba—ein trialo-
gische Portrait*" ("The Queen of Sabah—A Trialogical Portrait"), composi-
tions of Jewish, Christian, and Muslim origin that feature prominent female
figures in the three traditions. The concert was a success, and the choir
leaders were strengthened in their determination to establish a permanent
interreligious choir in Frankfurt built on the vision of "learning, tradition
and respect." On the IRCF website, Kempin states, "I founded and sing in
the IRCF because interreligious dialogue in words and music is a central
theme in my life," and adds that he is convinced that they "are doing a
valuable job."[26]

From the beginning, the choir was set up as an independent, religiously and
politically unaffiliated association without formal ties to any governing body.
Thus, the cantors stress, the choir does not represent any religious institution

[24]Isabel Laack, "Sound, Music and Religion: A Preliminary Cartography of a Transdisciplinary
Research Field," *Method and Theory in the Study of Religion* 27, no. 3 (2015): 220-46 (at 221).
[25]William Dyrness, foreword to *(un)Common Sounds: Songs of Peace and Reconciliation Among
Muslims and Christians*, ed. Roberta R. King and Sooi Ling Tan (Eugene, OR: Cascade, 2014),
xiii-xiv.
[26]IRCF website: http://ircf-frankfurt.de.

but is free to implement its vision without such restraints. As a consequence, the choir is dependent on external funding in the form of grants and scholarships, and each concert is carried out as a separate project, for which partners and funding are actively sought. Needless to say, this is both time consuming and precarious. Hence, in order to secure the continuity of the work, to relieve the choir leaders of some of the bureaucratic burden and free their time to focus on the artistic work, an aid society was founded in 2014 to handle grant applications, practical concert arrangements, advertising, and so on. The choir has come to engage a large group of "friends" in their interreligious activities, reaching out far beyond the ranks of the singers.

IRCF is a nonprofessional mixed choir, but the level of ambition of this amateur choir is high. As the choir works on a project basis, the singers sign up for each concert separately, and thus the size and composition of the choir varies from project to project. Usually, the number of singers is close to fifty. Many of the singers are engaged in music, education, or religious organizations also in their professional lives: pastors and educators, music school teachers and researchers, but also lawyers, medical doctors, students, and entrepreneurs are found in the ranks of IRCF. The lion's share of the singers come from an Evangelical Lutheran background, but numerous other Christian denominations as well as Orthodox and liberal Jews and Muslims from all over the world have found their way to the choir. The instrumentalists and soloists engaged for the concerts are, however, professional musicians. "We are not professional theologians and we don't represent any official institutions but this does not diminish our seriousness and professional engagement," Strübel asserts. Kempin agrees, adding, "Rather, it gives us the chance to be an independent and explorative voice in the interreligious conversation."[27]

Psalm 46 in Jewish, Christian, and Muslim Light

As mentioned above, the specific focus of this chapter is the tenth Tehillim-Psalmen concert in Frankfurt on November 21, 2017, dedicated to Psalm 46. The concert took place in an old convent in the old town of Frankfurt, and the approximately 250 persons in the audience filled the concert hall almost

[27]Interview, November 22, 2017.

to the last seat. A film team also followed the entire concert as part of a documentary project for the German national TV. Approximately fifty singers had joined the choir on this evening, accompanied by a small instrumental ensemble on strings, percussions, guitar, and clarinet, as well as four professional vocal soloists. The choir leaders had chosen Psalm 46 as the leitmotif of the concert not only due to its universal message of God as a safe haven and rescuer in times of need but also because it inspired Martin Luther to write his most well-known psalm, *Ein Feste Burg* ("A Mighty Fortress Is Our God"). The year 2017 marked the five-hundredth anniversary of the Reformation, which was widely acknowledged all over the Protestant world and contributed to the decision. The text reads as follows:

> God is our refuge and strength,
> an ever-present help in trouble.
> Therefore we will not fear, though the earth give way
> and the mountains fall into the heart of the sea,
> though its waters roar and foam
> and the mountains quake with their surging.
> There is a river whose streams make glad the city of God,
> the holy place where the Most High dwells.
> God is within her, she will not fall;
> God will help her at break of day.
> Nations are in uproar, kingdoms fall;
> he lifts his voice, the earth melts.
> The Lord Almighty is with us;
> the God of Jacob is our fortress.
> Come and see what the Lord has done,
> the desolations he has brought on the earth.
> He makes wars cease
> to the ends of the earth.
> He breaks the bow and shatters the spear;
> he burns the shields with fire.
> He says, "Be still, and know that I am God;
> I will be exalted among the nations,
> I will be exalted in the earth."
> The Lord Almighty is with us;
> the God of Jacob is our fortress. (Ps 46 NRSV)

The Jewish and Christian musical compositions to this passage of Scripture presented in the concert stretched from the 1500s until today. Psalm 46 was presented (1) through a composition by the prominent nineteenth-century composer of the Jewish Reform Movement, Louis Lewandowski (1821–1894); (2) as traditional (Ashkenazi) Torah recitation (*nusach*); and (3) in a newly composed piece by the Argentinian Jewish composer Daniel Galay (b. 1945) utilizing a Yiddish translation of the Hebrew Bible. From a Christian perspective, the psalm was performed, for example, as a Swedish folk melody and in compositions by a number of European Catholic, Anglican, and Protestant composers originating from the sixteenth century all the way to the twentieth century.[28] During the concert, Psalm 46 was performed in no less than seven languages: German, English, French, Swedish, Latin, Hebrew, and Yiddish.[29]

Over the years, IRCF has commissioned several newly written pieces for their projects—this has become somewhat of a trademark for the choir. Also, the current concert included two first performances: the Yiddish composition by Daniel Galay mentioned above and a new composition by the Syrian-born German composer Samir Mansour. While Psalm 46 is part of the Hebrew Bible and the Christian Old Testament, it does not appear in any of the Islamic scriptural sources. Therefore, Mansour based his work on parallel texts pertaining to the same theme from Islamic holy Scriptures: a prayer from the *Sunna* ("I seek refuge in the perfect words of God") and two Qur'anic Surahs (113 and 114, the two final Surahs of the Qur'an) elaborating on the theme of refuge and comfort in God in parallel with Psalm 46:

Surah 113: Al-Falaq/The Daybreak
Say, "I seek refuge in the Lord of daybreak
From the evil of that which He created
And from the evil of darkness when it settles
And from the evil of the blowers in knots
And from the evil of an envier when he envies."

[28]For example, Johann Pachelbel (1653–1706), Hugo Distler (1908–1942), and Benedetto Marcello (1686–1739).
[29]The entire program booklet is available at the IRCF website: https://ircf-frankfurt.de/wp-content/uploads/2017/12/Programm-Ps-46_Druckfassung.pdf.

Surah 114: An-Nas/The Mankind
Say, "I seek refuge in the Lord of mankind,
The Sovereign of mankind.
The God of mankind,
From the evil of the retreating whisperer—
Who whispers [evil] into the breasts of mankind—
From among the jinn and mankind."[30]

Presenting his composition to the concert audience, Mansour underlined that these particular texts, in his view, offered apt Islamic dialogue partners for Psalm 46 as they pertained to the same theme. Although settling for a traditional Arabic key, Mansour faced many challenges in creating a melody to these texts, as they were not originally composed as poems and thus lack the regular structure and rhythm of the psalms. Furthermore, even though Qur'anic texts are often recited in melodically beautiful and elaborate ways, composed religious music and singing are not part of the Islamic tradition, neither in the form of cantorial nor communal singing.[31] Therefore, this composition was a rare undertaking—even contested in some circles. This progressive stance was powerfully underlined by the fact that a young woman, Dilruba Kam, recited the texts during the concert. For many of us in the audience, this was an extraordinary experience; the very first time we heard the words of the Qur'an uttered so beautifully and poignantly by a female voice!

As mentioned above, however, the three traditions were not merely presented side by side in the concert but also entered into dialogue and intermingled at times in innovative, often somewhat humoristic ways. As the choir performed the newly composed piece by Mansour, for example, the clarinetist—dressed not in a *kippah* but nevertheless in a stylish hipster cap—improvised a few distinctly klezmer-like melody lines to accompany the Islamic sacred texts. The Anglican choral setting of Psalm 46, for its part, ended up as Jewish *niggun*, a wordless melody repeated simply to the syllables of *lay-lay* as a way to continue the prayer.[32]

[30]Translation retrieved from https://quran.com.
[31]Dastmalchian, "Music as a Means," 92–95.
[32]In a previous publication, I have offered the following definition of niggunim: "Niggunim are (mostly) wordless prayer tunes associated with the performance of repetitive melodies accompanying plain syllables or mantra-like text fragments from the Torah or the Jewish prayer books.

ACADEMIC RESPONSES—THE TRIALOGUE DISCUSSIONS

Each concert of the Tehillim-Psalmen Project is also accompanied by a panel discussion, where theologians from the three traditions meet to discuss the themes raised by the psalm in question—similarities as well as differences. To these panel discussions, many prominent scholars from the three traditions—liberal as well as conservative, representatives of the religious majority as well as minority positions—have been invited. These academic conversations serve to illustrate how a nonbinary approach to dialogue can be realized in a practical, art-oriented setting, bridging the gap between intellectual and emotional or experiential dimensions of the interreligious encounter.

The choir has tried out several formats for these scholarly discussions: sometimes they have been arranged in direct connection to the concerts, but for the concert in November 2017, a panel called Trialogisches Tehillim-Psalmen-Gespräch ("A Trialogical Tehillim-Psalm Conversation") was arranged for the following day in a different location so as not to make the concert evening too lengthy. This panel discussion drew significantly fewer interlocutors than the concert the previous evening; perhaps forty persons were present. Three German scholars—Protestant professor of Old Testament Rainer Kessler, Jewish Bible scholar Elke Morlok, and Muslim scholar of Islamic philosophy Hureyre Kam—formed the panel under the moderation of choir member Doctor Eberhard Pausch. They engaged in discussing various topics related to Psalm 46, most prominently the images of God described in the psalm and their roots in, connection to, and significance for the respective traditions. Interestingly enough, a majority of the choir members themselves were present and active in the discussion. This clearly showed how deeply the close engagement with the psalm text within the creative interreligious context of the choir community had influenced the singers.

The panel discussion after the event was not the only occasion when theological and ethical reflection was given to the musical work of the choir,

Most characteristic are the Hasidic, wordless tunes performed to syllables such as lay-lay-lay or ya-ba-bam, but niggunim have become popular in all kinds of Jewish settings today." Ruth Illman, "Singing in Hebrew or Reading in English? An Ethnographic Analysis of Music and Change Among Progressive Jews in the UK," *Contemporary Jewry* 38, no. 3 (2018): 365-86, https://doi.org/10.1007/s12397-018-9252-y.

however. During the concert itself, various members of the choir gave short introductions and responses to the pieces to be sung and the theological ideas underlying the build-up of the repertoire. These short interludes were significant in many ways. The reflections of the singers brought substantial depth to the concert and showed how deeply engraved the dialogical ideals of the choir are. Together with the substantial program booklet, they provided a rich insight into the intellectual—rational and ethical, historical and mythical—depths of the creative choir endeavor. For those who were present only at the concert, the short intermediate speeches by the choir members stepping out of the choir line to tell a story was a great advantage. For the audience, this gave accessible insight into the more thorough dialogue process the choir members had been part of all the way through the rehearsal period.

Taken together, the concert program as well as the performance during the concert and the trialogue discussion aptly illustrate the vision of art as dialogue outlined in the first section of this chapter. Before the theoretical framework is reengaged, however, the reflections of the choir leaders and members will be presented more closely to offer a deeper insight into the motivations and convictions guiding the work of the IRCF.

ART AND DIALOGUE AS TRANSFORMATIVE PRACTICE

Many interesting aspects of the relationship between art and interreligious dialogue emerge from the interview narratives collected for this analysis and from the reflections offered by members of the choir in various forums. Musical dialogue as a transformative practice, as suggested in the theoretical outline, is one of the prominent themes in these conversations. Other central themes arising from the ethnographic material concern the musical practice of sharing while not mixing religiously significant tunes, the importance of taking a stand for values one believes in and the intersectional engagement of the choir, combining an openness to religious difference with engagements in regard to peace, gender, justice, and the environment.

In many respects, IRCF is an extraordinary choir that requires a value-based commitment and conviction stretching far beyond the regular choir experience. The rehearsal periods in preparation for each concert become space for open and deep-reaching dialogues in themselves. During the rehearsal periods,

the choir not only focuses on the melodies and compositions to be presented at the concert but also engages in study circles where the texts are read, discussed, and reflected upon. In addition to the texts to be performed during the concerts, primary texts from the holy Scriptures of the three traditions and related scholarly works are also consulted, explaining the background, themes, and debates related to the psalm in question. Bibliodrama is also used as a working method during the rehearsal period.[33] The singers enact the texts, not only reading and analyzing them intellectually but also embodying them and trying them out in a social setting.

Hence, the dialogical approach of the choir is far-reaching and illustrates the nonbinary approach suggested in this chapter, combining intellectual reflection with emotional and embodied experiences into a comprehensive understanding. The choir builds on the idea that music can bring special incitements and dimensions to interreligious dialogue that complement other forms of dialogue in a fruitful way, Kempin underlines. Sometimes, he concedes, they are criticized for not being serious because they are not theologians. In their view, however, the musical engagement with other traditions can be far more multidimensional and deep-reaching than scholarly scrutiny. Kempin concludes, "Sometimes, singing together will give you a much deeper knowledge. If you also sing it's not just intellectual; you're doing it yourself, you taste [the other tradition]; you take it into your mouth. It is both physical and emotional, and it gets very personal."[34]

Dialogue is needed on several levels in society, Kempin believes, and music constitutes only one of them. The advantage of musical dialogues is, in his view, the richness they create, especially for the singers, who immerse themselves in a thoroughgoing and durable dialogue process as they prepare for each concert. In music, differences can be approached and discussed without leading to conflict. He stresses that in music, difference symbolizes richness rather than conflict, estrangement, or competition. "In music, you can actually take delight in difference," cantor Strübel adds. This approach to difference is greatly needed in many other spheres of society, she concludes.

[33]Bibliodrama, or bibliologue, is a form of role playing or improvisational theater based on biblical motifs and stories. The term originates from the context of action methodologies, where it refers to using a given text as a platform for investigation. See www.bibliodrama.com/what-is-bibliodrama.
[34]Interview, November 22, 2017.

The very tangible engagement and commitment to interreligious dialogue described by the choir leaders seems to be a core value and motivation also for the members of the choir, in addition to the strictly musical and artistic aspects of the work. As the choir member Frances notes, both religious conviction, social engagement, and personal preferences come together in her dedication to the choir. It offers a theologically deep and meaningful engagement and is also a fun and fulfilling social pastime activity:

> I sing in the IRCF because it is important to me to promote interreligious dialogue and to give it more concrete space both in my personal and in my social life. I appreciate the very lively and intense choral work with Hebrew and German psalms from a wide array of musical epochs. . . . Particularly, I like the friendly atmosphere among the choir members with their respective backgrounds, be it Jewish, Christian or Muslim. For me, the IRCF shows what an important opportunity for diversity collective artistic work can be.

SHARING BUT NOT MIXING

As noted above, the singers of IRCF come from different traditions and bring different experiences, beliefs, and engagements with them to the mutual musical work. Under the guidance of the two cantors, they develop a concert program that bears traces of this working process: it is not a monolithic and fixed concert repertoire but rather a forward-moving and profound musical dialogue where the different religious, temporal, and musical elements are related and speak meaningfully to one another while still not merging into a single blend. In this process, the cantors stress, choir improvisation and different musical collage technics play a prominent role.[35]

Sharing but not mixing is thus a guiding principle for the choir as they go about creating collage medleys for their concerts. According to the cantors, the vision is to bring together, quite concretely, melodies from different times and cultures in a unified performance to show the similarities and common concerns that unite people over the divides of time and place. However, as different musical settings of a certain psalm are sung as a medley during a concert, interspersed with instrumental sections elaborating on the theme

[35]"Musical collage" is a notion used by the cantors to describe a characteristic musical structure developed within the choir where melodies from different times and cultures are interwoven as a form of medley so that themes from one melody overlap and merge into the following one.

in relation to various Jewish, Christian, and Islamic musical traditions, it is important to maintain the distinguishing features of each melody. The collage technique results in a musical form that resembles a string of beaded pearls rather than an interreligious potpourri or intercultural concoction.

In this way, common ground is created while neither the musical nor the religious integrity of the different musical pieces—and singers, for that matter—is disturbed. The many creative efforts to give musical expression to the psalms and other holy texts handed down over generations offer a tool for creative collaboration, choir member Gisa points out. For him, the musical dialogue between melodies and expressions from different times and cultures points to universal values and convictions that sustain him in his everyday life. The collage technique seems particularly appreciated by the singers: "I especially like the Psalm collage, it is very creative," Annegret contends.[36]

In line with these characterizations, cantor Strübel points out that the work of the choir is "serious but not a service." By this, she strives to highlight that the concerts may have a liturgical form at times and that the melodies carry religious significance, but the concert events are not to be taken as joint interreligious services. That is why it is possible to bring melodies together in the collage fashion described above; it offers a form that allows for proximity while not fusing the traditions. "How can we weave together our lives without losing ourselves?" she asks to make her point clear.[37]

INTERSECTIONAL COMMITMENTS TO PEACE AND JUSTICE

It is obvious that the aspect of peacebuilding through creative interreligious work is quintessential for many of the singers in the choir. For example, Margaret poignantly states, "I sing in the interreligious choir because the dialogue between religions is an important contribution to peace." Similarly, Ursula claims that the peaceful and creative coexistence of religions, as it takes form in the work of the IRCF, is not just a crucial commitment in conflict-ridden and violent times as ours; it is also "lots of fun!"[38]

Bettina Strübel and Daniel Kempin are constantly negotiating how they ought to relate to the wider world in their musical work: should the concerts

[36]IRCF website: http://ircf-frankfurt.de.
[37]Interview, November 22, 2017.
[38]IRCF website: http://ircf-frankfurt.de.

be a safe haven, free from political discussions and social engagement, or is it necessary to take a stand against atrocities and injustice also as artists? This balancing act has proven difficult at many times: on the one hand, the choir wants to be politically uncommitted, but on the other hand, they cannot turn their backs to the evils of the world and pretend not to see the oppression and violence carried out in the names of various religions all around them. At this point, Kempin is more radical: "Our visions are worth nothing if we cannot address the difficult questions as part of our musical work." He states emphatically that "the musical dialogue is worthless if it becomes too naïve, too rosy." His dream is that one year, the choir could choose to work with a psalm dealing with the temple of Jerusalem, addressing the devastating conflict in the Middle East from Jewish, Christian, and Muslim perspectives. So far, the time has not been ripe.

Strübel is more careful in her approach and holds that even if the choir cannot solve the most difficult and sore issues in current interreligious relations, they can at least try to create a space where believers of other faith traditions can be recognized in their full humanity: "Perhaps, we can resonate together in the music that we create? We can create musical expressions that engage people, that opens their eyes to the suffering of the religious other, creating confidence and respect."[39] Thus, the example of IRCF shows that dialogue work conducted within the arts can also become a building block for durable political and social changes toward a more just world.

The two choir leaders often return to the set of interdependent values they wish to promote in their work: respect, understanding, and peace but also equality between cultures, generations, and genders. "My vision is to encourage these values through the work I do," Strübel says. "We are all human beings, connected by a human desire to find meaning in life, to see that there is a deeper meaning with our existence. We're united by a shared hope."[40]

The choir leaders also stress the role of music as a bridge between religious and secular worldviews today. Many secular people today have no contact with people who are actively religious in any tradition and no apprehension of what it might mean for a person to hold a religious faith. For such persons, religious lifestyles, values, and beliefs feel utterly strange and

[39]Interview, November 22, 2017.
[40]Interview, November 22, 2017.

incomprehensible, and it is hard to find common ground on which to build mutual relationships and deeper understanding. In this situation, music can offer an approachable gateway into the religious mindset. The cantors stress that taking part in a concert where religious music is performed might feel like an easier way to approach the religious other than taking part in a religious service. Due to its multivocal engagement of mind, emotions, and body, religious music may help a secular person to see glimpses of the world as it appears for a believer. Strübel concludes, "This potential of music remains largely untapped in today's world."[41]

CONCLUSION

In sum, both the theoretical framework and the ethnographic narrative support the argument developed in this chapter, stating that the arts in general and music in particular are more than mere tools for dialogue. In light of the work of the IRCF, it is clear that this is too simple a perception of the multifaceted role of art and music in interreligious encounters. The arts are not just "illustrations" of the more substantial theological points underpinning dialogue endeavors. Instead, the arts can be approached as constitutive dimensions of the interreligious encounter in themselves. This chapter has shown that the tangible and embodied character of music as a form of dialogue engages several senses: tasting the words of another tradition as you sing, touching otherness as you create music with your hands, or hearing the other as you are enveloped by the sacred sounds of a tradition other than your own. This is nonbinary dialogue in practice.

Finally, one may wonder, is it really possible to change the world with choir music? What can an interreligious choir accomplish in a world of very concrete unfairness, where religious difference seems to lead to war, misery, hatred, and abuse rather than inspiring mutual dialogues guided by respect, sincerity, and curiosity toward diversity as an enriching feature of our shared world? Is the vision guiding the work of the IRCF a mere utopia, a rosy dream in a harsh world driven by the urge to dominate and profit, by political agendas as well as ecological, economic, and cultural exploitation? Daniel Kempin answers with an emphatic "No!":

[41]Interview, November 22, 2017.

Our work builds community on a very practical level. First of all, of course, the members of the choir are transformed by the experience of participating in the concerts. They will bear traces of this experience in their souls forever, and this will affect their actions and attitudes in all spheres of their lives. Second, awareness of music as a way to create increased interreligious understanding spreads like rings on the water because of our work. Not just the fifty singers, or the 400 persons in the audience, are affected by the dialogue; by now at least 10,000 persons have heard about our work and know that it is possible. I think we really can contribute to changing the world.[42]

Recalling my own experience of taking part in the concert in Frankfurt in November 2017, I am prone to side with *hazzan* Kempin on this point. It is not an exaggeration to say that the audience was ravished: encores were delivered after standing ovations, and especially the newly composed pieces of music seemed to speak powerfully to the listeners. Even if some of the more modern pieces proved demanding for the amateur ensemble to perform, this did not diminish the delight that the interlocutors found in the concert. To me, it seemed as if the "sonically aware space for interreligious dialogue" called for in this chapter materialized before our eyes—and ears. As Roberta R. King and Sooi Ling Tan note, "Intimate, expressive links between music, art, and world religions provide rich resources for understanding the belief systems of peoples and their influence on society and daily living."[43] Therefore, the key conclusion of this chapter suggests not only that interreligious theology should be concerned with dialogue in and through music and other art forms, but it should also acknowledge art as dialogue.

[42]Interview, November 22, 2017.

[43]Roberta R. King and Sooi Ling Tan, prologue to *(un)Common Sounds: Songs of Peace and Reconciliation Among Muslims and Christians*, ed. Roberta R. King and Sooi Ling Tan (Eugene, OR: Cascade, 2014), 1-16 (at 13).

6

..

"Simba Nguruma"

The Labor of Christian Song
in Polycultural, Multifaith Kenya

Jean Ngoya Kidula

Song speaks. It speaks of and in itself. It speaks of and about the people who produce and consume it. It speaks of the times and places of its inception and travel. Often its footprints are visible and audible, and they indelibly and subtly inform other spaces, being appropriated and interpreted in ways unintended or unheard of by the originators. Song is more than the text; the soundings by instruments, including the voicing and intonation, often become indices of particular cultures, religions, histories, age groups, and even genders. In an increasingly connected world, contemporary quests for identity and frames of belonging have led to an unprecedented mélange of soundings. In this chapter, I engage in a close reading of a song in an effort to describe the webs of resources that intentionally and unconsciously inform the production of a performance that may appear to be primarily framed as Christian religious song. I ultimately seek to demonstrate the labor of song in contemporary Christian practice in Africa with a case study from Kenya.

In 2016, Reuben Kigame, a renowned and decorated Kenyan Christian musician, producer, and apologist, released the album *Usifadhaike*.[1]

[1]Recordings of Kigame's work can be found at www.kigamemedia.org. For sample videos, see Kigame Media TV. He has been interviewed on radio and TV, and some interviews are posted on the internet. He has also been written about and recently published *Christian Apologetics Through African Eyes* (Nairobi: Posterity, 2018). All song translations in this chapter are by the author, Jean Ngoya Kidula.

Usifadhaike had new songs and reissues of previous releases of Kigame's and other artists' materials. The album also contained two songs sourced from Kigame's earliest incursions into the gospel music ministry and industry while affiliated with Word of Life Ministry, housed in Nairobi and Mombasa, Kenya's biggest and busiest cities.[2] The Kiswahili songs *"Kile Unachopanda"* and *"Simba Nguruma"* became very popular in Christian gatherings sponsored by organizations such as Youth for Christ that targeted high school and college students. They were also staples in young adult church meetings and in Christian youth conventions in the 1980s before the gospel music industry jelled, and before compositions by African Christian musicians and in African languages were acknowledged or copyrighted for posterity or economic return.

Kigame, a well-reputed national and international composer and performer, is a venerated worship song leader. His work addresses musics, issues, and anxieties of the time in appropriate musical styles and Scriptures across generational, denominational, and social barriers. His compositions present the gospel, but he also adjudicates discussions on contentious or unstable opinions. Additionally, he rearranges known songs that speak to a prevailing situation, event, or debate in a style that captures the public across the board. For example, "worship wars" in Kenya engage genres traditionally marginalized in Christian communities, such as indigenous African musics previously demonized by mainstream churches before, during, and after colonization. Kigame legitimizes musics from indigenous resources and "spirit" churches by repackaging them using modern instruments or by simulating indigenous musical aesthetics in the studio. Thus, he re-sounds their return and disseminates them through contemporary media.[3] He may also rework Western hymns that are part of the collective Christian lore in the country. Beside hymns, Kigame translates popular and contemporary worship songs into Kiswahili.

Some of Kigame's recordings, however, are an intentional apologist's response to the use of styles associated with secular music in Christian

[2]For discussion of this relationship, see Jean Kidula, "'There Is Power': Contemporizing Old Music Traditions for New Gospel Audiences in Kenya," *Yearbook for Traditional Music* 42 (2010): 62-80.
[3]This kind of brokerage is not unique to Kigame. He, however, was a pioneer of the gospel music industry in Kenya in the late 1980s. He continues to reinvent himself as a composer, performer (vocals, instruments), producer, marketer, and media personality.

assemblies. His musical response to reggae's suitability in Christian worship was to produce an album in the style.[4] The dissenters decried the style's association with youth revolt, drug addiction, unkempt hair, and so on, which messaged irresponsibility, loitering, thuggery, and other vices. Kigame not only offered responses in blogs, interviews, and seminars, but writing songs furthered his argument to a larger audience. Kigame also sought to allay fears about using styles and instruments related to other religious beliefs as these were coded and subtle indices of a syncretistic Christianity that had no place in the conservative climate of fundamentalist, Pentecostal, or charismatic Christianity characteristic of Africa in the 1990s. It is this nexus of religious anxiety that I would like to explore by considering Kigame's production and performance of "Simba Nguruma."[5] The piece, in my opinion, represents a dimension of past and ongoing discussions that enact, affirm, critique, and problematize (re)turning, (re)tuning, (re)sounding, and (re)assembling disparate resources to service and postulate Christian belief, theology, and doctrine as well as the accompanying lived experiences, core expectations, and future hopes of Africans through popular religious musical expressions that began in the mid-twentieth century and continue to this day.[6]

PREPARING FOR THE ROAR OF THE LION

"Simba Nguruma" ("Roaring lion," or the imperative, "Lion, roar!") is set in a continentally pervasive popular style, soukous. Soukous is generically understood as an African rumba form that was codified in the Congos in the 1950s. It assumed derivatives and birthed subgenres in the Congos over time. However, it was equally reinvented by the Congolese exile and diaspora in other African countries, in Belgium, and in France from the 1960s, when Congo had its first political turmoil. More subgenres were birthed from

[4]Reuben Kigame and Douglas Jiveti, *God's Reggae* (Kigame Music Productions, 2005).
[5]Reuben Kigame, *"Simba Nguruma," Usifadhaike* (Kigame Music Productions, 2015). Song by Edward Kamonde Lubembe (lead vocals, composer), and Challenge band members: Benjamin Onyango (lead guitarist), Kamau Wanyoike (bass), "Kariz" (drums), Peter Muli (rhythm guitar), Elizabeth Dryango (vocals), Mercy Nakhisa Lubembe (vocals), and Elizabeth Wanyoike Muli (vocals).
[6]While my case study is Kenya, similar trends occur in South Africa, Zimbabwe, Tanzania, Ghana, Nigeria, and the Congo, where there is a thriving religious music industry for both Christianized and Islamized populations.

Congolese musicians' dialogues with music styles and musicians from host countries, or they were initiated during projects where Congolese were studio musicians.

Congolese rumba itself was a remake of Cuban son and rumba—genres that had African foundations or overtones. It was therefore a return (to the mother continent) that was re-turned (in language, structure and form), then retuned/reimagined (contextualized in story and style) and resounded (made audible in clubs, in recordings, and on radio).[7] The mostly Cuban base was thus re-created in Congolese urban and industrial environments, themselves places of exile and displacement. Congolese cities or mining towns where these genres emerged housed multiple African groups and also interacted with European colonizers and adventure seekers. Traditional beliefs and values were forced to cohabit and dialogue. For example, the Katanga province of the Democratic Republic of Congo had a rich mining region whose lingua franca was Kiswahili rather than Lingala, Congo's premier trade language. The presence of Kiswahili was a strong indicator that Islam was among the various religions practiced among the miners. German-Dutch anthropologist Johannes Fabian, writing about the Congo, wondered if there was a shared discourse between popular culture and religious movement when he observed the impact of charismatic Christianity and Pentecostalism in identity formation in the mining region where he carried out his research in the 1960s and 1970s.[8] Though the gospel music industry solidified in the early 1990s, there was already speculation regarding the work of popular arts, of which Soukous was a definitive genre.

The most enduring frame of Congolese Soukous was a two-part structure equivalent to a Cuban son/rumba-montuno structure. The son/rumba part was usually slower in tempo, and a story was narrated by a soloist or in duet.

[7]For a succinct study of the historical development of the genre in the Congolese context, see Kazadi Wa Mukuna, "The Evolution of Urban Music in Democratic Republic of Congo During the 2nd and 3rd Decades (1975–1995) of the Second Republic—Zaïre," *African Music* 7, no. 4 (1999): 73-87; Wa Mukuna, "The Genesis of Urban Music in Zaïre," *African Music* 7, no. 2 (1992): 72-84; Gary Stewart, *Rumba on the River: A History of the Popular Music of the Two Congos* (London: Verso, 2000). When these styles were incorporated in church services, sometimes a "praise and worship section" included a "praise break," renamed "seben" in Congolese congregations. Here the leaders cued the congregation to "praise" dance, displaying the latest dance moves as appropriate in their assembly.

[8]Johannes Fabian, "Popular Culture in Africa: Findings and Conjectures," *Africa* 48, no. 4 (1978): 315-34.

The montuno was in call-response. Here, the main message was reinforced using a signature riff or phrase and reiterated by a responding chorus against an extemporizing soloist. The Cuban two-part form in Congolese return was translated as "rumba-*seben*" in mid-twentieth-century cities, where it jelled (Kinshasa and Brazzaville), or in the mining regions, where mostly male workers congregated. This music/dance was their primary leisure activity. The *seben* was announced by a definite cadential break from the rumba section. While dancers swayed to the beat in the rumba section, with couples holding onto each other, they invariably broke apart at the *seben* and displayed their best contemporary dance moves.[9] The singing ceased during a subsection of the *seben* so that stage singers could dance or demonstrate to the revelers how to respond bodily. They even competed with the audience or provoked them to display their bodily internalization of the music. These dancers and instrumentalists behaved as if they were possessed by the spirit of the music. When Congolese exiles ruled the club scene and airwaves in Kenya from the late 1960s to the early 1980s, Kenyans referred to this section of the *seben* as "the climax." To mark its end, the lead singer re-called the message, and the choral response often included revelers who brought themselves from the dance "high" through singing. Of course, if the music was too "sweet," a subsequent "climax" was effected—similar to Pentecostal spontaneous singing, "shouts," or "praise breaks" in African American gatherings.

DECODING "*SIMBA NGURUMA'S*" MULTI-MUSICS, MULTI-CULTURES, AND MULTI-RELIGIONS

"*Simba Nguruma*" was composed in the 1980s by Kamonde wa Lubembe, who had become a Christian through Word of Life ministry in 1976. In its soukous style setting, instruments index the genre—hand drums and drum set, guitar combo or solo, mi-solo (second guitar that dialogues with the solo or provokes through its riffs), rhythm guitar, bass, brass instruments, other percussion, and synthesizers. The song is structured in two sections, patterned in the form of rumba-*seben*. In a shout-out to stereotypical Africa,

[9]Some movements were sourced from indigenous leisure dances or were part of rites of belonging where several moral licenses were suspended or were part of a larger indigenous religious assembly that featured dancing and/or masquerades.

hand drums (possibly congas) open the piece—amplified with shakers—to provide the "dirty" or noisy percussive aesthetic typically associated with African music.

Kigame does not set this first part in rumba form. Instead he invokes a *taarab-chakacha* style signaled through the opening drum/percussion riff.[10] Taarab is itself associated with the African and west Asian, Indian Ocean coastline and islands, but it extends inland through the Red Sea to Egypt, Morocco, and Tunisia as a particular and dominant Arabic cultural aesthetic. It is therefore linked to Islam or Islamized populations. Chakacha is dance music that also has its roots among coastal Kenyan ethnic groups, particularly the Mijikenda. It was prominently performed at weddings and related rites in indigenous and Islamized ritual spaces.

Kigame begins the song as if he is dancing, a sound that portrays a satisfied grunt. An English translation of his opening Kiswahili spoken word is: "The praises of the Lion of Judah should begin from the coastlands and extend into all the earth." The opening lyric/chant, *"Simba nguruma aaa"* by the chorus can be translated in various ways: recognizing a titled person as the Roaring Lion, the lion that roars, or an imperative command—"Roar, lion!" It is repeated four times, ending each time with *"aaa,"* a sung imitation of a roar, an expression of joy or relief that the lion is roaring, or an acknowledgment that a lion is roaring. During the opening drum phrase, the bass, synthesizer, and Kigame utter a sliding sound to index the roar of a lion. After this, Kigame pronounces the story. The lyrics proceed in this way:

Choral chant:
Simba nguruma aaa (x 4)
Roaring Lion, Roar Lion! The lion roars "aah"
Kigame story:
Simba wa Yudah namsikia akinguruma kule kuzimu e
I hear the lion of Judah roaring in the underworld/hell
Tembeo lake kule latetemesha (x 2)
His stride over there invokes fear/panic/fright/distress/alarm

[10]In an email interview in 2018, Kigame stated that this first section was composed by Kamonde wa Lubembe, a friend with connections to coastal Kenya, although he is not ethnically originally from there, who worked with Life ministry (a different Christian organization). Lubembe first record the song in 1986 with the group Challenge. Kigame reworked the song for his project.

Choral comment:

Shetani oh kule atetemeka, Mapepo o kule yanatoroka

Satan is in a panic over there, Demons over there flee.

Kigame continues:

Amewapiga pigo la milele

He has given them a thorough beating (one that will last forever)

Choral affirmation:

Simba nguruma aaa

Kigame exclamation (spoken during brass interlude):

Watoto wa pwani muko?

Children of the coastline, are you in the house?[11]

These lyrics gesture to coastal people's beliefs in spirits. Stories of genies ("*Majini*" also means "of or in the water") are rife in their folklore, whether in intersection with west and south Asians over time, or as part of indigenous myths. Kigame brings this awareness to the table. His opening lyric situates the Lion of Judah as invading the depths of hell/the underworld, with his roar. The sound is such that Satan and the demons tremble with fear. He further states this Lion has trounced Satan and the demons with an eternal damnation (he has given them a lashing that they will never recover from). The title text frames this section as a response or statement of the "congregation" or audience that surrounds Kigame's rhetoric. Kigame's solo iteration is developed in typical modern *taarab* form; his opening phrase sets the stage, while the choral response between solo parts describes the impact of the roar on the devil and demons. Notwithstanding their fright, the Lion of Judah executes judgment. The singer tells the story as an observer of what he has seen or heard. This is typical in sung *chakacha*, *taarab*, and rumba.

To further index the coastal/Islamic ethos, Kigame recounts this statement by employing Indic and Arabic voicing and tone color, including melismas and other embellishments. He also incorporates instrumentation borrowed from Hindu practice—the harmonium, which he effects as an accordion sound punctuating his statements, together with bowed strings (originally *rebab*, but later violins) and drums (*darabuka*, but congas or a drum set are substituted) to simulate a *takht* (an Egyptian-Arabic ensemble)—in a response typical of instruments used in storytelling, ballads,

[11]Kigame, "Simba Nguruma." Lyrics used by permission from Kamonde wa Lubembe.

or epics. This instrumental response can also be read as an extension of the embellishment ideal, an Indic idea of "flowering" the rhetoric. Other Indic markers include occasional slides on the drum that reference this technique on a tabla but also index a lion's roar. To underline the coastal ethos, Kigame in ad-lib calls out, *"Watoto wa pwani, mko?"* ("Coastal people [children of the oceanfront], are you in the house?"). Beyond these coastal signifiers, the opening and punctuating brass riff echoes the use of such instruments in Congolese *soukous*, sourced from European military and Christian religious or educational parades. Curiously, they sound like a mariachi quotation, since mariachi styles are part of the layer of resources that inform contemporary African musicking.

In response to and agreement with the soloist, the choir sings in harmony in parallel thirds and sixths, typical in rumba but adopted in *taarab* during the convergence of rumba as a popular traveling music that serviced the tourist industry in coastal Kenya and was performed by musicians who also played *taarab*.[12] The chorus not only provides the contrasting impact of the roar on the inhabitants of the underworld but also grounds the presence of the "Lion of Judah" by repeating the title phrase several times as a statement, a response and a cadential point. This grounding is uttered in unison in contrast to the sung section that describes Satan and the demons. The underlying *chakacha* basis for this *taarab*-like "rumba" has its roots in wedding rites of the Mijikenda with a dance that emphasizes the hips. Although it has an underlying compound triple meter, it is built on a 3-2 clave characteristic of Cuban rumba. However, the piece is squarely in a major key, a marker of contemporary Christianity, modern Western culture, and generic popular music.

The *seben* section after the cadential break ushers in an exuberant celebration with vocals designed to demonstrate the source of the authority of the roaring lion. It is established not by the typical solo guitar or brass but with a string sound, taking the edge off the expectation to respond with the suggestive dancing associated with secular clubbing. The soloist begins by

[12]For discussion on Taarab in Mombasa, see, for example, Douglas Henry Daniels, "Taarab Clubs and Swahili Music Culture," *Social Identities* 2, no. 3 (1996): 413-38; Andrew J. Eisenberg, "The Swahili Art of Indian Taarab: A Poetics of Vocality and Ethnicity on the Kenyan Coast," *Comparative Studies of South Asia, Africa and the Middle East* 37, no. 2 (2017): 336-54; Mwenda Ntarangwi, *Gender, Performance and Identity: Understanding Swahili Cultural Identity Through Songs* (Trenton, NJ: Africa World, 2003).

stating, "We acknowledge the lion of Judah," to which the crowd responds, "He is alive." When he states, "Death cannot defeat him"—it has nothing on him—the crowd responds, "He is resurrected." Kigame declares, "He reigns," and the crowd agrees. Kigame says, "He will come back to take us with him." The crowd picks up on the fact that he will come back. Kigame then begins again by declaring he is talking about the Lion of Judah, and the chorus informs the listeners that "He is alive." The dialogue continues with Kigame expounding on the jurisdiction of the Lion of Judah and how ecstatic we are that he will come back to take us with him. Extemporizing on the text and in dialogue with the speaking solo guitar, the commentary by the mi-solo, the bass riffs, and the drum/percussion groove provoke bodily response. There is an unspoken understanding that the authority of the underworld over mankind is undone through the work of the Lion of Judah. Those in the world—living in the in-between space—thereafter are ushered into the kingdom of the Lion of Judah, with hope of everlasting life because of the work and reign of the Lion of Judah. This is the message of the gospel, well demonstrated using imagery of spiritual warfare that is biblical and contextually appropriate to Kenyan coastal beliefs.

In terms of musical style, Kigame assumes the Congolese *seben* to the letter. It is also based on a 3-2 clave of a different ethos and speed than that of the *chakacha-taarab* section. The sung sections are a call and response, with the solo calling, ad-libbing, and encouraging the response and commenting. The choir responds in characteristic *seben* triadic harmony. The instruments are also treated as in popular secular *seben*, with an extemporizing lead guitar, mi-solo (guitar) riffs, rhythm guitar harmony, and a bass that behaves as a drum with occasionally melodic riffs that resolve on a repeated tonic note.[13] Usually bass resolution grounds the declaration, like a final cadence insisting that the action is accomplished. Between the sung parts, there is an extended instrumental break—the climax. In such sections, body movements utter what words cannot tell on a foundation laid by instruments. The lead guitar extemporizes, conversing with the dancers in sound rather than words, and also expressing "praise" in each one's own utterances. Dancing in the climax is standard at concerts and also during church services where this style is utilized.

[13] Apart from Kenyans, Kigame's Congolese studio musicians further authenticate the arrangements.

In an interview, Kigame stated that he wanted the contrasting *seben* to be as exuberant as the text it carried.[14] He also decided to move the action from the coast to the hinterland. Such a transition also symbolized the transfer of power from the underworld to the heavens. He then applied the soukous reassembly that was collated among the Luo, a group that lives at an inland waterfront—Lake Victoria. When Congolese musicians were forced into exile due to war, some secular musicians played a circuit that included Kisumu, a town on the banks of Lake Victoria that had and still has a vibrant club scene. They influenced Luo musicians who already played a popular music called *Benga* drawn from indigenous Luo oratory and wedding or courtship styles. The resulting hybrid was re-appropriated by Congolese musicians into a soukous subgenre. Some Luo musicians also performed the Kenyan club and tourist circuit of Kisumu (on the western border), Nairobi (inland and the capital city), and Mombasa (the coastal hub of tourism and the seat of Islam). A fusion of Congolese soukous dance and Luo wedding dances morphed into a style and musical form known as *Kanungo* that became favored not just in Kisumu but on the circuit. This musical style is the backbone of Kigame's *seben*.[15]

OF RELIGIOUS ANXIETIES, POLYCULTURAL IDENTITIES, AND CHRISTIAN WITNESS

"Simba wa Yuda" is an apt musical illustration of anxieties about polycultural identity in postcolonial, Christianized Africa. Kigame re-turns and re-tunes styles, and re-sounds and re-assembles different music styles bearing different associations. Most of his resources—texts, instruments, instrumentalists, and styles—have already been reassembled in other spaces and times. He re-assembles them yet again with an added awareness of his broad potential audience in real and virtual space.

Kigame's performance is also a return, a re-tuning, a re-sounding, and a re-assembling of an old composition. He reworks Lubembe's song in contemporary musical footage. Kigame's solos actualize nuanced coastal inflections. He rearranges the response to definitely highlight the signature lyric

[14]Interview with Reuben Kigame, October 7–8, 2018.
[15]When performed in Christian gatherings (religious or social), the dance did not source Kanungo, so named for the hip gyration. Other, more modest dance styles of the Luo people are appropriated.

"*Simba Nguruma*" voiced by a group to paint and energize the text. He then adds a celebratory section read as a "radical contrast" to the first part, which "climaxes" in the instrumental section to allow a praise dance "break."[16] Kigame candidly reflects on the decisions he made consciously or unconsciously in the music and its production. He is well aware that his upbringing and the environment of his physical location, including those who surround and inform the space, influence his tastes and subsequently his resourcing and assembly of elements. Other factors include how he has been and continues to be socialized. In various interviews, Kigame has spoken of the ways his identities morphed.[17] He was born in a village and has a good grounding in his Bunyore cultural and linguistic heritage. He started to become blind when he was three years old. Notwithstanding, his parents decided he needed independence and responsibility.

Because of his disability, Kigame was sent to a boarding school, Kibos School for the Blind on the outskirts of Kisumu and run by the Salvation Army, from preschool through elementary (primary) school. He attended Thika School for the Blind on the outskirts of Nairobi for high school. He attained his undergraduate degree at Kenyatta University. In all these spaces, he encountered students from other Kenyan ethnic groups and learned other languages and ways of musicking beyond his home and village. He also performed in ensembles whose members had varied ethnic backgrounds, diverse Christian affiliations, and manifold secular orientations. These other students cohabited with other denominations and religions, including African religious heritages or Islamic or Indic traditions. This residence was not just physical; Kigame speaks about the impact of the radio in introducing him to worlds he would never see or imagine (other Kenyan, Pan-African, Asian, European, American, etc.), with programs of popular secular and other musical styles. He therefore was constantly retuning his musical aesthetic while imbibing diverse traditions that make for the plural identities that are a fact of life for most Africans. Kigame's immersion into mostly Christian musicking crystalized after high school and continued during his undergraduate studies at Kenyatta University. This was a liberal

[16]Interview with Reuben Kigame, October 7–8, 2018.

[17]See, for example, Mpoke Leo's 2017 interview of Kigame for the television series "Family Media: This Is My Story," www.youtube.com/watch?v=muR1yL6Y9PQ.

and liberating space where he intentionally articulated his Christian stance by releasing his first recording project. And even here, he credits the influence of Philip Nthiwa, a fellow student, with steering him toward an alternative setting of Kiswahili songs beyond the Makwaya styles that were the bane of church choirs, including popular secular Congolese types, because the text setting seemed to sit better than Makwaya's pseudo-hymns.

Kigame really came to his own as a gospel and Christian music artist in the 1990s. He credits the television programs *Joy Bringers* and *Sing and Shine*, which were aired nationally, with vastly expanding his audience.[18] In my opinion, the exposure and burden of audience relevance may have motivated him to seek out styles that would speak to the broadest base, whether it was a return and reassembling of hymns or "spirit" songs of classical Pentecostal and Africanist churches, or new compositions in international "praise and worship" idioms in English and Kiswahili with a decidedly Kenyan aesthetic. Some of these had text-heavy lyrics as a response to the criticism leveled against other songs of the time as having little textual depth. Singers collaborated with other musicians and mentored aspiring composers and performers.[19] Kigame indicated in an email interview that "individual prayer and meditation produce . . . very specific orientation and priorities" in regard to text, melody, and arrangement. He is intentional in picking particular musical styles and idioms in order to reach a specific audience. So, while he targets an audience, the music gains broader coverage and acceptance.[20]

In our discussion I commented on a song he produced in 1996, *"Nitainua,"* which I first heard during my doctoral research on gospel music in Kenya.[21]

[18] For definitions of *makwaya* and the two programs, see Jean Kidula, "Sing and Shine: Religious Popular Music in Kenya" (PhD diss., UCLA, 1998).

[19] Kigame manages a revolving musical group, Sifa Voices. In 2018, Kigame had received several recognition awards that motivated tribute concerts by former and current members. During one recognition at the Global Consultation on Music and Mission in Brackenhurst, Kenya, on August 8, Kigame solicited singers and instrumentalists from the audience who had performed with Sifa Voices or knew the songs, since they are integrated into Kenyan Christian repertory. Kigame also manages a "Whatsapp" group, "Christian Music in Africa," where concerts and events are advertised. The group also generates discussion forums on theological issues, industrial concerns, and musical/technical knowledge and resourcing.

[20] Interview with Reuben Kigame, October 7–8, 2018.

[21] The song is part of Kigame's most popular and groundbreaking album *Wastahili Bwana*, which established him as a worship leader. Almost all the songs on the album were immediate hits across denominations in eastern Africa.

The coastal (Indic/Arabic) overtones in the piece at the time were unusual in Christian circles as they were understood to signify Islam even more than Hinduism. The religious anxieties in the country during this period were not sympathetic toward Islam. Then, there was an Islamic insurgence on the continent, with Muslims employing tried techniques that had advanced Christianity on the continent, such as building hospitals and sponsoring students to study in the Middle East but also encouraging intermarriages with non-Muslims to gain converts. This was spoken about publicly and was discussed in undocumented lore of Christian circles. For Kigame to produce a song that clearly indexed Islam was a bold risk. In my analysis of the piece, I noticed intended but not well-realized vocal embellishments that harkened to *taarab* sounds. The song was rendered in unison similar to what happened in a *madras*. I also recognized the appropriation of instruments such as the *qa'nun*, *'oud*, the *darabukah*, *daf*, and *tabla*, which were the preserve of the Islamized. But I noted that the tone color was too "up country"—too relaxed compared to the nasal aesthetic associated with the Arabized coastal populations. The piece also was too situated in a minor key on a tempered scale to qualify for a proper Arabic or Indian mode. The text, based on Psalm 121, seemed to suggest such an ethos—a type of self-encouragement in the face of adversity and abandonment.[22] It was to me much more in the vein of African American blues—a sorrow song in Duboisian classification whose intention is cathartic and motivational. I further ascribed Kigame's foray in this direction to trends in the budding industry where musicians sought standout branding, whether it was linguistic, stylistic, narrative, or poetic, in an effort to carve a niche in the market.

When I questioned Kigame about the piece, his response was:

> My experiments on the song back in 1996 were just that. I knew the sounds I wanted to include in the instrumentation, but I did not even know what some of them were called. I had never seen one [*qan'un*, *'oud*], and to be honest with you, I have never played or touched a Harmonium, Sitar or Tabla. I just love the sounds and am fascinated and impressed by how they are used musically.

[22]The text of the refrain reads in Kiswahili *Nitainua macho yangu nitazame Milima. Msaada wangu utatoka wapi, Msaada wangu u katika Bwana.* This was a direct lift of the Kiswahili translation of Psalm 121: "I will lift up my eyes to the hills, Where will my help come from? My help is in the Lord."

... So, in a sense, both curiosity and the availability of my very first synthesizer Keyboard which was bought as a gift for me by ... Betsy Stafford, a missionary volunteer with us in the ministry, made a major impact in my musical journey. There were many sounds I could now experiment with from a machine that was probably one of the best at the time, thus catapulting me and the musical arrangements I was putting out to another level of acceptance and appeal. ... Now, part of the reason why those half and quarter notes are missing in all my Ta'arab, Eastern or Coastal music is that I did not enjoy them then. ... For me, my inquisitive apologetic mind had stumbled upon and vehemently rejected a teaching by Barry Smith at NPC Valley Road back in 1992 to the effect that music written and sang in minor keys was dedicated largely to the devil and that it portrayed sadness, etc. I was eager to prove otherwise, and, I guess, my "rebel mind" was happily rewarded by the transformation that followed ... "Nitainua Macho Yangu."

Kigame's response provides a small window into how ideas and identities are percolated to inform the composer's works and how these works are both "written" and translated into performance.

COHABITATIONS OF RELIGIONS, POPULAR ARTS, AND THE LABOR OF CHRISTIANITY

In analyzing and theorizing about the diversity of religions that traverse Africa, Dutch scholar Marleen de Witte describes the situation as "cohabitation religions."[23] De Witte, a scholar in the anthropology of religion with colleagues such as Birgit Meyer, theorizes on the phenomenology of post-1970s Pentecostal-charismatic Christianity in Africa. Among other reasons, they ascribe the spread of ideas such as prosperity theology to models of successful Christian living manifested in material culture by American and African televangelists through televisual media and other virtual or digital sites. In my opinion, these anthropologists still dissect the work of Pentecostalism as a faith and spiritual venture. They do not successfully explore the tapestry from which and into which Pentecostalism speaks in terms of the fluidity of African identity formation. More specifically, they do not explore the labor of Christianity in Africa. Therefore, I assessed de Witte's observation

[23]Marleen de Witte, "Pentecostal Forms Across Religious Divides: Media, Publicity and the Limits of an Anthropology of Global Pentecostalism," *Religions* 9 (2018): 217.

as a realization that layers of religion undergird the lives of most Africans. Indigenous religions index ethnic affiliation. These systems ground a second layer of religion, externally sourced or imposed, such as Christianity or Islam. Beyond these, Hinduism or Sikhism may also permeate the landscape because of the British practice of indenturing South Asians in their colonies.[24] De Witte's cohabitation of religion only scratches the surface. I contend that Kigame's "*Simba Nguruma*" better reflects the African reality, demonstrating not just a cohabitation but the progeny of that cohabitation and how they are expressed through the arts, particularly through music. The brokers of this music—composers, performers, producers, and scholars— present, interpret, interrogate, and resolve the issue/offspring writ large. I will even further posit that rites of community have created fertile ground for the crosspollination of religions from the continent.

James Ogude, a Kenyan scholar, provides a reading on the work of popular arts informed by the work of British anthropologist Karin Barber's groundbreaking essay "Popular Arts in Africa."[25] Barber asserts that popular arts are often instigated, produced, and consumed in informal and unofficial spaces inhabited by the masses. They often transcend borders and have great mobility in part because of the media through which they are transmitted. They are also extremely accessible, attracting a public rather than a community. In the urban milieus where these arts fermented in Africa, there was a public rather than a community. In essence, these arts created community. To create a community, forms of engagement were necessary. Ogude assesses the work of popular arts as mediating the boundaries of class, gender, age, and ethnicity that were destabilized by colonialism, external religions, and new sociopolitical communities.[26] The city or other spaces of displacement, crucibles of modern popular cultures, were open and fluid, permitting new expressions of this reality "relived through music, dance, and other artistic performances away from mainstream or official culture,

[24]South Asians not only worked and traded in colonial British Africa; they were employed across the larger British commonwealth. To demonstrate the formation of South Asian ethnic communities and their artistic practices and expressions, including music, see, for example, Helen Meyers, *Music of Hindu Trinidad: Songs from the India Diaspora* (Chicago: University of Chicago Press, 1998).
[25]Karin Barber, "Popular Arts in Africa," *African Studies Review* 30, no. 3 (1987): 1-78.
[26]James Ogude, "The Invention of Traditional Music in the City: Exploring History and Meaning in Urban Music in Contemporary Kenya," *Research in African Literatures* 43, no. 4 (2012): 147-65.

allowing for experimenting with new forms." This public space allowed for resources and forums in which "communities could be discussed, refined and popularized in order to produce common-sense frameworks for understanding [themselves and their worlds]."[27]

Johannes Fabian had already wondered if there was a shared discourse between popular culture and religious movement in contemporary African cities. He observed that similar to popular culture, new waves of Pentecostalism seemed to emerge "as a response to social anomie, mission impact, political-economic oppression, and a need to revitalize traditional culture."[28] He theorized that these were not just "derivatory mixtures or superficial adaptations of imported western elements"; rather, they were labors designed to interrogate and make sense of a world with disparate elements. Somehow they had to be harnessed and worked out to create a semblance of order and to justify decisions and practices of modern life.[29]

The emergence of these popular arts in Christian circles created an ambivalent and conflicting relationship as works of ministry and works of commerce. However, they provided a space to work out identities that had previously been navigated via indigenous rites of passage and belonging in order to circumscribe social and political frames of belonging. Christianity and colonialism had ushered in an era of complex social relationships beyond kinship primarily through the church and the school. Daily school parades congregated modern education communities, while weekly church services created networks that over time crossed ethnic and locational borders. Each of these institutions had its rites of belonging, such as baptism for church identity or examinations for passage to the next level of academic, economic, or political order.[30] A third layer, one of nationality, was shrouded over the church and the school.[31] In much of East and central Africa, Arab or Arabized

[27]Ogude, "Invention of Traditional Music," 152.
[28]Fabian, "Popular Culture in Africa," 316.
[29]Fabian, "Popular Culture in Africa," 316.
[30]For a discussion of how indigenous African rites coexisted with those instituted by Christianity, see my case study of the Logooli of Western Kenya in Jean Kidula, *Music in Kenyan Christianity: Logooli Religious Song* (Bloomington: Indiana University Press, 2013), chaps. 2-3.
[31]Kimani Njogu has dissected the formation of Kenyan national identity through his projects. For examples, see his coedited volume, *Culture, Performance and Identity: Paths of Communication in Kenya* (Nairobi: Twaweza, 2008). The volume contains essays on religion, music, and other arts (visual, verbal, written, and motor) that theorize on how identity is formulated, assigned, performed, promoted, rejected, and so on.

traders often preceded, led, or followed European explorers and missionaries. Therefore, Islam was often established in the same vicinity as Christianity. In that case, family and kin could belong to different external religions or to different countries carved out by colonial governance. Thus, four identifiers were possible for those who joined church, went to school, and were located in a particular country.

Dislocation began to impact the ways these cohabitations interacted. Children were sent to boarding schools, where they met colleagues from different culture groups and religious affiliations. Travel and work in the cities, where different ethnic groups cohabited, intensified the desire to assimilate. Political unrest, exile, and displacement exaggerated the coalescence of disparate nationalities bearing religious and other affiliations. Travel and migration beyond the continent brought its own anxieties so that emergent and ongoing scholarship on African identity is still anchored on the impact of colonialism and foreign religions (particularly Christianity, but also Islam).

Modern African countries and their citizens identify in polycultural terms and navigate polyreligious identities. Music is embedded in these cultures and religions. Both music and religion still index and express each other. Musicians as creatives often broker the symbiotic relations of music and religion. In Kigame's case, the intersection of musics with Christianities drawn from a broad array of affiliations may be engineered in social spaces that already index an assortment of values, beliefs, and expectations. This is typical in most cities around the world. The situation in Africa is particularly interesting because most nation-states were formed based on European ideals undergirded by each imperial powers' prevailing Christian religious orientation. While it would have made sense for only one imperial power's Christian culture to be exported to their colony, in reality there was also a religious scramble for Africa within each nation. Therefore, various Christianities were sown in the same land, pollinating it with an inconsistent palate of beliefs, doctrines, and values. These Christianities intersected or cohabited with indigenous African systems alongside Islam. Pentecostal-charismatic Christianity and popular culture have surprisingly provided one template for working out these anxieties. While these identities may be expressed in religious terms but also according to religious affiliation, they are part of the labor of Christianity in Africa.

An understanding of the labor of Christianity during and after colonialism is necessary. The work of religion in European or Western psyche may have been understood as servicing a spiritual dimension. Hence the contrast with secularity. Christianity in Africa was about a total and radical denunciation of African identity, even if it still circumscribed people's geography, physical attributes, and histories. Beyond religion, the process of eradication was enacted from many fronts. Christianity introduced new social relationships that both isolated and expanded relationships. Unless whole families converted, Christian members performed a new spiritual consanguinity transacted in a "new birth" through the blood of Jesus with its set of behaviors, expectations, and rites of belonging. Thus, while they still lived with their genetic blood relatives, Christians also operated in this new religious reality aimed at restructuring and directing moral and other values. Further, the colonial government through Western schooling introduced yet another set of expectations designed not just to transform how knowledge was processed, produced, consumed, and transmitted but also prepare students for new vocations such as white-, pink-, or blue-collar jobs. Socialization for the purposes of identity creation and affirmation together with expected outcomes was transferred to school or church. Previous leisure activities that included creative and performing arts as well as sports were adjusted, or their message was changed to reflect the new way of life. The tensions that therefore accompanied coexisting modes of living were often expressed in the audio, visual, verbal, creative, and performing arts. Therefore, the oft-expressed frustration regarding the impact of new Pentecostalism by anthropologists and scholars in religion and other disciplines with a different lived experience and expectation of religion fails to take into account the labor of Christianity or Islam in Africa, imposed partly as a component of imperialist European colonialism or Middle Eastern jihadist agendas. In my opinion, the arts provided a liminal space to express and work out these anxieties and adjudicate possible resolutions while also projecting a possible future. It is in this space that the issues of cohabiting and sometimes competing religions are performed and effected. Therefore, popular arts and their artists thrive because of the never-ending and fast turnout and turnaround of knowledge and the continuing displacement and relocation of African peoples occasioned by unstable governments, economic imperialism,

environmental disasters, and other factors. The arts in official, formal, informal, and popular forms continue to articulate and process these tensions.
Those who have discovered its power and impact harness them.

ON THE LORD'S SONG IN TWENTY-FIRST-CENTURY AFRICA

Christian song in Africa defies categorization. In this moment, the mission
of that song is probably its most salient feature. Its assembly and practices
are as diverse as the peoples on the continent, drawing not just from inherited European traditions but from the many African beliefs and systems
that Europe and the West encountered on the continent. These were not the
only competing systems; Islam and other Asian religions began to inform
the composition and performance of this song that struggled to articulate
and codify the kaleidoscope of Christian or Christianized doctrines imported or emerging from the continent. However, there is no doubt that the
mass media and popular arts have been the most impactful in driving this
song. While ministry has been at the heart of Christian religious song, the
industrialization of the product in the form of a gospel music industry has
provided a commentary on the working out of Christianity through the resources that are assembled to codify lived, preached, and aspired Christianity.

The gospel music industry as an economic force in Africa gelled in the
1990s. It coincided with a liberalization of the media that enabled the dissemination of alternative narratives to what had marked the previous
twenty-five to thirty postindependence years. This liberalization was a direct
response to structural adjustment programs mandated by the International
Monetary Fund, and it resulted in widespread unemployment. However, it
also necessitated entrepreneurial projects, including a thriving and popular
informal arts culture. Popular culture, probably the best index of a response
to colonialism and postindependence realities, provided an alternative account to the official narrative about Africa and its newly independent nations recounted by its political and academic elite. Popular culture provided
a voice for the majority public still coming to grips with dislocation and
boundaries solidified during the colonial era, as well as new community
relationships established through modern education systems or new religions, such as western Christianity or Islam, that competed against each
other for African believers while denigrating indigenous African religions,

beliefs, and values. Most popular arts, born among populations margin-
alized either by religion or education, spoke to and about historical and
contemporary experiences, and many were fantasies about harnessing a
material culture that was perceived as located among the educated elite, the
economically rich, and the politically powerful. The liberalization of the
media then opened the door to more informal and unregulated entrepre-
neurial possibilities, such as investments in the religious music industry.

With changes in the ways communities were formulated that under-
mined boundaries along ethnic lines, new publics were formed that needed
to cohere in order to coexist. Rites of community—rather than rites of
passage or belonging—were then enacted at significant events and spaces
such as churches, schools, social halls, entertainment venues, and other re-
configurations of social being. It is within these new spaces that different
belief systems intersected. The ensuing products have garnered critical por-
trayals and responses in scholarship, exemplified in the language used to
describe the processes: syncretism (usually seen as a negative idea that as-
sumes a contamination of the sacred doctrine or idea), Westernization (a
rather amorphous term that is as ambiguous as it is derogatory), imitation
(suggesting a lack of originality), and shallow (lacking depth of engagement
or understanding). Beyond that, interventionist strategies, particularly in
attempts to harness indigenous resources for Christian expression and song,
have been initiated, usually not from within the continent but from else-
where. The effectiveness of these interventions is still being measured par-
ticularly in regard to how they are utilized in the worshiping body of the
churches that embrace them, that is, whether they are disseminated and
accepted by other assemblies as legitimate representations of the modes of
spiritual engagement in the ways popular Christian religious songs from
around the world gain traction.

My analysis of one of Kigame's songs hopefully demonstrates the labor of
song in Christian practice in Africa. This labor does not isolate the spiritual
from the everyday; in fact it infuses the everyday with God's Spirit. Neither
does it necessarily dichotomize the secular from the sacred, although it takes
exception to negate the profane. It also demonstrates the more-or-less ho-
listic approach to Christian faith, where all the senses are invoked in worship
of the living God. Christianity has to do with turning, orienting, testifying,

and building a community of faith that is the body of Christ. The various ways that Kigame and other music ministers speak for and to the Christian community globally are a metaphorical demonstration of the Christian call: to turn and return, to align with and into the kingdom of God, a tuning and being in tune as well as a retuning to be in accord with both the living God and the church at large. This re-turn, re-sourcing, and re-sounding draws from the past with all its anguish as it is a call to repentance for realignment. Often tensions and anguish accompany the outworking and eventual catharsis of the whole person.[32] The ultimate goal ought to be one of praise, a testimony of the person, mission, work, and vision of the living God through Christ to the nations—in every land, of every tribe and creed—to acknowledge and live in awe, obedience, and honor of the living God through Jesus Christ. That is what makes for a song that is different from the ones that serve other than the worship of the living God.

[32]Special thanks to Dr. Alexis Abernathy, whose response deepened my appreciation of the processes and fruits of labor.

Christians Creating New Interfaith Expressions

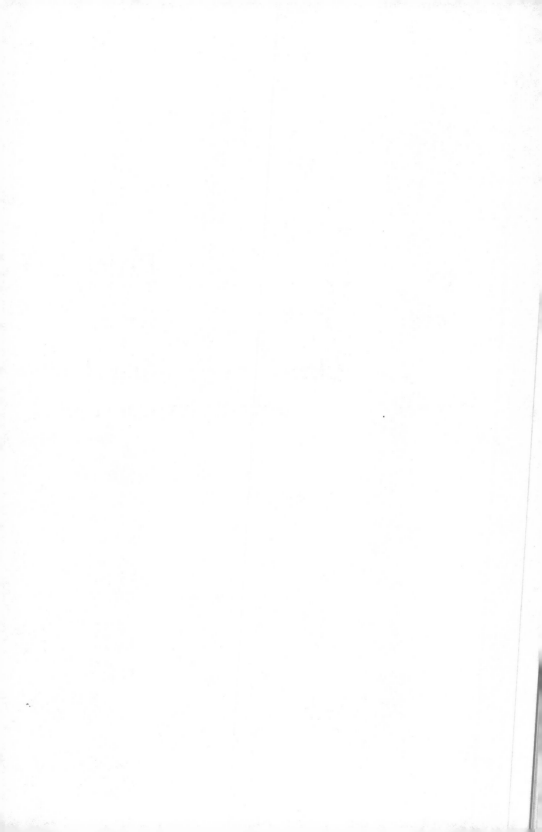

Crate-Digging Through Culture

Hip-Hop and Mission in Pluralistic Southern Africa

Megan Meyers

Africa's youth are ignored at everyone's peril.

Dayo Olopade

Over the weekend of May 26, 2018, ten people were decapitated by young Islamist militants in Palma, a sleepy town in northern Mozambique. This shocking event was one of a series of ongoing attacks fueled by a mix of poverty and corruption. Due to its location on the Indian Ocean, Mozambique has participated in the global marketplace for centuries, enduring opportunistic Muslim traders, oppressive Portuguese sailors, and their religions. What precipitated such violence in an area known until recently for its beaches?

Palma is located in the northeastern corner of Cabo Delgado, the poorest province in Mozambique. Over the course of a few decades however, it has become the hub of legal and illegal trade and large people movements toward South Africa, earning the region a reputation as the place that will make Mozambique rich. Unfortunately, locals are not reaping the benefits. Frustrated by a lack of jobs, "marginalized and uneducated youth with surprising links to national and international networks—of contraband, military training, religious leaders, and financial support—are at the core of

Islamic attacks."[1] While researchers have varied views on the insurgency, all agree that underemployed youth searching for a means of a better life are at the heart of the issue.

BACKGROUND

Christianity is now one of the two most widely practiced religions in Africa; almost half of the African population is Christian. This trend shifted Christianity's center from European industrialized nations to the Global South. Walls contends, "Africa may be the theatre in which some of the determinative new directions in Christian thought and activity are being taken."[2] When one looks at Christianity's explosive increase on the African continent and concomitant reduction in a post-Christian West, it is easy to agree.[3] Africa is, indeed, the "theater" of Christianity today. Yet in this realm, who are the actors, what are their actions, and how are they enabled or constrained by their current stage?

The purpose of this chapter is to describe a facet of the African Christian theater by exploring one specific actor: a Christian rap artist named Ibraimo and his performative actions localized on the stage of Beira, a port city in the central region of Mozambique, located in Southern Africa. The goal of this narrative inquiry is to understand his lived and told stories as expressed through his lyrics and to discover how Mozambican Christian youth are making sense of the world around them. Ibraimo's life experiences provide a window through which to view broader missiological concerns, demonstrating how Ibraimo's search for relevance gains him cultural capital in a globalized world. This chapter addresses how arts are currently being engaged in local church contexts in relation to witness, worship, and discipleship, and provokes key considerations for culturally appropriate communication and critical contextualization of the gospel.

[1] This study was based on a month of fieldwork of Islamic cleric Sheik Saide Habibe, IESE director Salvador Forquilha, and Jõao Pereira, assistant professor at Eduardo Mondlane University and director of MASC. IESE is the Social and Economic Research Institute, and MASC is the Civil Society Support Mechanism. Preliminary results were presented on May 22, 2018, at the Universidade Pedagogica in Maputo (Hanlon, May 29, 2018).

[2] Andrew Walls, *The Cross-Cultural Process in Christian History* (Maryknoll, NY: Orbis, 2002), 119.

[3] The evangelical growth rate in Mozambique is 5.4 percent, outstripping the United States at 0.8 percent and the global rate of 2.6 percent.

CONTEXT: ALL THE WORLD'S A STAGE

If indeed "all the world's a stage,"[4] what does Ibraimo's stage look like? Africa is increasingly urban, and the tsunami of globalization has long crashed on the continent's shores. Contrary to dominant Western stereotypes of Africa, "rural populations are streaming into African mega-cities faster than in almost any other part of the world. If the traditional vision of Africa is windswept savannah or quiet forest, the new one is of urban jungle."[5] Here we explore two theoretical frameworks undergirding this chapter, that of culture change and popular music studies, and then describe the stage on which Ibraimo acts—a cultural platform with specific political, generational, and causal constraints.

Culture change: Urban globalization and creolization. Globalization has radically altered the world, hybridizing cultures and accelerating culture change. "Globalization is not just changing the world; it is changing us and the way we view the world."[6] Urbanization is a major contributing factor in heightening and broadening the experience of the global economy, facilitating cultural change at a dizzying pace. "For some, 'globalization' is what we are bound to do if we wish to be happy. For others, 'globalization' is the cause of our unhappiness. For everyone, though, 'globalization' is the intractable fate of the world, an irreversible process."[7] Regardless of our experience, globalization is here to stay.

Historically, culture change is located in a place—the territorialization of meaning.[8] However, through the globalization process, "the groundedness, fixity and location of cultures becomes disturbed."[9] Particularly in urban centers, one quickly realizes the world is at one's fingertips—most cultures no longer exist in isolation. We need to ask how globalization is impacting cultures worldwide. Three paradigms dominate the literature for

[4]William Shakespeare, *As You Like It*, act 2, scene 7.

[5]Dayo Olopade, *The Bright Continent: Breaking Rules and Making Change in Modern Africa* (New York: Houghton Mifflin Harcourt, 2014), 182.

[6]Bryant Myers, *Engaging Globalization: The Poor, Christian Mission, and Our Hyperconnected World* (Grand Rapids: Baker, 2017), 38.

[7]Zygmunt Bauman, *Globalization: The Human Consequences* (New York: Columbia University Press, 1998), 1.

[8]Robin Cohen, "Creolization and Cultural Globalization: The Soft Sounds of Fugitive Power," *Globalizations* 15, no. 5 (2007): 369-84.

[9]John Tomlinson, *Globalization and Culture* (Cambridge: Polity, 1999), 29-31.

interpreting globalization's impact on culture: homogenization, hetero-
genization, and hybridization.

Table 7.1. Globalization's impact on culture

Category	Type	Definition	Example
Homogenization	Consumerist	Growing connectivity leads to standardization and uniformity, cultural detrition, "McDonaldization"	McDonaldization of Society (Ritzer 1993)
Heterogenization	Primordialist	Increased interaction leads to fragmentation and conflict, as immutable cultural entities play out their divisions	Clash of Civilizations (Huntington 1997)
Hybridization	Creolization	Fuzzy cultural boundaries lead to assimilation of various elements, a "trend to blend"	Global Mélange (Nederveen Pieterse 2009)

Though each paradigm has merit, many observers now believe that both
homogenization and heterogenization are problematic. In fact, even hybrid-
ization is too simplistic to describe the effects of globalization on culture.[10]
Globalization and its results are experienced in diverse and uneven ways.
"This means that no single model will be adequate, but rather each cultural
context will need to be studied and understood on its own terms."[11] Local
contexts are not only hybridized but also deterritorialized and hyperdiffer-
entiated, thus "people are now participating in different realities at the same
time—there is multiple belonging."[12] Nowhere is this more illustrated than
in global pop culture and the consumption and commodification of music.

 Pop culture: Practices and performances. One can argue that "nothing
better exemplifies this new world . . . and the changes in it than music, for
the very kind of malleability of music makes possible local appropriations
and alterations . . . resulting in all kinds of syncretisms and hybridities."[13]
Pop music's ubiquity has inspired exceptional research by an increasing
number of African music academics.[14]

[10]L. Martell, *The Sociology of Globalization* (Malden, MA: Polity, 2010), 89-104.

[11]Craig Ott, "Globalization and Contextualization," *Missiology* 43, no. 1 (2015): 49.

[12]Robert Schreiter, *The New Catholicity: Theology Between the Global and the Local* (Maryknoll, NY:
Orbis, 1997), 26.

[13]Timothy Taylor, *Global Pop: World Music, World Markets* (New York: Routledge, 1997), xv.

[14]See John Miller Chernoff, "Africa Come Back: The Popular Music of West Africa," in *Repercus-
sions: A Celebration of African-American Music* (London: Century Publishing, 1985); David Cop-
lan, *In Township Tonight! South Africa's Black City Music and Theater,* 2nd ed. (Chicago: University

Africanist academicians note, "Popular arts in Africa are syncretic forms that draw on multiple indigenous and foreign sets of symbols in order to create new conventions of expression."[15] Pop music is a means to cultivate and transform existing collective and individual sensibilities. Popular forms should be understood as a vital part of the process of identity formation—creating communal narratives about tradition, modernity, and ultimately national belonging through creative popular expression.

Early Africanist scholars discussed theories of cultural imperialism and its impact on music cultures of the non-Western world, lamenting that African music was irrevocably altered, "exposed and vulnerable to attack by determined proselytizers, both progressists and priests."[16] This analysis is indicative of a center-periphery model, where "Western colonialists 'damaged' local cultures to the point where the locals could not prevent the changes taking place in their music."[17]

Recently, scholars have critiqued this position, offering alternative views of local-global exchanges of culture. Many of these new theories depict engaged culture brokers rather than passive cultural recipients, suggesting a bartering of ideas (even though inequitable) between the West and the rest. However, even these recent ideas tend toward reductionist notions of culture change. One way to overcome these dichotomies is to consider how people use music in their daily lives. "A person continually innovates on sounds, symbols, language, and ideologies to interact with others in different communities and social contexts."[18] Rather than viewing cultural exchange as

of Chicago Press, 2008); Christopher Waterman, *Jùjú: A Social History and Ethnography of an African Popular Music* (Chicago: University of Chicago Press, 1990); Kazadi wa Mukuna, "The Genesis of Urban Music in Zaïre," in *African Music* (*African Music* 7, no. 2 [1992]: 72-84); John Collins, *West African Pop Roots* (Philadelphia: Temple University Press, 1992); Michael Veal, *Fela: The Life and Times of an African Musical Icon* (Philadelphia: Temple University Press, 2000); Louise Meintjes, *Sound of Africa! Making Music Zulu in a South African Studio* (London: Duke University Press, 2003); Mwenda Ntarangwi, *East African Hip Hop: Youth Culture and Globalization* (Chicago: University of Chicago Press, 2009); Eric Charry, ed., *Hip Hop Africa: New African Music in a Globalizing World* (Bloomington: Indiana University Press, 2012); and Msia Kibona Clark and Mickie Mwanzia Koster, eds., *Hip Hop and Social Change in Africa: Ni Wakati* (Lanham, MD: Lexington Books, 2014).
[15] Karin Barber, "Popular Arts in Africa," *African Studies Review* 30, no. 3 (1987): 38-41.
[16] Hugh Tracy, "The State of Folk Music in Bantu Africa: A Brief Survey," *Journal of the International Folk Music Council* 6 (1954): 32-36.
[17] Alex Perullo, "Imitation and Innovation in the Music, Dress, and Camps of Tanzanian Youth," in Charry, ed., *Hip Hop Africa*, 188-89.
[18] Perullo, "Imitation and Innovation," 189.

static, ethnomusicologists can discover how differing creative expressions are used to affirm a sense of belonging in multiple environments.

The internationalization of rap music is perhaps one of the most important recent developments in contemporary popular culture. Yet even as it allows access to a broader world, it ironically promotes a feeling of "global disconnect."[19] New actors on the global stage are keenly aware of their marginalization and subjugation to powerful global constraints, and "attempts to fashion oneself as a transnational subject exact a certain price."[20] Popular culture practices, through the consumption and commodification of music, both permit and constrain people to relate to each other and the broader world.

African rap: Roots and routes. Rap music and the larger hip-hop culture are but the latest in a long line of foreign music imports in Africa, carrying within them the larger musical systems in which they are embedded.[21] However, each genre has experienced such significant transformation that they can rightfully be considered African music. "Hip hop is currently undergoing a similar process and provides an extraordinary window into processes of musical and cultural change."[22] These foreign influences, including hip-hop, have become authentic African musical expressions.

Many elements of hip-hop are said to have originated in Africa.[23] Rap music is a "diasporic genre at home—in Africa—but also a genre having many homes. Within these many homes claims to authenticity are expressly mobilized and contested."[24] Cross-border connections in hip-hop demonstrate rap's ability to articulate global consciousness in a local manner—a global consciousness that is both real and imagined. "If anything, this genre reveals that the notion of roots in the modern world is negotiable, changing,

[19]Brad Weiss, *Street Dreams and Hip Hop Barbershops: Global Fantasy in Urban Tanzania* (Bloomington: Indiana University Press, 2009), 24.

[20]Robert Foster, *Materializing the Nation: Commodity Consumption and Commercial Media in Papua New Guinea* (Bloomington: Indiana University Press, 2002), 138.

[21]Foreign music imports include Arab styles of solo chanting spread by Muslims in the seventh century; European styles of sacred and secular vocal and instrumental melody and harmony of the nineteenth century, brought by the missions movement; Latin American and Caribbean song and dance rhythms of the early twentieth century; and American jazz, rhythm and blues, and rock from the 1950s onward.

[22]Charry, ed., *Hip Hop Africa*, 283-84.

[23]Jean Kidula, "The Local and Global in Kenyan Rap and Hip Hop Culture," in Charry, ed., *Hip Hop Africa*, 185.

[24]Charry, ed., *Hip Hop Africa*, 57.

and subject to the tenuous nature of contemporary life."[25] Rap music is composed with a sense of double consciousness, reflecting roots and routes.

The first generation of African hip-hop artists relied heavily on imitation. However, the genre quickly became indigenized and politicized. African rap as a genre is about a decade behind its American predecessor. The genre first arrived in Africa in the 1980s, an incubation period marked by an imitation of its American source. However, African rappers came of age in the 1990s, demonstrating maturity and urgency in their music. The current widespread popularity of hip-hop across the African continent affirms that the genre has become one of the most relevant cultural forms of expression for African youth.

As African rap developed second- and third-generation hip-hoppers, critical and commercial voices emerged. One widespread effect has been to rekindle interest in older local traditions. "African youth continually search for new ways to make rap relevant and unique, which often means digging through local culture, almost like American deejays would crate-dig— search through crates of obscure vinyl record albums for new sounds."[26] While African youth may feel ostracized and constrained by their sociocultural realities, they also use culture to affirm the authenticity of their music, to demonstrate that rap is really their own.

Hip-hop's emergence in Africa and the variety of creative expression across the continent is tied to specific cultural, social, and political realities on the ground. Some Africanist scholars contend that neoliberal dynamics peddled by international financial institutions configure the particular structure of values and social interactions performed in popular practices.[27] It is not surprising that hip-hop arrived in Africa in the 1980s and 1990s, concurrent with important political and economic changes. Similar to conditions that birthed hip-hop in the United States, rising poverty and increased migratory flows to urban areas greatly impacted African youth. Seeking an outlet for the frustrations caused by unemployment, crime, and poverty in overcrowded cities, many turned to hip-hop, identifying with the lived and told stories of African American youth.

[25]Charry, ed., *Hip Hop Africa*, 57.
[26]Charry, ed., *Hip Hop Africa*, 57.
[27]Ray Bush, Msia Kibona Clark, Eric Charry, Mwenda Ntarangwi, and Brad Weiss, among others. See Brad Weiss, *Street Dreams*, 15.

In addition to the challenges of being simultaneously exposed to and excluded from global wealth, African youth are minimized by the surrounding authoritarian society in which power and influence accrue with age. Stuck between childhood and adulthood, the prevailing state for youth in sub-Saharan Africa is "waithood."[28] It is important to note here that Africa is young, the quality most widely shared across the vast continent. "Seventy percent of sub-Saharan Africa's population is less than thirty years old—the highest proportion in the world."[29] At the same time, youth make up 37 percent of the working-age population but 60 percent of the unemployed. "Even as hierarchical societies insist that the young defer to elders and wait their turn, they also fail to provide adequate support, training, and engagement for eventual leadership."[30] It's a recipe for frustration for the youth cohort of Africa and the very dynamic that has instigated recent violence in Mozambique.

Finally, a persistent traditional cosmology of evil, an evident cultural value throughout sub-Saharan Africa, hinders youth initiative. Evil doesn't occur as a natural result of the fall but is due to the power of evil spirits or the living dead and their propensity to harm. People don't advance because of their credentials or personal drive but because of their *afiliação* ("social connections"). Fundamental differences between Christianity and African traditional religions may be reason for a reticence to accept personal sin in the African context.[31] "Christianity acknowledges personal responsibility for sin, whereas traditional African beliefs externalize the origin of bad occurrences."[32] The power to help or to harm lies beyond the self, limiting agency. It is a fatalistic culture—reactive rather than proactive. This cultural game profoundly restricts youth activities.

Within this double constraint of youth identity and fatalistic agency, it is perhaps easier to understand that it was not necessarily the deep historical

[28]Alcinda Honwana, "Waithood: Youth Transitions and Social Change," in *Development and Equity: An Interdisciplinary Exploration by Ten Scholars from Africa, Asia, and Latin America* (Leiden: Brill, 2014), 28-40.
[29]Olopade, *Bright Continent*, 191.
[30]Olopade, *Bright Continent*, 194.
[31]This traditional cosmology of evil may also explain the ongoing popularity of cults of affliction and a continuity with the prosperity gospel that has proliferated across Africa.
[32]Todd Vanden Berg, "Culture, Christianity, and Witchcraft in a West African Context," in *The Changing Face of Christianity: Africa, the West, and the World* (New York: Oxford University Press, 2005), 57.

and cultural connections that caused African youth to embrace American rap. In fact, it was initially only an elite, Westernized segment of African youth with access to Western music imports and higher education in English that first accepted rap. "Rap was a youth music, which was perhaps its most attractive quality."[33] Rap music, by and large, appeals to a younger audience. It is a generational music—a culture demarcated by age, socioeconomic struggles, and a sense of oppression or exclusion.

An additional reason for hip-hop's popularity is the genre's flexibility. "Furthermore, (rap) was a malleable form and could be shaped to fit local circumstances."[34] Of note here are some key differences between African rap and its American progenitor. Profanity and gun culture are much less widespread in Africa than in the United States, particularly in majority Muslim countries. Other factors that may influence the lack of profanity and glorification of violence in African rap are a socialist political past and strong family ties. Female performers are still a minority presence in African rap, though female artists dominate the African gospel genre. While there are numerous ongoing debates about the roots and routes of African rap, it is important to recognize the specific political, social, and cultural contexts in which the genre has flourished. The stage on which Ibraimo performs is bounded by neoliberal economic reforms in a country that recently gained independence vis-à-vis socialist political assistance.[35] It is further constrained by an authoritarian and passive culture that demeans youth and externalizes agency.

ACTOR: IBRAIMO'S LIFE AND LYRICS

Having described the stage upon which African hip-hop emerged, I now move to describe an actor, Ibraimo, exploring how the arc of development as an artist follows his personal pilgrimage.[36] His life and lyrics can be subdivided into three distinct phases: "*Meu Teu Retrato*" (musical beginnings), "*Grande*" (growing up), and "*Deus da Minha Vida*" (maturing in ministry).

[33]Charry, ed., *Hip Hop Africa*, 3.

[34]Charry, ed., *Hip Hop Africa*, 3.

[35]Mozambique gained independence from Portugal in 1975. The newly formed Marxist nation quickly devolved into a second conflict—supported by apartheid South Africa and Rhodesia—destabilizing their communist neighbors. A peace accord was signed in 1992.

[36]Information for this chapter and all unattributed quotes from Ibraimo were gleaned over the course of seven months in 2018 from three individual interviews with the artist (January, April, and July) and one focus group interview (June) with Sementes de Abrão (the artist's rap group).

"Meu Teu Retrato": *Musical beginnings.* Manuel Ibraimo António was born in 1989 in Nampula, a region dominated by Islam. He is the first-born son of a multifaith, multicultural family. His father was Makhua and nominally Muslim, while his mother was Koti and a member of an African Initiated Church, or AIC (Twelve Apostles). However, when they married, Ibraimo's mother acceded to the faith of her husband, a typical practice throughout Mozambique. Ibraimo's early years were characterized by change and loss. His father's professional development involved six moves by the time Ibraimo was thirteen. Ibraimo's mother died when he was just six. He and his two younger sisters were then sent to live with his aunt for a year. Within a year of his father's return, Ibraimo had a stepmother, who was replaced in four years by another stepmother.

Ibraimo's decision to leave the house at thirteen to study at a boarding school is not surprising. It was during his three years at school that his natural artistic proclivities began to blossom. He was shy but wanted to express his feelings of isolation and loneliness initiated by his mother's death and heightened by the resultant transitions. A fellow student and rapper took Ibraimo under his wing, teaching him the craft of writing lyrics. Ibraimo admits, "Writing helped free me, it opened me up."

Similar to other songs written in the early years of his musical career, "*Meu Teu Retrato*" ("My Portrait") was a form of introspective therapy. The first verse reflects his pain:

> Could it be that the destination that I'm seeking is darker than I thought
> The road that I'm on is narrower than I thought
> The life that I live is worse than I thought
> Can someone give me a hand to end my suffering?

Ibraimo initiated his rap career by watching American rap music videos. Although he couldn't speak English, he was especially drawn to T.I. and Game. Ibraimo states, "I admired Game's form of expression, he's got an attitude. Though I didn't understand the words, I understood his story. I knew that if he could survive, then I could too." T.I., on the other hand, was clean-cut. He didn't have tattoos, and he dressed well. Ibraimo felt that he looked like T.I., and he liked his style. By the following year, Ibraimo started imitating Mozambican rappers in Portuguese, covering their songs at cultural

arts shows while writing his own lyrics and experimenting with creating back tracks. In 2005, he sang his own song solo in a show.

"Grande": *Growing up.* In 2006 Ibraimo moved to Beira for further education. Beira was the place where Ibraimo thrived academically, musically, and spiritually. Though he was a self-professing "Catholic" in the sense that he wasn't Muslim like the rest of his family, his spiritual development was not a priority. However, in the middle of class, his professor alleged, "Many people are just *defuntos ambulantes* ('walking dead')." Ibraimo revealed, "This made me so curious, I approached him after class. He said that I needed to accept Jesus Christ as Savior and Lord to have a spirit and to communicate with God." Ibraimo started regularly going to his professor's home for Bible study and church services, bringing a small group of fellow students with him. He was baptized a few months later.

He continued to write and record songs, volunteering in a home studio so he could learn how to produce, mix, and record. "My life was studio, school, church. Only this. I left other things behind—sports, friends. I would study and listen to music. It was crazy!" He attended a worship training course at Igreja da Família Vitoriosa (Victorious Family Church) and created a rap group made of youth that lived in the same *bairro* of Matacuane.

"Grande" ("Grownup") best describes his social and musical aspirations:

> In a community, the boys want to be like the ones
> That represent nearby socialites
> This is the life, every guy wants to be a man of the plaza
> I can dream of being Afonso[37] but never Obama
> Feet on the ground, this goes for my hands that dream high
> For those who dream of becoming the hood reps
> The next Eusébios[38] and Lurdes Mutola[39]
> Two seconds of silence for those who dream now . . .
> I just want to be something
> And show society that I'm already useful for others

[37] Afonso Dhaklama—the late head of RENAMO (resistance fighters and opposing political party located in Central Mozambique).

[38] A famous Mozambican soccer player who played for Portugal, scoring 733 goals in 745 matches over the course of his professional career.

[39] A retired female athlete from Mozambique who specialized in the 800-meter race. She is a three-time world champion in this event and a one-time Olympic champion.

Worried about how to explain increased ministry responsibility to a Muslim family, Ibraimo took the opportunity to step away from his church when it moved to a different location. Instead, he began attending Família Vitoriosa services on a regular basis when he entered university as an engineering student.

"Deus da Minha Vida": *Maturing in ministry.* Ibraimo's current season of life has been one of maturing as a Christian leader, discovering his ministry calling, and discipling others. Guided by Ephesians 2:10, Ibraimo realizes that his life has purpose and that he has a responsibility for others. He uses his rap groups as a training ground for young artists, providing a sense of community for the participants. Most of the members see him as an older brother, coming to him for advice about various life issues. Through his positive influence in their lives, some have come to faith, some quit using drugs and alcohol, and others have gotten married, pursuing sexual fidelity.

Many Mozambicans assume that "secular" musicians live illicit lifestyles. In some cases, this is true. However, as Ibraimo says, "It's possible to be a good artist and avoid these negative things. We're normal people." In fact, he believes that it is his good reputation rather than the music itself that has gained him such credibility in both the Christian and secular communities. Ibraimo is regularly invited to interviews on national TV and radio networks and to preach at various churches.

The lyrics of *"Deus da Minha Vida"* ("God of My Life") demonstrate a dramatic shift in Ibraimo's priorities. Rather than wanting to be a "man of the plaza," Ibraimo submits to the Lord's direction. The chorus states:

> I need to feel you all day long
> And look for your light so I won't lose my way
> My Lord you are my happiness I need!
> God of my life, stay with me
> I'm your house, live in me
> Let me tell you what I need, Father
> I need the Lord.

In 2014, Ibraimo's ministry calling solidified through an initiative called Pregação na Comunidade, or preaching in the community through rap. He also launched Concerto Gileade, an ongoing open-mic Christian concert at

Família Vitoriosa that draws youth from across the city. The purpose of the concert is to provide a place to perform, restoring the faith of artists who were rejected in their churches, as well as a place for secular artists to be evangelized. Though he had an opportunity to leave Beira for a lucrative job in Nampula a few years ago, Ibraimo has remained in Beira, continuing his mission to create Christian rap, disciple artists, and witness among "secular" rappers. In his own words, "I'm an artist and a Christian. What is my responsibility? To be a light, to show people what God's done in my life through my music—to shine the values, the transformation, the liberty from sin, and to show God's love to my neighbors."

ACTIONS: IDENTITY ASSERTED THROUGH MUSIC

There are a number of key themes that emerge from Ibraimo's lived and told experiences. We can see through Ibraimo's life and lyrics that his music is not only descriptive but prescriptive. His "identity is asserted through music."[40] Though still a "youth" by Mozambican standards, situated in a passive cultural context, Ibraimo has demonstrated incredible agency through his musical practices and performance. Let's look at some of the pathways that assert his identity.

Identity. Identity is best illustrated through language and style. Ibraimo raps in street Portuguese with phrases borrowed from English. "Linguistic code-switching reflects the way that many urban youth communicate. In this sense, his use of language indexes a collectively imagined community."[41] By using both languages, he demonstrates a global and local identity. His back tracks consist of beats that could come from anywhere, though he is starting to experiment rapping over local music styles. The Internet has made sounds from all corners of the globe accessible to anyone, removing rhythms from their geocultural bounds and challenging notions of authenticity. "Language is perhaps the only indication as to how real a song is, as once the language is removed, the beats and the music will erase any notion of authenticity or origin. One would not be able to tell where the music is

[40]See Roberta R. King, *Global Arts and Christian Witness: Exegeting Culture, Translating the Message, Communicating Christ* (Grand Rapids: Baker Academic, 2019).
[41]Charry, ed., *Hip Hop Africa*, 40.

from."[42] This means that language use is the primary means by which Ibraimo and other rappers lay claim to their authenticity.

Ibraimo dresses in Western clothing (often sporting a Detroit baseball cap), projecting a cosmopolitan image. Many urban youth borrow symbols and styles from the United States, though the localized meaning differs from its original intent. Rarely do the wearers of baseball caps know what team or city the cap represents. Rather, baseball caps are worn to demonstrate notions of blackness, Americanness, and power. "This mimetic process provides youth with the means to identify and associate with an international and imagined community of hip hop culture."[43] African youth become part of a global society through assumed style and fashion choices.

Another important point here is black consciousness. Ibraimo was first drawn to rap in part because he saw a successful young black man expressing a story he related to. Other Mozambican rappers (who were drawn to American rap without understanding the lyrics) have mentioned similar connections. "They're *negros* like us!" When pressed for more details, they indicate that similar stories of a "hood life" bond them together. This explains why they also identify with Eminem—a white rapper that grew up in a poor neighborhood in Detroit. He was called *negro* because of his past, not because of his race. "The sliding meanings of blackness allow rappers to draw on a symbolic register of sameness to American hip hop, yet also to mark their own authenticity as African rappers."[44] Although most African rappers were first exposed to the genre via American rap, they credit its African roots, thereby laying claim to hip-hop as their own. Race, then, is a free-floating signifier to describe points of connection and identity.

Ibraimo asserts, "I am Nellybraim. My formal name is Manuel Ibraimo António. I'm from the north, my parents are of Arabic origin. I am Mozambican and I'm a Christian and a rapper." Ibraimo is proudly Mozambican, embraces his multicultural, multifaith heritage, and respects his familial name. He believes that his faith and his art are inextricably interwoven as a Christian rapper.

[42]Charry, ed., *Hip Hop Africa*, 72.
[43]Charry, ed., *Hip Hop Africa*, 191.
[44]Dorothea E. Schulz, "Mapping Cosmopolitan Identities: Rap Music and Male Youth Culture in Mali," in Charry, ed., *Hip Hop Africa*, 138-39.

Agency. Ibraimo maintains, "Rap is a music style characterized by freedom. There are no rules about what you express. A rapper has autonomy. You say what you think, what you believe." He appreciates the flexibility to borrow from multiple cultural contexts. In fact, the idiom of hip-hop provides "an elastic poetic structure within which (he) can elaborate both socially and musically."[45] This appropriation of rap is especially significant because "hip hop sensibilities justify youth in taking a place on the public stage and speaking as legitimate national subjects and transnational consumers." Rather than keeping quiet as the surrounding culture prescribes, rap gives youth a means to publicly voice their opinions and concerns. It affirms Ibraimo's desire to "be someone and show society that I'm already useful for others."

For some, relying on foreign sounds demonstrates not only an unhealthy obsession with the West, but also a lack of creativity. However, it is important to note that African producers intentionally mimic songs. Most musicians are self-taught, learning chiefly through imitation. Ibraimo developed credibility as a producer by spending hours in a home studio learning how to create hip-hop beats—chiefly through imitation. Once he learned the needed skills however, he branched out—experimenting with local sounds, languages, and styles. "Innovation occurs in the ways that youth modify their music, appearance, and lifestyle to connect with the many communities with which they want to be a part."[46] When Ibraimo raps locally, he wears Western clothes. When he rapped in Kenya at the 2018 Global Consultation on Music and Missions, he wore a shirt made of African print, a baseball cap, and jeans, and he carried a Mozambican flag. In this way, he demonstrated his national affiliation as a cosmopolitan African youth.

The communal process of identity creation and maintenance, visible in Ibraimo's life and lyrics, gives Ibraimo and his friends firm ground to stand on together while the sands of political upheaval and job insecurity shift around them. When one lives in a world where everything is negotiable and the margins of life are wider than the page, Ibraimo's practices and performances demonstrate a young man flourishing on the fringes.

[45]Charry, ed., *Hip Hop Africa*, 39.
[46]Charry, ed., *Hip Hop Africa*, 188.

MISSIOLOGICAL CONCERNS: RAP AND MISSIONS

I recently sent out a questionnaire about youth to WorldVenture mission-aries across Africa. Out of the sixteen responses, nine countries were repre-sented, including all regions of sub-Saharan Africa. When asked, "How are youth viewed in your context (in and beyond the church)?" 73 percent had negative descriptors.[47] When asked how youth self-identify, 56 percent also had negative descriptors.[48] *Ambiguity* seems an apt summary word to de-scribe perceptions of youth across Africa.

According to the survey, the most pressing issues for youth in Africa are employment (94 percent), education (50 percent), sex (50 percent), and social status (19 percent). A ranking question (fig. 8.2) mirrored the open-ended responses.

When asked, "What is the church doing to reach youth?" the responses varied from Bible study to youth events. However, most stated, "Not much."

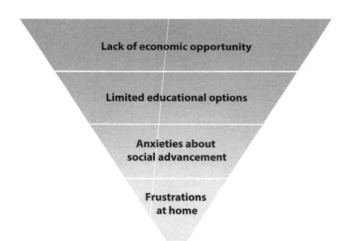

Figure 7.1. Ranked concerns for African youth

[47]Negative descriptors of youth included "problem, entitled, lazy, different, unresponsible, bottom (of totem pole/social ladder), trouble-makers, less important, keep place, no voice."
[48]Negative self-descriptors of youth included "suppressed, misunderstood, uninvolved, no place, no need to contribute to society, lots to contribute but no chance to do so, torn, not own person, lack of opportunities for advancement/dissatisfaction with future, question/reject parent's traditions."

This is concerning. The median age of all countries who responded to the survey is between sixteen and twenty-one years of age. Why is it that over a third of the churches surveyed are "not doing much" to reach the majority of the population? I contend that churches must step up to the challenge of reaching the future voice of the church.

Rap as a genre isn't seen as Christian in Africa. Though rap lyrics may be biblical and promote positive moral values, the music is condemned. Ibraimo affirms, "I think rap is a threat." Negative stereotypes of youth may impact opinions of rap as a genre always in flux, "faddish, incoherent, yet pervasive because of its loudness and seeking to destabilize tradition while invoking indigenous heritage for life and continuity."[49] Rap represents youth and immorality—neither of which are viewed favorably by the church. This popular expressive form—unavoidably present across the continent—further distances older Christians from younger believers.

We need to address the generational gap that plagues the African church. "What happens to these youth matters—mischief and misfortune often occupy the space left behind by lack of work and structure."[50] This is clearly evidenced in the ongoing conflicts in northern Mozambique, where marginalized youth are weary of watching economic opportunities slip through their fingers. With millions of youth stalling in the march to adulthood across the continent, discovering how to reach and raise these youth is the most urgent task of the African church in the next decade.

KEY CONSIDERATIONS FOR CULTURALLY APPROPRIATE COMMUNICATION OF THE GOSPEL

In this chapter, I have sought to clearly demonstrate that culture is open-ended, mobile, relational, and virtual. In this regard, hip-hop shares with culture the ability to reconfigure itself. "Perhaps the most controversial and urgent concern among the young African hip-hop generation is how to embrace, shape, and use hip hop so that it can function as an authentic expression of their identity."[51] This concern is hardly unique to Africa. One would be hard pressed to find a corner of the globe untouched by hip-hop,

[49]Charry, ed., *Hip Hop Africa*, 185.
[50]Olopade, *Bright Continent*, 195.
[51]Charry, ed., *Hip Hop Africa*, 285.

and youth everywhere are finding ways to make it their own. In the face of
an increasingly flattening and shrinking world, what does it mean to reach
and raise urban youth in southern Africa?

The enormous demographic change of Christianity worldwide and the
globalization of missions highlights the need to reconfigure how mission is
done. Ott argues that we must move toward a complementary model of
contextualization, a model that enables people to navigate rapid social
change and the process of hybridization while remaining rooted in biblical
truth and identity and drawing upon ecclesial historicity and the global
hermeneutical community.[52] Below are key considerations for culturally ap-
propriate communication and contextualization of the gospel in relation to
hip-hop and mission.[53]

Authenticity. Here I define authenticity as being true to who you are—to
be authentic is to have integrity. "Authenticity is thought of as residing in a
person who has acquired the knowledge that permits him or her to perform
authentically."[54] Daniel White Hodge enlarges the definition to include re-
alism, openness, transparency, and honesty—redemptive qualities that lead
to transformation.[55] Authenticity is a key value—both in rap and in sharing
the gospel message. Rappers place a high priority on "keepin' it real," pro-
claiming truth that speaks into a given locality. Ibraimo goes so far as to state,
"I don't think I'll have a market beyond my context. I speak from my context
to my context." A rapper's life and a rapper's message are connected. "Our
style has more *sentido* (sense) when it's true. It's futile without a connection
to reality." The most respected rappers always voice who they are.

While authenticity and identity are fluid terms that can easily be con-
tested, they can still be effective fields of analysis. However, from an ethno-
musicological standpoint, the key issues are not authenticity but rather the
criteria and codes of authenticity used by the artist and audience. These
codes of authenticity must be explored and understood in each cultural

[52]Ott, "Globalization and Contextualization," 43-58.
[53]Based on Sandra Van Opstal's categories of reconciliation in worship found in *The Next Worship: Glorifying God in a Diverse World* (Downers Grove, IL: InterVarsity Press, 2016), 62.
[54]Bonnie C. Wade, *Thinking Musically: Experiencing Music, Expressing Culture* (New York: Oxford University Press, 2004), 142-45.
[55]Daniel White Hodge, *The Soul of Hip Hop: Rims, Timbs and a Cultural Theology* (Downers Grove, IL: InterVarsity Press, 2010), 36.

context to contextualize the gospel in a way that rings true and keeps it real. Striking a balance between local authenticity and global citizenship is an important concern not just for African youth but for an increasing number of people with multiple homes and identities. Grounded performance enables hip-hoppers and missionaries alike "to negotiate a sense of authenticity on their own terms."[56]

Solidarity. Solidarity, an identification with the story of another, is another value in rap music. Even though Ibraimo couldn't understand the American slang in the music videos he watched as an adolescent, he identified with the images of a young black man overcoming incredible odds and transforming pain into creative expression. "Hip hop brings a community into being through performance, and it maps out real and imagined relations between people that speak to the realities of displacement, disillusion, and despair."[57] Social capital gained from a shared history (imagined or inferred) is important currency.

Community through performance can be created by collective listening to music and mimetic expressions of solidarity through style and language. For many young audiences, "mobilizing and representing emotions offered a fertile ground for processes of collective and individual identity formation."[58] Listening together to lived and told stories coalesces rappers and missionaries into a shared experience of *communitas*, a shared identity that can be transformed into action.

Hospitality. Hospitality is a sense of welcome, a place of belonging. It is what youth feel the lack of when they approach churches. Ibraimo reveals, "When someone talks about church, from the beginning we youth think of it as something very conservative. Because of this conservative aspect when a young person goes to church the first thing they see is there is no love, no welcome, there is just rules. We need to work more to create ways to attract youth, to show them that the church is a way for them to receive help and liberty—a liberty that won't harm their future." For instance, the Christian concept of personal agency empowers youth to make choices that produce

[56]Charry, ed., *Hip Hop Africa*, 73.
[57]Charry, ed., *Hip Hop Africa*, 73.
[58]Seebode, "Popular Music and Young Male Audiences in Contemporary Malawi," in Charry, ed., *Hip Hop Africa*, 237.

positive consequences in their lives rather than passively accepting fate, that is, *se Deus quizer* ("if God wishes").

Concerto Gileade is an example of a safe space where youth can perform and process relevant life issues. Events like these are central to youth culture; they provide artists with opportunities to transmit a message in an environment that asserts their identity through performance. They function as "performance events, peer gatherings, political soap-boxes and identity forges."[59] At least in the case of Mozambique, it is clear that if African churches do not open their arms and embrace the future of their faith, youth will find alternate spaces for support.

Mutuality. Mutuality is where we learn from each other. Ibraimo declares, "I want to be a good influence, a role model for others in my *bairro.*" He recognizes that music is influential, that his life and his lyrics testify about his relationship to Christ. "I control what I say because I know the power of my words." This view that words have power is common throughout sub-Saharan Africa. Self-conscious invocation of the power of words and public speaking continue to reinforce youth's right to speak in public—giving voice to a transformative process of learning together.

Many rap songs are didactic in nature, and artists take on the role of educators, raising youth consciousness in performances. "It is at this nexus of social practice and musical performance that a youth identity in politics emerges, employing performance as a way to generate awareness, if not effect change."[60] Rap provides a platform for processing societal problems through education and entertainment. Youth learn from each other through artist-based camps or apprenticeship in studios. These platforms provide youth with a strong social network that aids them in establishing a career and getting their message out to a broader community.

What can we learn from hip-hop's global popularity that can be applied to missiological initiatives? The success of rap throughout southern Africa attests to the fact that while hip-hop is a global genre, it addresses regional and national issues and draws on distinctly local traits. In other words, rap has contextualized to the point that it is a genre at home in Africa and an authentic creative expression of grounded realities. Hip-hop's global appeal

[59]Charry, ed., *Hip Hop Africa*, 114.
[60]Charry, ed., *Hip Hop Africa*, 116.

attests to the fact that comprehensive, complementary, and perhaps even creative contextualization is needed. Can missiologists take a page from "the global spread of a culture of being true to the local"?[61]

CONCLUSION: CREATIVITY FOR A CHANGE

Appropriating and transforming a foreign art form into a locally meaningful genre is not new for Africans. However, hip-hop's relatively recent arrival on the continent's shores and its subsequent alterations provides us with a rich laboratory in which to observe processes of cultural change. In this laboratory, three paths to reach and raise the future voice of the church are clear:

1. Giving youth relevant experience through practical training.

2. Reaching youth through more creative channels.

3. Encouraging a spirit of responsibility in future leaders.

African churches are ill equipped, under resourced, and hesitant to reach and raise youth. Yet coherent ministry strategies and commitment to youth can challenge ecclesial stagnation and fill the void of "waithood."[62] Ibraimo's rap group regularly meets for Bible study and self-theologizing through composing rap lyrics based on the Scriptures. These times of group study provide the members with a community and a sense of purpose, and the reflexive process of writing enhances and extends the scriptural truths in their lives. As they refine their lyrics together and then perform them in neighborhoods, their worship response to God's Word becomes a witness, drawing other youth into communion with Christ.

It is time for African youth to be the voice of positive change and social healing in their communities. The ongoing conflict in northern Mozambique attests to the fact that youth are increasingly restive and pressing for solutions to persistent problems of poverty and corruption. Rather than sit idly by, churches can creatively engage in this transformative process by providing real skills and increased leadership opportunities within and beyond the four walls of the church.

[61] Alastair Pennycook, *Global Englishes and Transcultural Flow* (New York: Routledge, 2007), 98.
[62] Practical examples of these pathways include developing grassroots leadership and role modeling, creating safe spaces to learn and establish adaptive habits, and generating attachment employment via apprenticeship (Olopade, *Bright Continent*, 195).

As most Mozambican churches use youth to lead worship through music, one practical way churches can minister among youth is to provide platforms for musical performance. By developing a fully orbed worship arts ministry and investing in its members, churches give youth real opportunities for training and leadership. Music then becomes a means of empowerment and a form of expressive agency, allowing Christian youth to voice a counternarrative of hope and build a bridge for interreligious dialogue and peacebuilding.

Rap demonstrates that interconnectedness across time, space, culture, and language can happen. Ibraimo claims, "We are globalized so we can flow." Global flows reach every shore. Perhaps a fluid identity is not as new as it appears. First Corinthians 9:19-23 states, "Though I am free and belong to no one, I have made myself a slave to everyone, to win as many as possible. . . . I have become all things to all people so that by all possible means I might save some. I do all this for the sake of the gospel, that I may share in its blessings."

Here the apostle Paul clearly references multiple belongings (Jew, under the law, not having the law, weak) as a means of reaching people for the kingdom. Is it possible that the *missio Dei* is more globalized than we realize? I believe so. We are all pilgrims searching for *imago Dei*, and as we travel along the way, we can welcome, walk with, and learn from each other, and cocreate together.

"Let the Sacred Be Redefined by the People"

An Aesthetics of Challenge Across Religious Lines

Michelle Voss Roberts and Demi Day McCoy

In search of holistic Christian witness, missionaries have increasingly sought to take into account all the dimensions of people's cultural and religious lives, including their songs, their dances, their dramatic performances, their proverbs, their epic narratives (storytelling), and their visual arts."[1] From the early weeks in Ferguson after Michael Brown was killed, ministers of the gospel have been vividly enacting this process in the public eye. This is not a calculated attempt to evangelize by meeting people where they are. Rather, by joining people where they are, they have discerned the contours of the gospel for an age of militarized police forces, for-profit prisons, and systematic dehumanization of black bodies.

Applying *rasa* theory—an aesthetic theory originating in India—to understand transcendence in hip-hop music, this chapter discerns the role of aesthetics in bridging diverse cultural and religious groups through the common human experience of resisting injustice.[2] We (Demi and Michelle) will then propose that in order to preach the gospel for a time such as this,

[1]Fuller Theological Seminary, "2018 Missiology Lectures: Global Arts and Witness in Multifaith Contexts," www.eventbrite.com/e/2018-missiology-lectures-global-arts-and-witness-in-multifaith-contexts-tickets-45736713742.

[2]As such, it contributes to the larger project of conference organizers Roberta King and William Dyrness to develop an "interfaith aesthetics." See William Dyrness, *Senses of Devotion: Interfaith Aesthetics in Buddhist and Muslim Communities* (Eugene, OR: Cascade, 2013), xi.

Christian ministers must listen. Indeed, many are doing just this by going to where the people are, by standing amid the protests, and by awakening to the idea that they know how to define justice.

THE RASA OF CHALLENGE

This project represents an extension of Michelle's comparative study of Hindu and Christian religious emotions through the lens of classical Indian aesthetic theory. This theory analyzes how art produces *rasa*—the transcendent experience of aesthetic tasting or savoring a mood—by elevating common human emotions. Classically, there are eight basic aesthetic moods (*rasas*): erotic love, humor, fury, compassion, disgust, heroism, fear, and wonder; later thinkers added peace as the ninth *rasa*. The *rasa sutra* is a pithy formula that states that *rasa* arises in an audience when certain excitants, indicators, and complementary emotional states are present. Michelle's 2014 book *Tastes of the Divine* follows Indian philosophers and theologians in using this concept to examine features of contemplative peace, devotional love, and prophetic fury; and it argues that the commonalities embodied in these modalities facilitate interreligious understanding.

Around the time this research was published in 2014, Michael Brown, a young black man, was shot and killed by police officer Darren Wilson on the street that runs through the Canfield Green apartment community in Ferguson, Missouri. Michael Brown died with his hands raised in surrender. His bleeding body was left in the street for four hours. The ensuing protests lasted for months outside the police station. As similar incidents were publicized in subsequent years, Black Lives Matter movements proliferated. Communities around the nation memorialized the slain with rituals of reading the names of Michael Brown, Eric Garner, Freddie Gray, Trayvon Martin, Tamir Rice, Philando Castile, Alton Sterling, Walter Scott, and other black and brown victims of police violence. Americans were encouraged to "Say Her Name" in order to remember the women who shared the same fate.[3] Interfaith coalitions have mobilized around these issues, bringing people of faith together to work for justice.

As we participate in these movements and observe similar movements around the globe, we identify what may qualify as an additional *rasa*: the

[3]"#SayHerName," Black Lives Matter, http://sayhername.blacklivesmatter.com/.

rasa of challenge. To qualify as a *rasa*, the heightened emotional state must be common enough to human experience to be understood across contexts. We believe we are discerning this kind of cross-cultural human understanding. Weaving throughout the contemporary moment is an aesthetic that hones and heightens the mood of protest, that rises against injustice in the face of danger, and that inspires solidarity among diverse cultural and religious groups.

We offer evidence of this shared aesthetic by focusing on one of its principal forms: the physical and emotional expressions of hip-hop. It is true that other genres participate in the *rasa* of challenge, as exemplified by the diverse "movement music" employed by Repairers of the Breach and the Poor People's Campaign.[4] However, hip-hop offers an especially salient example of a genre whose contexts and expressions are being mobilized to challenge injustice across cultures. Although US hip-hop charts are primarily dominated by records focused on wealth and pleasure, a plethora of justice-oriented hip-hop artists are creating art that lies at the heart of recent movements such as Black Lives Matter.

By attending to the *rasa* of challenge, with hip-hop expressions as our focus in this chapter, we are not advocating that Christian missions adopt hip-hop as a medium for the message. Rather, the learning for us as religious leaders is that we should become *sahrdayas*, as Indian aesthetic theory puts it: our hearts (*hrd*) should learn to resonate with (*sa*) this aesthetic. We will not adequately understand the contexts for mission today without attending to the *rasa* of challenge. However, it takes training to become a cultured and receptive audience for these expressions. For this reason, we will spend some time outlining the factors that evoke this mood across religious and cultural contexts, using the *rasa sutra* as our guide. By attuning our hearts to the aesthetic of challenge, by learning how justice is being redefined by the people, we might hear something of the heartbeat of Christ and participate in this movement of the Spirit.

This treatment of religion and hip-hop builds on earlier scholarship that has demonstrated the relationship between hip-hop and the black religious experience. Derek Hicks and Anthony Pinn both give voice to the black

[4]Phone conversation with Yara Allen and Shyrl Uzzell, director of cultural arts and seminary tour coordinator for Repairers of the Breach, North Carolina, June 1, 2018.

religious experience with particular emphasis on its relation to oppression. According to Hicks, the hallmark of the black religious experience is its protest against degradation, abuse, and constriction.[5] It is a quest for full humanity—or, as Pinn argues, for a "complex subjectivity" that holds different ontological possibilities in tension with one another.[6] For Pinn, the quest is a movement from identity as an object controlled by oppressors to a subject and creative conveyor of cultural meaning. These definitions of the black religious experience coalesce with the ethical orientation of hip-hop music and culture. However, whereas Pinn and Hicks focus on this expression within a black religious context, the particular aesthetic theory we use attunes us to how hip-hop communicates religious values across communal contexts.

HIP-HOP AT THE CENTER

Birthed in Bronx, New York, hip-hop was a movement of expression developed at house parties alongside a postindustrial backdrop.[7] The movement was pioneered by the record spinning of DJ Kool Herc and others such as DJ Grandmaster Flash and Afrika Bambaata.[8] The success of this newfound style of disc jockeying with breakbeats quickly became popular and led to the art of emceeing and breakdancing.[9] In hip-hop culture, emceeing is a form of poetic articulation in which the master of ceremonies (known today as an emcee, MC, or rapper) speaks rhythmically over the breakbeats spun by the DJ and commands the crowd.[10] Likewise, breakdancing is a form of body expression that b-boys and b-girls perform over the breakbeats.[11] Graffiti writing became the latest leading visual expression of the hip-hop movement.[12]

Although hip-hop may have gained its popularity at parties, it quickly became a vessel for social justice messages as many early hip-hop artists

[5]Derek S. Hicks, "Youth, Hood, and Hip-Hop," lecture delivered at Wake Forest University School of Divinity, Winston-Salem, North Carolina, January 28, 2015.

[6]Anthony B. Pinn, *Terror and Triumph: The Nature of Black Religion* (Minneapolis: Fortress, 2003), 158.

[7]Joseph C. Ewoodzie, *Break Beats in the Bronx: Rediscovering Hip-Hop's Early Years* (Chapel Hill: University of North Carolina Press, 2017), 21-24.

[8]Ewoodzie, *Break Beats in the Bronx*, 17-19, 40, 51, 52, 58.

[9]Ewoodzie, *Break Beats in the Bronx*, 88-89.

[10]Emmett George Price, *Hip Hop Culture* (Santa Barbara: ABC-CLIO, 2006), 34-36.

[11]Ewoodzie, *Break Beats in the Bronx*, 46-48.

[12]Ewoodzie, *Break Beats in the Bronx*, 31-36.

used their forms of expression to address social issues within their community. One of the earliest and most notable examples of this type of subject matter is the record *The Message* by DJ Grandmaster Flash and the Furious Five. The song features lyrics that speak about the reality and impact of living in poverty. In addition to the illumination of the lyrical content, the music video for this song also serves to bring forth the realities of poverty. It depicts scenes of the barrenness of abandoned buildings in the Bronx and juxtaposes it with scenes of the business of downtown New York. The video also concludes with a skit that shows police brutality toward black men as the Furious Five themselves are seemingly approached and arrested for no crime at all. Other popular and earlier influential songs that carry a social justice message with them include, "F*ck the Police" by NWA, "Police State" by Dead Prez, "U.N.I.T.Y." by Queen Latifah, "Get By" by Talib Kweli, and "Brenda's Got a Baby" by Tupac. Songs like these and their accompanying music videos help to highlight various issues such as poverty, police brutality, sexism, and more.

Since its emergence from the Bronx, New York, hip-hop has proliferated and permeated mainstream culture and become a dominant force in the music industry. Following the recording of "Rapper's Delight" by Sugar Hill Gang, hip-hop has spread across the country and across the world.[13] Once hip-hop reached a national audience, artists in various demographics added to its complexity and depth. However, even with the diverse boundaries that hip-hop has crossed, we will see that a certain overall aesthetic continues to pervade these expressions, especially when hip-hop has been used as a catalyst for change through the *rasa* of challenge.

A good example of the overriding aesthetic of hip-hop is the record *F*ck the Police* by NWA. They recorded this record on the West Coast six years after *The Message* was recorded on the East Coast. Despite the coastal difference and time gap, the record still possessed many similarities to *The Message*. It takes on the task of bringing to light the reality of social injustice, this time with a primary focus on police brutality rather than an emphasis on poverty. The visual that accompanies the record depicts police brutality and the forceful arrest and mistreatment of black men. It also shows poverty

[13]Ewoodzie, *Break Beats in the Bronx*, 164-65.

in the Compton area of Los Angeles, California. The group asserts a bold stance toward this topic while shedding light on these conditions.

Over the last few decades, hip-hop has spread tremendously across the globe, putting it in a unique nexus of intercultural and interreligious dialogue. The proliferation of hip-hop can be seen in the diverse array of hip-hop artists worldwide. Additionally, the universal popularity of hip-hop can be seen in the sold-out shows played by US hip-hop artists in countries abroad. The worldwide transcendence of hip-hop is especially seen when artists perform for audiences whose primary language differs from the language of the music being showcased, as at the Trinity International Hip-Hop Festival. Now embarking upon its fourteenth year, the festival has become a staple event for Trinity College in Hartford, Connecticut. Although US-based, the festival brings together hip-hop artists from all over the world for hip-hop cyphers, breakdancing, graffiti exhibits, academic panels, and stage performances. Artists perform in different languages and shared cultures with one another while also bonding over the common artistic expression hip-hop offers.

A couple of examples of hip-hop outside of the United States can illustrate the intercultural dimensions of hip-hop as a phenomenon. In 1999, the genesis of hip-hop in Palestine came by way of a group from Lod, Israel/Palestine called DAM. The group was initiated by rapper and artist Tamer Nafar and his brother Shuel, who first discovered hip-hop through the music of Tupac Shakur. Tamer was captivated by the similarities of police brutality and poverty depicted in Tupac's music video with conditions in Lod. He began to memorize and translate Tupac's lyrics and soon began to write and record his own.[14] In the wake of the Second Intifada, politically charged songs such as "Innocent Criminals," "Who Is the Terrorist," and "Channels of Rage" employ many of the same visual and lyrical cues that Tupac and others employ to challenge the status quo in their contexts.[15] In another part of the world, the hip-hop duo Krudas Cubensi views their hip-hop

[14]Joshua Metnick, "Meet the Hip Hop Artist at the Center of Israel's Culture Wars," *LA Times,* January 11, 2017, www.latimes.com/world/la-fg-palestinian-hip-hop-2016-story.html.

[15]A documentary film, *Slingshot Hip-Hop,* follows this development as well as the international connections, including with rap groups in Israel, made possible through this aesthetic. See Jacqueline Reem Salloum, *Slingshot Hip-Hop,* directed by Jacqueline Reem Salloum (USA/Palestine, 2008).

writing as a form of art activism. With many of the same visual and lyric elements, they give voice to feminism, veganism, queer sexuality, and political issues in Cuba. We will return to the work of these two groups, as well as a selection of rappers from the United States, to illustrate features that translate across cultural contexts.

HIP-HOP, AESTHETIC THEORY, AND THE RASA OF CHALLENGE

Classical Indian aesthetic theory would attribute the ability of cultural form to transcend cultures to the power of *dhvani,* or the "resonance" of the expression with common embodied human experiences in the heart of each viewer.[16] In different languages and political contexts, hip-hop taps into a powerful human urge to challenge injustice. This phenomenon points us in the direction of naming a new *rasa*: the *rasa* of challenge. This aesthetic mood (*rasa*) is a heightening of the ordinary attitude (*sthayibhava*) of defiance into a shared experience of *challenge* that calls into question, disputes, or confronts the injustices of dominant cultural norms.

Immediately, we must note that the aesthetic we are describing does not fit easily into the classical list of nine aesthetic moods. Written in Sanskrit, an elite language, the *Natya Sastra* reflects the values of the priestly and ruling classes. The purpose of drama, as stated in *Natya Sastra* 1.108-10, is that it

> teaches duty to those who have no sense of duty, love to those who are eager for its fulfillment, and it chastises those who are ill-bred or unruly, promotes self-restraint in those who are disciplined, gives courage to cowards, energy to heroic persons, enlightens [persons] of poor intellect and gives wisdom to the learned. This gives diversion to kings, and firmness [of mind] to persons afflicted with sorrow, and [hints of acquiring] money to those who are for earning it, and it brings composure to persons agitated in mind.[17]

These stated functions reinforce rather than challenge the status quo by emphasizing art in the service of duty, order, and composure. The *Natya Sastra* also acknowledges certain moods in a distinctly class-based manner.

[16]Anand Amaladass, SJ, *Philosophical Implications of Dhvani; Experience of Symbol Language in Indian Aesthetics* (Vienna: Institut für Indologie, Universität Wien, 1984).

[17]Bharata, *Nātyaśāstra of Bharatamuni: Text, Commentary of Abhinava Bhāratī by Abhinavaguptācārya and English Translation,* ed. Pushpendra Kumar, trans. M. M. Ghosh (Delhi: New Bharatiya, 2006), 1:33.

For instance, it describes the furious sentiment, the *rasa* related to the ordinary emotion of anger, as having its origin in low-class persons naturally given to fighting and violence. "Well-bred" people do not act in this manner.[18]

Although the culturally privileged perspective of the classical tradition does not portray such "naturally" furious characters sympathetically, human experience is broader than what is prescribed by dominant cultures. In the contemporary period, the means of production have been democratized. Social media make nonelite art forms globally accessible. Theorists can now attend to these marginalized perspectives with greater nuance.

Because the affective postures that defy dominant norms also belong to the human repertoire, we playfully propose to write a "missing" section of the *Natya Sastra* by exploring the *rasa* of challenge. To this end, we ask, What is it about this aesthetic that resonates so strongly across cultures? *Rasa* theory can assist us in naming the ingredients for this potent recipe. *Rasa* arises in the spectator of a drama through "the combination of excitants, indicators, and transitory emotional states."[19] According to the *rasa sutra*, when these three things combine, the attuned audience member will be able to taste the essence of this core human experience—challenge. We will take a look at the excitants, indicators, and accompanying emotional states of this *rasa* by returning to some of the hip-hop acts previously mentioned.

Excitants. The excitants or contextual markers (*vibhavas*) for the *rasa* of challenge are those that illustrate the injustices or cultural norms being called into question. The most prevalent excitants seen in hip-hop performance include poverty, police brutality, drugs, and gun violence. Excitants such as poverty and police brutality show the realities that this *rasa* protests. This is similar to the furious sentiment, which emerges from depictions of anger at outrages such as rape, abuse, insult, untrue allegations, threats, jealousy, and the like.[20] In the song "Born Here," the rap group DAM aims to shed light on the conditions of their neighborhood. Poverty is evident through visual cues such as a police station that replaced a school, an area slated for demolition, and a lack of utilities such as water and electricity. The

[18]Michelle Voss Roberts, "Dalit Arts and the Failure of Aesthetics," *Tastes of the Divine: Hindu and Christian Theologies of Emotion* (New York: Fordham University Press, 2014), 129-30.

[19]Author's translation of the *rasa sūtra: tatra vibhāvānubhāvavyabhicārisamyogādrasanispattih.* See also the prose after Bharata, *Nātyaśāstra of Bharatamuni* 6.31 (227).

[20]Bharata, *Nātyaśāstra of Bharatamuni* 6.63 (262).

music video begins with a scene of an armed Israeli patrol approaching and harassing the Palestinian rap group as they begin to belt out their lyrics to the music. In the first verse, rapper Mahmud Greri introduces listeners to the town of Lod, where law enforcement officers label Palestinians as criminal just for living there. The second verse is rapped by Tamer Nafar, who talks about how many homes are destroyed in Lod, and the video eventually cuts to scenes of the rap group performing amid the rubble and dust of their homeland. The chorus poetically compares the city to a bride without a veil and a bird that will break free of its cage.

Drugs and gun violence also function as excitants of the *rasa* of challenge, though with somewhat more complexity, as these show how community members themselves are intertwined in the situation being challenged. The music video for "Chrome" by Rapsody displays these as a (criminal) solution to poverty. In the opening scenes, one sees several young black people carrying guns in their hands and pockets. They approach someone sitting in a vehicle and steal the car. Later, the viewer sees this group drinking and smoking—self-medicating through alcohol and drug use—when the person whose vehicle they stole approaches them with a gun and begins to shoot at them. The final scenes show a cop approaching the situation and pulling out his gun to resolve the issue. Rapsody then walks slowly past the cop car. This cycle of destruction of self and others, all within the context of police surveillance, creates the conditions for challenge to emerge.

Indicators. The second feature in the *rasa sutra* is the indicators (*anubhavas*) that characters display in response to the contexts just named. For instance, for the furious sentiment, the *Natya Sastra* prescribes "red eyes, knitting of eyebrows, defiance, biting of the lips, movement of the cheeks, pressing one hand with the other" as well as acts of violence in combat.[21] For the *rasa* of challenge, hip-hop performances in "Slingshot Hip Hop," a documentary about DAM, shows shameless gestures such as shouting, crowds raising their fists, dancing, and wearing divergent styles of clothing. Gathering in a crowd is another important indicator of this *rasa*. "Born Here" by DAM depicts large groups of Palestinians, presumably from this area and affected by difficult living conditions, actively engaging in protest. A variation

[21]Bharata, *Nātyaśāstra*, prose after VI.63: 261.

on the theme of community gathering appears in the music video for Kendrick Lamar's song "King Kunta." The opening scene shows the sign "City of Compton" to signify the community Kendrick wants to uplift, and he is surrounded by people from his community for the remainder of the video. In one scene, Lamar raps on top of a building with a crowd beneath him cheering him on; in another, he sits on a throne, surrounded by men from different generations dancing defiantly for the camera. These community gatherings permeate hip-hop culture both as a challenge to the individualistic scripts of modern society and to display strength to groups in power.

Complementary emotional states. The third major ingredient for the *rasa* of challenge is its complementary emotional states (*vyabhicaribhavas*)— a variety of sentiments that add depth and nuance to the mood through various combinations. For the *rasa* of challenge, these might include anger, anxiety, fearlessness, numbness, hope, motivation, innovation, pride, survival, and solidarity. Bravado pervades the hip-hop aesthetic of challenge, demonstrated through the use of fashion and particular displays of demeanor. Kendrick Lamar expresses a great deal of bravado in the lyrics as well as the physical delivery captured in the music video for "King Kunta." In the chorus, Kendrick boasts that he is in charge not only of his life but the "game" of rap. In the hook, he declares himself "King Kunta," placing a royal title on a recognizable slave name. This bravado is often accompanied by a reclamation of devalued bodies and voices. Stating, "Everybody wanna cut the legs off him, black man taking no losses," Lamar reclaims his legs or body for himself to run, not walk, to enact his own power.[22] These complementary emotional states appear again in Krudas Cubensi's performance of "Mi Cuerpo Es Mio" ("My Body Is Mine"). In solidarity with marginalized groups of women of African, Latin American, and Caribbean descent, the artists reclaim their bodies as well as their voices as queer women. In the repeated lines, "Keep your rosaries out of my ovaries," the duo challenges religious authority with the claim that women, not the church, own their bodies.[23]

[22]Mark Lawson, "Roots Revival: How Does the New Kunta Kinte Compare to the Classic?," *The Guardian*, February 8, 2017, www.theguardian.com/tv-and-radio/2017/feb/08/roots-revival-how-does-the-kunta-kinte-remake-stand-up.

[23]Isis Madrid, "Rap Duo Krudas Cubensi Give Queer Afro-Cubans a Voice," *PRI*, March 22, 2016, www.pri.org/stories/2016-03-22/rap-duo-krudas-cubensi-gives-queer-afro-cubans-voice.

The various complementary states of a *rasa* can exist simultaneously, in sequence, or in juxtaposition with each other. The music video for "This Is America," directed by Hiro Murai and performed by Childish Gambino, is a salient example of how they can unsettle one another in the *rasa* of challenge.[24] The video lays out an ironic dissonance between the emotional states of pride and rage for black men in the United States. Gambino is seen asserting himself as both a powerful entertainer advancing popular musical genres and dance moves in America and a member of a race that can be shot and killed in an instant without much remorse or care at all. Visual political chaos proliferates as Gambino both entertains the audience with popular dance moves and senselessly shoots a whole choir dead. This combination leaves the viewer feeling challenged. In the midst of the tug-of-war between black humanity and its dehumanization, what is the viewer to do?

IMPORTANCE FOR CHRISTIAN MISSION

Through the lens of hip-hop music, we have demonstrated that the *rasa* of challenge transcends particular cultures and is rooted in common human experiences of injustice, resistance, and the range of emotions that accompany it. We have suggested that it is a *rasa* distinct from others named in the classical Indian aesthetic tradition, such as anger, because it is a fundamentally life-giving impulse that challenges whatever is oppressive about the status quo. It arises from the margins of society and within those who stand in solidarity at the margins, so it expands and even counteracts the social function of art imagined in the ancient aesthetic tradition.

The aesthetic brings people together to work for justice. We have outlined the power of hip-hop to bridge international borders by building expressive bridges between movements of disenfranchised youth in Palestine, Israel, the United States, Cuba, and many other countries. Although religious bodies have an important role in these movements, the momentum is born on the margins of society. As Brittani Gray, a Ferguson activist and seminary student, puts it:

Though this sense of self-possession may make Christians squeamish if they emphasize God's sovereignty or insist on a pro-life stance, it is crucial for people who have experienced the history and residual traces of a slave system.

[24]Jordan Darville, "'This Is America' Director Hiro Murai Breaks Down the Video in New Interview," *The Fader*, May 11, 2018, www.thefader.com/2018/05/11/this-is-america-director-hiro-murai -music-video-interview.

While I agree that there is a moral authority that comes from the church, this movement was not started by the church . . . this is really a movement of the streets. It's a hip-hop movement. And so, as much as I am made and informed by the church, I am just as much made and informed by hip-hop as a culture. I live and breathe it, and so, yes, I would have been engaged regardless because I grew up listening to Tupac and Biggie, to Common, to Dead Prez, to Eric B. and Rakim. I grew up on all of it. All of it which told me that the system was messed up, and I cannot listen to those lyrics, see those lyrics, internalize those lyrics, and not have a response.[25]

We now insist that this resistance belongs to the work of the gospel. Christians taste the *rasa* of challenge when they meditate on the Jesus story— when they see the oppression of the exodus people under the Roman Empire, when they observe how Jesus gathered a community around him to reverse its values, and when they feel his anger at exploitation and the hope and compassion he embodied. Many Christians today recognize this pattern and venerate the priests and nuns who entered into solidarity with the base communities of Latin America in the twentieth century. Today, cell-phone cameras and social media have made it impossible to deny that the violence of empire against the poor is being enacted in ordinary communities all around us. The excitants, indicators, and complementary emotions are present, and if ministers of the gospel are attuned to it, challenge will arise. Jesus's solidarity provides a template for Christian mission in the world.

Ancillary leadership roles for clergy. Where does mission happen, and who are the leaders? Clergy are joining activists in the streets. When Leah Gunning Francis interviewed clergy and young leaders in Ferguson for her book *Ferguson and Faith: Sparking Leadership and Awakening Community*, she quickly realized that "the *young leaders* ignited the leadership among the clergy; they created space and impetus for the clergy . . . to live into their roles as leaders," and *not the other way around*.[26]

This ancillary relationship was illustrated beautifully at the September 29, 2014 protest at the Ferguson police station. At a particularly tense moment when protesters and police were lined up across from one another, the clergy

[25]Cited in Leah Gunning Francis, *Ferguson and Faith: Sparking Leadership and Awakening Community* (Atlanta: Chalice, 2015), 111-12.
[26]Francis, *Ferguson and Faith*, 5.

knelt in the street between them to pray. By all accounts, "the atmosphere changed from raucous and rowdy to silent. The chanting stopped and the protesters listened to the prayer. The police seemed uncertain how to respond, since they were confronted with a different kind of protester and tactic."[27] However, after the prayers, the clergy asked the protesters what they wanted them to do. They were told, "We appreciate your support, but this is our thing now."[28] The clergy stepped back to the sidewalk while the activists continued to chant and organize. This case carries important implications for the work of mission and missiology. Far from ending the clergy's work in Ferguson, their retreat to the sidelines signifies an even more important mission. Observing that the clergy "didn't try to take over or commandeer our protest," activist Jamell Spann realized over time the nature of their support: "They show up, and they lend us their bodies and their strength and their prayer, and they let us take actions and push things in the way that we felt it should go."[29]

How does mission look in this context? By listening to how justice is redefined by the people, clergy develop an understanding of the systemic injustices that lead to challenge. This enables their ministry of presence to take many forms. In Ferguson, sometimes the clergy put their bodies on the line by positioning themselves between police and protesters, assigning "the gravitas of their moral authority to the moment and the movement."[30] They went to the jail when activists were arrested and were allowed to meet with them. They lent the imprisoned activists their phones to pass news to the grassroots networks. They brokered assistance of various sorts. They called judges and lawyers who could help with getting the activists released. They became an important source of information about what "was really happening on the ground, sharing an account that was different from media reports," countering the media portrayal of the protestors as looters and testifying to the work of God in them.[31] And when the clergy were arrested, the young leaders came to wait for their release as well.[32]

[27]Francis, *Ferguson and Faith*, 10.
[28]Francis, *Ferguson and Faith*, 16.
[29]Francis, *Ferguson and Faith*, 65-66.
[30]Francis, *Ferguson and Faith*, 10.
[31]Francis, *Ferguson and Faith*, 15.
[32]Francis, *Ferguson and Faith*, 70.

Diversity and mission. Why must ministry take these countercultural forms? Rima Vesely-Flad connects this shift of attention toward grassroots activism to Jesus's own mission: he touched the untouchable, associated with the outcast, and died upon a symbol of state-inflicted violence. Today, clergy embody the teaching of the incarnation when they protest "racialized pollution boundaries."[33] Associating their vestments and rituals with black and brown bodies, formerly incarcerated persons, hip-hop artists, people of diverse faith traditions or no religion, and other unauthorized bodies, they perform a symbolic reversal. These same people, "in their brown skin and confrontational stance, in their raised fists and angry hip-hop chants, in their constant vigilance and presence . . . [represent] moral purity: a resurrected Christ, an unwillingness for death, oppression, and injustice to remain the last word."[34]

The religious leaders embodied the values in their tradition, and the activists—who never asked for their permission or guidance—heard the message loud and clear. Alexis Templeton, Millennial Activists United's cofounder, recalls hearing United Church of Christ minister Starsky Wilson preach about Jesus turning over the tables in the temple. She connected the corruption of the moneylenders with the cycle of ticketing and warrants that generates revenue for the city of Ferguson. Templeton also references Rabbi Susan Talve, who showed up because "God was a revolutionary . . . and she believes that if everybody's made in God's image, then everybody out there is a part of God. So she needs to be out there too."[35] Being present on the margins, challenging death-dealing powers, reversing social purity codes, affirming the *imago Dei* in all, and proclaiming eschatological hope—this is how ministers embody mission in the United States today.

This is not only the case for Christian ministers of the gospel. Rabbis, imams, priests, and Christian ministers from all denominations are joining activists, who often are wary of religion, to work for justice. This is a moment in which "missions" does not signify the attempt to convert others to one's own religious framework. Rather, the work consists in building coalitions

[33]Rima L. Vesely-Flad, *Racial Purity and Dangerous Bodies: Moral Pollution, Black Lives, and the Struggle for Justice* (Minneapolis: Fortress, 2017), 184.
[34]Vesely-Flad, *Racial Purity and Dangerous Bodies*, 191.
[35]Francis, *Ferguson and Faith*, 63.

for shared visions for life together. United Church of Christ minister Traci Blackmon testifies to the confluence of diverse groups in Ferguson as "God moments," with the Nation of Islam, white and black clergy from Christian traditions, and gay ministers standing side by side with their conservative counterparts.[36] The energies that brought diverse religious groups together at the Ferguson police station are flowing elsewhere. They are not one-off events but evolving relationships that have grown into formal coalitions. We have seen these coalitions grow close to home, where the Moral Mondays movement, which began in 2013 in response to systematic voter disenfranchisement and other forms of discrimination in North Carolina, draws people together from a range of faith traditions. The new Poor People's Campaign, an outgrowth of this movement, is a good example of the evolving nature of leadership. Though Rev. William Barber often serves as the figurehead for the movement, his organization, Repairers of the Breach, works with grassroots leaders across the country.[37]

Other examples are not hard to find. The Declaration of the Interfaith Coalition for Police Reform was drafted by humanist, Jewish, Muslim, and diverse Christian signatories in 2013. Citing the "sacredness of the spirit within each and every person," they challenge "the Stop-and-Frisk policy, and . . . unfair police practices including quota systems; profiling on the basis of race, gender identity, sexual orientation, and religious identity; and the resulting abusive tactics" (PoliceReformOrganizingProject.org). Eboo Patel's forthcoming book tells the story of Rami Nashashibi and the Inner-City Muslim Action Network (IMAN) in Chicago. Even before 9/11, when anti-Muslim sentiment gave common cause to the immigrant Muslim American community and their inner-city, African American coreligionists, IMAN had bridged these divides to draw Muslims together to improve their city. They began with service work such as organizing food baskets, a health clinic, and a hip-hop music festival. Soon interfaith dimensions began to emerge. From black Pentecostal leaders, they learned the importance of community organizing to create structural change. The Jewish

[36]Francis, *Ferguson and Faith*, 25.
[37]Laurie Goodstein, "Ministers Look to Revive Martin Luther King's 1968 Poverty Campaign," *New York Times*, December 3, 2017, www.nytimes.com/2017/12/03/us/martin-luther-king -poor.html.

Council on Urban Affairs helped IMAN to develop as an institution, and the local synagogue shared their building to host an *iftar*, the meal with which Muslims break the fast during the holy month of Ramadan, with members of both communities.[38]

Religious leaders are becoming attuned to the ethical dimensions of the hip-hop movement in powerful ways. The theme of (im)purity in relation to this art form crosses religious lines. Like Vesely-Flad, Patel notes the perceived impurity of this art form and how naming this perception generates solidarity. For the first-generation immigrant Muslim community, hip-hop was an easy target as an example of the decadence of American culture. Patel's own parents resisted his interest in "black expressive culture," such as breakdancing. His research confirms that "when the immigrant narrative dominates, the African-American Muslim experience"—from slave ships to hip hop—"is often erased from the picture." However, when Na-shashibi became interested in hip-hop in the 1980s, he became attuned to references to Islam in the music and to the "connections between Islam and the black experience," and he wanted the two American Muslim communities to know more about one another.[39] The music festival—centered on an art form that many Muslim and Christian authorities view as "impure"— was key to bridging that divide. Through hip-hop, the communities found partners in a shared mission that watches the margins for cues to God's challenge to injustice.

CHALLENGE, PURITY, AND PEACE

The conference theme—art and aesthetics—is crucial for ministers of the gospel who are discerning God's call today. In Ferguson and beyond, clergy develop what Dyrness calls a "shared bodily knowledge" with the protesters.[40] In developing this bone-deep awareness, the clergy participate in the conversion that God calls for today in the United States, which is to perceive the truth that every person is fully human and a full bearer of the divine image. Their presence on the street also contributes to the aesthetic of challenge in

[38]Eboo Patel, *Out of Many Faiths: Religious Diversity and the American Promise* (Princeton: Princeton University Press, 2018), 99-101.
[39]Patel, *Out of Many Faiths*, 96-98.
[40]Dyrness, *Senses of Devotion*, 5.

redemptive ways. We conclude with a word about the difference ministers can make in justice movements.

Both Vesely-Flad and Patel have gravitated toward the perception of the impurity of the unauthorized black and brown bodies that come to voice in hip-hop and street protests. This perception is aesthetic in nature. Officer Darren Wilson's testimony was convincing to the jury because he could paint a picture of Michael Brown as "a thug or 'Hulk Hogan'" (though the two men were the same height).[41] The jurors shared in a cultural imaginary in which a black body signifies something simultaneously superhuman and animalistic. If persons like Wilson feel afraid in proximity to such a black body, then he or she is justified in shooting and killing "it." The trigger finger does not perceive someone's child, someone with a future, someone made in the image of God. Insofar as the disproportionate killing and incarceration of black men and women is undergirded by an aesthetic in which black bodies are dangerous, impure, and less than fully human, a different aesthetic sensibility must take hold in society. To reverse the inherited cultural meaning attached to certain bodies, America needs to be converted, to have a deep change of heart.

The aesthetics of challenge contributes to this conversion by drawing sympathetic hearts into a bone-deep, instinctual response to others that feels the humanity and worth of every life. This requires a change of heart, and aesthetics are one crucial means of learning to feel the world differently. The Jesus story can be integral to creating this new aesthetic. Jesus reached out precisely to those overlooked and rejected by his society. He perceived what others could not: the image of God in each person. The message of God's acceptance of each person, regardless of respectability or worth in the world's eyes, lies at the revolutionary heart of the gospel. As Brittany Ferrell, one of the founders of Millennial Activists United emphasizes, not only do *black lives matter*, but *all* black lives matter, "inclusive to black life that's gay, straight, bi, transgender, poor, well off, educated, uneducated."[42] The protesters in today's movement understand this. But does the church understand?

Clergy in Ferguson have described the instinctual shift to recognize the worth and authority of the lay protesters as "repentance." Shaun Jones,

[41]Francis, *Ferguson and Faith*, 56.
[42]Francis, *Ferguson and Faith*, 73.

assistant pastor of Mt. Zion Baptist Church Complex in St. Louis, recalls, "We apologized for not getting it. We apologized for the inconsistent presence of the black church in the community before this moment."[43] By listening to people fed up with injustice, and by accepting the protesters as they are, Christian leaders and clergy are inspired, drawn in, and converted anew to the gospel task. More than a notional acceptance, their affects and emotions change when they have tasted the *rasa* of challenge. They start to experience the affective states appropriate to this mode of engagement. Because they have entered into the embodied practices, music, and stories of the protest, their response to others is not the disgust with which one reacts to the impure but a love and solidarity that permeates their ministry.

A final aesthetic dimension that emerges when clergy are present in protest situations is the complementary emotion of peace. Michelle's earlier examination of the *rasa* of peace documented how Dalits and other Christians object to upper-caste religious ideals of meditation.[44] If pacification of the mind, senses, and all emotions is the religious goal, then does religion encourage people suffering under oppressive structures to accept the status quo? Should they suppress their anger and grief? Are they sinning if they cannot achieve calm and equanimity?

On September 29 in Ferguson, when the clergy stepped forward and Rev. Osagyefo Sekou knelt and began to pray, there was quiet for a moment. One participant remembers a "really powerful moment of peace, and the police didn't know what to do."[45] Leah Gunning Francis argues that, here, "peace did not equate silence; peace emerged in a way that gave voice to the angst and suffering of those who fought for justice."[46] It was a taste of peace on earth, of *shalom*. Forces wielding batons, tear gas, and rubber bullets dispersed. Tensions dissipated, and no one went to jail. Those who had been shouting for recognition of their humanity stood alongside those who had heard their cries. This peace was not pacifying. It was a taste of the inbreaking reign of God.

[43]Francis, *Ferguson and Faith*, 51.
[44]Voss Roberts, *Tastes of the Divine*, 45-47.
[45]Tori Dahl, an Episcopal intern from Minnesota, cited in Francis, *Ferguson and Faith*, 16.
[46]Francis, *Ferguson and Faith*, 15.

Peace is a complementary emotional state (*vyabhicaribhava*) within the *rasa* of challenge. Its surprise appearances are placeholders for the eschaton: the desired future state of affairs in which all are accepted, recognized as created in the divine image; in which everyone can walk down the street and drive a car without being molested; in which each person has a chance at a future where they are free, flourishing, and fed. These tastes of peace, which are part of the ministry of presence, hold a place for hope. And so, ministry and mission still anticipate the eschaton. Until God's will is done on earth as in heaven, ministry will have the flavor of challenge. Prophetic Christian mission will question institutional power, empower people to push back against dominant systems, and be present in the struggle for reformation.

> There's a reason why we do what we do
> Move how we move
> Basis for the way that we groove
> Speaking in tunes
> Culture birthed from rhythm and blues
> Hip Hop the news
> Come and take a walk in our shoes
> We are canvases lifted up by justice's easel
> Rewriting the narrative, this is only a preview
> If you want to make a difference in society's sequel
> Swallow your pride
> Let the sacred be redefined by the people
>
> —Demi Day McCoy, lyrics to unpublished song, "HipArt"

9

Wild, Wild China

Contemporary Art and Neocolonialism

Joyce Yu-Jean Lee

OUR TIME: THEATER OF THE WORLD

Our contemporary time is one rife with opposing social and political views. Specifically, in the United States the divide between conservatives and liberals has become increasingly pronounced. In his op-ed "The End of the Left and the Right as We Knew Them," Thomas Ebsell comments on the nascent partisan divide: "for or against 'traditional values'; young versus old; rural versus urban; the college educated versus those without degrees; blue collar versus white collar; us versus them; whites versus nonwhites; immigrant versus native born."[1]

I begin here to frame a discussion about the controversy surrounding *Art and China after 1989: Theater of the World*, the largest exhibition ever of contemporary art from China in North America, presented at the Solomon R. Guggenheim Museum in the fall of 2017. Spanning 1989 to 2008, the exhibition surveyed Chinese art starting from the end of the Cold War and the Tiananmen Square student protests to the Beijing Olympics and ascendency of the Chinese international art market. During this time, a generation of artists like Ai Weiwei arose from the creative suppression of the Cultural Revolution to bring Western ideas to China, initiating art movements, performances, and manifestos that subversively thwarted political party propaganda and established new ideals

[1]Thomas Ebsell, "The End of the Left and the Right as We Knew Them," *The New York Times*, June 22, 2017, www.nytimes.com/2017/06/22/opinion/nationalism-globalism-edsall.html.

unique to China. Ai Weiwei espouses, "The power of art is a psychological one. . . . The obligation of the artist is to use a process of self-criticism. Always distrust authority, be suspicious of centralist theories, doubt your alleged cultural influences."[2]

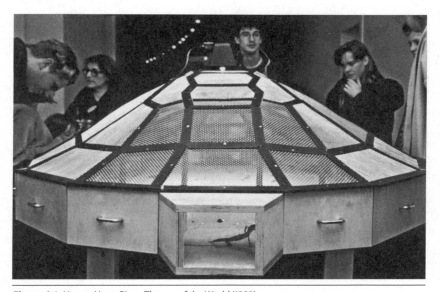

Figure 9.1. Huang Yong Ping, *Theater of the World* (1993)

The exhibition was the namesake of *Theater of the World* by Huang Yong Ping, a cage that housed hundreds of live reptiles and insects, which, over the course of the exhibition, would hunt, become prey, live, die, and give birth (fig. 9.1). Originally presented in 1993, the "survival of the fittest" metaphor is perhaps even more relevant now for the age of globalization, "foreshadowing an underlying sense of visceral realism and realpolitik." Huang Yong Ping plays with "Chinese cosmology, Western enlightenment ideas of the panopticon as a structure of control, and Michel Foucault's critiques of modernism," revealing the self-awareness Chinese artists have of their international audience and platform.[3]

[2]"Black, White and Grey Cover Books," Solomon R. Guggenheim Museum, retrieved October 9, 2018, https://www.guggenheim.org/audio/tracks/black-white-grey-cover-books.

[3]"Art and China After 1989: Theater of the World Exhibition," press release, Solomon R. Guggenheim Museum, www.guggenheim.org/press-release/guggenheim-presents-art-and-china-after-1989-theater-of-the-world-opening-october-6-2017.

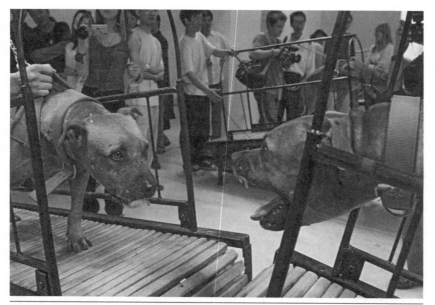

Figure 9.2. Sun Yuan and Peng Yu, *Dogs That Cannot Touch Each Other* (2003)

Similarly, husband and wife artists Sun Yuan and Peng Yu's *Dogs That Cannot Touch Each Other* was a video documenting a futile performance of eight American pit bull dogs running toward each other on handmade wooden treadmills (fig. 9.2). Chinese artists of the 1990s were emerging from a dark cloud of cynicism against the creative annihilation of the Cultural Revolution and used their own bodies, as well as those of creatures, to represent the turmoil and pressures they felt during that time of rapid transition. During the Open Door Policy period, Chinese artists watched Western audiences voraciously consume their artwork, oftentimes ignorant of the nuanced social and political commentary embedded in the content of the work.

A Case Study of Transference, Xu Bing's 1994 video of a boar and sow copulating in a performance where their flesh is painted with nonsensical English words and invented Chinese calligraphy, was intended to provoke analysis of this political and economic relationship between the West and China (fig. 9.3).[4]

[4]Matthew Haag, "Guggenheim, Bowing to Animal-Rights Activists, Pulls Works from Show," *The New York Times*, September 25, 2017, www.nytimes.com/2017/09/25/arts/design/guggenheim -dog-fighting-exhibit.html.

These three artworks garnered dizzying publicity before the Guggenheim exhibition even opened, because American animal-rights activists and protestors denounced the works "certainly not as art" and demanded "cruelty-free" works. The protests escalated to the point of death threats on Guggenheim staff when finally, the museum decided to pull the works from the exhibit to ensure the safety of its workers. These Chinese artworks were created in the context of strict Chinese government censorship and suppression of personal freedoms. The American backlash against them ironically mirrored that dramatic time in Chinese history—generating controversy in US media that disclosed a glaring cultural illiteracy of Chinese history and society. Western audiences imposed their value system (in this case of insects, animals, and pets) to judge Chinese art while simultaneously attributing value to it as an exotic foreign commodity. When Chinese discontent and activism is exported overseas, the artist's intent is often lost, oversimplified, or misinterpreted, exposing neocolonialism at its worst.

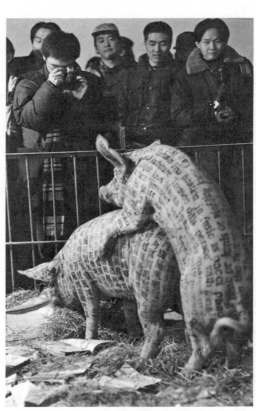

Figure 9.3. Xu Bing, *A Case Study of Transference* (1994)

This is the time in which artists and Christians live and work today. It is particularly relevant for me because my art practice criticizes how institutions of mass media and visual culture shape notions of truth and understanding of the "other." Wayne Roosa, an art historian and artist teaching at Bethel University, comments, "It is the great misstep of religion to have become conservative in posture—that is, reactive instead of

generative—out of fear of not conserving our institutions against change. And ironically, the inverse dynamic has risen up in the contemporary art world as it seeks to conserve what is nearly an orthodox dogma of avant-garde freedom."[5] This is our time. How did we arrive at this current situation?

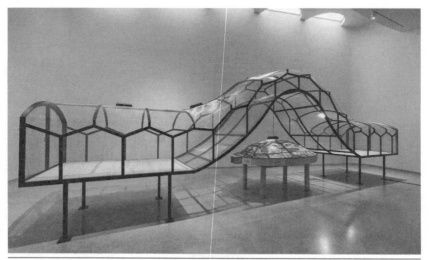

Figure 9.4. Huang Yong Ping, *Theater of the World* (2017) (as displayed after animal rights protests)

I will try to answer this question by sharing my opinions on the arts and aesthetics in the religious and political context of China today. Without minimizing the hostilities between these two contexts, I will echo Roosa's method, which he refers to as "a posture—of asking questions that promotes complexity and allows for nuance."[6] My chapter title, "Wild, Wild China: Contemporary Art and Neocolonialism," is taken from the title of Barbara Pollack's seminal book about Chinese contemporary art published in 2010, *The Wild Wild East: An American Art Critic's Adventures in China.*[7] My focus on the wild complexities of contemporary Chinese art illustrates more broadly the convoluted context of any current discussion about art and Christian witness.

[5]Wayne Roosa, "A Conversation Between Contemporary Art and the Church," in *Contemporary Art and the Church: A Conversation*, ed. David O. Taylor and Taylor Worley (Downers Grove, IL: InterVarsity Press, 2017), 30.
[6]Roosa, "Conversation," 28.
[7]Barbara Pollock, *The Wild, Wild East* (Hong Kong: Timezone, 2010).

MY POSTURE

I embody the many complicated issues and perspectives at the heart of this discussion. My personal positions are as an artist, art educator, and Christian believer living in New York City and working in Beijing, Shanghai, and Hong Kong. I will discuss the context of our current times, the struggle to identify "Chineseness," case studies of contemporary Chinese art, and my missiological prescriptions. I hope to spur ideas and conversation about how Christians today might communicate and engage with more awareness and sensitivity to contemporary visual culture in China and elsewhere.

As an artist. The transformation of art in China since the Cultural Revolution has been intense and radical, thus it is difficult to summarize concisely. Suffice it to say that museums, academic institutions, and art historians are struggling to keep pace with the rapid cultural developments in China, and relatively very little has been published about contemporary Chinese art compared to art histories prior to the Communist Party of China coming to power. How to fairly contextualize "Chineseness" in this scholarship much less "Christian Chinese art" is staggeringly arduous. As a *Chinese American* artist, are my opinions "Chinese" enough as a member of the diaspora to comment on the missiology of arts in China? I will detail these challenges later.

As a Christian. Although I live very active art and faith lifestyles, I keep them distinctly separate. Without going into details of my own trauma, I, like many artists, have been deeply wounded by some Christian people and church communities. Most of the time I agree with artists about the egregiousness of Christian criticism and judgment on art or artistic behavior in the name of God. Some churches oversimplify the Bible or apply teachings out of context, lacking understanding of diversity in both theology and in localized or individual expressions of faith. This misrepresents the grace of God and the salvation message and unfortunately can drive creative individuals away from the church. Art communities are often composed of demographics that fall outside the Christian ideal of a married, nuclear, heteronormative family structure—and subsequently operate from a completely different social paradigm and historical metanarrative. As a Christian *artist*, I aim to speak truth in love to both sides, and I consider it to be a miracle that I write about these tensions in hopes of reconciling them in some way.

As an art educator. I feel deeply fraught over the issues raised at the 2018 Missiology Lectures at Fuller Seminary: Global Arts and Witness in Multi-faith Contexts. I am neither a theologian nor a traditional academic with a doctorate; instead I am constantly striving to be a translator and ambassador between Christians and artists—and yet I am frustrated about how the arts are currently engaged in churches worldwide to witness, worship, and disciple. Art critic and theorist James Elkins explains in *On the Strange Place of Religion in Contemporary Art* that "serious art has grown estranged from religion. Religious artists aside, to suddenly put modern art back with religion or spirituality is to give up the history and purposes of a certain understanding of modernism. . . . And yet there *is* something religious or spiritual in much of modern art."[8] Modernism aside, I do indeed deem this discussion to be of the utmost importance and urgency in our times. I believe art can become a third space for mutual learning and deeper exchanges between people of different generations, national contexts, and faith backgrounds.

THE INFECTIOUSNESS OF ART

When I say or refer to *art* in this discussion, it will be specifically in reference to the definition of *contemporary* visual art put forth by the Getty Museum in Los Angeles. I prefer the Getty's definition because it takes into account the fact that artists today work in a wide range of mediums to reflect and comment on a global environment that is culturally diverse, technologically advancing, and multifaceted.

> The term "contemporary art" refers to art made and produced by artists living today. . . . When engaging with contemporary art, viewers are challenged to set aside questions such as, "Is a work of art good?" or "Is the work aesthetically pleasing?" Instead, viewers consider whether art is "challenging" or "interesting." Having an open mind goes a long way towards understanding, and even appreciating, the art of our own era.[9]

This type of art is being exhibited in art galleries in urban centers, traveling to international art fairs and biennial festivals, and being reviewed and critiqued in leading art and thought publications like *ArtForum, ArtNews, The*

[8]James Elkins, *On the Strange Place of Religion in Contemporary Art* (New York: Routledge, 2004), 22-23.
[9]"For the Classroom: About Contemporary Art," J. Paul Getty Museum, www.getty.edu/education /teachers/classroom_resources/curricula/contemporary_art/background1.html.

New Yorker, *The Washington Post*, and *The New York Times*. Of course, this "high art" is not the only valuable type of visual art being made today, but it is the art accredited by the gatekeeping institutions aforementioned as it contributes to the formation of the art canon. Peter Berger says, "Ideas don't succeed in history because of their inherent truthfulness, but rather because of their connection to very powerful institutions and interests."[10] Explicitly Christian contemporary art is not generally accepted by these art gatekeepers. To comprehend why it's left out of the art discourse, we must further explore the function of art. Leo Tolstoy describes the function of art and its relating to others: "Art is a human activity consisting in this, that one man consciously, by means of certain external signs, hands on to others feelings he has lived through, and that other people are infected by these feelings and also experience them."[11]

Art with an explicitly Christian message, which I will differentiate as "sacred art," operates only within the subculture of religion, thereby isolating viewers who do not share the same faith. The function of sacred art, as Jane Dillenberger defines, is "used exclusively for worship, to teach doctrinal principles or that the viewership should follow the tenets of the work."[12] Included here are some examples of explicitly Chinese Christian art by Chen Hu, from his stations of the cross series exhibited at Hongkou Sacred Heart of Jesus Church in Shanghai (fig. 9.5).[13] I deem the infectiousness or contagiousness of such sacred art to be weak as it only attracts the attention of those already predisposed to its conditions.

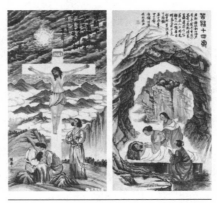

Figure 9.5. Chen Hu, *Station 12 of the Cross: Jesus Dies on the Cross* and *Station 14 of the Cross: Jesus Is Laid in the Tomb* (2015)

[10]Scott Crosby, "Faith and the Arts: a Story of Exclusion and Embrace," lecture at College of Arts and Sciences Assembly, Regent University, Virginia Beach, Virginia, April 8, 2013.

[11]Leo Tolstoy, *What Is Art?*, trans. A. Maude (London: Oxford University Press, 1932), 123.

[12]Jane Dillenberger, *Style and Content in Christian Art* (New York: Crossroad, 1986), 13.

[13]Grace Zhi, "Wash Paintings of the Bible: 'Jesus' 14 Stations of the Cross,'" *China Christian Daily*, May 11, 2016, http://chinachristiandaily.com/news/category/2016-05-11/wash-paintings-of-the -bible—-jesus—14-stations-of-the-cross-_1208.

Makoto Fujimura describes how artists embody "Mearcstapa," or exist in our world as border stalkers.[14] As people who walk on the border, artists are unseen fully by either world and thus enabled to speak with subjective distance to both sides. I have come to accept that this marginalization actually works to my advantage. It shapes my unique and idiosyncratic perspective of the world, which in turn enables me to develop creative vision for my art practice and research about institutional critique, relational aesthetics, and social practice, as many contemporary artists are also doing. As natural interlopers, artists transgress boundaries and disciplines and thus have the ability to create ubiquitous religious resonances in their creative production that enables multifaith discourse.

One such artist is Pakistani artist Huma Bhabha, who I had the privilege of interviewing. Affirming the "Mearcstapa" characteristic of artists, Huma describes how she does "not make work specifically about an event or time." Rather, she believes "work is successful when it can speak to many about many topics. Art is not to be ideology, it is to reach out to large audiences."[15]

The Metropolitan Museum of Art commissioned Huma to create *We Come in Peace* (fig. 9.6) as the 2018 site-specific installation for the museum roof garden. This monumental sculpture presents a first-encounter narrative of a totemic, five-faced figure standing in front of another figure prostrate on the ground and enshrouded in black plastic (fig. 9.7) trailing a tail of feces.

"Bhabha's work addresses themes of colonialism, war, displacement, and memories of place."[16] Her anthropomorphic characters fashioned from simple, crude forms inhabit a surreal fictional narrative that parallels how societies are reconciling "alien" and foreign cultural and religious differences. What does this artwork communicate about loving our religious neighbors? It visually references today's global international refugee crisis and anti-Muslim sentiment through a fantastical yet familiar narrative that weaves together historical tribal and colonial motifs with humble modern materials like plastic sheeting and Styrofoam. The artist addresses serious power tribulations with sensitive poeticism and human presence.

[14]Makoto Fujimura, *Culture Care: Reconnecting with Beauty for Our Common Life* (Downers Grove, IL: IVP Books, 2017), 44.

[15]Huma Bhabha, phone interview, October 28, 2018.

[16]"The Roof Garden Commission 2018: Huma Bhabha," The Metropolitan Museum of Art, www.metmuseum.org/metmedia/video/collections/modern/huma-bhabha-roof-garden-interview.

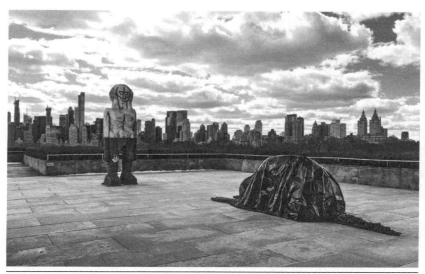

Figure 9.6. Huma Bhabha, *We Come in Peace* (2017)

Huma grew up in a Muslim home to parents who were rather private about their faith and later immigrated to the United States. Although personally she no longer holds Islamic beliefs, she acknowledges that religious signs and symbols crop up in her work nonetheless. Her motivation for this figurative sculpture stemmed from the pose of surrender in 2001 and developed over time into a series. In her fourth iteration for the Met rooftop, she incorporated the plastic that preserved the clay moisture into the sculpture's materials, its fragile tactility and banality referencing body bags and death. She expressed her horror over the violence still ravaging Iraq and Afghanistan since the

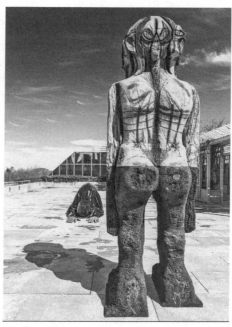

Figure 9.7. Huma Bhabha, *We Come in Peace* (2017)

9/11 terrorist attacks and the staggering number of casualties over the last seventeen years resulting from the business of warfare. Her voice vibrated with anguish lamenting the US role in the loss of human life in the Middle East and beyond, hundreds of which are civilians and go unreported in mainstream American media. In exasperation she exclaimed, "There's not much artists can do. . . . What can we do but to *bear witness*?"[17]

I also share Huma's distress over the persecution of the innocent. Leading up to the US presidential election of 2016, I created a motion-sensitive light installation at Center Art Gallery of Calvin College titled *Verti-Call* (fig. 9.8).

Aghast over fear-inducing rhetoric against Muslims and the new Middle Eastern and North African travel bans, I empathized as a person of faith. Leading up to my exhibition, I reflected on the elections and victimized minorities, and in response decided to pray three times a day for twenty-eight days in a drawing performance. Tracing the contour of my Sujud kneeling position onto sixty feet of scroll paper, I animated these line drawings into five prayer rug patterns that slowly dance across the entire gallery floor. As a viewer enters the darkened gallery and walks across this

Figure 9.8. Joyce Yu-Jean Lee, *Verti-Call* (2016)

[17]Huma Bhabha, phone interview, October 28, 2018.

evolving rug, the twenty-two-foot rectilinear skylight above them senses their bodily presence and illuminates in a vertical call and response, alluding to the activation of the Spirit by communal supplication.

To me, *We Come in Peace* represents a stellar critical example of how contemporary art today can respond to and challenge the social discrimination and violent persecution in our world's multifaith context. As an artist myself, I cannot help but also make artwork in response to religious intolerance. Since seeing Huma Bhabha's artwork, I cannot stop remembering it and pondering its meaning. As Tolstoy describes, the artwork infected me. It infected me more than any sermon or Christian event I have recently attended that promotes loving your neighbor. Can missions today in China encompass this type of cultural sophistication and emotional infectiousness? What narratives are exhibited in contemporary Chinese art?

ON CHINESENESS IN CONTEMPORARY ART

The Guggenheim exhibition demonstrated how market forces shaped Chinese identity during the 1990s and early 2000s, constructing the way that Chinese art would first be interpreted abroad. According to Barbara Pollack, "Auction houses wanted identity, galleries wanted identity and collectors wanted identity." The exhibition illustrated that this search for identity underscored "how confusing life in post-Mao China was in the 1980s and 1990s, where fanaticism and idealism of the Cultural Revolution was supplanted by the greed and competition of a capitalist economic system."[18] Considering the commercial motivations that popularized Chinese contemporary art, the academic impulse to inspect the role of missiology in it seems irrelevant and out of place to artists like myself and the professionals I interviewed working in the field. Much of Chinese contemporary art now focuses on not only cultural identity but also how Western capitalization is shaping China into a global leader. Yet Chinese artists are reacting against the limitations of such "Chineseness." Hou Hanru, consulting curator of the Guggenheim exhibition, specifically calls for an expanded concept of identity that goes "beyond" or operates "in-between": "Rather than a 're-centralization' of a 'national identity' split within art, artists prefer to expose

[18]Barbara Pollack, *Brand New Art from China* (New York: I. B. Tauris, 2018), 26, 28.

their inert and inevitable contradictions and conflicts to shake established conception and values, so as to tell the truth; now, we must learn to live in permanent and paradoxical transitions of cultural identities and differences."[19]

As an "ABC," or "American-born Chinese" of the Chinese diaspora, the commodification of identity, specifically "Chineseness," is confusing. Barbara Pollack explains, "'Chinese-ness' is a term that is slippery to define, because Chinese identity means many things to many people and has often been employed for divergent political and cultural agendas. . . . At the same time, 'Chinese-ness' is an honest attempt to evaluate one's identity at a moment when it is threatened by outside influences."[20] The current generation of young Chinese artists have moved away from making artwork that is recognizably "Chinese," reflecting instead the current newfound comforts of Chinese life and issues beyond identity.

Eric Liu asks in *A Chinaman's Chance*, "What does it mean to be Chinese American at this moment of China and America? It means being a vessel for all the anxieties and hopes that attend the arrival of China on the world scene." Transnationalism is a term popularized in the early twentieth century to describe a new way of thinking about relationships between cultures and nationalism. My transnational identity is a hybrid formed from the many places my grandparents, parents, and I have lived and the hopes and dreams we have carried along the way.[21] Liu continues, "Millions of ethnically Chinese . . . find themselves in a world with a new Mandarin-speaking superpower, and it is not the one whose passport they carry."[22] My identity traits clearly demonstrate this paradoxical transnationalism: I speak Mandarin yet cannot read Chinese characters well; I dress with Westernized fashion sensibilities yet have almond-shaped eyes and east Asian physical features, and I behave according to my bicultural/bipolitical upbringing— obstructing my identification as wholly Chinese or American. Alan Chun reflexively questions this further in his journal article "Fuck Chineseness: On the Ambiguities of Ethnicity as Culture and Identity": "Do native academics really speak on behalf of natives? I suggest that the ability of natives

[19]Pollack, *Brand New Art from China*, 31.
[20]Pollack, *Brand New Art from China*, 8-9.
[21]Quoted in Randolph S. Bourne, "Trans-National America," *Atlantic Monthly* 118 (1916): 86-97.
[22]Patti Waldmeir, "The Quest for the Meaning of Chineseness from Beijing to U.S. Sitcoms," *Financial Times*, June 22, 2015, www.ft.com/content/bd5c465e-1513-11e5-9509-00144feabdco.

and of native scholars, in particular, to speak on their own behalf is as much a function of the way academia at the metropole has relegated to them a 'local' role as the way native academia is embedded in the discourse of local society and politics."[23]

Chun warns against the dangers of locally synthesizing "outside" threats into ethnic nationalism, pannational fundamentalism, supranationalism, cult fanaticism, and cultural creolization, which can impinge on notions of identity. How can a nuanced understanding of transnational and hybrid Chinese identity become incorporated into art and missiology?

The cultural scales are only just starting to tip with weight of "model minority" Chinese Americans like myself. I hope this tipping point is not only a result of opportunistic capitalization of the world's largest population of consumers. *Crazy Rich Asians* became Hollywood's highest grossing romantic comedy in nine years, after *Joy Luck Club* premiered as the first Hollywood film with an all-Chinese cast. Fifteen years after this precedent, a Caucasian director created *Crazy Rich Asians*, casting a myriad of actors from the Chinese diaspora.[24] It may be many years before Chinese and transnational Chinese representation find equal footing with other minority counterparts in visual culture, but at least it is a step in the right direction, led by pop culture and mass media.

A Diagnosis: Neocolonialism

The disparity of international representation points to how countries or corporations engage in neocolonialism through the commodification and patronage of art and culture. "Neocolonialism has been broadly theorized as a further development of capitalism that enables capitalist powers (both nations and corporations) to dominate subject nations through the operations of international capitalism rather than by means of direct rule."[25] Control can be applied through withholding consumption or outright suppression of art and culture. Censorship and prohibition of art disseminates cultural

[23] Allen Chun, "Fuck Chineseness: On the Ambiguities of Ethnicity as Culture as Identity," *boundary 2* 23, no. 2 (Summer 1996): 133.

[24] Andrea Park, "'Crazy Rich Asians' Becomes Most Successful Studio Rom-Com at the Box Office in 9 Years," CBS News, September 4, 2018, www.cbsnews.com/news/crazy-rich-asians-becomes -most-successful-studio-rom-com-at-the-box-office-in-9-years/.

[25] "Neocolonialism," *Encyclopedia Britannica*, www.britannica.com/topic/neocolonialism.

values and ideologies, as when the Communist Party of China eradicated traditional Chinese arts and replaced it with Western socialist propaganda.

Current ideologies can be detected in the relatively recent establishment of the Western museum and not-for-profit systems in China as well as in the Western-owned galleries in the trendiest Chinese arts districts. Ironically sanctioned and developed by the Chinese government, these new paradigms demonstrate American and European influence over Chinese contemporary culture and China's willingness to be colonized. Trevor Molag describes,

> Much of the time, these practices are not resented by the recipient culture. We can see that by exporting their culture in its most appealing form to other nations, countries around the world are making good use of . . . an ability otherwise known as soft power. . . . One of the most astute concepts that illustrates the worldwide flow of American culture by mostly economic means is called "Coca-Colonization." This concept calls attention to Coca-Cola's global pervasiveness as a symbol for the Americanization of nearly every corner of the earth.[26]

That said, colonization can manifest from the opposite direction too—from artists trickling down influence to pop-culture tastemakers. The Chinese are still figuring out how to establish a unique art ecosystem distinct from the various regulations in China but have come to recognize the value of their cultural capital. In the meantime, members of the emerging Chinese upper class have begun to collect their own artists' work in an effort to retain investments within the hands of Chinese rather than export it overseas. Mass influence can arm artists with significant power. Unfortunately, as demonstrated by the protests of the animal rights activists to artworks in *Theater of the World*, I do not yet see that contemporary Chinese artists have this type of broad cultural efficacy.

ON CHRISTIANITY AND CHINA

As I followed the controversy surrounding the Guggenheim exhibition, I found myself asking why Christian community and the sense of loving our foreign neighbors had failed to present itself. Rather than delineating

[26]Trevor Molag, "Neo-Colonialism in the Modern Age: An Overview of Hegemony and Cultural Imperialism and Its Motivations and Consequences," *Medium*, January 19, 2014, https://medium .com/@trevormolag/neo-colonialism-in-the-modern-age-39138aaf2d82.

innumerable examples of how Christians do not address or engage the arts appropriately, I will focus instead on a couple of shining examples where I do find Christians thoughtfully engaging the arts in China. I will overview the Christian church in China as well as examples of the infectiousness of the Two Cities Gallery in Shanghai and another art space in China.

According to the Council on Foreign Relations, the harsh repression of traditional Chinese religions during the Cultural Revolution reduced the influence of Buddhism and Taoism and opened the door for Christian expansion. Historic events like Deng Xiaoping's reforms in the 1980s followed by the Tiananmen Square Massacre in 1989 paved the way for Christian churches, official and unofficial, to arise in the spiritual vacuum left by the void of tarnished communist ideology. "Believers are not only searching for meaning in their own lives but also for the future of their country as China adapts to a rapidly changing economy and society."[27] Are the Chinese creating their own cultural faith independent from American Christianity? One of my mentors divulged her conversations with Chinese people about this: "Outsiders think Christianity in America is about comfort. Foreigners think Christians in America only pray about their jobs, career, etc. How can we have an impact on them?"[28] While this perception of American Christianity is very convicting, fortunately, the religious environment in China is quite open and unencumbered—ready to receive Western ideologies as a better option than the Chinese Communist party.

There are three types of modern churches in China. Carsten Vala recently published a comprehensive book in which he explains in detail the three types of Christian churches in China: the Three-Self Patriotic Movement (TSPM), administered and supervised by the Chinese government; the international church led by independent foreign communities in China; and local house churches organized by Chinese citizens in private homes. Since the 2000s, local Chinese Christians have founded large, public, urban churches that enlarge the bounds of the public transcript. "Urban church leaders have emerged from TSPM settings to found congregations that violate the red lines circumscribing the public impact of Protestantism by

[27]Eleanor Albert, "Christianity in China," Council on Foreign Relations, March 9, 2018, www.cfr.org /backgrounder/christianity-china.

[28]Anonymous in-person conversation, August 22, 2018.

building trust-filled ties with local authorities to assuage fears about Prot-
estant disloyalty."[29] These relationships with local officials are built on
guanxi, a Chinese term meaning "networks" or "connections," that open
doors for new business and facilitate deals.[30]

Congregations of hundreds of Chinese people now worship in urban
settings apart from the official church system but not without clear limits
on the public dimension of urban churches. No external building signs are
allowed atop venues of worship, and ambitious gatherings either fall apart
due to Protestant infighting or have been explicitly blocked by the Party.
Crosses were torn down this spring in central Henan province from "ille-
gally built" churches as the Chinese government seeks to control the huge
number of unregistered churches.[31] In light of such repression, Cartsen
advises theologians and missionaries to address the dire need for Christian
mental health and counseling services. He also suggests supporting book
publishing in China, specifically advocating bookstores as platforms for
reaching nonbelievers.

When I asked Carsten about his observations on art during his research in
Chinese Christian enclave communities in the early 2000s, he admitted that
while he saw sacred art incorporated into church worship, its integration was
a "naive effort at best." More generally, he believes art is a form of expression
which develops only after faith has taken root.[32] He asserts that although
Christian faith is growing quickly in China, it is still a relatively young religion
compared to Buddhism; thus, Christian artistic expressions extending
beyond the Bible have not yet developed. I contend that Western countries,
while already established in their Christian doctrine and history, likewise lack
sophisticated contemporary Christian art production and primarily only gen-
erate sacred art for religious worship, teaching, and contemplation.

Two Cities Gallery in Shanghai: A model of hospitality. I interviewed
Scott Crosby, director of Christian Union in New York City and founder of

[29]Carsten Vala, *The Politics of Protestant Churches and the Party-State in China: God Above Party?*
(London: Routledge, 2018), 154.
[30]"What Is Guanxi?," Investopedia, www.investopedia.com/terms/g/guanxi.asp.
[31]Christian Shepherd, "'Two or Three Illegal' Church Crosses Torn Down in Central China," Re-
uters, October 18, 2018, www.reuters.com/article/us-china-religion/two-or-three-illegal-church
-crosses-torn-down-in-central-china-idUSKBN1HH0VS.
[32]Carsten Vala, phone conversation, August 29, 2018.

the now-defunct Two Cities Gallery in Shanghai, because his gallery was a healthy model of an innovative, hospitable space to support the arts and cultivate Christian community in China. With Campus Crusade, he conducted a poll of Chinese Christian college student leaders and found that just one year after graduation, 92 percent of them no longer considered themselves Christian anymore. With that in mind, he and a few others launched Two Cities Gallery in 2002 in Shanghai, China, as a bona fide art business. I visited Two Cities in 2006 while working for Makoto Fujimura when his exhibition traveled there.

Scott described how the concept of "truth" in China is often connected to figures in positions of power; so Chinese government leaders' words and behaviors can debase the value of truth. Because of this, Chinese people increasingly look for good outside their government as well as Chinese Confucian ethics, trust in both of which has been eroded. Scott asserts that "the Chinese want to *see* what you believe, rather than hear about it."[33] On the other hand, he believes that the arts are capable of reflecting the beauty of the creation story and not just the Christian story of salvation: "Art is good in and of itself because it reflects how God made us and the world." He named Two Cities Gallery after Augustine's book *City of God*, alluding to the "city of God" and the "city of man." Its mission was to build into that city all the good things that people long for: beauty, justice, hope, plenty. Shanghai city officials loved this mission too, so they granted business permits and supported the gallery's activities. Two Cities hosted events with artists, meetings between gallerists and collectors, and produced jazz nights featuring speakers like Tim Keller, who discussed questions such as, "Why does music move us?" to spark conversations about humanity, creativity, and faith.

In the early 2000s, the emerging art scene in Shanghai had a low barrier of entry, and Two Cities pioneered an unprecedented creative platform for glass art when no other galleries in Shanghai were focusing on exhibiting or shaping discourse about contemporary craft. I believe this was an act of creativity in itself that avoided any negative associations, repeating tired missiological models, or competing with any other missionary pursuits.

[33]Scott Crosby, in-person conversation, September 2018.

Two Cities did not require the art exhibited to be Christian in content nor for the artist to be Christian themselves. Eva Ting, former gallery director, shared with me how they immersed themselves in the arts: "We created an environment for hospitality and relationship-building through thoughtful programming, bringing people into a space where faith happened."[34]

When evangelical churches engage the arts, they often make a parallel structure and "Christianize it," as Scott would call it. In doing this, Christians bifurcate art into Christian and non-Christian. Scott outlines the theological flaws with "Christianized" art: "Christians often and inadvertently reject the redemption of art—of how God is making all things new, and the role His Church plays in this process. . . . A cultural mandate from Jeremiah 29:7 is to 'seek the welfare of the city where I have sent you into exile, and pray to the Lord on its behalf, for in its welfare you will find your welfare.'"[35] In this way, I recommend that churches in the United States and China reorient their efforts in the arts to embrace it as it already exists in the world rather than use it merely as a vehicle for evangelism.

Two Cities was careful with its curatorial program, yet this innovative gallery platform was not without its challenges. Eva testified how the Chinese are very practical people, so they want to know how art is *useful*, and they often question how contemporary art serves the needs of the church. Additionally, wealthy Shanghainese Chinese people who bought art from them sometimes only invested in art for its monetary value. Older generations of Chinese Christians were not the primary attending audience at Two Cities gallery receptions but rather young, urban members of local Chinese house churches. Eventually, lack of financial sustainability led Two Cities to close its business.

Another art space: A model gatekeeper. Another example of art as witness in China is another art space, the names and location of which I keep anonymous for security reasons.[36] This art space is a nonprofit project space located in an urban village. Its aim is to serve emerging artists and art communities of China by providing exhibition, curatorial, writing, and

[34]Eva Ting, phone conversation, September 19, 2018.
[35]Scott Crosby, "Faith and the Arts."
[36]Gender-neutral pronouns "they," "them," and "their" will be used in reference to anonymous persons.

mentoring opportunities in its gallery space. I interviewed its founder, an American artist, curator, and gatekeeper in the art world. Their expertise and experience empower their art space to be a cultural bridge, providing exposure and opportunities abroad for emerging Chinese artists. I assisted them the summer of 2011, coordinating an artist residency in China, when we brought a dozen North American artists on a cultural exchange residency. We researched local art culture, galleries, museums, art workers, and patrons in order to create artwork in a large industrial studio space. That time spent meeting Chinese artists and visiting their studios in various arts villages was one of the most transformational experiences for me as an emerging artist and person of color.

Prior to curating independently in China, this individual worked with emerging artists at a prominent museum in the United States. Although secular, the mission of the museum is akin to the standard to which I believe Christians in the arts should be aspiring; the institution "believes in the promise of art and ideas to illuminate our lives and build a more just world." Although it may be their vocational success in the art world that initially attracts young Chinese artists to the art space, they are also a gatekeeper to Christian truth and faith. They ask, "Don't you want to see God do miracles amongst you? We just have to go be there. This is more important than lectures and statistics. *God* is up there wanting to do things. *God* works through everything, *God* works out of left field, through unorthodox Artists, and even in the church pew."

This person toes the strange Mearcstapa boundary between art and faith as an ambassador, liaison, and partner to the art community in China.[37] They share, "When I go to studios, that's mission—it's just doing what I naturally do as an artist and curator. But doing it for God's purposes. His purpose is so big, it includes good art, good exhibitions, good food, good wine and all these things. That is missiology."[38] They have witnessed innumerable everyday miracles in China as Chinese artists discover Christ over the years. They fulfill their missional calling and witness fruit of the Great Commission outside the church through curatorial excellence, loving Chinese artists, and supporting the art world in China.

[37] Roosa, "Conversation," 14.
[38] Anonymous, phone conversation, October 1, 2018.

The struggle and risks of being an artist and disciple of Christ in China are always evolving, but they spoke of these factors rather matter-of-factly, as part and parcel with life. People are lost along the way, and I can personally attest to that. After working with them that summer, we lost our local assistant, a talented young performance artist, to suicide the following summer. His death was devastating and left a wake of questions behind, inspiring my project, *FIREWALL* internet Café.

I was profoundly struck by how this young artist's self-perception and understanding of others and his own place in the world was influenced by what he saw (and did not see) represented online. *FIREWALL* is a socially engaged, interactive art project designed to foster public dialogue about internet freedom (fig. 9.9). The goal of my art project is to investigate online censorship by comparing the disparities of live Google searches in Western nations with those on the Baidu search engine in China. All queries are automatically translated from the input language into the other, and image results are displayed side by side with the motivation to confront censorship through a participatory process of discovery about internet visual culture.

To my surprise, my project garnered the attention of Chinese authorities. "Mia" (not her real name), a Chinese human rights lawyer and a fellow at Yale Law School, was scheduled to speak on a "Networked Feminism in China" panel that I planned in conjunction with my *FIREWALL* exhibition.

Figure 9.9. Joyce Yu-Jean Lee, *FIREWALL* pop-up internet café (2016, ongoing)

Chinese authorities prohibited Mia from participating, instructed her to return to China immediately, and forbid her from ever speaking in public again. She obliged and refrained from speaking on my panel, but she remains in the United States indefinitely as an asylee continuing her research and activism for Chinese women's rights. This intervention from the Communist Party of China taught me that Chinese government oversight extends overseas and that art has power to challenge authority. How might the power of Christian art become more glorious? How can Christians make more art (socially engaged or otherwise) that impacts the world? "For our struggle is not against flesh and blood, but against the rulers, against the authorities, against the powers of this dark world and against the spiritual forces of evil in the heavenly realms" (Eph 6:12).

How Can the Church Become Infectious?

I see common postures among Two Cities and the other art space that are also present in the proliferation of Chinese local house and urban churches: postures of hospitality, or *guanxi*, the Chinese way. Taylor Worley of the Center for Transformational Churches writes about hospitality: "Nouwen describes authentic and meaningful hospitality as both receptivity and confrontation. By confrontation, he means the assertive presence of a somebody rather than an indistinct, supposedly neutral nobody. . . . This balance of receptivity and confrontation . . . is the essence of hospitality's risk, and without such risks, how could hospitality ever prove itself?"[39]

Another posture worthy of adoption is deep engagement with Chinese art and the inner workings of its art industry. "Art is something you can go see prayerfully. In the spirit world, it does something. Go see. If the artists are there, go talk to them. Talking to artists will lower the level of discomfort to understanding their work and them as people. Listen to what they have to see. That's something concrete the Church can do."[40] Engaged seeing will also benefit Christian artists, freeing them to make more authentic artwork with excellence for a broader audience and contribute to cultural discourse in a generative rather than oppositional way.

[39]Taylor Worley, "From Hostility to Hospitality: Felix Gonzales Torres' 'Curtains,'" *CIVA SEEN Journal* 14, no. 2 (2014): 24.
[40]Anonymous, conversation.

Last, missional efforts become more effective when they are decoupled from contemporary Chinese art and aesthetics, allowing art and faith to coexist peacefully in separate spheres, each fully reflecting and expressing the breadth of human experience differently. Although we may wish these spheres overlapped more, they simply cannot. The church does not comprehend modern or contemporary art, as evident in Immanuel Kant's insistence that to take part in the experience of art allows the "free play of imagination," where things are no longer bound to any external reference.[41] Yet James Elkins upholds this quandary: "The name *God* does not belong in the language of art in which the name intervenes, but at the same time, and in a manner that is difficult to determine, the name *God* is still part of the language of art even though the name has been set aside. That is the stubbornness and challenge of contemporary art."[42]

[41]Jonathan Paul Gillette, "Sacred Decay" panel discussion, Chicago, 2009.
[42]James Elkins, *On the Strange Place of Religion*, 116.

10

···

The Poetic Formation of
Interfaith Identities

The Zapatista Case

William Dyrness

This chapter attends to the visual imagery accompanying and promoting the Zapatista struggle for justice in southern Mexico. The several chapters in this book focusing on the role of music have illumined the central role of musicality in the spiritual culture of people. The traditions of visual art have been more difficult for missionaries to integrate into their work—something that is discussed further in the introduction. The chapter by Joyce Lee demonstrates one of the reasons for this that reflect the powerful influence of the Western art world. Another is the lack of any visual tradition in the worship and spirituality of Protestant missionaries. This chapter reflects a newer and more promising approach to the visual arts that moves religious reflection on the arts away from a focus on individual images or artifacts, requiring special times and places, toward a broader view of the aesthetic dimension of life, including religious life. This approach follows Nicholas Wolterstorff's notion that we live and act aesthetically.[1] Further it is an attempt to broaden the ecumenical focus of this book to consider the pluralistic, multireligious context of—especially—minority subcultures and consider the implications of this for missions.

Careful observation of these subaltern groups reveals the multiple repertoires that their projects draw upon and the way their various norms

[1]Nicholas Wolterstorff, *Art in Action: Toward a Christian Aesthetic* (Grand Rapids: Eerdmans, 1980).

interact. Aesthetics calls attention to the affective surface—the look and feel—of these performances. Sally Promey and Shira Brisman have pointed out the multiple factors that make up this aesthetic situation: "Objects, images, and a proliferation of materialities engage, shape, interact with human bodies, events, and ideas just as profoundly, subtly, and emphatically as the textual and literary 'objects' with which scholars generally exercise more comfortable familiarities. Pictures and things surround us and people work with them—and they with people—in constructing selves, communities, and worlds."[2]

This is especially true of the way indigenous communities interact with dominant religious and cultural traditions. So, for example, while it is helpful to learn that Muslim aesthetics focuses on the beauty—the sound, shape, and performance—of the Qur'an, or that Hindus are attracted by aesthetic emotions in the form of "tastes" or "flavors" (*rasas*), these foci must be examined within the specific political and cultural constellations in which they are mobilized.

To illustrate this claim, the focus of this chapter will be on the religious and aesthetic practices of the Zapatista movement, especially the role of women in the recent history of Chiapas in southern Mexico, and I will seek to explore them in the light of the multiple religious, political, and cultural factors of that context. The Zapatista movement is part of a global awakening of indigenous communities that frequently use aesthetic practices to mobilize communities to assert identity and resist perceived injustices. As an introduction to these grassroots movements in their multireligious settings, I offer two brief glimpses of parallel Islamic and Hindu situations in Iran and south India.

Consider first the life and impact of Mohammed Reza Sharjarian during the Iranian revolution of 1979.[3] Though growing up in a strict Muslim home, he had become a champion of the traditional Persian texts and poems (a classical style of music called *avaz*) and was forced during the revolution, out of love for his homeland and for humanity, to create an alternate public

[2]Sally M. Promey and Shira Brisman, "Sensory Cultures: Material and Visual Religion," in *The Blackwell Companion to Religion in America*, ed. Philip Goff (Malden, MA: Wiley-Blackwell, 2010), 177-205 (at 179).

[3]For what follows see Nahid Siamdoust, *Soundtrack of the Revolution: The Politics of Music in Iran* (Stanford: Stanford University Press, 2017), esp. chap. 3.

space where this traditional Persian repertoire could become a vehicle of protest. As Nahid Siamdoust shows, Sharjarian created his music out of the various transcripts he inherited—the recitation of the Qur'an, the conflicting influences of both traditional Persian and modern Western music (though the latter was dismissed by religious leaders as "idle talk" that distracts from God's remembrance), and his own growing love for indigenous (pre-Islamic) forms. From these sources Sharjarian created musical artifacts that embodied his Muslim faith, his love for his homeland, and his attraction to the rich tradition of Persian music, and that circulated as currency in the symbolic market of the Iranian search for a contemporary identity—both in Iran and the Persian diaspora. Though using multiple religious, political, and cultural transcripts, Sharjarian owes his success and his immense popularity to his childhood vocation of offering Qur'anic recitations that attracted wide admiration. This gave his subsequent work as a world-famous singer sufficient gravitas to protect him from the wrath of authorities and, despite their restrictions, allowed him to restore traditional Persian musical forms to legitimacy. But though it was, arguably, the aural world created by Qur'anic recitation that allowed his music to resonate so deeply with his Muslim audiences and that provided resources for his subsequent role as an icon of reformist protest, this religious aesthetic was conditioned by the political and cultural situation in which it emerged. Still it was the power of this indigenous musical tradition—its embodied aesthetic—that both carried and fueled the movement toward reform.

The Dalit people of south India, though religiously diverse, have been overrepresented in the Christian minority of India. They represent the lowest class of people, called by the British the Untouchables, or Scheduled caste. (*Dalit* means crushed, broken, or oppressed.)[4] As a result, Christian activist Dalits have resisted the appeal of the Hindu Brahmanic tradition of aesthetics and its focus on the aesthetic emotions, or *rasas*, of peace and love, even as the mainline Protestant and Catholic churches have increasingly appropriated this dominant aesthetic in their liturgies and spirituality. This appropriation, Michelle Voss Roberts believes, has often involved an overemphasis on the aesthetic experience of these *rasas*, which absorbs the

[4]For what follows see Michelle Voss Roberts, *Tastes of the Divine: Hindu and Christian Theologies of Emotion* (New York: Fordham University Press, 2014), esp. 115-55.

worshiper into her "own immediate situation."[5] By contrast, what unites
Dalit activists is their common experience of oppression, leading Christian
theologian Arvind Nirmal to insist that the Christian gospel is only
Christian if it calls attention to the realities of Dalit oppression.[6] Further,
these Christians have appropriated indigenous folk art in the form of
dances, drumming circles, and street dramas, generally despised by Hindus
as mere entertainment, as a vehicle that gives voice to a community's
emotion. Theologian James Appavoo describes the appropriation (and re-
sistance) mobilized by these multiple repertoires: "(1) People reflect on and
include their experience in the [folk] music, (2) they develop self-esteem
by proudly reclaiming folk Dalit culture and identity, (3) they resist the
tendency to internalize the hegemonic Brahmanical and Western cultures,
and (4) they struggle together (in ritual, action, and performance) against
multiple oppressions."[7]

Voss Roberts has argued that while appropriating popular musical forms,
Dalit aesthetic performances also embody the Hindu *rasa* of fury (*Krodha*),
allowing them to resist oppressive structures in a widely accepted cultural
idiom. This construct is important for Appavoo because, he says, God
speaks to and through the entire community in its expressive life. So, the
appropriation of indigenous art forms, as in the case of Sharjarian, becomes
a carrier of the movement against oppression, even as this is directed by
their religious commitments.

In both these examples, the dynamic of religious values was conveyed by
aesthetic forms, which sparked an attractive look and feel. Aesthetics here,
following Frank Burch Brown, stands for "those things employing a medium
in such a way that its perceptible form and 'felt' qualities become essential
to what is appreciative and meaningful."[8] This is perhaps better described as
a people's poetics: those practices that, rooted in primal stories and oriented
by contemporary religious forms persisting in various social and political

[5]Voss Roberts, *Tastes of the Divine*, 115. She writes, "The aesthetic excitants of devotional love
. . . cannot capture as distracted spiritual imagination."
[6]Voss Roberts, *Tastes of the Divine*, 122.
[7]Quoted in Voss Roberts, *Tastes of the Divine*, 133. See also 135.
[8]Frank Burch Brown, *Religious Aesthetics: A Theological Study of Making and Meaning* (Princeton:
Princeton University Press, 1989), 22.

circumstances, move people toward a fuller human flourishing.[9] Just as the aesthetics of these communities provides an essential frame in which to illumine the living heart of these movements, I argue that attending to the Zapatista aesthetics provides an important, and mostly overlooked, perspective on the multiple roles of religion (and religions) in that setting. These forms, shaped again by their religious commitments, are both carriers and motivators for their social protest.

THE ZAPATISTAS OF SOUTHERN MEXICO

In this chapter I will extend our reflection to Latin America and explore the role both of its dominant Catholic faith and the continuing influence of indigenous religious traditions by focusing in particular on the Zapatista movement of Chiapas over the last century.[10] The rural poverty of Chiapas in southern Mexico (until 1824 part of Guatemala), resulting from the sixteenth-century *encomienda* system and later by the *finca* system of debt peonage, helped fuel the Mexican revolution in 1910. This led to forms of communal ownership of the land (*ejido*) and to various revival movements of indigenous Mayan communities that later came to be called Zapatistas—named for Emiliano Zapata, the agrarian reformer and commander of the southern army during the Mexican Revolution. This indigenous revival was, more recently, encouraged by the Roman Catholic Diocese of San Cristobal, calling an Indigenous Congress of Mayan groups who began claiming their rights in 1974 (fig. 10.1).

This included the subsequent formation of a liberation movement known as EZLN (*Ejercito Zapatistas de Liberacion Nacional*). The contemporary Zapatista movement owes its origin to the New Year's Day uprising in 1994, when the EZLN took on the Mexican army in twelve days of inconclusive fighting that ceased with the agreement of the government to enter into peace talks; the resulting San Andrés Agreement (1996), which granted

[9]I have developed this idea in *Poetic Theology: God and the Poetics of Everyday Life* (Grand Rapids: Eerdmans, 2011). Even as I will show with the Zapatistas, the myths in many ways represent the resistance to globalization and its attendant cultural flows.

[10]Thanks to Grace Roberts Dyrness, whose interest in Zapatista women preceded and stimulated my own, for many of the images and sources used in this section. See also William Dyrness, "Can We Do Theology from Below? A Theological Framework for Indigenous Theologies," *International Journal of Frontier Missions*, 35, no. 2 (2018), 1-9.

limited autonomy to indigenous regions, though agreed to by all parties, has never been implemented. Since then the Zapatistas, against all odds, have sought to realize their autonomy by drawing on both indigenous and Christian values. With a substantial number of women in leadership, the movement has developed into a vital nonviolent and collaborative effort to create self-sustaining and productive communities that resist both the global neoliberal economic consensus and the oppressive control tactics of the Mexican government. The process has been enlivened and illustrated by a revival of indigenous art forms.

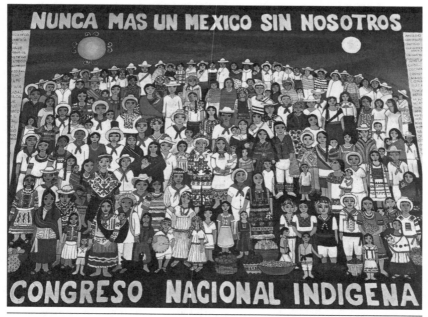

Figure 10.1. Mural portraying first national indigenous congress, 1974

Noteworthy are the multiple—religious, cultural, and political—repertoires that the movement selectively marshals. Underlying the movement and its fundamental religious motivation is the widespread commitment of (especially) the women leadership to Catholic Christianity.[11] As noted above, the Catholic diocese of San Cristobal, and its revered Bishop

[11]For what follows see Hilary Klein, *Compañeras: Zapatista Women's Stories* (New York: Seven Stories, 2015), 5-40.

Samuel Ruiz, already in the 1970s called an Indigenous Congress and introduced the impulses of Vatican II and of liberation theology, to the people. Later, in the 1970s and 1980s, Bishop Ruiz organized Bible study groups in each community that served as a catalyst for the movement. These "base communities" (*comunidades de base*), where many women learned to read and apply scriptural principles, shaped their vision of change. The women credit their study of Scripture for their ambition to claim their rights. As one woman told Hilary Klein, "We learned organizing by studying the 'Word of God' (*palabra de Dios*)." And significantly, the community organizing that resulted invariably took on aesthetic form, as they explained to Klein: "We drew, sculpted, and sang our way to empowerment." Klein records an interview with a woman named Esmeralda: "We sang one song in front of the men because the men were very sexist and didn't understand that women had rights too." As the women organized against alcoholism and for access to health care and education, Klein reports, "the women authorities were singing; the men were scratching their heads."[12] As we will see, though these Christian women did not see any barrier to joining the EZLN cause, they did resist any form of violence as a condition of their participation. The specifically Christian component of the movement has subsequently developed into a separate organization known as "Las Abejas" ("The Bees"), founded in 1992, two years before the uprising. This became well known after the December 22, 1997 Acteal Massacre, when forty-five of them were killed by state police—the majority elderly, women, and children—while they prayed.

Though the women struggled against lingering patriarchy and often had children to care for (and thus were inclined to turn down leadership positions), they succeeded in promoting a collaborative and collective style of governance that issued in a strikingly new political paradigm that has come to characterize the EZLN.[13] Their efforts began to bear fruit

[12]Klein, *Compañeras,* 53, 54, 69. Klein notes that only gradually did women become catechists.
[13]The originality of this political model has attracted considerable attention. See, for example, Richard Stahler-Sholk, "The Zapatista Social Movement: Innovation and Sustainability," *Alternative* 35 (2010): 269-90; Pablo González Casanova, "The Zapatista 'Caracoles': Networks of Resistance and Autonomy," *Socialism and Democracy* 19, no. 3 (2003): 79-92; Mary Watkins, "Notes from a Visit to Several Zapatista Communities," *Psychological Studies* 57, no. 1 (2012): 1-8; Amory Starr et al., "Participatory Democracy in Action: Practices of the Zapatistas and the Movimento Sem Terra," *Latin American Perspectives* 176 (2011): 102-19.

already during the 1980s, when they were able to materially improve their lives: alcohol consumption declined, and the long, hard work of providing medical care and education was beginning. Notably, when the EZLN was forming, the women understood their church work and the goals of the EZLN as "the same"; they were convinced God wanted liberation and not oppression.[14] After 1994, the women were active in taking over land for *ejido*; they said, "Because the land belonged to our ancestors . . . we plant everything we want and Mother Earth gives us everything."[15] These testimonies betray a second layer of religious influence, traditional Mayan belief and practice, which continues to play an outsized role in Zapatista consciousness. Many of the women, in addition to their other roles, served as elders in one or another of the Mayan groups. In 2003,

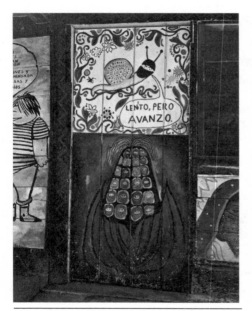

the Zapatistas organized their territory around five centers (of the various language groups) that they called "*Caracoles*" (or "conches").

The *caracol* (snail, and snail shell, or conch), featured frequently in Zapatista art, expresses a central communitarian value of the Mayan cultural identity—the snail shell itself is a symbol of the journey of life toward death. It has also informed a traditional ritual consisting of making three turns from the atrium of the church toward the community in the shape of a snail. The ritual

Figure 10.2. *Caracoles* (conches) offer religious and cosmic symbolism

[14]Klein, *Compañeras*, 59. Klein notes that earlier this movement was infiltrated by Maoist groups, but these were never able to take over the leadership. See also 32.

[15]Klein, *Compañeras*, 83. Gonzalo Ituarte states, "For the indigenous people, the land is much more than something to buy and sell; the land is their mother." Quoted in Marco Tavanti, *Las Abejas: Pacifist Resistance and Syncretic Identities in a Globalizing Chiapas* (New York: Routledge, 2003), Kindle loc. 1515.

expresses the service to the community, which Las Abejas have interpreted as God's call of "becoming mediators of the life generation process between God and the community."[16] It also traces its significance to the Mayan mythology where one of the gods was designated to hold up the sky. In order to fulfill his role, this *"sostenedor del cielo"* ("one who holds up the sky") hung a shell or conch on his chest. This enabled him to listen to the sounds and silences of

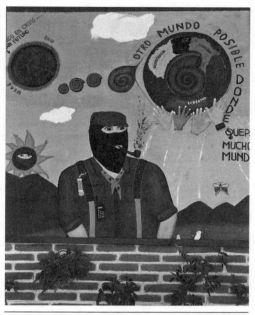

Figure 10.3. Those who hold up the sky while listening

the world to see if all was well. The image of the conch calls attention both to the central role of listening—so critical to the collective practices of the Zapatista—and to the need to call on other *"sostenedores"* to awaken them so they would not fall asleep.[17]

The Zapatistas are deeply aware of the five hundred years of struggle (*lucha*) that lie behind the current efforts, and they are adamantly opposed to forgetting this history—a fact that made recalling Columbus's voyage in 1992 especially significant for these people. They see this long journey as living and active in their current struggles.[18] José Rabasa has described this existential feel for history as "immanent history"—a living story that expresses the deepest values and identity of a people. An important artifact of this sense of history is provided by the mural *Vida y sueños de la Cañada*

[16]Tavanti, *Las Abejas*, Kindle loc. 2438. The second quote was from an interview with a member of *Las Abejas*.

[17]Casanova, "Zapatista 'Caracoles,'" 87.

[18]José Rabasa, *Without History: Subaltern Studies, the Zapatista Insurgency, and the Spectre of History* (Pittsburgh: University of Pittsburgh Press, 2010), 6, 7. On the *testimonios* of Las Abejas see 165-70 (quotation at 169).

Perla, from the community of Taniperla, Chiapas, but destroyed by the army on April 11, 1998 (fig. 10.4).

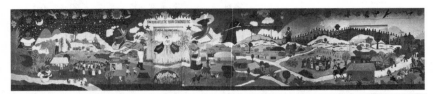

Figure 10.4. *Vida y Sueños de la Cañada Perla,* mural in Taniperla, Chiapas (destroyed)

This image collects references to the 1910 revolution, picturing Emiliano Zapata and an armed Ricardo Flores Magón, and highlighting the collective work of building community and working the land by the Zapatistas—land that is described as belonging to those who work on it.[19] One sees also in the sky images of animals that represent the spiritual affiliation of the human other in Mayan cosmology. The famous mural by Sergio Valdez had been inaugurated on April 10, the day before its destruction, and Valdez was subsequently detained by authorities for his creative efforts. The irony of the "destruction" of the mural lies in the fact that its influence and distribution has been encouraged by this mindless iconoclasm, with the result that the image of *Vida y Sueños* has become a symbol of resistance and pride to indigenous people around the world.

A further concrete example of this sense of history is represented by the *testimonios* produced by Las Abejas to memorialize the 1997 Massacre. In the morning of December 22, 1997, 250 members of Las Abejas living in a refugee camp had gathered in the Catholic chapel for prayer. Around 10 a.m. they heard shots by sixty PRI (government) paramilitary troops with AK-47s. Though they tried to flee, the troops positioned themselves between the village and forests; the attack continued until 4:30 p.m., killing forty-five (including twenty-one women—five were pregnant, and fifteen were children); twenty-five were wounded, many seriously. After official government inquest and autopsies, it was concluded that the cause was strife among "violent armed indigenous communities"—no mention was made

[19]Flores Magón, known for initiating what has become known as direct action, died in the Federal Penitentiary at Leavenworth, Kansas, in 1922. For a description of the context and meaning, see Rabasa, *Without History,* 92, 93, and for the aporias in the mural, 120-21.

of paramilitary groups.[20] Though official sources downplay the long-term attempts by local elite and government policy to deprive these groups of their rights, the people themselves have recorded their *testimonios* of these events—both in writing and photography.

A particularly moving example of these *tesimonios* is provided by the description of Rabasa.[21] This photo (fig. 10.5) shows a woman holding a dry piece of tortilla while the women recount their story. The gesture captures their mourning and their poverty as a *testimonio* to the massacre—the tortilla representing both their usual meager nourishment and the host, which communicates the presence of God. (When speaking of the host, these Tzotzil speak of the *santa tortilla [sh'ul waj]*—which is also used to break a fast.) The celebration of the mass every month on the twenty-second day reminds them of this immanent history as the dead are recalled and brought back to live among the living. José Rabasa comments on this gesture: "The revenant of all revenants, the sacrifice

Figure 10.5. Testimony to Acteal massacre

of Christ, and his return in the Eucharist, which now includes those massacred as witnesses to the truth, is embodied in the dry tortilla held by the old woman." These women have learned the discourse of human rights organizations, but this has been animated both by their deeply held Christian faith and by their own Mayan past. And as they tell their stories, their *testimonios,* they refuse to subordinate their situation to a global order, ending each *testimonio* with the words: *esta es nuestra palabra* ("this is our word").

While hearing and reflecting on these stories, one senses no tension between their (Mayan) past and their Christian present—they live in a multitemporal present (Rabasa); they are modern and premodern without contradiction. And this past is an effective history that opens up new

[20]Tavanti, *Las Abejas*, 9-13 (Kindle loc. 1608-93).
[21]Described in Rabasa, *Without History*, 165-67 (at 169).

possibilities of resistance and autonomy. But what is important for the purposes of my argument is that their story is carried and propagated by deeply felt images and symbols.

Subcomandante Marcos, the well-known spokesperson of the Zapatistas, famously makes use of symbolic figures from this past in what he calls his *cuentas* ("stories"). One such figure is named *Dorito* ("Little Hard One"), Marcos's "other self," who is at once a knight errant and a beetle.[22] Marcos playfully represents himself as the beetle's lackey, enduring sleepless nights and hours of dictation, all expressed with a mantle of self-mockery. Another character in Marcos's posse is Don Antonio, a Mayan shaman that he has gotten to know. The subcomandante eagerly passes on the stories of Don Antonio that have been kept alive in the oral tradition of the community. These stories are full of questions and ponderings that highlight the conviction that it is only by remembering and wondering—by listening—that we can begin the process of change.

These figures and stories suggest the Mayan past provides both an orientation for their collective identity and the leverage that enables them to resist the forces of globalization and the economic and cultural forces this has unleashed. Gary Gossen has described the pan-Mayan roots of this cultural uprising in terms of the "extra-somatic location of individual identity, self, and destiny."[23] The human other, such as Dorito described by Subcomandante Marcos, offers a shared spiritual affiliation, the shared essence of humans with various creatures that have survived in Mayan mythology for centuries. According to traditional understanding, humans are not an autonomous center of consciousness but a microcosm of forces outside of them. What counts, then, are not intentions of individuals but acts that harmonize with this larger order of things. Gossen notes these forces seldom appear in public life but are alive and well in the family and private world of Mayan people. Shamans help the people find equilibrium among these forces, and this collective consciousness has fostered a robust social identity that is able to navigate the complexities of the modern world (and may, Gossen suggests, offer a striking parallel to African American

[22]Casanova, "The Zapatista 'Caracoles,'" 81n4.

[23]Gary Gossen, "From Olmecs to Zapatistas: A Once and Future History of Souls," *American Anthropologist* 96 (1994): 554.

notions of "soul" as the essence of an oppressed people). Gossen summarizes the impact of this Mesoamerican context: the Zapatistas exhibit a "strikingly low profile for individual Indian leaders, sensitive reliance on collective judgments, and selective reliance on non-Indian allies."[24] The emergence of Zapatistas, often with women in leadership, José Rabasa believes, "signals a [potential] re-centering of rationality and the nation in and on Indian terms."[25]

Outside observers have tended to draw attention to the political procedures that these communities have produced. And it is certainly true that the Zapatista movement has created an emerging political economy that is impressive: Each community seeks to become an autonomous producer of goods and services necessary for its flourishing; health and education promoters are recruited and trained within the community; and diverse gifts and resources are selectively mobilized. Early on, the women began forming cooperatives that have come to play a central role in this emerging economy. They promote collective gardens, stores, and bakeries while the men grow the coffee and tend the chickens and hogs. The political scientists understandably take away from this a list of practices that might be transferable: the role of consultations and assemblies, good government juntas, local economic bases, and above all the constant sense of listening—to each other and to the universe itself. As Amory Starr summarizes this, "Zapatista autonomy is collective, relational, intercultural and centrally concerned with territory, self-governance and control of resources."[26] Others have pointed out the way power has been reframed in the Zapatista world. They have opted for a radically democratic formation of civil society from below rather than seeking change through violence or electoral politics. And their construction of new social entities grows from multiple and simultaneously held identities.[27] Despite the fact these values are fragile—the forms that carry them are at a very early stage of development and are frequently threatened by a government eager to exploit divisions and control by violence—their politics of *compañerismo* based on mutual respect and collective effort has earned them widespread respect.

[24]Gossen, "From Olmecs to Zapatistas," 568.
[25]Rabasa, *Without History*, 52.
[26]See Starr et al., "Participatory Democracy," 104-12 (at 112).
[27]Stahler-Sholk, "Zapatista Social Movement," 272-83.

Important as these practices are, it is critical that we not lose sight of the multireligious context that funds these practices or the collective aesthetic practices that have become the public face of these values. They have opened up spaces for construction and resistance. My argument is that these aesthetic artifacts and practices both define and bridge their overlapping identities. Hilary Klein describes the women's gatherings as celebrative and empowering festivals of dance, music, and mutual support. They sing an anthem—often led by youth playing their guitars—and they play sports together. As one woman reported, "We want to maintain things in our culture like respecting our elders, and dancing to traditional music."[28] They understand this call to hold these aspects together as a collective performance of contention. And though it incorporates the multiple repertoires I have described, they are experienced by the community as an integrated whole.

The aesthetics of this is embodied in their collective practices—their assemblies, their collectives that weave the bright colored cloth, their cooperative bakeries and markets. But it is represented to themselves and those observing in the stories they tell of their past and the continuing struggle (*lucha*) to find their own way. Anonymous artists called *camilios* sell their work in San Cristobal to promote their corporate communal vision (see fig. 10.6). Here one sees the common slogan

Figure 10.6. Symbols of Mayan corporate identity

of the desire for a world that is capacious enough to welcome many worlds.

Among the many symbolic images, two stand out as typical expressions in their collective representation. The first is the black ski mask (*pasamontana*) often worn by Zapatista cadre, both men and women.

The Zapatista territory is frequently marked by clear boundaries, and when one approaches the entrance to these territories, a masked person approaches to inquire into the reason for the visit. The visitor asks the representative for permission to enter, and the member disappears for a long

[28]Klein, *Compañeras*, 59, 60, 224.

consultation with others about the request. Mary Watkins, who describes such a visit, notes that people who have been faceless others, disposable in the global economy, now represent themselves in the mask that hides their face.

But we visitors—who, we think, come from the center of things—now must ask *their* permission to enter this liberated territory. The mask becomes, Watkins notes, "a multi-valent visible image to toxic messages that assault their psychic health," worn by people who since colonial times have felt themselves invisible. Confronting a person wearing a black ski mask offers a shock of reference—bringing to mind bank robbers and ISIS warriors decapitating their cap-

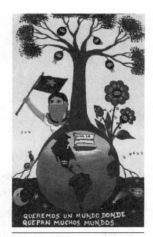

Figure 10.7. Anonymous community artists (*camilios*) promote the corporate vision of the community

tives—here worn by an army that has given up their weapons, or rather have exchanged these for consultation and collective decision making. But now the tables are turned: it is we who have become supplicants to this process. Watkins comments, however, that this border crossing "allows us to return to the center, seeing it anew, as itself a potential border site where revolt and creativity become possible."[29]

A similar shock is offered by another practice of Zapatistas, in particular of Las Abejas. When protesting the presence of the Mexican army, they have carried a red brick, which has become common in their imagery, an in-your-face reminder

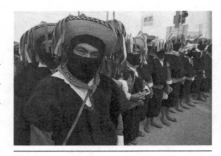

Figure 10.8. *Pasamontana* (ski mask) as representation of subversive identity

of the red blood spilled by the army in the 1997 massacre (see fig. 10.3).[30]

But to them the brick does something more important: it symbolizes their intent not to return evil for evil but to build a new world, which, as they put it, is a world in which all worlds will fit. The artifact—the red brick—

[29]Watkins, "Notes from a Visit," 2, 6.
[30]Klein, *Compañeras*, 113.

becomes a symbolic expression of their mourning and their resistance, a form of symbolic currency deployed in the struggle to build this world.

The shock provided by such images is central to the notion of aesthetics that the Zapatistas display. James Jasper, in his description of the *Art of Moral Protest*, notes that moral (and I would add aesthetic) shock is often the first step of recruitment into a social movement. The poetics is a call to action. The ski mask and the red brick offer a synthesis of morality and feeling, providing the ongoing glue of solidarity—something, Jasper notes, that is often belittled in Western, rationalist cultures. But note it is the effect, the shock, that attracts attention and solicits emotions for the hard work of resistance and construction, even if this is always rooted in deep-seated moral and religious beliefs.[31] If it is the shock that attracts attention and recruits affection and loyalty, it is the images, artifacts, and stories that, brick by brick, construct a world for these people to indwell and feel at home. This diverse repertoire offers them spaces to explore what the good life means for them and resist the oppressive machinations of global processes. Stories about Dorito, the conch, the ski mask, the brick, and the *sostenedores del cielo* give flesh and blood to their religious and cultural values. They offer places where real human bodies can come together and work for something new. Above all, they offer strident opposition to the habit of thinking that ideas about things is somehow more important than the things themselves.

CONCLUSION: ON RETURNING HOME

In the Zapatista painting of murals, traditional dancing, and singing, one is rarely confronted with the artist-creator—indeed, in most cases, this is impossible to discover. Rather it is the community that has become the creator, and the colored walls and cloth, the anthems that mark their collective gatherings, appear as the necessary component—the dress of their communal identity. Indeed, as with traditional dances, their very creation is collaborative, representing a form of embodied knowledge that builds networks of relationships that emerge over time.

One might be tempted to say that religion plays only a marginal role in these practices; few if any have specific religious content. But this would be

[31]James M. Jasper, *The Art of Moral Protest: Culture, Biography, and Creativity in Social Movements* (Chicago: University of Chicago Press, 1999), 104-11. See also 65 and 376.

a mistake. Many scholars have pointed out that globalization has not made religion less important; rather the opposite is the case. As Sandra Garner points out, "Particularly important in contemporary forms of religious life are what [scholars] call 'little religions,' sets of beliefs that are 'lived extra-institutionally' and emphasize embodiment and senses."[32] These extrainstitutional forms of religious life are often the ones that take on unique aesthetic form—the playful appropriation of traditional Persian music in Iran; the folk songs, drumming, and dances appropriated by the Dalit people; the communal murals of Zapatistas. These marginal forms provide what Michel de Certeau calls the weapons of the weak, especially as they are deployed in everyday practices.[33] In settings of oppression and violence, practices of joy and play become subversive acts.

Returning home to the liturgies of my church, I am not usually reminded of the subversive character of joy—the moral shock is mostly missing. Perhaps like the church of south India, my church has been taken captive by aesthetic emotions centering on peace and love; perhaps my church and others overlook all those who practice the little religions in our culture—those practices of shock and joy that seek to subvert and overturn structures of injustice and violence.

Still, I am reminded that liturgy is meant to be a kind of play and an act of resistance—indeed, Christian liturgy is subversive at its very core. Perhaps we need *testimonios* to be reminded of those in our community who do experience the kind of vulnerability and violence the Zapatistas know. Some of our black friends two years ago found a reason to remember this subversive story embodied in the Eucharist. In Pasadena, for an entire year after the killing of J. R. Thomas by the police in September 2016, a group of black students and their friends celebrated the Eucharist every Thursday evening from 8 to 9 p.m. at the main door of the Pasadena police station (fig. 10.9).

There with the flowers adorning the pictures of the slain youth—just starting out on his journey of life—they sing and listen to Scripture. Repeating the words of Christ, "This is my body broken for you, take and eat all of you,"

[32]Sandra Garner, "Aztec Dance, Transnational Movements," *Journal of American Folklore* 122, no. 486 (2009): 414-37 (at 433).
[33]Michel de Certeau, *The Practices of Everyday Life* (Berkeley: University of California Press, 1984), xix.

takes on a subversive character when performed at that site. But it also represents a moral shock: perhaps this is what it means to be taken up into the liberating story of the Scriptures—the *palabra de Dios*—which become, as Las Abejas women say, *nuestra palabra*—our own words too.

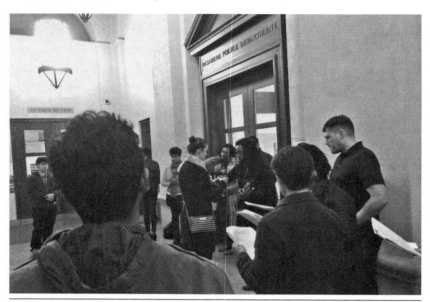

Figure 10.9. Subversive liturgy at Pasadena police station

In the context of the other chapters in this book, these reflections suggest that an important and often neglected aspect of the global mission of the Christian church resides in its artifacts and rituals. These symbols often serve as its public face, and when they express the weight and vitality of the liberating gospel, they find audiences and attract attention well beyond traditional methods. But as the Zapatista community has demonstrated, when expressing a deep religious solidarity, they can do even more: they can become instruments in the hands of the Spirit, who is creating a new world with room for all worlds.

List of Contributors

William A. Dyrness, senior professor of theology and culture, School of Theology, Fuller Theological Seminary

Ruth Illman, director of Donner Institute for Research in Religious and Cultural History, and associate professor of comparative religion, Åbo Akademi University

Jean Ngoya Kidula, professor of music (ethnomusicology) and chair of ethnomusicology, Hugh Hodgson School of Music, University of Georgia

Roberta R. King, professor of intercultural communication and ethnomusicology, Fuller Theological Seminary

James Krabill, senior mission advocate, Mennonite Mission Network

Joyce Lee, assistant professor of digital media, Marist College

Demi Day McCoy, project coordinator at Anna Julia Cooper Center, program coordinator at School of Divinity Office of Admissions, Wake Forest University

Megan Meyers, adjunct professor of global arts and world religions, Fuller Seminary, and lecturer of worship arts, communication, and contextualization, Bible Institute of Sofala and Baptist Bible Institute, Beira, Mozambique

Michelle Voss Roberts, principal and professor of theology, Emmanuel College of Victoria University in the University of Toronto

Ruth Marie Stone, professor emerita of ethnomusicology and African studies, and director of Ethnomusicology Institute, Indiana University

Sooi Ling Tan, academic dean, Asia Graduate School of Theology (AGST) Alliance, and adjunct assistant professor, Fuller Theological Seminary

Image Credits

1.1. Bridge illustration. Adapted from Ron Man, "The Bridge: Worship Between Bible and Culture," in James R. Krabill, general editor, *Worship and Mission for the Global Church* (Pasadena, CA: William Carey Library, 2013).

3.1. St. Peter's Lutheran Kpelle Choir, praying before rehearsal begins. Photo courtesy of Ruth and Verlon Stone.

3.2. Videographer James Weegi setting up to film in St. Peter's Lutheran Church, Monrovia, Liberia (2016). Photo courtesy of Ruth and Verlon Stone.

3.3. St. Peter's Lutheran Church Kpelle Choir performing (2016). Photo courtesy of Ruth and Verlon Stone.

9.1. Huang Yong Ping, *Theater of the World,* 1993. Wood and metal structure with warming lamps, electric cable, insects (spiders, scorpions, crickets, cockroaches, black beetles, stick insects, centipedes), lizards, toads, and snakes. 59 x 67 x 104 1/4 inches (150 x 170 x 265 cm) overall. Installation view: Akademie Schloss Solitude, Stuttgart, 1993. ©Huang Yong Ping. Courtesy of the artist and Gladstone Gallery, New York and Brussels.

9.2. ©Sun Yuan and Peng Yu, *Dogs That Cannot Touch Each Other,* 2003. Color video, silent, 7 minutes. Solomon R. Guggenheim Museum, New York. Purchased with gifted funds in honor of the exhibition *Art and China After 1989: Theater of the World,* 2018. 2018.22. Photo courtesy of the artists. Used with permission.

9.3. Xu Bing, *A Case Study of Transference,* 1993-94. Performance and video with two live pigs inked with false English and Chinese characters, discarded books, barriers. Installation view at Han Mo Arts Center, Beijing, 1994. ©Xu Bing Studio. Xu Bing, *A Case Study of Transference,* 1994/2017. Color video, with sound, 10 minutes. Solomon R. Guggenheim Museum, New York. Purchased with gifted funds in honor of the exhibition *Art and China After 1989: Theater of the World,* 2018. 2018.22. Used with permission.

9.4. Huang Yong Ping, *Theater of the World,* 1993. Wood and steel structure with wire mesh, warming lamps, electric cable. Installation view: *Art and China After 1989: Theater of the World.* Solomon R. Guggenheim Museum, New York. October 6, 2017–January 7, 2018. Photo: David Heald. Used with permission.

9.5. Chen Hu, *Station 12 of the Cross: Jesus Dies on the Cross* and *Station 14 of the Cross: Jesus Is Laid in the Tomb* (2015). Photos by the artist, courtesy of *China Christian Daily.*

9.6 and 9.7. Huma Bhabha, *We Come in Peace* (2017). © The Metropolitan Museum of Art. Photo by Hyla Skopitz, courtesy of the artist and Salon 94, New York.

9.8. Joyce Yu-Jean Lee, *Verti-Call* interactive installation with motion-sensitive LED lights in skylight, 2-channel video projection, 28-day drawing performance, 2016. ©Joyce Yu-Jean Lee, photo courtesy of the artist.

9.9. Joyce Yu-Jean Lee, *FIREWALL* pop-up internet café, interactive internet café installation with simultaneous Google versus Baidu search sessions, 2016 – ongoing. ©Joyce Yu-Jean Lee, photo courtesy of the artist.

10.1. Mural portraying first national indigenous congress, 1974. Photo by Grace Dyrness.

10.2. "*Caracoles*" (conches) offer religious and cosmic symbolism. Photo by Grace Dyrness.

10.3. Those who hold up the sky while listening. Photo by Grace Dyrness.

10.5. Testimony to Acteal massacre. Image courtesy of Jutta-Meier Wiedenbach.

10.6. Symbols of Mayan corporate identity. Photo by Grace Dyrness.

10.7. Anonymous community artists (*camilios*) promote the corporate vision of the community. Photo by Grace Dyrness.

10.8. Zapatista *pasamontanas*. From Dan La Botz, "Twenty Years Since the Chiapas Rebellion," Solidarity, January 13, 2014, https://solidarity-us.org/p4082.

10.9. Subversive liturgy at Pasadena police station. Photo by William Dyrness.

Name and Subject Index

2 Kings Shadow, 80
aesthetics, 26, 31, 74, 108,
 111-12, 127, 131, 136, 138, 194,
 196, 212-14, 216
 Arabic, 131
 Kenyan, 137
 Muslim, 214
 relational, 198
 religious, 215
 theory of, 177-81
 Western, 36
 Zapatista, 217
Africa, 22, 27, 69, 126, 128, 131,
 139, 142, 151, 153-54, 156,
 164-65
 Christianized, 135
 southern, 166
African Initiated Church, 158
African Methodist Episcopal,
 69
The African Queen, 21, 23
Age of Discovery, 35
agency, 157, 161, 163, 170
 fatalistic, 156
 personal, 167
Allah, 40, 60
Americanness, 162
animal rights, 192, 204
anthems, 74-75
anthropology, 1, 8, 73
 mission, 8, 11
 of religion, 139
António, Manuel Ibraimo,
 157-62, 167-68
anxiety, 164, 180, 202
 religious, 135-39
Apostle's Creed, 25
Appavoo, James, 216
architecture, 28
 church, 25-26
art activism, 177
art experience, 7, 12
artists, 193, 198, 211, 228
 Chinese, 191-92, 202, 209
 Christian, 211
 local, 31
 Native American, 38
 North American, 209

religious, 196
art, 4-14, 25, 33, 39, 110, 140
 Christian, 197, 208
 commodification of, 203
 contemporary, 196-87,
 201-3, 212
 devotional, 26
 digital, 92
 entertainment, 11
 fine, 26
 indigenous, 216, 218
 modern, 196
 patronage of, 203
 performing, 5, 88, 143
 popular, 129, 139-45, 153
 sacred, 197
 visual, 11-12, 171, 196-97,
 213
 Western, 213
 Zapatista, 220
authenticity, 14, 166-67
Azim, Hezekiah, 94, 96, 106
Bambaata, Afrika, 174
baptism, 23, 34, 141
Baptists, 69, 86
Barber, Karin, 140
Barber, William, 185
base communities, 182, 219
Batumalai, Sadayandy, 87
Bauer, Michael J., 26
beauty, 45, 60-61, 99, 207, 214
Begbie, Jeremy, 112
belonging, 154, 167
 multiple, 170
Berger, Peter, 197
Bhabha, Huma, 198-99, 201
Bibliodrama, 120
Bing, Xu, 192-93
Black Lives Matter, 173
blackness, 162
Bliss, Philip P., 78
BM Boys, 91, 95
Book of Genesis, 28
bonding, 6, 56, 59, 62, 90, 176
bridge building, 58, 64, 66
Brink, Emily R., 28
Brisman, Shira, 214
Brown, Frank Burch, 111, 216

Brown, Michael, 171-72, 187
Buddhism, 2, 87, 90, 97, 100,
 205-6
 Asian, 4
Burrows, William R., 36
call-response, 130
Cambodia, 5, 102-5
Campus Crusade, 207
cantors, 107, 121, 124
capitalism, 203
capitalization, 201, 203
censorship, 203, 210
Certeau, Michel de, 229
charismatic-Pentecostals, 26,
 69, 128-30, 137, 141-42
 in Africa, 139
Chenoweth, Vida, 8
Chia, Edmund, 88
China, 12, 91
 transformation of art in,
 195
choir, 70-71, 74-76, 79, 84, 86,
 107-8, 114, 117, 119, 122, 133
 interreligious, 113
Christendom, 35
Christian Missionary
 Alliance, 103
Christianity, 34, 87, 90, 97,
 139-45, 150, 166
 African, 33, 139
 American, 2, 205
 Celtic, 35
 Chinese, 204-11
 contemporary, 133
 syncretistic, 128
 Western, 33-34, 144
Christians, 39, 46, 70, 81, 86,
 121, 172, 182, 193, 196, 211
 Cambodian, 104
 Malaysian, 95-97, 106
 Thai, 100-101
Chung, Alan, 202-03
civilization, 35
Cold War, 190
colonialism, 90, 140-44, 153,
 198, 204
 European, 143
colonization, 127, 129

Columbus, Christopher, 221
commerce, 35
communication, 14, 25, 70, 76, 78, 87, 165-69
 gospel, 30, 32
 intercultural, 50
communitas, 167
community, 44-46, 50, 52-66, 76-77, 81, 83, 105, 109-10, 180, 216, 218, 221-22, 224-25
 Arab-American, 50
 art, 195
 choir, 118
 Christian, 207
 diasporic, 46
 global hermeneutical, 166
 imagined, 161-62
 indigenous, 214
 invisible, 49
 Islamic, 64
 Middle Eastern, 53
 Muslim, 82, 185
 sociopolitical, 140
composers, 6, 24-25, 91, 100, 116, 127, 137, 139-40
composition, 25, 29, 58, 107, 117, 120, 135, 144
 Christian, 113, 116
 Jewish, 113, 116
 Muslim, 113
Confucianism, 3, 207
Congo, 6, 26, 128
Constantine, 34
contextualization, 83, 88, 95, 100, 104-6, 113, 129, 166-68, 195
 critical, 13, 150
conversion, 69, 73, 187
cosmology, 156
 Chinese, 191
 Mayan, 221-22
Côte d'Ivoire. *See* Ivory Coast
Cowper, William, 5, 73
creation, 13, 28, 31
creativity, 10-11, 32, 110, 155, 163, 167, 169-70
creolization, 151, 203
critic, art, 14
Crosby, Scott, 207
cross, 95
Cuba, 129-30
Cultural Revolution, 190, 192, 195, 201, 205

dance, 13, 25, 28, 35, 41, 44, 69, 80, 92-93, 98, 101, 105, 130-31, 134, 136, 140, 171, 216, 226, 229
 folk, 42, 93
 Malay, 93
 traditional, 228
Darkwa, Asante, 36
de Witte, Marleen, 139-40
dehumanization, 181
democratization, 178
demons, 132-33, 156
dialogical spaces, 108
dialogue, 84, 88, 110, 113, 117, 119-21, 129, 134
 intercultural, 176
 interreligious, 107, 109-13, 120-21, 170, 172, 176
 Jewish-Christian-Muslim, 108
 musical, 119-20, 122-23
 Muslim-Christian 39
diaspora, 70, 154
 Chinese, 202
 Congolese, 128
 Persian, 215
Dillenberger, Jane, 197
disabilities, 105, 136
discipleship, 150, 160-61, 210
dislocation, 142
diversity, 13, 50, 53, 57, 61, 92, 96
 cultural, 173
 ethnic, 3
 religious, 3, 39, 139, 173
 theological, 195
Doe, Samuel, 73-74, 76, 79, 84
drama, 28, 176
 street, 216
Eastern Orthodoxy, 26, 35, 114
Ebola epidemic, 6, 69, 74, 77-82, 84, 86
Ebsell, Thomas, 190
economic inequality, 90, 95, 101
economics, 90-91, 124, 127, 141, 144-45, 155, 164-65, 192, 218, 224, 225-26
 capitalist, 90, 151, 201
Elkins, James, 196, 212
embodiment, 110, 177, 182, 188, 229

embrace, 44
empathy
 relational, 60, 65-66
empowerment, 103-5, 189, 219
Enlightenment, 191
enmity, 42
ensembles
environment, 119, 129, 144
Epic Arts, 105-6
Episcopalians, 23, 26, 86
equality, 113, 123
ethnicity, 90, 93, 95, 140
ethnodoxology, 8, 10, 14
ethnomusicology, 8-9, 14, 53-54, 64, 73, 89, 154, 166
Eucharist, 223, 229
Eurocentrism, 33
evangelicalism, 26, 37, 208
evil, 156, 228
 spirits. *See* demons
exclusion, 42, 157
Fabian, Johannes, 129, 141
Facebook, 85
family, 62, 81, 142-43, 157-58
 Muslim, 160
feasts, 28
Ferrell, Brittany, 187
Flash, DJ Grandmaster, 174-75
folk culture, 33
forgiveness
 musical, 57
Francis, Leah Gunning, 182
friendship, 1, 45, 48-49, 59-60, 63-65, 114, 159
 cross-cultural, 50
 global, 50
Friends of Middle East Music Association, 54, 59, 62
Frith, Simon, 89
Fujimura, Makoto, 198, 207
fundamentalism, 128, 203
Furious Five, 175
Gambino, Childish, 181
Garner, Sandra, 229
Gbowee, Leymah, 77
gender, 119, 123, 126, 140
generational gap, 165
Germany, 113, 115
Ghana, 75
globalization, 2, 11, 150-52, 166, 170, 191, 224, 229
 urban, 151-52

God, 30, 37, 66, 74, 95, 104,
 106, 115, 117-18, 159, 168, 183,
 186, 195, 208-9, 212, 215-16,
 220-23
 as an artist, 28
 Creator, 28, 38
 grace of, 195
 living, 146
 love of, 65-66, 101, 161
 people of, 30
 power of, 101
 as revolutionary, 184
 as sovereign, 95, 101
 Spirit of, 31
 Western perspective on,
 37
 will of, 189
gospel, 36, 127, 134, 150, 165-70,
 171, 182, 184, 186-87, 216, 230
Gossen, Gary, 224
Gray, Catherine, 36
Great Commission, 29
Guinea, 77
Hackett, Rosalind, 112
Harris, William Wadé, 22-23,
 26, 31, 38
healing, 69, 78
 social, 169
heart music, 22
Hebrew Bible. *See* Old
 Testament
Herc, DJ Kool, 174
Heschel, Abraham Joshua, 111
heterogenization, 152
Hicks, Derek, 173
Hiebert, Paul, 13
Hillsong, 94, 100, 104
Hinduism, 2-3, 132, 140, 172,
 214, 216
hipco, 80
hip-hop, 2, 5-6, 12-13, 103, 157,
 162-63, 165-69, 171, 173-81,
 184, 186
 African, 155, 157, 165
 American, 162
 intercultural dimensions
 of, 176
 justice-oriented, 173
Hodge, Daniel White, 166
holiness, 112
Holy Spirit, 30, 145, 173, 201,
 230

homogenization, 152
hope, 69, 101, 111, 123, 128, 170,
 180, 182, 184, 189, 195, 202,
 207
hospitality, 14, 167-68, 206-8,
 211
Hu, Chen, 197
human trafficking, 104
Hunter, George G., III, 35
hybridity, 88-89, 93, 102, 135,
 152, 202
hybridization, 151-52, 166
hymns, 21, 23, 73-74, 78, 80,
 83, 94, 100, 104, 137
 Christian, 74-75
 Euro-American, 70
 praise, 24
 Western, 74, 127
icon, 26
identity, 88, 103, 113, 126,
 135-39, 143, 161-63, 165-67,
 215, 224
 Chinese, 203
 Christian, 88-89, 94, 101
 commodification of, 202
 cultural, 201-2
 global, 161
 group, 89-90, 224
 kingdom, 89
 local, 161
 Malaysian, 91-94
 Mayan, 220
 national, 88-91, 97, 102,
 106
 multiple, 90, 106, 225
 personal, 89
 religious, 113, 142, 185
 Thai, 97
 transnational, 202-3
 youth, 156, 168
identity formation, 88-90, 129,
 153, 163, 167
 African, 139, 142-43
imagery
 oral, 25
 visual, 213
imagination, 110-11
 moral, 45
imago Dei, 184, 187
imitation, 145, 155, 163, 167
immigrant, 2
immigration, 2

imperialism, 143
 cultural, 153
incarnation, 36
inclusion, 93, 97, 105
India, 91, 171, 215
Indonesia, 3, 11, 46, 64
injustice, 88, 95, 104, 123, 171,
 173, 176, 178, 181, 184, 186,
 188, 214, 229
 social, 175
 systemic, 183
instrumentation, 130, 132, 132
instruments, 25, 29, 47, 69-70,
 88, 96, 99, 103, 115, 121, 128,
 134-35, 138
 Chinese, 91
 ethnic, 93
 Malaysian, 93
 modern, 127
 Western, 94
integration, 11
interculturality, 105
intermarriage, 138
International Monetary Fund,
 144
Internet, 85, 108, 161, 210
Interreligiöser Chor
 Frankfurt, 107-8, 113-14, 119,
 121, 123-24
intonation, 126
Iranian Revolution, 214
Islam, 2, 27, 42, 87, 91, 97, 108,
 116-17, 129, 131, 136, 138, 140,
 142, 144, 158, 199
Ivory Coast, 22, 24, 26, 75
Jasper, James, 228
Jerusalem, 123
Jesus Christ, 30, 32, 65-66,
 75-76, 89, 101, 106, 146,
 168-69, 173, 182, 184, 187,
 209-10, 230
 blood of, 143
 body of, 146
 incarnation of, 36-38
 sacrifice of, 222
 as savior, 159
Jews, 114, 121, 170
Jirattikorn, Amporn, 98
joy, 13, 39-42, 59, 61, 63, 131, 229
Judaism, 3
justice, 119, 172-73, 181, 183-84,
 188

social, 174
Kabbalah, 27
Kampot Playboys, 103
Kant, Immanuel, 212
Kempin, Daniel, 107, 113
Khmeng Khmer, 103
Khmer Rouge, 102-4
Kigame, Reuben, 126-28, 131,
 135, 137, 140, 145-46
King, Robert R., 9
kingdom of God, 10, 13, 146,
 170, 188
Kirk, J. Andrew, 34
Kita Serumpun, 92-93
Klein, Hilary, 226
Kreider, Eleanor, 32
Kuzzy, 80
Laack, Isabel, 112
Lamar, Kendrick, 180
lament, 102
languages, 91, 106, 116, 153,
 161, 163, 170, 176-77
 African, 127
 Hakka, 91
 Hokkien, 91
 Khmer, 102
 Kiswahili, 129
 Kpelle, 70, 72-73, 75, 84
 Malay, 91, 94
 Mandarin, 91
 multiple, 94-95
 Portuguese, 158, 161
 Teochew, 91
 verbal, 112
Latin America, 217
leadership, 56, 59, 107, 156,
 169-70, 182, 185
 bimusical, 56
 choir, 119, 121, 123
 Christian, 160
 grassroots, 185
 Liberian political, 77
 religious, 149, 173, 186, 215
 women in, 218, 225
 worship, 127
learning, cross-cultural, 61
Lebanon, 11, 46
Lederach, John Paul, 44
Lewandowski, Louis, 116
liberalization, 144-45
liberation, 220
Liberia, 6, 22-23
Liberian Civil War, 73-82

Liberian Council of Churches,
 77, 81, 84
liminality, 65, 143
Lingenfelter, Sherwood, 5
liturgy, 26, 29, 35, 122, 215, 229
Liu, Eric, 202
Lord's Supper, 29
love, 12-13, 39, 48, 65, 167, 172,
 195, 198, 215, 229
Lubembe, Kamonde wa, 130
Luther, Martin, 115
Lutheranism, 69, 71-72, 86,
 107, 113-14
Malaysia, 5, 91-97
Malaysia Gospel Music,
 94-96, 106
Marcos, Subcomandante, 224
marginalization, 90, 154, 163,
 180-81, 184
marriage, 160
media, 127, 139-40, 144-45, 183
 social, 178, 182
 US, 193, 200
McGavran, Donald A., 66
McIntyre, (Bird) Thongchai, 98
memorization, 25
Methodism, 23, 26, 69
Mexican Revolution, 217, 222
Mexico, 6-7, 213
Meyer, Birgit, 139
Middle East, 3, 40, 44, 52,
 61-62, 123, 138, 200
migration, 142, 155
miracles, 209-10
missio Dei, 170
missiology, 8, 10, 150, 164-65,
 168, 183, 195-96, 201, 203,
 207, 209
mission, 1, 10-11, 13, 25, 33, 161,
 164-66, 182-83, 189, 201, 209,
 213
 Christian, 173, 181-86, 189
 diversity, 184-86
 emic, 25
 etic, 25
 foreign, 35
 global, 230
 history of, 32
 prophetic, 189
missionaries, 4, 10, 30, 69-70,
 72-73, 104, 139, 142, 167, 171,
 206-7, 213
 Protestant, 34, 213

modernism, 153, 191, 196, 223
modernization, 102
Molag, Trevor, 204
monarchy, 97
Morgan, Samuel 'Shadow,' 80
Morocco, 46, 131
Mozambique, 149-50, 156, 158,
 160, 165, 168-69
multiculturalism, 52, 97,
 130-35, 158, 162
multireligosity, 110, 130-35,
 158, 162, 213-14
music
 African, 73
 African American, 70
 Arab American, 46
 Cambodian, 102-5
 Christian, 69, 122, 137
 classical, 40
 concert, 11
 contemporary, 96
 in crisis and conflict, 72
 cultural, 10-11
 Euro-American, 36
 folk, 40, 91, 98
 gospel, 127, 129, 137, 144
 Islamic, 122
 Jewish, 122
 Malaysian Christian,
 94-97
 Middle East, 41, 45, 62
 Persian, 55, 215
 popular, 40, 88-89, 91, 94,
 96, 103, 133, 151, 153
 secular, 127, 160-61
 Thai, 97-99
 Western, 40, 62, 96, 157, 215
music making. *See* musicking
musical space, 42, 44, 58
musicality, 213
musicking, 5-6, 39-40, 45-46,
 48-50, 54, 58, 62-66, 71, 90,
 136
 African, 133
 Christian, 136
musicians, 93, 133, 138, 142
 African Christian, 127
 Congolese, 129, 135
 Muslim, 108
 secular, 135
Muslims, 39, 46, 65, 70, 81-82,
 86, 90, 114, 121, 159, 185-86,
 200

mutuality, 14, 50, 65, 121, 124, 168-69, 196, 226
Myers, Kenneth, 33
narrative, 201
 biblical, 27-28
 communal, 153
nationalism, 35, 97, 202-3
nationality, 141, 153, 163, 201
Nation of Islam, 185
Neely, Paul, 10
neighbor, 4, 13, 15, 43-45, 58, 63-65, 161
 ethnic, 45
 foreign, 204
 multiethnic, 88
 multireligious, 88
 religious, 4, 39-40, 45, 53, 198
neocolonialism, 193, 203-4
neoliberalism, 155, 157, 218
networks, 49, 141, 206, 210, 229
 social, 168
New Testament, 73
Nirmal, Arvind, 216
non-binarism, 108-11, 118, 120, 124
nonviolence, 218
North Africa, 40
Ogude, James, 140
Old Testament, 28, 116
Open Door Policy, 192
oppression, 123, 157, 174, 181, 184, 188, 216, 218, 220, 225, 229
 Dalit, 216
 political-economic, 141
otherness, 124, 193, 224
 religious, 110, 123
pageantry, 28
painting, 25
Paradise Bangkok Molam, 98-99
Passover, 28
Patel, Eboo, 186-87
Pathomvat, Narawan, 97
patriarchy, 219
patriotism, 93
peace, 76-77, 81, 113, 119, 122-23, 172, 188-89, 201, 215, 217, 229
peacebuilding, 11, 57, 122, 170
people

African, 143
Arab, 53
Arab American, 51
Armenian, 55
coastal, 132-33
Dalit, 215-16, 229
Egyptian, 51
indigenous, 222
Kpelle, 71, 74-76, 83, 86
Lebanese, 51
Middle Eastern, 41, 50, 56
Moroccan, 51
Palestinian, 51, 179
Persian, 53, 55
Turkish, 53
performance, 25, 39, 69-70, 82, 84, 90, 93, 126, 135, 139, 144, 152-54, 216
 community through, 167
 Dalit aesthetic, 216
 dramatic, 171
 drawing, 200
 identity through, 168
 music, 83, 85, 105, 161, 170
 religious, 83
performers, 61, 140
 Middle Eastern, 43, 59
 West African, 43
perspectives
 Christian, 108
 ethical, 108
 insider's, 60
 Jewish, 108
pilgrimage, 157, 170
Ping, Huang Yong, 191, 194
Pinn, Anthony, 173
Piper, John, 30
Planetshakers, 94, 104
Pleng Lukthung, 97-101
Pleng String, 97
pluralism, 213
 cultural, 1
 religious, 1, 27, 63, 201
poetry, 35, 47, 117, 138, 163, 174, 198, 214
police brutality, 175-76, 178
politics, 90-91, 113, 123, 141, 145, 151, 155, 157, 168, 176, 181, 192, 194, 214, 218, 225
Pollack, Barbara, 201-2
popular culture, 26, 141, 144, 152-54

post-Christianity, 150
postcolonialism, 102, 135
postindustrialism, 174
poverty, 88, 104, 149, 175-76, 178-79, 222
practice
 incarnational, 50
 missional, 50
 transformative, 5, 107, 110, 119-21
praxis
 mission, 8
 musical, 60
prayer, 22, 24-25, 29, 41, 87, 104, 108, 117, 137, 183, 219
 musical forms of, 25
preaching, 25, 78, 144, 160
priest, 75
proclamation, 28-29
Promey, Sally, 214
proselytism, 153
Protestantism, 26, 37, 115, 205-6, 215
Qur'an, 116-17, 214-15
Rabasa, José, 221, 223, 225
race, 162, 181
Rah, Soong-Chan, 33
Ramlee, P., 91
rap, 150, 155, 158-60, 162-65, 168, 170
 African, 154
 Christian, 161
 internationalization of, 154
rasa theory, 171-74, 176-81, 188-89
realpolitik, 191
re-creation, 13
redemption, 13
Reformation, 35, 115
refugees, Syrian, 40-41
relationships, 39-46, 48, 50, 52, 54, 58, 62, 90, 124, 229
 imagined, 167
 social, 141, 143
religion, 48, 91, 93, 97, 107-9, 126, 143, 149, 173, 184, 193-94, 214, 229
 African, 136, 144, 150
 African American, 70
 Asian, 144
 Black, 173-74

cohabitations of, 139-44
ethnic, 27
external, 140, 142
folk, 3
foreign, 142
indigenous, 140, 217
majority world, 32
minority, 87-88
non-Christian, 32
politicization of, 90
traditional, 33, 156
resounding, 128-29, 135, 146
rites
of belonging, 141, 143, 145
of community, 140, 145
of passage, 141, 145
rituals, 29, 35, 172, 216, 220, 230
death, 81
religious, 81
Rivera, Alejandro García, 112
Robert, Dana, 50, 52
Roberts, Michelle Voss, 215-16
Roman Catholicism, 26, 33, 37,
69, 116, 159, 215, 217-18, 222
Roman Empire, 182
Roosa, Wayne, 193-94
rumba, 129, 131, 133
Sabbath, 28
Salvation Army, 136
Saphan, Linda, 102
Satan, 132-33
Schrag, Brian, 31
Schutz, Alfred, 71
Scripture, 27-30, 101, 116, 120,
169, 206, 219, 230
Second Intifada, 176
secularism, 101, 123-24, 143, 209
Senegal, 40
sexism, 175, 219
Shakur, Tupac, 176
Sharjarian, Mohammed Reza,
214-15
Shaw, R. Daniel, 36
shock, 228-29
Siamdoust, Nahid, 215
Sierra Leone, 77
Sihanouk, Norodom, 102
Sikhism, 140
silence, 77, 81, 83, 102-3
sin, 156
singing, 13, 25, 28, 56, 69, 74,
77, 79, 84, 86, 101, 104, 228

interreligious, 77-76
spontaneous, 130
Sisamouth, Sin, 103
Small, Christopher, 44, 90
Small World, Small Band, 103
Smith, W. Alan, 109
social isolation, 49
socialization, 143
social spaces, 48
solidarity, 14, 90, 101, 167, 173,
180, 182, 230
songs
Arabic, 47
Christian, 126
folk, 229
gospel, 70
Indonesian Christian, 94
popular, 80
religious, 80
Soukous, 128-29, 133, 135
South Africa, 149
South Asia, 140
Southeast Asia, 87, 92, 106
Southern California, 39-40,
42, 46, 49-50
Spafford, Horatio G., 78
spirits, 132
spirituality, 35, 111, 213, 215
spirituals, 70
Starr, Amory, 225
Strübel, Bettina, 113
sub-Saharan Africa, 3, 26, 33,
164, 168
suffering, 48, 102, 123, 158, 188
Sugar Hill Gang, 175
Sullivan, Lawrence E., 27
symbols, 35, 153, 162, 184, 224,
226, 228, 230
syncretism, 145, 152-53
tabernacle, 28
Tan, Sooi Beng, 91
Taoism, 205
Taylor, Charles, 76
Tehillim-Psalmen Project,
107-8, 114, 118
temple, 28
tension
ethnic, 88
religious, 88
Thailand, 5, 97-101
theologians, 14, 118, 196, 206
Indian, 172

theological training, 87
theology, 128
of the arts, 109
contemporary, 111
interreligious, 125
liberation, 219
living, 112
prosperity, 139
Thomas, J. R., 229
Three-Self Patriotic
Movement, 205
Tiananmen Square, 190, 205
Tolstoy, Leo, 197, 201
transformation, 50, 139, 153,
161, 167-69, 209
translation, 100, 104
transmission, 25
transnationalism, 202
trauma, 49
trust, 42, 45, 59, 65
truth, 110
Turkey, 58
Twe, Edwin 'D-12,' 80
urbanization, 15
Vala, Carsten, 206
Valdez, Sergio, 222
Vatican II, 7, 219
Veerapen, Michael, 92-93
Vesely-Flad, Rima, 184, 186-87
violence, 123, 149, 156-57, 179,
182, 199, 222, 225-26, 229
police, 172
state-inflicted, 184
voicing, 126, 132
Walls, Andrew, 150
war, 103, 198
religious, 84
warfare, 200
spiritual, 134
Wayrana, Rasmee, 98-99
Weiwei, Ai, 190-91
West Africa, 40, 78, 131
Westernization, 145
witness, 4, 11, 38, 52, 65, 150,
161, 169, 200
Christian, 45, 135-39, 171, 194
incarnational, 52, 58, 63,
65-66
interreligious, 46
in multifaith contexts, 18
performing, 52
Wolterstorff, Nicholas, 213

women, 77, 84, 113, 157, 172,
 180, 214, 219-20, 223, 225
 Christian, 76, 84, 219
 Muslim, 76, 84
 queer, 180
Word of Life Ministry, 127, 130
Worley, Taylor, 211
worship, 28, 30, 32, 38, 74,
 86-87, 104, 128, 146, 150, 170,
 197, 206, 213
 Cambodian, 102-5
 church, 206
 contemporary, 90, 94, 96,
 100, 104, 127

Indonesian, 96
missional, 30
Old Testament, 30
popular, 88
Taiwanese, 96
Thai, 97-101
Western, 96
youth, 149-50, 157, 159, 161,
 163-69, 230
 African, 155, 157, 162-63,
 167, 169
 African American, 155
 Christian, 150, 170
 disenfranchised, 181

Mozambican, 150, 161
sub-Saharan African, 155
urban, 162, 166
Youth for Christ, 127
Yu, Peng, 192
Yuan, Sun, 192
Yung, Hwa, 89
Zapata, Emiliano, 217, 222
Zapatistas, 217-28

Scripture Index

OLD TESTAMENT

Psalms
46, 114-18
121, 138

Jeremiah
29:7, 208

Micah
4:1-2, 29

NEW TESTAMENT

Matthew
22:38-39, 66

Luke
10:25-27, 11

John
4:24, 29

Acts
2:42, 29
2:44, 13
2:46-47, 29

Ephesians
6:12, 211

Revelation
7:9, 38

MISSIOLOGICAL ENGAGEMENTS

Series Editors: Scott W. Sunquist,
Amos Yong, and John R. Franke

Missiological Engagements: Church, Theology, and Culture in Global Contexts charts interdisciplinary and innovative trajectories in the history, theology, and practice of Christian mission at the beginning of the third millennium.

Among its guiding questions are the following: What are the major opportunities and challenges for Christian mission in the twenty-first century? How does the missionary impulse of the gospel reframe theology and hermeneutics within a global and intercultural context? What kind of missiological thinking ought to be retrieved and reappropriated for a dynamic global Christianity? What innovations in the theology and practice of mission are needed for a renewed and revitalized Christian witness in a postmodern, postcolonial, postsecular, and post-Christian world?

Books in the series, both monographs and edited collections, will feature contributions by leading thinkers representing evangelical, Protestant, Roman Catholic, and Orthodox traditions, who work within or across the range of biblical, historical, theological, and social-scientific disciplines. Authors and editors will include the full spectrum from younger and emerging researchers to established and renowned scholars, from the Euro-American West and the Majority World, whose missiological scholarship will bridge church, academy, and society.

Missiological Engagements reflects cutting-edge trends, research, and innovations in the field that will be of relevance to theorists and practitioners in churches, academic domains, mission organizations, and NGOs, among other arenas.

Finding the Textbook You Need

The IVP Academic Textbook Selector
is an online tool for instantly finding the IVP books
suitable for over 250 courses across 24 disciplines.

ivpress.com/academic
